MASTER
PHOTOGRAPHY
Take and make perfect pictures

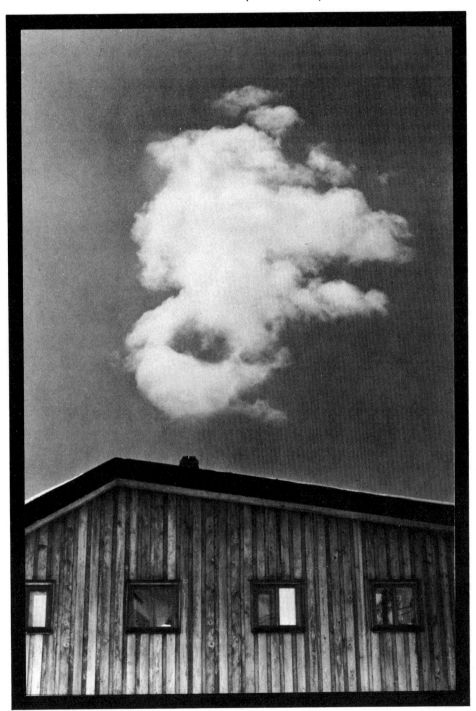

"*Your photography is a record of your living, for anyone who really sees.*"

PAUL STRAND

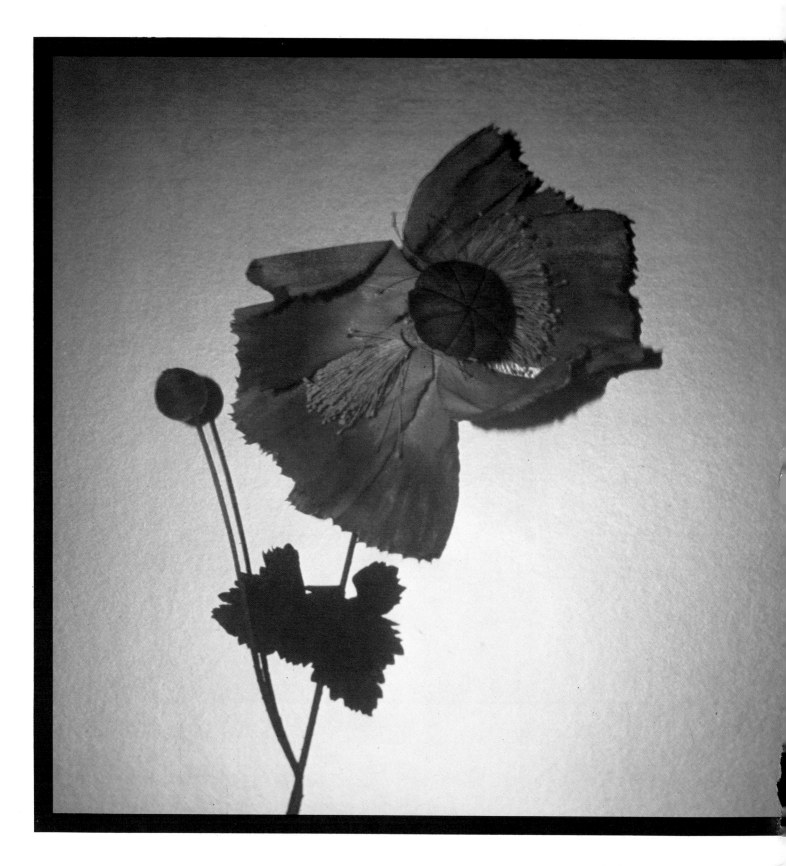

MASTER
PHOTOGRAPHY
Take and make perfect pictures

Michael Busselle

The Joy of Living Library

MITCHELL BEAZLEY PUBLISHERS LIMITED, LONDON

MASTER PHOTOGRAPHY

was edited and designed by
Mitchell Beazley Publishers Limited, Mill House,
87–89 Shaftesbury Avenue, London W1V 7AD

The Joy of Living Library
©Mitchell Beazley Publishers Limited 1976

The Joy of Living Library/MASTER PHOTOGRAPHY
©Mitchell Beazley Publishers Limited 1977

First edition published 1977
Typeset by Servis Filmsetting Limited, Manchester
Reproduction by Gilchrist Brothers Limited, Leeds

Printed by Sackville Press Billericay Limited
Bound by R. J. Acford Limited, Chichester

Consultants

David Cole, Hon FRPS, FIIP, DGPh, Head of
the School of Art and Photography at Ealing
Technical College, London W5

Fred Dustin, Senior Lecturer in Colour
Photography at the London College of
Printing, London SE1

Bob Dove of Keith Johnson Photographic,
Great Marlborough Street, London W1

Roy Green of *Amateur Photographer*

All photographs appearing in this publication,
except where credited in the captions or on
page 224, were taken by **Michael Busselle**

ISBN 0 85533 125 9

Editor	**Richard Widdows**
Art Editor	**Len Roberts**
Assistant Editors	**Tony Livesey**
	Gilead Cooper
	Dougal Dixon
	Susie Courtauld
Designer	**Lyn Cawley**
Design Assistant	**Gerry Douglas**
Editorial Assistant	**Pam Taaffe**
Picture Researcher	**Susan Pinkus**
Production	**Hugh Stancliffe**
Publisher	**Bruce Marshall**
Art Director	**John Bigg**
Production Director	**Michael Powell**
Senior Editor	**Iain Parsons**

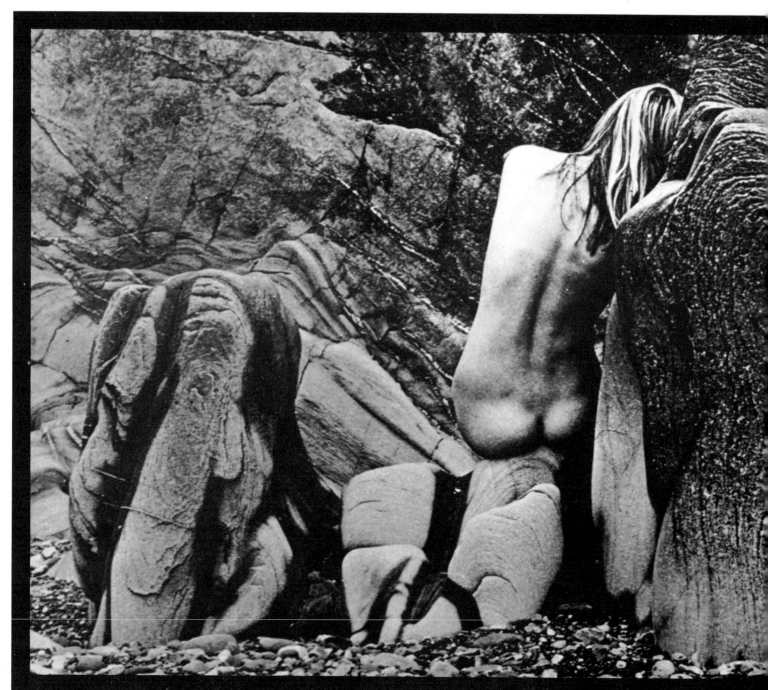

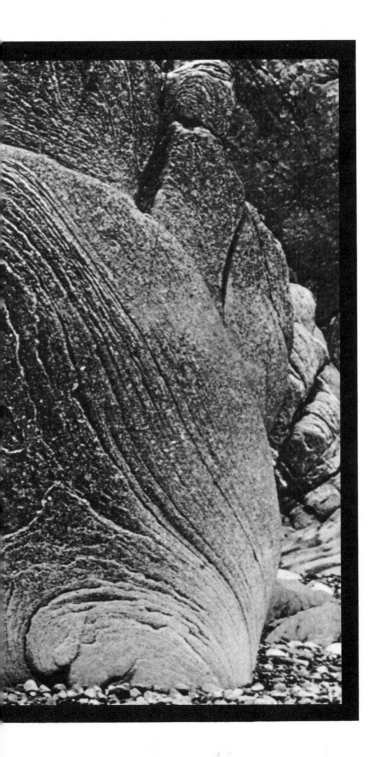

Contents

Introduction

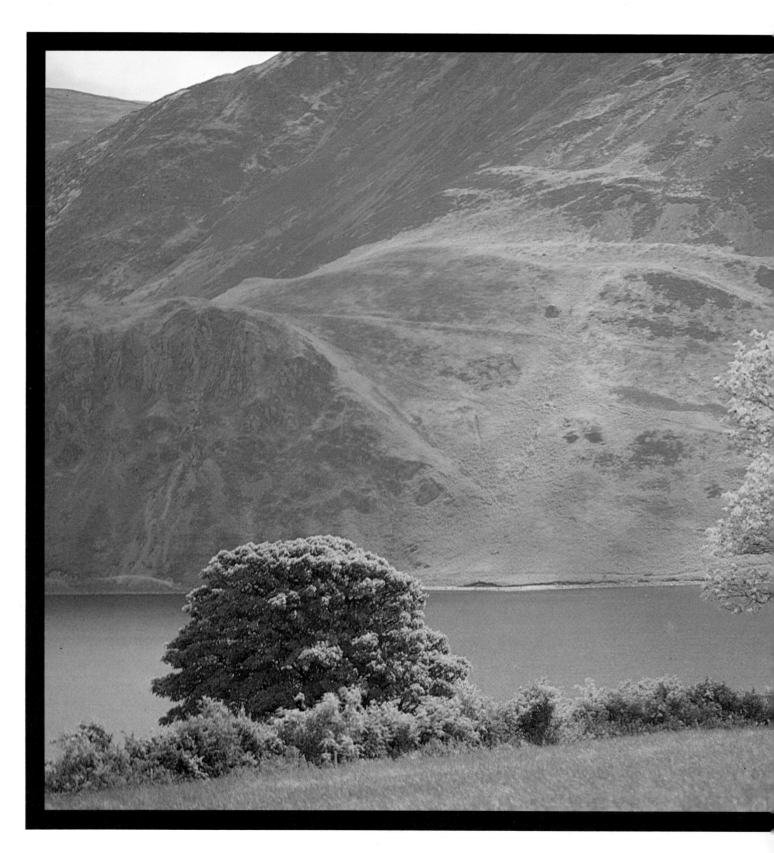

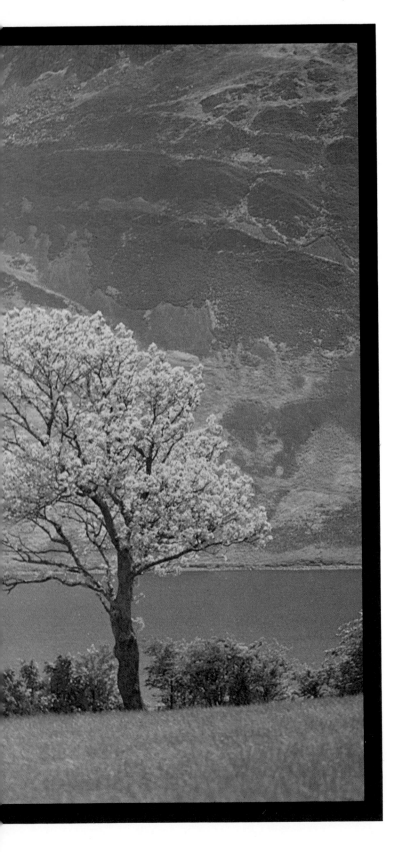

"The illiterate of the future will be the person ignorant of the use of the camera as well as of the pen." Written in 1936 by the Hungarian photographer László Moholy-Nagy, these words alone justify a knowledge of photography. But knowing how to take and appreciate photographs does very much more than make us merely literate, for photography transcends the language barrier, adds immeasurably to our understanding of the world and its peoples, and brings a more heightened awareness of beauty to our everyday lives.

Yet extensive literature on the subject has failed to make a significant contribution to our understanding at a practical level. Often, either from ignorance or in self-interest, academics have made the subject pretentious, while professional photographers have cloaked it with mystique. In writing this book I have attempted to cut through this by treating the visual and the aesthetic approach in as straightforward a manner as the technical aspects.

The only really successful way to become a better photographer is by taking pictures, but this book offers a method of by-passing a lot of things that are normally learned only by trial and error. It puts into visual form the thoughts that pass through the mind of a professional photographer when he is working.

The words and pictures provide an insight into what goes on before the shutter is pressed. Most people who take photographs take them for one of two reasons: either they want to record for interest's sake the ordinary and the extraordinary events of their lives, or their intentions are more serious and they want to express something that they feel but cannot successfully put into words. This book will help the first by explaining how to make the most of every common situation, and the second by heightening their visual awareness and by giving them a clear understanding of the mechanics of darkroom techniques, their realistic possibilities and their limitations.

Most enthusiasts are capable of becoming good photographers. It is worth pointing out that many of the world's top photographers received no formal art training; they acquired their artistic and visual senses through cultivating their awareness, observation and perception. By exercising a little visual discipline and attaining a few modest technical skills, any photographer is capable of producing photographs that will rank alongside those of the leading professionals.

Michael Busselle

THE MAGIC FRAME

"The camera is a mirror with a memory, but it cannot think."

ARNOLD NEWMAN

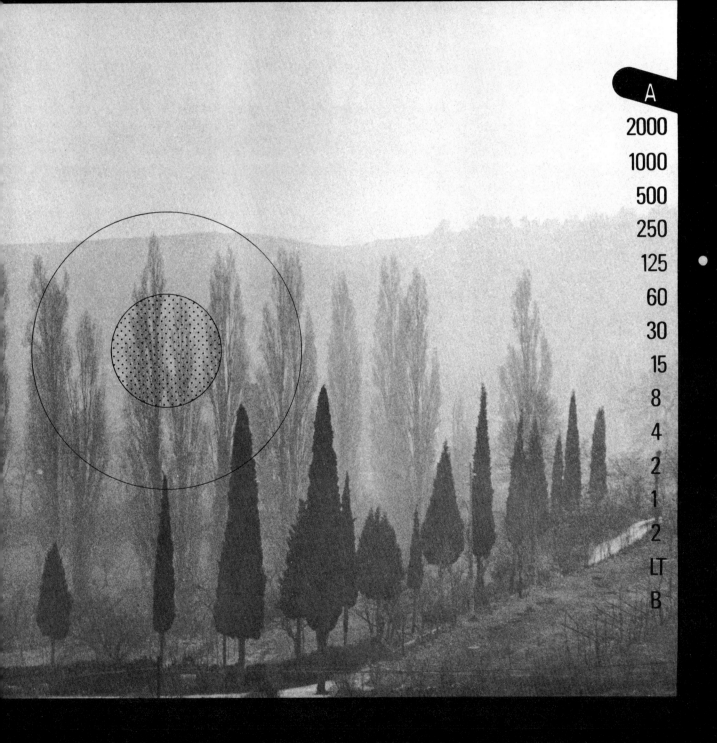

The eye and the camera

"My whole mind is a camera."
Don McCullin

Photography, like music, is a universal language; it speaks with more force and with greater directness than words. But to communicate with the maximum impact in this medium, certain basic principles must first be understood, and an appreciation of both the potential and the restrictions of the camera is a vital preliminary to exploring the art and technique of photography.

Perhaps the most important fact the photographer should recognize is that the camera works in a way totally different from the human eye. To a certain extent there is an analogy between the two. The eyelid is a shutter; the cornea and lens of the eye work together to focus images on to the light-sensitive retina; the iris controls the amount

of light that enters the eye and also aids the lens to produce a sharp, well-defined image, in exactly the same way as the diaphragm of a camera; the retina is similar to photographic film in that it contains chemical substances that are changed by light of different wavelengths. Here, however, the analogy ends.

The crucial difference is that the information collected by the eye is interpreted by the brain. Photographers, not cameras, take pictures. The man behind the camera will be influenced by sounds, smells and atmosphere, by his mood, feelings and experience —and all will determine how his brain interprets the image seen by the eye. In this way the response to the information from the eye can be very different from the reality of the scene before it. Even experienced photographers can sometimes allow themselves to be influenced by outside factors.

The viewfinder of a camera is to a photographer what a blank canvas is to a painter. What goes into it is completely at the discretion of the photographer, but he has much less control over the elements than a painter. In most instances the photographer has to find his scenes, not create them, and can then record only what he sees. A painter, on the other hand, can physically alter and adjust the relationships between the elements of his picture. Thus, what a photographer sees and how he is able to record that image is the essence of good photography.

This opening section of the book is designed to help the photographer discipline his vision so that he learns to see more like the lens of a camera. Fortunately, much can be learned with a viewing frame without the expense of actually making an exposure.

Like the camera the eye has a lens, a shutter (the eyelid), a variable aperture stop or diaphragm (the pupil) and a light-sensitive surface (the retina). The muscles of the pupil give the eye a normal working range of $f4$ to $f8$ but, with more time, it can cover a range from $f1.8$ to $f12$ (8.5–1.25 mm/0.33–0.05 in). For distant vision, the internal focal length is about 22 mm/0.875 in, and the diameter of the lens about 10 mm/0.4 in.

The picture above, taken with a special wide-angle camera from the site of the Duke of Wellington's command post for the battle of Busaco Ridge in the Peninsular War (1810), gives a field of view similar to that seen by the human eye—between about 150° and 170°. An average 35 mm camera with a standard lens can attain only a limited field of view. Examples of interesting images worth masking off from the wider scene taken in by the eye are indicated by the frames; some of these assume either a closer viewpoint or the use of a lens longer than normal. (JULIAN CALDER)

THE VIEWING FRAME

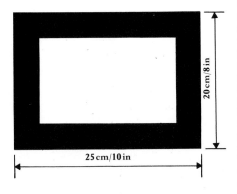

25 cm/10 in

20 cm/8 in

This simple device is a useful way of learning to isolate a potential image from the extraneous material or elements of which it is a part, and can save the beginner time and money. If this is used whenever there is the possibility of an interesting photograph, being moved around the field of view and at various distances from the eye, the novice photographer—although he may have no intention of actually taking a photograph—will soon acquire the ability to use his eyes like a camera lens. Experienced professionals know the value of this technique, and film and art directors often use their thumbs and forefingers to make such a frame when lining up a shot.

To make a viewing frame, take a piece of black card (about 25×20 cm/10×8 in) and cut an aperture (15×10 cm/6×4 in) in the centre. When this is held about 25 cm/10 in in front of one eye, with the other closed, the field of view will be the same as that given by a standard lens on most 35 mm cameras.

Awareness: the first essential

"There will always be those who look only at technique, who ask 'how', while others of a more curious nature will ask 'why'. Personally, I have always preferred inspiration to information."
Man Ray

Every photograph should have its reason for being taken. This is more significant than it may sound, for it is vital that before shooting a particular picture the photographer should fully understand why he wants to take it. Both what he takes and the quality of the results will be greatly influenced by this understanding.

The first decision to be made is whether the approach is to be objective, trying to record factually, or subjective, when the photographer will try to make a comment on, and express his opinion about, a scene or person. All subjective photographs, and to a lesser extent objective ones, represent a personal statement, and the photographer should know what he wants to express.

But he should be conscious of more than that. He should not only know why he wants to take a particular photograph but also precisely what it is that interests him.

Suppose the subject is a landscape. Should it be photographed simply because it is beautiful? Or because it is dramatic? Or unusual? And what element makes it arresting? The sky? The contours of the land? The quality of the light? Or perhaps the foreground? It may be some or all of these things in combination, but the photographer must be aware of all the components of the scene before he can decide how best to approach it.

The thinking photographer

This aspect of "awareness" sounds simple, even obvious, but it is not something that comes naturally. Thousands of mediocre photographs are taken every day because technically competent photographers have not been fully aware of exactly what they wanted to take and why. "Most photographers aim the camera and shoot without using their brains," asserts the American photographer Philippe Halsman brusquely. "Think first, photograph later. Your head is your main instrument." It is surprising how quickly the answers come once the questions are asked, and the person who is honest with himself is well on the way to getting good results. Those who are not will continue to take inferior and disappointing pictures.

Almost everyone who travels to an unfamiliar environment will find a multitude of things that excite him, but he may find little of interest in his usual surroundings. Familiarity tends to make us unobservant.

Everyday observation is, in reality, inattentive observation. It is like hearing but not listening; and while it will prevent a person bumping into a wall or tripping on a mound, it is totally inadequate for a photographer seeking to take interesting and original pictures. That requires concentration, imagination and training.

Learning to look more closely at everyday things will at first be a conscious effort, but with practice it becomes a vital habit. "The photographer need not suspect the familiar for fear of the domestic," maintained Dorothea Lange, who took legendary pictures of American poverty in the 1930s. "He will find the simple to be complicated, the miniature to be enormous, the insignificant to be decisive."

An appreciation of all these basic aspects combine to provide the photographer with a basic visual awareness; and without this he will be unable to exploit his greatest element of control—selection.

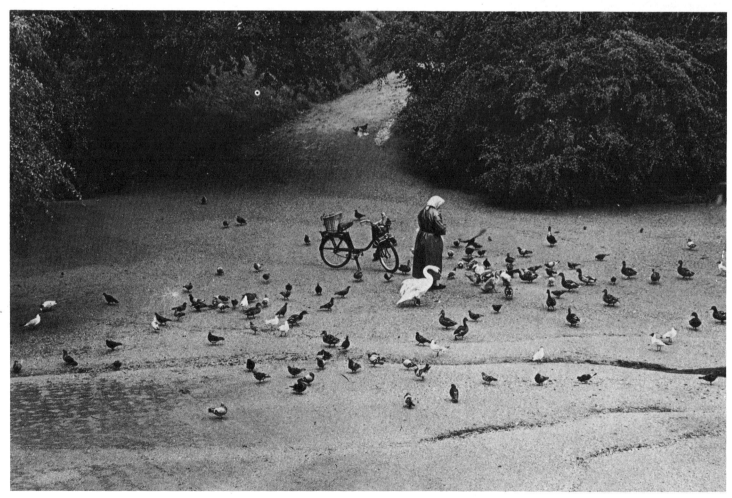

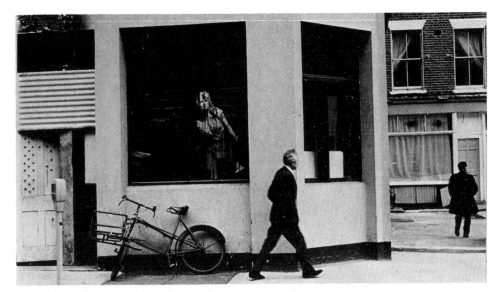

An eye for detail

An apparently casual shot taken one winter evening in central London could have been almost everyone's local street corner. Yet the contrast between black and white, the two men walking at different paces "against" the woman in the poster, the reflections in the window, the parked bicycle—all help to contribute to the strange feel of a disused film set. Closer examination (*below left*) reveals another aspect—a surreal attempt by Raquel Welch to jump from *One Million Years BC* and mount the bicycle. It can prove both constructive and rewarding for a budding photographer to take a fresh look at his immediate surroundings and produce a series of, say, 20 pictures within a certain radius from his home.
(SUSANNAH HALL)

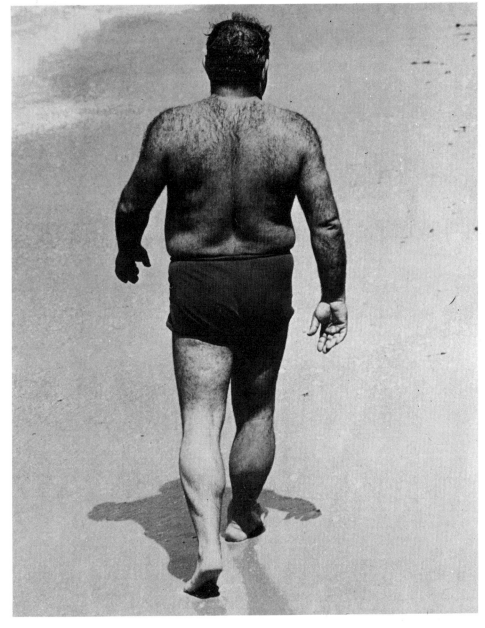

Rediscovering the familiar

An old lady feeding the birds is the kind of scene encountered every day in any city park. But just because something is common it does not necessarily mean it is banal. Here the arrangement of woman, trees, path, bicycle, swan and pigeons is both balanced and evocative, a picture possibility all too easily missed by the unobservant photographer.

Photographing the unusual

The essence of this candid camera shot is simplicity. The size, shape and hairiness of the man become vital elements merely because there are no others—only his shadow. Despite having no facial characteristics by which to judge, it is fair to assume from his build and gait that he is a strong, purposeful man.

The art of selection

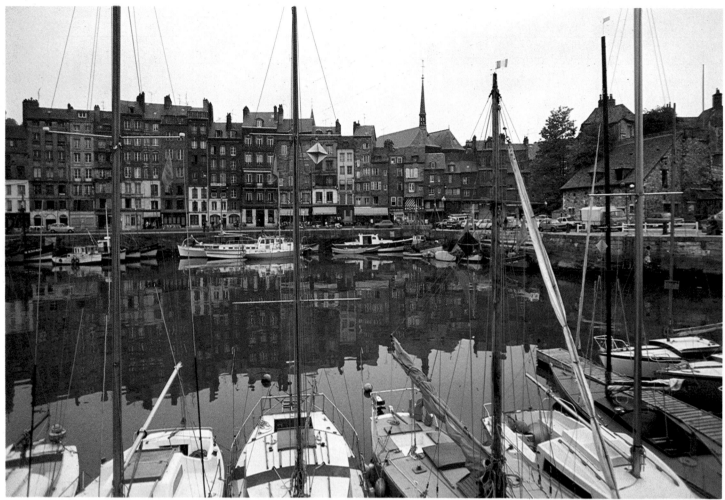

"To quote out of context is the essence of the photographer's craft. His central problem is a simple one. What shall he include, what shall he reject? The line of decision between in and out is the picture's edge. While the draughtsman starts with the middle of the sheet, the photographer starts with the frame."

John Szarkowski

When the photographer has decided what he wants to photograph and why, and has identified the various components of his subject, the next step is to decide on their relative contributions to the image.

It is usually as important to know what to leave out as it is to know what to include. The viewing frame (see page 11) can be a great help in deciding which are the most important parts or features and which can be excluded. Sometimes it is necessary to be ruthless and include only the main point of interest; alternatively, by using the viewing frame, other aspects of the scene may be discovered, ones that heighten the impact and increase the interest of the photograph.

A professional photographer, to whom the cost of film is rarely an important factor, will often take many shots of a scene, experimenting with every possible combination of the components. He knows that what he believes to be the most effective photograph may not necessarily be right for the purposes of his client.

The amateur photographer, on the other hand, has usually only himself to please and can make these experiments without cost, using his viewing frame before starting to expose film. Nevertheless, taking several shots of the same object and comparing the results can be a most effective way of learning how to be selective.

Exploring the possibilities

The top photograph illustrates the way most picture postcards—and many casual photographers—record the fishing village of Honfleur in Normandy. Yet it does justice neither to the place nor the visitor. It should serve merely as an establishing shot. By moving into that scene, exploring it, looking from various viewpoints, other aspects emerge—pictures which more accurately portray the mood and atmosphere of the village. This is an essential element in photography: the obvious can be good, but there is usually more than first meets the eye. This basic aspect of awareness applies as much to a portrait or still life as it does to a scene or landscape.

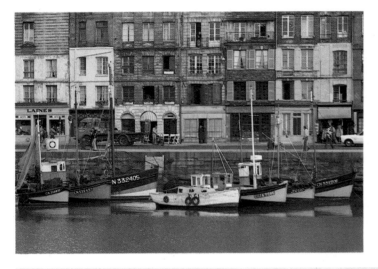

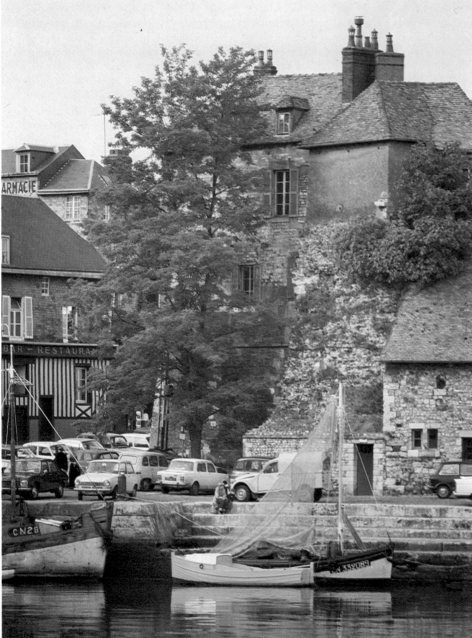

Viewpoint and composition

"If the original viewpoint concept is not right, all technical procedures have small meaning." *Ansel Adams*

The photographer's ability to select and arrange the elements of his photograph is almost totally dependent on his viewpoint. Indeed, where he places himself to take a photograph is one of the most vital decisions he makes, and often even slight changes in viewpoint can have dramatic effects on balance, structure and lighting. More than a century ago, in the early days of photography, the American scientist H. J. Morton summed it up like this: "The photographer cannot, like Turner, whisk an invisible town around a hill and bring it into view, and add a tower or two to a palatial building, or shave off a mountain's scalp. He must take what he sees, just as he sees it, and his only liberty is the selection of a point of view."

It is essential to move from one side to the other, closer in and farther away, higher and lower, in order to see the effect these moves would have on the photograph. With experience the selection of the best viewpoint tends to become instinctive, but the choices available should never be ignored.

Composition is simply the art of arranging the elements of the subject—shapes, lines, tones and colours—in a pleasing and orderly way. In most cases a well-organized picture is not only more satisfying to look at than a disorganized one; it is also easier to understand. "Composition", Henri Cartier-Bresson observed, "must be one of our constant preoccupations right up to the moment a picture is about to be taken—and then feeling takes over."

In addition to the basic "rules" (examples are shown on the opposite page), there are a number of other simple but important items that should be checked every time a photograph is taken. Is the picture "level"? Are there any unwanted or distracting details in the viewing frame? Is the principal subject clearly defined and separated from the background? Such considerations may seem all too obvious to the experienced photographer, for whom they are automatic, but they can save the beginner both time and money.

While viewpoint is the most important control over composition—and in landscapes, architecture and photojournalism, for example, often the only control—there are many occasions when the photographer can physically alter the positions of some or all of the elements in his photograph. In portraiture he can move his model; in a room he can move furniture and pictures.

In still life all the subjects can usually be positioned precisely where the photographer wants them, and it is in this area that pictures can be genuinely created rather than just taken. Even if an individual is not particularly interested in still life, taking a number of simple objects and arranging and rearranging them against different backgrounds is one of the best ways of learning about composition (see page 140). It is wise to start with a single object, preferably the one which is to be the most important, and then to add the others one at a time, stepping back repeatedly to examine the relationships between them. Though the unity of the composition can be helped by choosing objects that are related by a common theme, it depends more on the interaction of formal elements. It is not even necessary to photograph them: just to study the effects with a viewing frame.

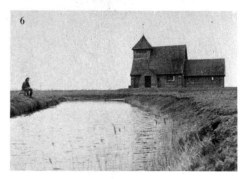

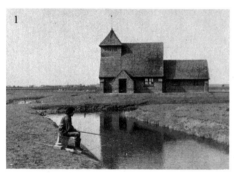

The effect of viewpoint
The choice of viewpoint is the prime determinant of composition, and the smallest changes can reproduce dramatic effects on the structure and balance of a picture. In the first photograph the three elements are fairly evenly balanced, with both man and the church —the dominant components—at the "intersection of thirds". This basic principle of composition puts the subject or subjects approximately at a point one-third of the way across a picture, either from the left or from the right, and one-third of the way up or down a picture. It is felt that this usually provides the more "comfortable" distribution of elements in a composition. By moving nearer the angler and above him (2), and adopting a poster shape, the whole scene retains its depth but becomes more compact, with the man increasing in scale. When the viewpoint is lowered (3), the man becomes even more dominant and the river least important. A viewpoint behind the man (4) reverses the positions of the two main elements, but again establishes the original balance. The same position as the first picture but a lower viewpoint (5) pushes the fisherman and the church more into the same plane and gives the river in the foreground a new prominence. Finally, a shot from the opposite bank (6) totally changes the emphasis, the river now splitting the other two elements.

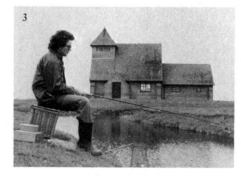

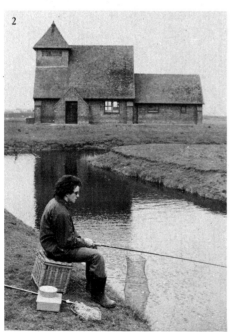

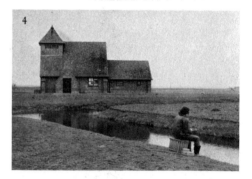

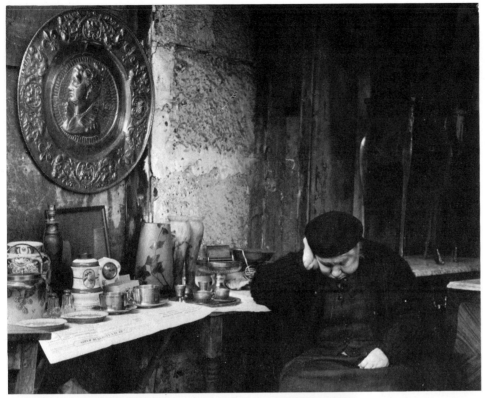

Balancing the image

Although it is often difficult to balance human and inanimate elements in a picture, the position and subdued pose of this old lady and the position and size of the plaque enable the composition to feel full and evenly balanced; neither is competing for the leading role.

Framing the picture

Where the viewer's eye is led out of the photograph, an object can be used as a natural frame. In this picture (*below left*) the houses take the eye to the church, the church spire (aided by the tall trees) points up the mountain, and the shape of the mountain top leads the eye out towards the edge of the picture. The leaves of the tree act as a barrier and hold the image, stopping the eye from "wandering". Such foreground devices should be almost devoid of detail and not of significant interest in themselves.

Following the cardinal rules

The photograph below obeys three basic "rules" of composition. First, the main point of interest is positioned on the "intersection of thirds"; second, a subsidiary element leads the eye to the main subject; third, at least part of the main subject is in strong contrast to the background. While such rules are really only guidelines—photography would become tedious indeed if they were always followed—they can be useful for the beginner with little artistic training to attain the feel of composition.

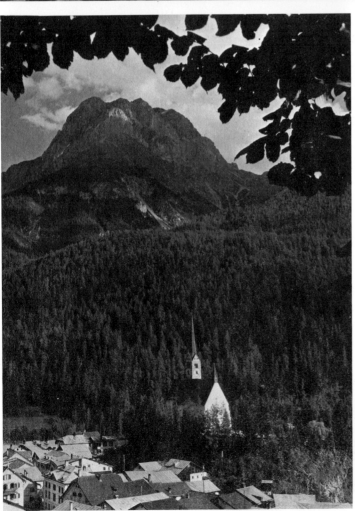

Composition: breaking the rules

The existence of "rules" presents the adventurous photographer with a challenge. While there are guidelines to composition, they can often be ignored to good effect and no photographer should let the rules dominate his own taste or artistic instinct. For every rule there are hundreds of first-class photographs where it has been deliberately broken. "It is impossible to give you rules that will enable you to compose," claimed the English art critic John Ruskin. "If it were possible to compose pictures by rule then Titian and Veronese would be very ordinary men."

While this is true, most rules are based on sound principles, born of experience and trial and error, and it is unwise to break them merely for the sake of it, or in the hope that an unconventional composition—one with several subjects of equal importance, for example—will necessarily be an artistic breakthrough. It takes experience to distinguish between an arrangement that is successfully asymmetrical or eccentric and one which merely confuses the eye.

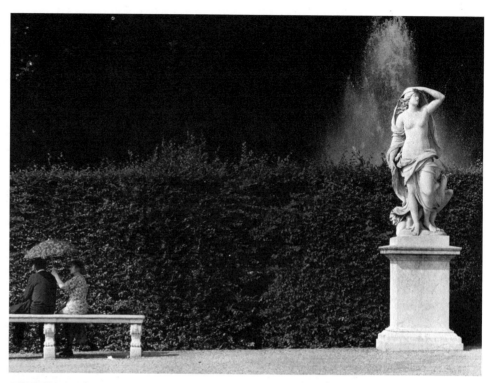

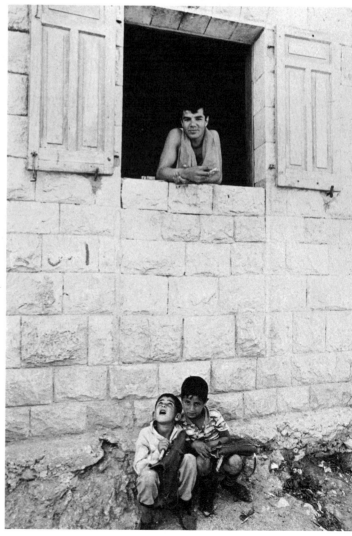

Sacrificing composition for effect
Composition must often take a back seat to a more important criterion in taking a picture—in this case that of humour. If more of the woman or of the statue had been included, the vital element of the crocodile "crawling" up on the unsuspecting would have been lost; if a poster shape had been adopted, cropping the right half of the image, the point may have looked laboured or contrived.
(NEILL MENNEER)

Dividing the image: vertical
Although only the top half of this picture (*right*) could stand up as an entity on its own, the two parts marry to form a new and very different image. The composition owes its validity to the expression on the face of one of the boys, which leads the viewer up to the natural pose of the man at the window. The link is reinforced by the lines in the stone walls.

**Dividing the image:
horizontal**
Both the ladies and the
statue seem to be
sheltering from the rain
in this shot (*left*), taken
in the Palace of
Versailles. In each case
the head is turning out
of the picture, and the
split is further exag-
gerated by the strong
vertical in the hedge.
No other viewpoint
would have given the
right effect.
(NEILL MENNEER)

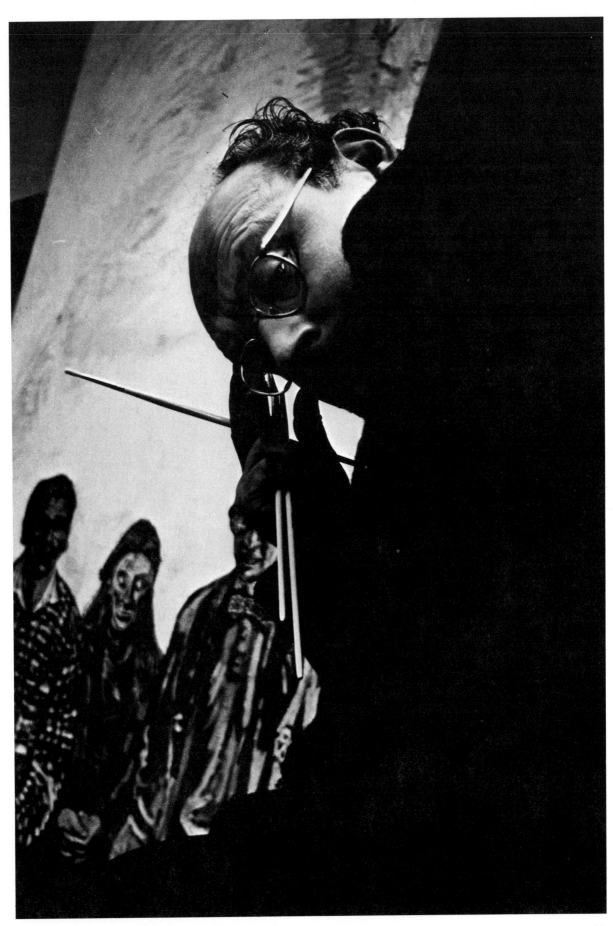

**Dividing the image:
diagonal**
A very low viewpoint
produces a heavy
diagonal division in an
unusual portrait of
artist John Bratby. One
half is almost solid black,
with the other half
containing almost all the
tonal range and detail.
The surrealistic quality
of the painting is
reiterated by the nature
of the artist's face and
hair, and the strong
expression directed into
the camera holds the
whole image together
both as a composition
and as a portrait.

Viewpoint and perspective

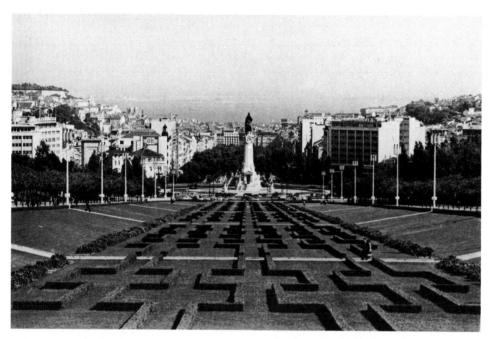

Photographs are two-dimensional, having breadth and length; to achieve the effect of depth, the third dimension, perspective must be introduced.

In reality, of course, perspective is an optical illusion. If a book is held at arm's length it will appear to be as large as a house a hundred paces away. The closer the book is moved towards the house, the nearer to their actual relative sizes the two objects will become. It is only when the book is in exactly the same plane as the house that their *apparent* relative sizes become the same as their *actual* relative sizes. If the book is placed, say, a hundred paces away from the house, and the viewer then walks farther away from both objects, they would again begin to approach their actual relative sizes.

Recognizing perspective

Essentially there are three ways of creating perspective. The most important is diminishing scale, where objects of the same size appear to become smaller the farther they are from the viewer. The second, and perhaps more immediately obvious, is linear perspective—straight, parallel lines that appear to converge in the distance. The third

Linear perspective
The most obvious manifestation of perspective— parallel lines that converge with distance—is rarely effective as the reason for a photograph. It should normally either be used as part of a composition or

broken with other elements. This view towards the centre of Lisbon combines both provisions: the perspective effect covers less than half the image and is relieved not only by the design of the hedges but also by the paths crossing the picture.

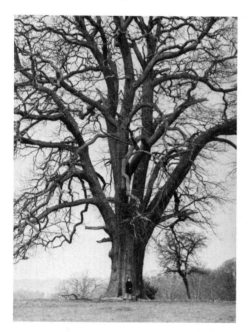

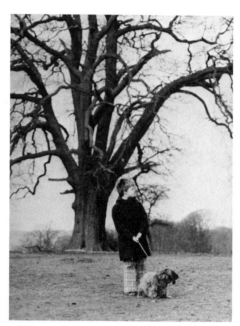

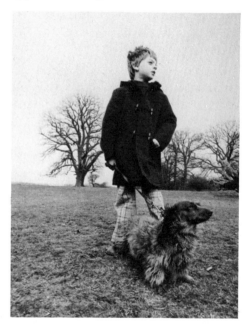

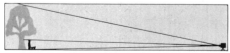

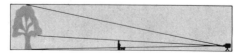

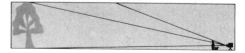

Perspective is an optical illusion, but one which is encountered continually in almost every sphere of photography, and changes in viewpoint can produce striking alterations in balance and composition. When two subjects of very different sizes are close together and a fair distance away (*above*), they are in the same

plane and the result is an accurate indication of their actual relative sizes. If the boy moves towards the camera, he increases in size and scale in relation to the tree (*above*). This proportion would remain the same whatever the distance between camera and boy and tree, provided the ratio of those distances

remained constant. As the boy moves closer to the camera, the difference in the apparent relative sizes of he and the tree becomes greater (*above*); the same result would be obtained, of course, if the photographer moved nearer the boy. The vital factor is the ratio of the distances.

Diminishing scale and overlapping perspective
A picture of the tops of oast-houses, used for drying hops, fuses two interrelated methods of creating and using perspective. Diminishing scale is where objects of the same or similar size seem to become smaller the farther they are from the viewer; in photographic images this often goes hand in hand with overlapping perspective—a feeling of depth produced by one object partly masking another behind it. In this shot the direction of the light results in dense shadows that help to emphasize the depth.

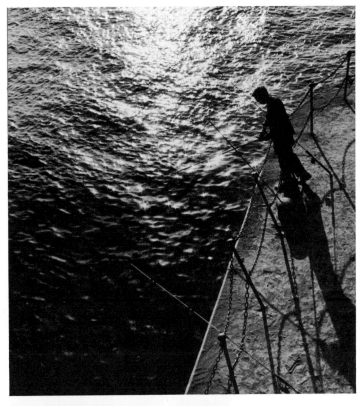

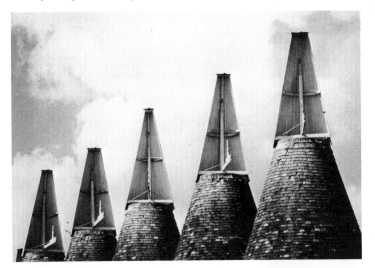

method is overlapping perspective, where a feeling of depth is given by one object partially masking another. Shadows, too, can emphasize the feeling of depth.

An understanding of perspective will help the photographer compose a better picture, for by using it he can control the relative importance of objects within the image area. Objects which progressively diminish in size create the impression of lines within the photograph—yet another factor of importance in composing a shot.

Depth and scale
However, many situations in photography present themselves where depth and perspective are positively undesirable—when depth is of less importance than the scale of objects. A building at the foot of a mountain would gain in impact if photographed from a sufficient distance so that the depth was minimized and the true scale of the two elements allowed the mountain to dominate the building.

There are nevertheless many other occasions when introducing foreground and mid-ground objects, and thus deliberately creating a feeling of depth, can greatly enhance a photograph. Take a view from a mountain top looking down on to a village in the valley below: by introducing a rock and part of the mountain slope into the foreground of the picture the impression of depth would be dramatically increased (see also pages 124–5).

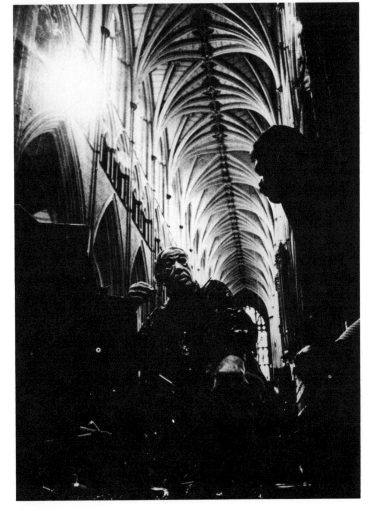

High viewpoint and perspective
Although covering only a small part of the image area, the converging lines formed by the pier rail and the picture's edge lead the eye to the main point of interest.

Low viewpoint and perspective
A low-angle shot of the composer and pianist Duke Ellington during rehearsals for a concert in Westminster Abbey creates a strange use of perspective. The roof of the nave is going away from the subject in the foreground, yet it still serves to lead the eye back and down to the central figure. A generous exposure and uprating of film was required to overcome the poor available light. (JOHN GARRETT)

Light, form and tone

"The photographer can function as long as there is light; his work—his adventure—is a rediscovery of the world in terms of light."

Edward Weston

Most everyday objects can be recognized by their outline alone. A vase silhouetted against a window will be immediately identifiable because we have all seen vases many times before. Yet the viewer can only assume that it is either round or square; he will not be certain which it is until he can see its form—and that is dependent on light.

Light is crucial to photography: the very term, coined by Sir John Herschel in 1839, comes from two Greek words that together mean "writing with light". Light creates shadows and highlights and it is these that reveal form, tone, texture and pattern.

Quality and direction of light

The two aspects of light that affect form are its quality and its direction. Quality is the term used to define the nature of the light source. This may be soft, giving faint shadows with imperceptible edges, such as daylight on a cloudy day; or it may be hard, like bright summer sunlight at noon, which casts dense shadows with sharp edges. There are also all the effects between.

The direction of the light is equally important to form. Light which is directed straight at the front of an object will not reveal much more information about its form than would a silhouette. There will be no shadows within the object itself, and unless it has a reflective surface—such as glass or metal—there will be few highlights. As soon as the object is moved so that the light source is directed from one side, shadows within the outline will appear and only then will the form of the object be revealed.

If the light source is hard the shadow within the object will be dark, with little or no detail. The change between the highlight and the shadow will be abrupt, so although the viewer will begin to see the form of the object, the visual information will still be limited. If a soft light is directed from one side of the object, however, the transition from highlight to shadow will be much more gentle and the shadow itself less dark. The detail and form will then be seen more easily. In general a soft, directional light is more likely to reveal form than a hard one.

A common exception to this is landscape photography, where form (in this case the contours of the land) is much less pronounced than it is with objects—or indeed with people. This is one of the reasons landscape photographers prefer to work either in the early morning or the late afternoon, when the sunlight is strongly directional and yet still quite hard. But it should also be noted that where the contours of the land are extreme, as in mountain scenery, this results in dense shadow areas with little detail.

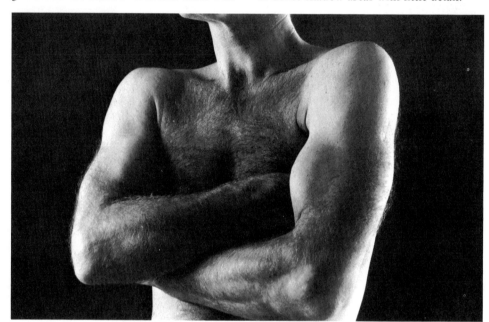

Tone and tonal range

The transition of highlight into shadow, the range of greys between white and black, is called tone. The range of tones used in a photograph has an enormous effect not only on its technical quality but also on its composition, impact and mood. If an object is silhouetted against a white background, its shape will totally dominate the image, but when tones are introduced shape itself will assume less importance.

The grey scale

The "grey scale" is a logarithmic progression of tonal densities from white to black, running from 0–9, with each change equivalent to a difference of one stop in exposure (see pages 56–7). The landscape (*far right*) uses almost a full and normal range of tones; the misty photograph of trees consists of tones mainly from the lighter end of the scale and is known as a "high-key" picture; the sombre image of the benches consists mainly of tones from the darker end of the scale and is known as a "low-key" picture.

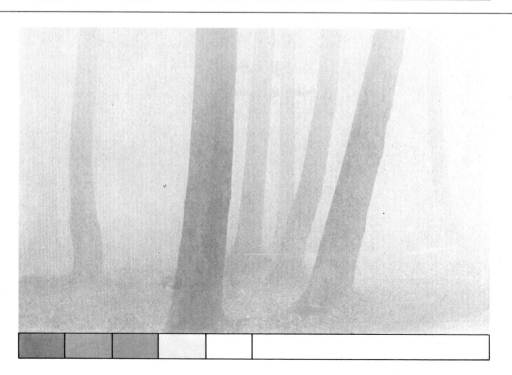

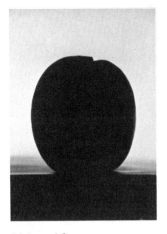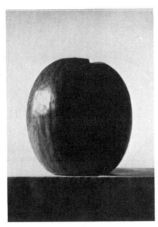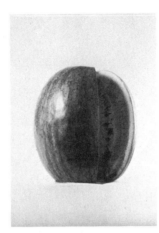

Revealing shape and form

These three pictures of a melon illustrate how the degree of visual information about a subject is related to the light it receives. First, with simple backlighting, it is no more than a silhouette, an outline; without the strange dip it could be a cut-out, some type of ball, or the end of a cone. Second, sidelighting reveals the object as basically spherical with a textured surface; it could be a melon. Third, fill-in lighting now shows a melon with a section taken out, revealing the internal texture and pattern of the object.

Light and form

As photographic images the body on the left and the view on the right are totally dependent on the quality (the nature of the source) and direction of the light. In both cases the light is strongly directional, the one manufactured in the studio by a combination of an incident light glancing across the chest and a second from behind the figure producing highlights round the shoulders and arms, the other created by the totally natural light of late evening. The torso reveals the soft, smooth contours and subtle texture of the body; the scene shows the hard, angular shapes of buildings with strong texture on the walls and roofs. Edward Steichen, the great photographer who organized the unique *Family of Man* exhibition in New York in the 1950s, reckoned there were "only two problems in photography. One is how to capture a moment of reality just as you release the shutter. The other is how to conquer light. Every man must learn to work out those two problems for himself."

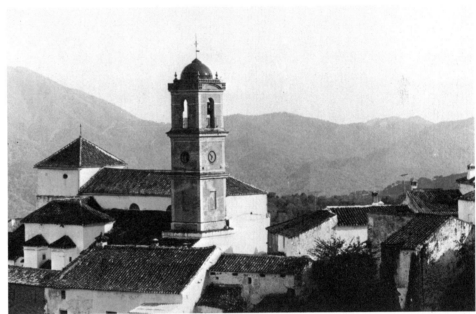

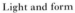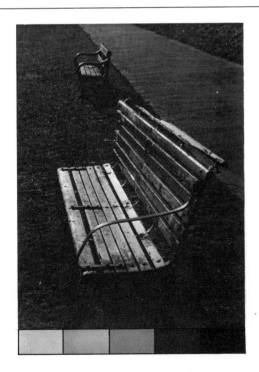

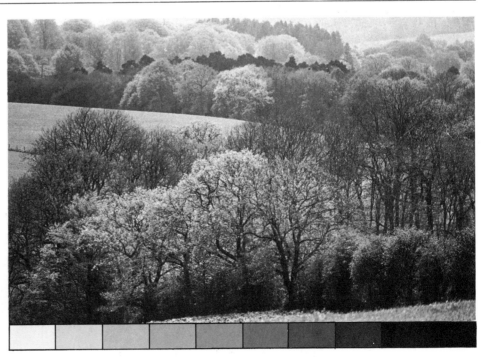

Light and texture

Texture and form are closely related, texture being the form of a surface. To a landscape photographer, for example, a ploughed field in the distance would be a texture within his image, but when seen from a few paces the individual furrows would have form in their own right. On the other hand, an egg viewed from a distance has only form, but when looked at closely the dry, pitted nature of the texture on the shell is apparent. The furrows in a ploughed field would also reveal the texture of the earth, of course, when viewed closely.

While form is generally best revealed by a soft, directional light source, texture usually needs a harder, even more directional light to be accentuated. But, as with form, the more pronounced the texture the softer the light source required. Powerful lighting will exaggerate the texture of a rugged surface and, although they can create a dramatic effect, the shadows cast by a strong directional light will tend to distort the true form of an object. These are generalizations; the more the photographer becomes aware of the distribution of light and shadow in his subject the more he will be able to utilize light for maximum effect.

Adding the tactile element

Texture can be an important aspect of a photograph because it creates visually a sense of touch, giving a tactile quality to shape, form, tone and colour: not only can we tell what an object looks like, we can also sense how it would feel. Our perception is, of course, dependent on our experience of a particular surface, the photograph merely recalling its softness, roughness or gloss. The camera is unique in its ability to record extremely fine detail and texture sharply and accurately, and photographers can magnify the texture of a familiar surface to a point where it is unrecognizable.

Before the spread of photography in the mid-19th century, painting was preoccupied with the faithful rendition and reproduction of detail, tone and texture. The advent of the camera was one of the factors which led to the massive changes which brought about Impressionism and abstraction in art. Now, when photographers attempt to be more "artistic", the first thing many of them do is to soften the image (see pages 88–9).

Balancing texture for composition
Texture and pattern are closely linked, textural repetition often being as strong as the repetition of shape. Like pattern, texture can be weak or mundane if featured on its own. While the wetness and highlights on the mud (*right*) give the substance an accurate feel, it required a strong compositional element to produce an effective image; this was provided by the bold diagonal of the chain, its shadow and pattern.

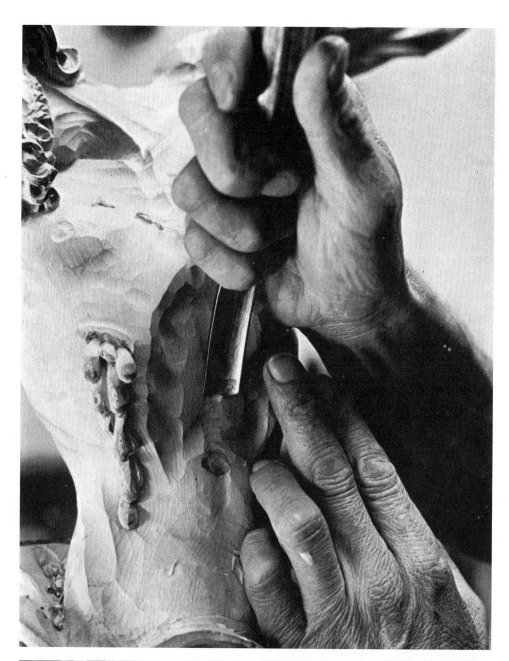

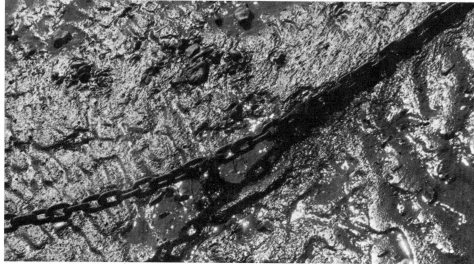

Contrasting textures
Two differing textures
—skin and wood—are
captured in a
photograph of an
Italian carver working
on a figure of Christ
(*left*). Though this is an
extreme example,
texture plays a role in
most photographs. It
gives depth and
dimension to a surface,
adding a tactile element
to shape and form,
colour and tone.
Photography can also
accentuate or even
magnify the character of
an object's surface with
strong sidelighting,
illuminating textures
not usually seen by
the eye.

**The camera and
texture**
Infinite variations of
texture can be captured
in a photograph, and in
this street picture (*right*)
a very low winter sun
picks out every bit of
gravel, grit and metal to
make an everyday scene
into an interesting
image. While the linear
shadow created by the
pole provides a strong
compositional element,
the pattern of studs on
the manhole cover
becomes an immediate
centre of attention.
Almost all surfaces,
however smooth they
may appear, are in fact
rough and pitted, and
the unique ability of
the camera to record
textural detail can be
both a blessing and a
handicap. In studio
portrait photography,
for example, it can
often tell more about a
sitter—particularly his
or her age—than any
number of angles,
expressions or poses.

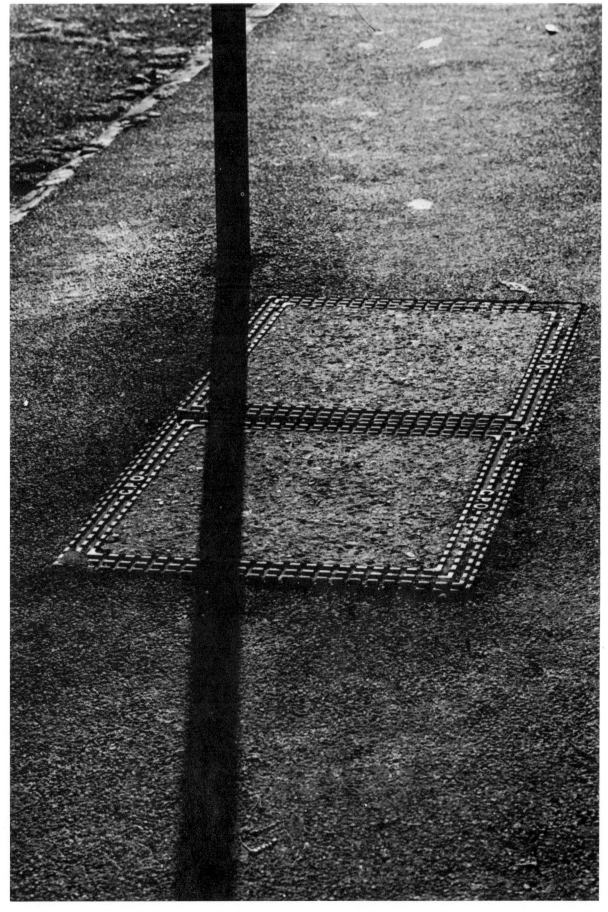

A place for pattern

"Because patterns are highly photogenic, they have become a photographic cliche. They should never be used for their interest alone, but only as an integral part of the picture."

Andreas Feininger

A pattern is merely the repetition of a shape, whether or not there is order or symmetry in the image. Repeated design emphasizes the tension between the abstract and the functional elements in a photograph, the picture being seen simultaneously as a decorative pattern of flat shapes and as an image of solid objects. Pattern can establish a motif and bring order and rhythm to a photograph that might otherwise appear chaotic, or, if the effect of pattern is sufficiently strong, it can dominate the image to the point where other elements can be almost totally lost. The use of pattern as camouflage is well known; sometimes the eye can be so hypnotized by an especially strong design that the identity of the objects creating it can themselves be disguised or hidden.

Patterns occur, or can be created by a viewpoint, in many everyday situations. A row of books, ripples on water, the windows of an office block, a pile of logs, the veins in a close-up of a leaf—all will form a pattern.

The list is endless, and once the photographer starts to look for patterns he will find they occur almost everywhere.

Light and pattern

There are no rules for the use of light to reveal pattern. If there is a pattern inherent in a subject, a hard directional light might destroy it since the dark shadows would tend to dominate the image. The pattern in a row of cups in a china shop, for example, would become lost among heavy shadows if photographed in that way.

In other cases a hard light may reveal a pattern that would not otherwise be noticeable. This could be the case with an aerial photograph of a ploughed field, for what at first glance seemed simply a flat brown patch would be revealed as differently coloured and textured furrows.

Patterns are often temporary. Another day, when the light is different or the subject is seen from a different viewpoint, they may no longer be there—absent for some time or, in that exact form, perhaps lost for ever. As Henri Cartier-Bresson observed in *The Decisive Moment*: "We photographers deal in things which are continually vanishing, and when they have vanished there is no contrivance on earth can make them come back again."

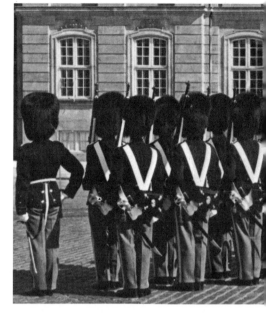

The varying role of pattern
The photograph of the guards outside the Royal Palace in Copenhagen is dependent on the even repetition of the pattern created by the uniforms—an impact reinforced by the lines in both the building and the cobblestones. In the case of the arrest at Twickenham, the home of rugby union, the pattern is a disorganized and secondary element relying essentially on shape rather than symmetry. (*Picture below by* JOHN GARRETT)

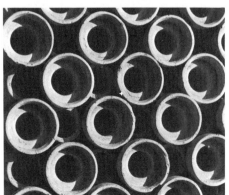

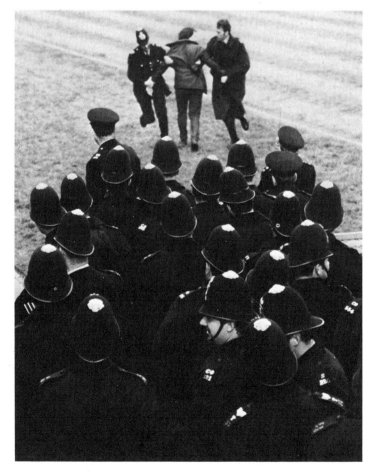

Dominant pattern
Pattern for its own sake rarely makes an interesting image; it is at best a cliché. The strong lighting saves the picture on the left from being flat, while the monotony of the pipes above is broken and relieved by the introduction of different shapes and angles and the contrast of the snow.

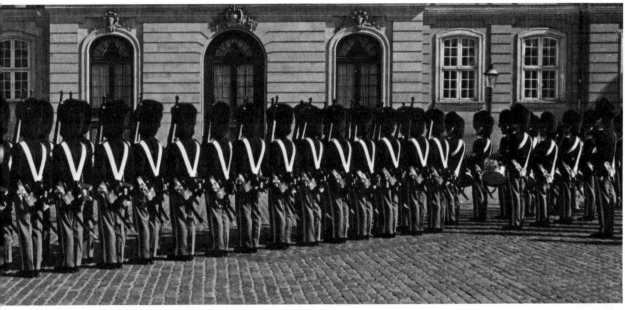

Light and shade
The light falling through
the windows of the John
F. Kennedy Memorial
outside Jerusalem
creates a second,
horizontal pattern on
the floor to complement
the vertical one formed
by the circular wall. As
with all the essential
elements of photography,
shadows and highlights
play a vital role in the
creation of pattern.
As in the case of many
photographs dominated
by pattern, closer
examination reveals
subsidiary repetitive
elements, provided here
by the black dots on the
pillars and the fanned
construction of the roof.

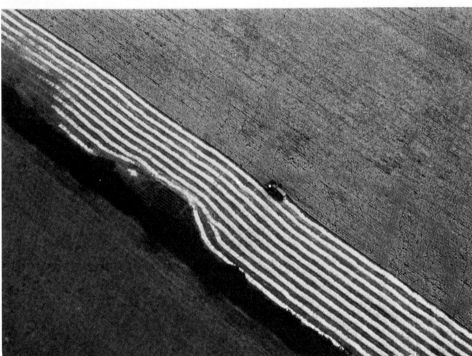

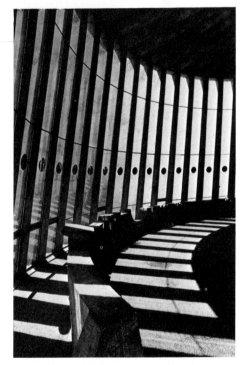

Pattern in composition
The strong diagonal pattern made by the harvester
plays a crucial part in the composition of this aerial
shot, breaking the image into two triangles and forcing
the eye to the tiny machine itself. It was necessary
to tilt the camera to gain the effect. (JULIAN CALDER)

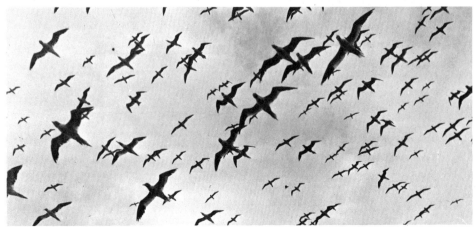

Transient pattern
While gannets will always fly overhead and form
patterns in the sky, this picture will almost certainly
never exist again in its exact form. Many patterns are
temporary, and capturing them calls for a subtle
form of spontaneity. (ERIC HOSKING)

27

THE WORLD OF THE CAMERA

"No photographer is as good as the simplest camera."

EDWARD STEICHEN

History/ The pioneers

The man who took the world's first genuine photograph—if we assume that to mean a permanent image produced by the direct action of light—was Joseph Nicéphore Niepce, who had been experimenting for ten years when he produced a view from his attic window at Chalons-sur-Saône in 1826. A reclusive technical inventor from Burgundy, he had become interested in producing camera images by the action of light on sensitive materials in 1816, three years after taking up lithography. His first efforts were weak negatives on paper treated with silver chloride and poorly fixed with nitric acid, and by 1822 he had settled for an asphalt varnish (Bitumen of Judea) on glass with a mixture of oils to fix the image. It was with this process that he took the picture of the buildings from his workroom—an 8-hour exposure. This heliographic process was unsuitable for normal photography and the significant breakthrough was to come from a much more urbane gentleman, Louis Daguerre.

This came in 1835, when Daguerre casually put away in a cupboard an exposed iodized silver plate which had not shown traces of an image. When he opened the cupboard he found a developed image on the plate. The legend has grown that the elusive developing agent, mercury vapour, had escaped from a broken thermometer; it is more likely that Daguerre spent some time tracking down the vital factor by a process of elimination. By 1837 he had standardized the process, using silvered copper plates coated with iodine vapour and developing the latent image by putting the plate over heated mercury. It was made permanent simply by washing in a hot solution of cooking salt. In July 1839 he sold his

Louis Jacques Mandé Daguerre
Gifted landscape artist, talented theatrical designer and shrewd showman, Daguerre made his name in 1822 by putting on the Diorama in Paris, combining panoramic views with changing light effects and foregrounds in a colourful spectacle. In 1829 he formed a partnership with Niepce but it was not until 1835, two years after Niepce's death, that he made the breakthrough which would virtually establish him as the inventor of practical photography.

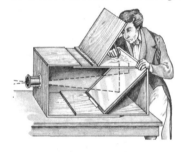

The camera obscura
The portable reflex box camera obscura was used by artists for 150 years before photography.

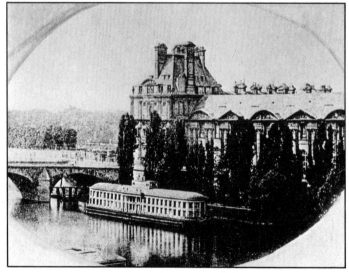

The first Daguerreotype
The Photographer's Studio (1837) is the earliest existing Daguerreotype. Two years before Daguerre had casually put away an exposed iodized silver plate in a cupboard and on returning to it the next day found it developed. The legend grew that the elusive developing agent, mercury vapour, had escaped from a broken thermometer.

The Daguerreotype arrives
With photographs like *The Tuilleries* (*left*), Daguerre quickly captured the attention of the fashionable sections of French society. In a sense the photographic revolution began on August 19, 1839, when the members of the Académie des Sciences and the Académie des Beaux Arts were told of the new technique and shown examples such as these. Within weeks opticians in the big cities of Europe were besieged for equipment.

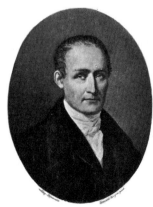

The first photographer
Joseph Nicéphore Niepce took the world's first photograph in 1826, but his heliographic process was unsuitable for normal purposes.

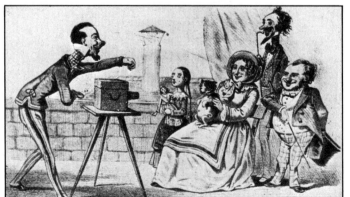

The photography craze
A French cartoon lampoons the new photographic craze. By October 1839 Daguerreotypes were being sold in seven European countries and the USA, and by the end of 1840 Daguerre's handbook was being sold in eight languages. In March that year Alexander Wolcott opened the first public portrait studio in New York, with Richard Beard following suit in London in 1841. Despite all this it was an inadequate invention, able to produce only a simple positive—one picture.

invention—the Daguerreotype—to the French government, and was guaranteed an annual pension of 6,000 francs for life.

Though the earliest Daguerreotypes were not good—the image was reversed left to right, there was little tonal contrast, exposure time was between 15 and 30 minutes—improvements were rapid. The sensitivity of the plates was increased by using silver bromide as an accelerator; prisms added to the lens righted the image; and by adding gold to the fixing process the metallic glare became the famous deep purplish tone. In addition to the large original cameras, others were soon available to provide pictures at $\frac{1}{3}$, $\frac{1}{4}$, $\frac{1}{6}$ and $\frac{1}{8}$ the original plate size of 21.6 × 16.5 cm/$8\frac{1}{2}$ × $6\frac{1}{2}$ in.

The most far-reaching innovation came from the Hungarian mathematician Josef Petzval, who in Vienna in 1840 produced a new double (achromatic) lens with separate components. With an aperture of $f3.6$, it was 30 times faster than the Chevalier lens usually employed, and exposure times were reduced drastically. It was this more than any other development which accounted for the rapid spread of the Daguerreotype, and indeed of photography.

In practical terms it was the wrong invention, since it could produce only a positive—one picture. Though the cleverly stage-managed introduction of Daguerreotypes gave birth to photography it was an Englishman, Fox Talbot, who would invent the first method for the easy production of any number of prints from the original plate, and it was this that laid the real foundation for the medium. "It is a joyous thing to be the first to cross a mountain," he wrote in the introduction to *The Pencil of Nature*, which charted his progress.

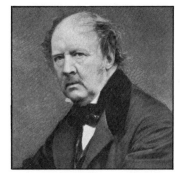

William Henry Fox Talbot
Scientist, linguist, traveller and former Member of Parliament, Talbot began his search for a permanent photographic image in 1833. Within months he was producing tiny negatives after exposure for 30 minutes in locally made cameras referred to by his wife as "mousetraps". It was not until late in 1840, however, after Daguerre's triumph, that he made real progress and created the first practical process producing any number of prints from the original negative.

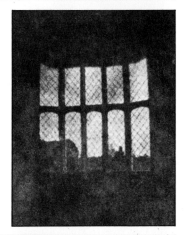

The first negative
By 1835 Talbot had produced the first negatives, the oldest example being the latticed window of his home at Lacock Abbey in Wiltshire. But it was another five years before he began using silver iodide and realized that exposure times could be drastically reduced—to less than a minute—by attempting a latent image and developing it afterwards: he in fact developed and printed his first Calotype (later Talbotype) on September 23, 1840, and related the history of his work in a magnificent book called *The Pencil of Nature* (1844); one of the plates, *The Ladder*, is shown below.

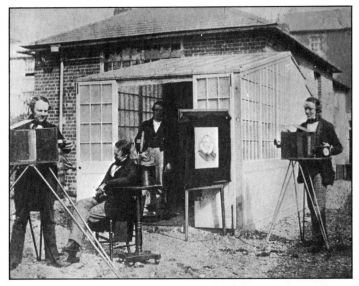

The Calotype
A Calotype of Talbot's photographic establishment at Reading, Berkshire, taken in 1845.
The process was used mainly by amateurs for landscape work but in Scotland David Octavius Hill and Robert Adamson combined to produce a superb series of pictures, including *The McCandlish Children* (1846).

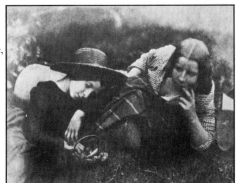

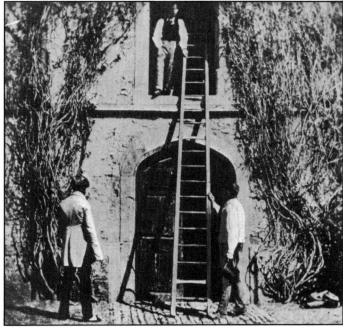

History/ Progress and portraits

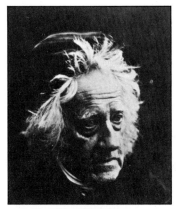

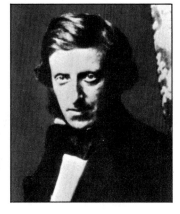

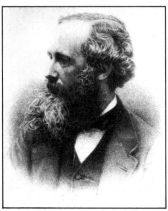

Above left Sir John Herschel, the scientist friend of Talbot who proposed many chemical processes, including hypo as a fixing agent. He coined the word photography (1839), and introduced the terms positive and negative.

Above Frederick Scott Archer, the originator of the wet collodion process (1851), which made both Calotypes and Daguerreotypes obsolete.

Left Sir James Clerk-Maxwell, the Scottish physicist who first demonstrated the colour combination principle in 1861.

If Daguerre's contribution to photography was wide-ranging but temporary, Talbot's was isolated but penetrating. Talbot allowed his Calotype process to be used freely by amateurs and scientists but, like Daguerre, he required professionals to pay for a licence from him. Despite the support of leading scientists, he lost a patent action against the London photographer Laroche, who in 1852 contested Talbot's assertion that the chemistry of the Calotype and the new wet collodion processes were essentially the same. Talbot's claim to priority of invention, however, was upheld by the courts.

Yet even before Talbot's reluctant surrender his process had been superseded—by Frederick Scott Archer's wet collodion process of 1851. This involved coating a sheet of glass with a solution of nitrocellulose containing a soluble iodide and sensitizing the plate in silver nitrate. The plate was exposed in the camera wet and developed in pyrogallol or a ferrous salt. Though inconvenient, inflexible and difficult, wet collodion produced excellent results and led directly to the birth of topical photography, with Roger Fenton's Crimean War pictures and Mathew Brady's American Civil War photographs notable examples. It was also responsible for the eventual death of the Daguerreotype, since it was cheaper and copies were easily made.

By the end of the 1870s, however, the wet plate itself had become obsolete. In 1871 Richard Leach Maddox, the English physician, produced the first workable plate using gelatin to hold the silver bromide; within two years gelatin emulsion was on sale, and by 1877 highly sensitive plates were available in boxes ready for use. There was no longer the need to coat

THE EVOLUTION OF THE CAMERA
The development of the camera has been a story of increasing sophistication and decreasing size (these illustrations are not to scale: the *Brownie* and the *Leica* would fit easily in one hand, while the *Giroux* camera measured $31.1 \times 36.7 \times 26.7\,cm/12\frac{1}{4} \times 14\frac{1}{2} \times 10\frac{1}{2}\,in$ when closed, and was $50.8\,cm/20\,in$ long when extended). Although plastic now plays a major role in manufacture, all the big hurdles had been passed after the first appearance of the prototype *Leica* in 1913. The notable exception is the 35 mm single-lens reflex camera, first developed in the 1930s.

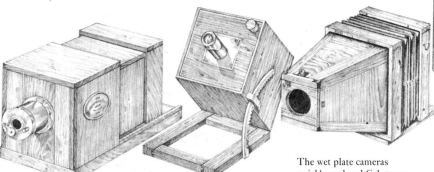

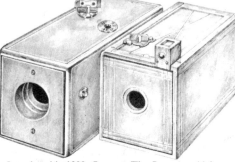

Built by André Giroux, the first Daguerreotype camera made for sale consisted of two boxes which slid inside each other for focusing the lens on the ground-glass screen at the back. A simple brass disc in front of the lens acted as a shutter. The lens had a focal length of 38 cm/15 in and an effective aperture of *f*14.

Used by Talbot about 1840 to make some of his early negatives, this camera had a simple microscope lens and adjustable rack. The focusing hole (top right) could be plugged with a cork; the sensitive paper was attached to the inside back of the box.

The wet plate cameras quickly replaced Calotypes and Daguerreotypes after 1851, but the invention of gelatin soon led in turn to the dry plate dominating photography.

Introduced in 1888, George Eastman's *Kodak* took 100 exposures on roll film, and anything beyond 1.2 m/4 ft was in focus. The camera was sent back to the factory for the film to be processed.

The *Brownie*, sold for a dollar or for five shillings, finally brought photography to the general public in 1900. It is shown here with the optional viewfinder.

The *Leica*, marketed in 1925, was the first precision miniature 35 mm camera and, with its focal plane shutter and coupled film transport, paved the way for the revolution in 35 mm system photography. It is still the supreme 35 mm non-reflex camera.

the plates before or develop them immediately afterwards.

The gelatin dry plate not only simplified photographic technique; it also led to a revolution in camera design, reducing the photographer's equipment to today's essentials. The new material was fast enough to capture moving objects, provided the cameras were equipped with an instantaneous shutter. Manufacturers responded quickly, and over the next two decades the market was flooded with cameras of all shapes and sizes. With fast bromide paper making enlargements possible, quarter-plate and 5×4 in hand cameras established themselves as the most popular in Britain and America, with 12×9 cm the equivalent in Europe. The new breeds—light, compact and relatively easy to use—were of four main types: change-box, magazine, roller-slide and roll film, and reflex.

The change-box camera, appearing in the 1850s, contained a dozen or so glass plates or cut films in a separate change-box attached to the camera, allowing a changeover in daylight. The magazine camera stored between 12 and 40 plates or cut films in a magazine and chamber inside the camera, with the plate being changed after each exposure in various ways, usually by dropping the old plate to the bottom of the body. Roller-slides and roll film cameras, using flexible film instead of glass plates or cut films, eventually superseded the change-box and magazine cameras. An early example was Warnercke's folding roll film camera of 1875, which featured a monorail, focusing screen and transport mechanism.

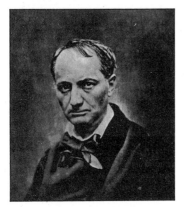

The portrait era

Cheap, quick and lifelike portraiture was the key to the rapid spread of photography, and particularly of the Daguerreotype and wet-plate processes. In 1849 the French poet Charles Baudelaire deplored "our squalid society that rushes, Narcissus to a man, to gloat over their trivial images on a piece of metal". He nevertheless had his picture taken by Etienne Carjat (*left*). Others (*below*) satirized the photographer and his methods. By 1850 there were 71 portrait galleries in New York, with almost as many in London.

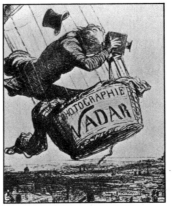
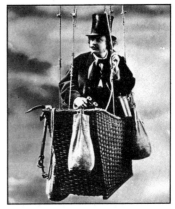

Nadar

Of all the portrait photographers active during its heyday (1845–90), Gaspard Félix Tournachon, or Nadar, was by far the most famous. One of his early exploits (1858) was to be the first man to photograph from a balloon—the interpretations of the press and of Nadar's assistant are shown above—but he made even more impact five years later with *le Geant*, the largest in Europe.

A former caricaturist and writer, Nadar turned to photography in 1853 and, as well as taking almost all the great men and women of Paris (including Sarah Bernhardt, *left*), he subsequently pioneered many fields. He was among the first of many to try electric light for photographs, the first to photograph underground (the catacombs of Paris in 1861), and the first to conduct a photo-interview, with the centenarian chemist M. E. Chevreul in 1886. It was at Nadar's studio that the Impressionist painters held their first ever exhibition.

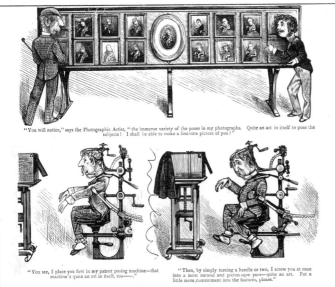

"You will notice," says the Photographic Artist, "the immense variety of the poses in my photographs. Quite an art in itself to pose the subjects! I shall be able to make a first-rate picture of you!"

"You see, I place you first in my patent posing machine—that machine's quite an art in itself, too——."

"Then, by simply turning a handle or two, I screw you at once into a most natural and picturesque pose—quite an art. Put a little more contentment into the features, please."

CARTE-DE-VISITE

In 1854 André Disderi patented a method of taking several portraits (up to ten) on one plate. The carte-de-visite, already big business, became a craze after 1859 when Napoleon III, who was leading his troops out of Paris to fight the Austrians, halted outside Disderi's studio for a multiple portrait. At its height, *cartes* of celebrities sold by the thousand. Disderi opened branches in Madrid and and London but died penniless, deaf and blind in 1890.

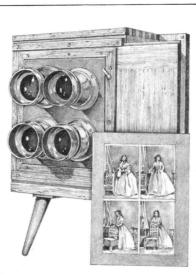

History/ The photographic tradition

The great debate over whether photography should emulate painting, and indeed whether it is an art form, began almost as soon as Daguerre had exhibited his first pictures. Initially photographers seemed content to merely record what was there, but exponents soon started experimenting with styles that imitated the painting of the day, and men such as Oscar Rejlander and Henry Peach Robinson used involved manipulative techniques in a determined attempt to make photography reproduce the scene before the camera, especially with landscapes.

The many-faceted argument raged throughout the Victorian era. Should photography reproduce or interpret? Were manipulative techniques valid? Was photography a graphic medium or an art form? All too often it degenerated into indulgent semantics. Eventually the central issue became clear—the acceptance or rejection of photography as an art—and the battle was on, helping to cause the formation of two important groups: *The Linked Ring*, led by Robinson and George Davison in England in 1892, and the more influential *Photo-Secession* in America ten years later, a band led by Alfred Stieglitz and including Alvin Langdon Coburn and Edward Steichen. Both organizations attempted to win recognition for pictorial photography as a fine art.

The Secessionists were particularly successful in promoting the higher aesthetic merits of photography at a time when Eastman was making it available to millions. Since then the expansion of photography on all fronts has been remarkable. Yet the reservations linger on: although photography is now perhaps the most important visual medium of our day, there is still a reluctance to grant it the position in the artistic spectrum which it deserves.

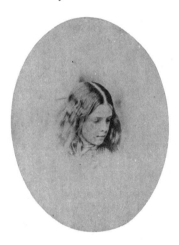 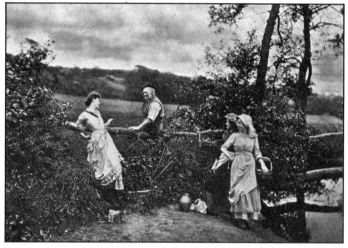 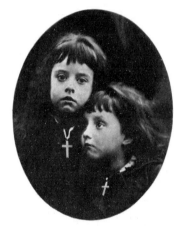

Lewis Carroll (the Reverend Charles Dodgson) was a fine photographer as well as author, and took several pictures of Alice Liddell, the girl who prompted Alice in Wonderland. Later, Carroll considered the dry plate "unfit for artistic effect" and stayed with wet plate.

Henry Peach Robinson followed Rejlander's lead in using combination printing to tell a story, and *She Never Told Her Love* is an example. His doctrinaire approach, expressed in numerous books, laid down principles of light composition and purpose in line with 19th-century painting, but he went even further, encouraging artificiality in every aspect of the medium. Despite the decline of "creative photography" after the advent of the gelatin dry plate in the 1870s, Robinson continued to use the combination techniques even after he helped form "The Linked Ring".

The outstanding English portrait photographer of the 19th century was Julia Margaret Cameron, partly because she took famous people—including Sir John Herschel (see picture by Cameron page 32)—but mainly because of her superb use of light. This is *Rachel and Laura*.

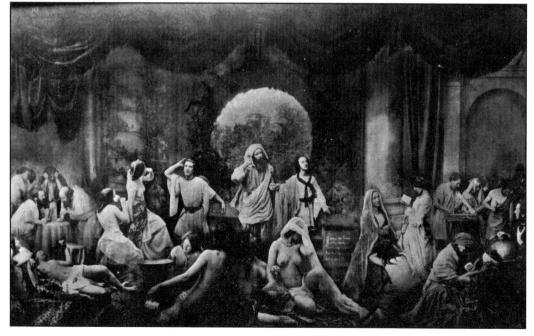

A former painter and the high priest of manipulative photography, the Swedish photographer Oscar Rejlander used 16 models and 30 negatives to construct *The Two Ways of Life*, one of the most ambitious examples of pseudo-painting ever produced by the camera, measuring only 78 × 41 cm/ 31 × 16 in. Shown in 1857, it was at first considered "indelicate", but when put on view at the Manchester Art Treasures Exhibition Queen Victoria bought the work and gave it to Prince Albert, who displayed it prominently at Windsor Castle. Later, tired of both "assemblages" and portraits, Rejlander turned to book illustration: his picture of a crying child for *Mental Distress* in Charles Darwin's *Emotions in Man and Animals* (1872) became a freak success, selling in thousands.

"Photography is my passion, the search for truth my obsession," wrote Alfred Stieglitz, who more than any man "legitimized" the new medium. In 1902 he founded *Photo-Secession*, a movement dedicated to dignifying a profession which had been increasingly seen as a trade. Though a wide-ranging photographer, Stieglitz is best known for his innovative views of Paris and New York, an example of which is shown here.

The wet plate process enabled photographers to capture the horror of war for the first time— notably Roger Fenton in the Crimea and Mathew Brady and Alexander Gardner in the American Civil War. The Scottish-born Gardner was for seven years assistant to Brady (later President Lincoln's photographer), but they split up during the war. This picture shows the scene before the execution of John Wilkes Booth.

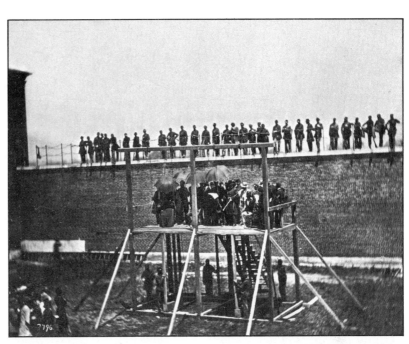

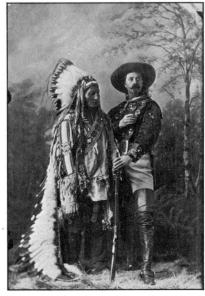

Peter Henry Emerson is best known for a series of photographs taken of life on the Norfolk Broads in 1885, including the one above. In 1889 he published *Naturalistic Photography*, in which he claimed that the photographer could produce high creative quality and reproduce nature without using the manipulative techniques previously employed, notably by Rejlander and Robinson. A year later, however, because Whistler convinced him that he was "confusing art with nature" and through pique at Davison's assumed leadership of the naturalistic movement, he repudiated this view and admitted the inherent limitations of photography. The abrupt change of heart serves to illustrate the confusion that existed over the relationship between photography and art in the 19th century.

Buffalo Bill Cody and Sitting Bull pose with a painted backdrop in the Montreal studio of William Notman in 1886. The Sioux chief was then "starring" in Cody's Wild West Show. Notman had emigrated from Scotland 30 years before, and though he became famous for his studio pictures he chronicled much of Canadian life, landscape and history and experimented with stereoscopic views.

The work of Robert Demachy reflects the influence of Degas and the Impressionists. His view that a photograph could not be a work of art unless a great deal of work was done on the plate led him to use all sorts of techniques—gum bichromate, oil transfers and (as here) scratching of the gelatin plate.

History/ The photographic revolution

If one man can be credited for making the pleasures of photography available to the general public, he is George Eastman. He first became interested in photography in 1877 as a 23-year-old bank clerk in Rochester, New York, buying a wet collodion outfit and taking lessons from a local professional. But he soon grew dissatisfied with the messy, expensive, laborious process—"it seemed that one ought to be able to carry less than a pack-horse load"—and, after reading of fast gelatin emulsion in the *British Journal of Photography*, he decided to try the new method. By 1880 he was making and selling his own, and the following year he left the bank to form the Eastman Dry Plate Company.

In 1884 William H. Walker, a camera maker, joined the firm and together he and Eastman developed a roller-slide attachment containing a coated paper roll for 24 exposures fitting any standard plate camera.

Eastman's ambition, however, was to devise a photographic system where the camera owner merely took the picture—nothing more. After a reasonably successful venture in 1886 he launched the *Kodak* ("a name that could be pronounced anywhere in the world") in 1888. It was small ($9.2 \times 7.9 \times 16.5 \, cm/3\frac{3}{4} \times 3\frac{1}{4} \times 6\frac{1}{2} \, in$); the integral roll holder took a roll of stripping film containing 100 circular exposures $6.35 \, cm/2\frac{1}{2} \, in$ across; the cylindrical shutter was cocked by a string and fired by a button; the film was wound on by a key; it had one speed ($\frac{1}{25}$ sec), one stop and a rectilinear fixed-focus lens.

"It can be employed without preliminary study, without a darkroom and without chemicals", wrote Eastman in the primer. And this was the real revolution; all the photographer had to do was take the picture. Eastman provided a complete back-up processing service. The owner returned his camera to the factory and it came back, reloaded and with 100 card-mounted prints. The camera cost $25 in America and five guineas in Britain, the service $10 or two guineas.

Launched with the slogan "You press the button, we do the rest", the camera was dramatically successful. "The phrase captured the whole world", explains author-photographer Wyatt Brummitt, "partly because it was catchy but mostly because it was true. And modern photography was born."

Improvements and further innovations came quickly. Eastman was anxious about the costly use of operators at the factory for the stripping film. In a search for a material as flexible as paper and clear as glass, his chemist, Henry M. Reichenbach, had been working on refining the thick celluloid then available in sheet film. By early 1889 they had perfected it, and later that year transparent celluloid films for both the *Kodak* and the roll film cameras were in production.

In 1889, too, Eastman brought out two more cameras—a new version of the *Kodak* with a modified shutter (called the *No. 1*), and a larger version taking negatives of $8.9 \, cm/3\frac{1}{2} \, in$ diameter. By 1890 there were five more models, two of them folding versions and all using darkroom-loaded roll film. The following year he introduced three daylight-loading models.

Although the advances and output were prodigious, Eastman was still looking for ways of reducing the price. The answer came with the cartridge roll film, and in 1895 the *Pocket Kodak* appeared on the market for a guinea or five dollars. This was much smaller ($5.7 \times 5.7 \times 7.8 \, cm/2\frac{1}{4} \times 2\frac{1}{4} \times 3\frac{7}{8} \, in$) and took 12 pictures $3.8 \times 6.35 \, cm/1\frac{1}{2} \times 2\frac{1}{2} \, in$. To increase this size a new folding model was introduced in 1897.

Remarkably, Eastman went still further. Millions could still not afford the cameras and a new, even simpler version, designed by Frank A. Brownell but named after the contemporary cartoon characters created by Palmer Cox, duly appeared in 1900. This was the *Brownie*, perhaps the most famous camera in history. It took $6 \times 6 \, cm/2\frac{1}{4} \times 2\frac{1}{4} \, in$ pictures on cartridge roll film, produced good photographs—and cost five shillings or a dollar. Here at last was photography for all. "Now every nipper has a *Brownie*", observed the photographer Alvin Langdon Coburn ruefully, "and a photograph is as common as a box of matches."

While Eastman had been capturing the new mass market, the foundations were also being laid in the more sophisticated areas of photography. The first twin-lens camera, with connecting lenses focusing simultaneously, was made by R. & J. Beck in 1880; in 1888 S. D. McKellen patented the first reflex camera where the mirror was automatically displaced during exposure by being connected to a roller-blind shutter.

The landmarks since the turn of the century have been ones of refinement and development rather than innovation and invention: the precision single-plate $f\,1.8$ *Ermanox* (1924); the superb *Leica*, the father of all 35 mm cameras (1925); the *Rolleiflex* TLR by Franke and Heidecke (1928); the 35 mm SLR (1930s); *Kodachrome* in 16 mm (1935) and 35 mm (1936); *Polaroid* in black and white (1947) and colour (1963); and the 126 cartridge *Instamatic* (1963).

DETECTIVE CAMERAS

Made possible by the new dry plate, these became popular after 1881, when Thomas Bolas designed his "detective" box camera for hand use, and a craze began for cameras disguised as parcels, bags, guns, binoculars and items of clothing like ties and hats.

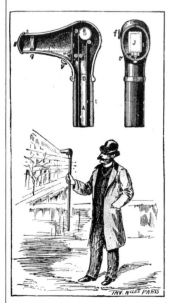

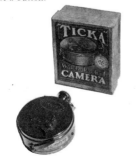

The only visible parts on this necktie camera were the lens disguised as a pin and a winding knob like a button.

This walking-stick camera, like the book camera shown top right, took roll film. The *Ticka* was a watch camera supplied with daylight-loading spools taking 25 pictures. On the whole lenses were weak and results poor, and most were little more than expensive and amusing toys for the wealthy.

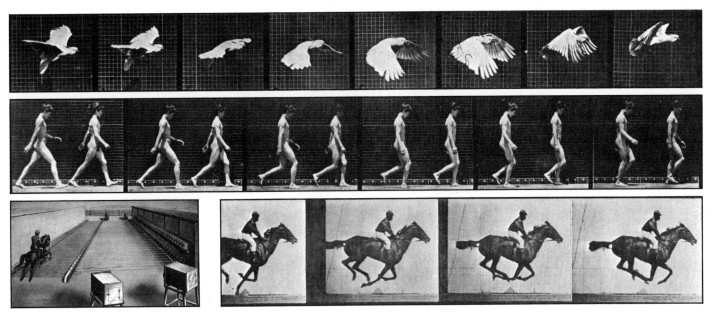

Early action photography

The first example of sequential photography was the result of a wager between railroad magnate Leland Stanford and a friend, Frederick MacCrellish, who refused to concede that a galloping horse had all four legs off the ground at any time. Stanford commissioned Eadweard Muybridge, an Englishman then working in California, to find out and eventually, in 1887, the bet was settled conclusively, as the three full frames above show. The equipment used included 12 cameras with electromagnetic shutters and an electric trip circuit. The subsequent work of Muybridge (*top*) and others led to the introduction of movies.

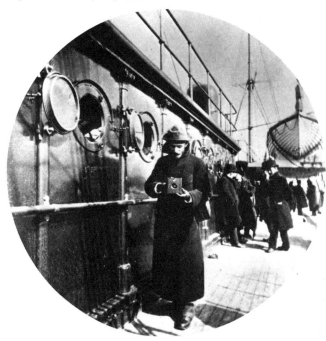

"You press the button, we do the rest"

George Eastman aboard ship in 1890, two years after the launch of the camera that set him on course for a fortune and made photography—previously a laborious and expensive process—available to millions. The *Kodak* saved all that fussing around with plates. The owner could process his film if he wished (*right*), but it was easier simply to send the camera back to the factory; it was returned with 100 card-mounted prints and a new film installed. In the next 12 years Eastman continually reduced the cost of his improving cameras, and then capped it all in 1900 with the *Brownie*: child's play and good pictures for five shillings or a dollar. One of America's great philanthropists, Eastman killed himself, aged 78, in 1932—"my work is done—why wait?"

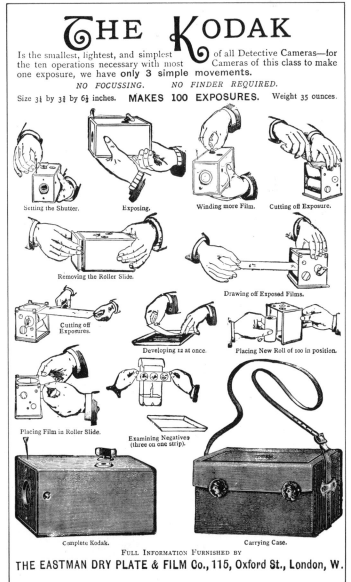

Black and white film

Many of the finest photographs ever taken have been in black and white. This is not simply because there was no other medium available, but because by eliminating colour it is possible to simplify and intensify the essentials of the subject: its shape, texture and the variety of light and shade. The two systems of photographic reproduction, colour and black and white, should really be regarded as two quite different media, even though, as a technology, colour is merely an extension of monochrome. The black and white system in particular offers a high degree of control during processing.

The photographic film

The sensitive material used today consists of two essential layers: an "emulsion" (light-sensitive silver salts suspended in gelatin) coated on to a transparent "base" (usually made of acetate). Despite decades of progress, the photographic process is still dependent even today on the action of light on silver salts, or, to be more specific, on silver "halides".

When light strikes the film it affects the basic structure of the silver halides—the individual grains—within the emulsion layer. The more light that reaches this layer, the more grains are affected. So far, however, no change is visible on the film: a chemical agent, the "developer", is needed to reveal the "latent image". It does this by converting those silver halides that have been affected by the light into minute grains of pure metallic silver, which appear black; the silver halides unaffected by the light—those in the shadow area of the image—are left unaltered by the developer. After development, a negative image is visible on the film (negative because it is the light areas that have produced black silver), but the emulsion is still sensitive to any further light. It is therefore necessary to "fix" the image by removing all the undeveloped silver halides. They are made water soluble by the fixer and then washed away, leaving only stable metallic silver on clear film.

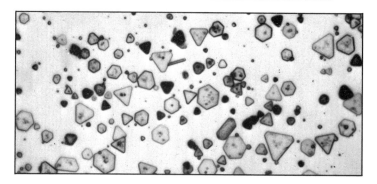

Gelatin supercoat — Foundation layer (gelatin and cellulose) — Cellulose-acetate film base — Anti-halation backing

Emulsion

Cross-section of film

The diagram on the left indicates the various layers which make up a modern black and white film. The emulsion is protected by a gelatin coating, while the layers underneath help to prevent curl and reduce halation.

The emulsion

The emulsion layer of a film is shown here magnified 2,500 times, and the individual silver halide grains are clearly visible. Large grains respond to light more easily than small ones.

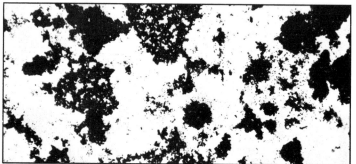

Emulsion during development

This photomicrograph shows the grains after exposure and partial development, again magnified 2,500 times. The clear silver halide crystals can be seen turning to black metallic silver (see page 172).

Emulsion after development

This picture (again ×2,500) illustrates the exposed grains after full development. It is these grains of silver that make up the photographic image.
(F. S. Judd, Research Laboratories, Kodak Ltd, Harrow, England.)

Photogram

The effect of light on photosensitive materials can be demonstrated by a photogram. This means simply placing an object on a piece of paper or film and projecting light on to it to form a latent image. Developer darkens any area of the emulsion that has been reached by the light.

The negative

The negative uses the same principle as the photogram, except that the image is formed by a lens. The black areas are caused by minute particles of opaque metallic silver formed by the development process.

Colour sensitivity

The human eye sees not only different intensities of light but also different colours, and black and white film has to represent both of these qualities in terms of light or dark. Moreover, the eye's response to colours is not uniform, so the "ideal" black and white film will be the one that reproduces most faithfully what the eye sees.

The simplest film is sensitive only to a small part of the visible spectrum, principally blue and ultraviolet light. By adding certain "sensitizing dyes", however, the basic emulsion can be made sensitive to a greater range of colours and, depending on what is added, various types of colour sensitivity can be created.

Types of film

Four main types of black and white film are now available: *blue-sensitive, orthochromatic, panchromatic* and *infra-red*. Film can also be made to record X-rays, but film of this type is for all practical purposes restricted to scientific and medical work.

Blue-sensitive film continues to be useful in some areas of photography, notably in line-reproduction or work demanding extremely high resolving power.

In *orthochromatic* film the colour sensitivity of the basic emulsion has been extended to include green, but not orange or red. This means that red and orange objects appear black in the final print and that orthochromatic materials can be handled safely in red or orange light. Until the spread of panchromatic film in the 1930s, "ortho" was used for everyday purposes, but today its usefulness is limited to specialist requirements such as some "lith" film.

The standard films used in modern cameras are *panchromatic*. Sensitivity has been extended to include the whole visible spectrum, though "pan" films, like basic blue-sensitive films, continue to be sensitive to a considerable area of ultraviolet. Moreover, they do not respond to colours in exactly the same way as the eye, and making them "see" more like our eyes is one of the functions of filters (see pages 66–7).

The colours seen by the eye represent a relatively small band of different wavelengths of radiation, violet being the shortest we can see and red the longest. Beyond red lies a band of wavelengths known as *infra-red* radiation, which we can feel as heat. Film can be made to "see" a portion of this area of the spectrum, allowing photographs to be taken in what to the human eye would be darkness.

Originally designed for scientific and military purposes, infra-red films have become popular in both professional and amateur photography for the unusual and interesting effects they produce (see pages 94 & 160): they can be obtained quite easily, and are handled in much the same way as panchromatic materials, the only difference being that the camera must first be made completely infra-red-proof.

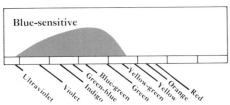

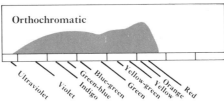

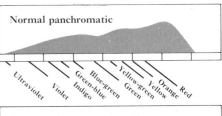

Blue-sensitive film

Known as "wedge spectrograms", these graphs illustrate the characteristic way in which each film responds to different wavelengths. By comparing the picture taken using the film with its spectrogram, it is possible to see how the colour sensitivity affects the final picture.

Orthochromatic film

On orthochromatic film, red and orange objects are recorded as black, while other colours appear in various shades of grey. The spectrogram shows that ortho takes in a greater part of the spectrum than blue-sensitive film, which indicated no response beyond green.

Panchromatic film

As can be seen from the photograph (*top*), panchromatic film records the whole visible spectrum. Its spectrogram shows a sensitivity range covering all the visible colours and extending some way into the ultraviolet region. A hypersensitive panchromatic emulsion is used for extra film speed under light rich in red.

Infra-red film

Infra-red film retains its sensitivity to short wavelengths, but also responds to infra-red (see pages 94 and 160).

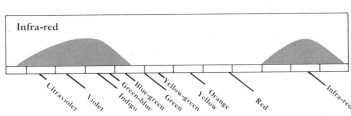

Film: speed, grain and contrast

The principle of using light-sensitive crystals in an emulsion as the basic photographic material has an inherent weakness: the smaller the grains of silver halide the less sensitive they tend to be. Thus an emulsion capable of capturing an image in very dim light requires large grains, but this can mean a loss of quality. If detail is essential, however, and a fine-grain film is chosen, then the film's sensitivity (its "speed") will be decreased. Modern films minimize such difficulties, but the basic relationship between grain size and film speed remains. Linked to this relationship is a third factor, contrast.

Film speed

Since it is not possible to make a "universal" film, ideal under all circumstances, the photographer must choose the best film according to the situation. The most critical part of this choice is the speed, which determines the correct exposure.

Film speed is a way of measuring sensitivity to light: the "faster", the more sensitive. Once a film's speed is known, it is possible to calculate accurately the correct exposure for a given level of light. A number of different systems for rating films have been devised, but only two are in widespread current use, the ASA system and the DIN system. The main difference is that ASA is an arithmetic scale, while DIN is logarithmic. Thus a film rated at 200ASA is twice as fast as one rated 100ASA (that is, it requires half as much exposure to produce the same effect); in the DIN scale, an increase of plus three is equivalent to doubling the speed, 25DIN being twice as fast as 22DIN.

Contrast

Almost as soon as development begins, metallic silver appears in the areas of the emulsion that received the brightest light (the highlights). As the process proceeds, the middle tones and shadow areas start to appear. If the process is allowed to continue further, silver continues to build up over the whole area of the negative—but it builds up faster where there is already an image. In more precise terms, density and contrast increase with time during development.

Eventually a point is reached beyond which density cannot increase because practically all the crystals have become silver; as this point in development is approached, the low-density areas begin to catch up and contrast starts to decrease.

The photographer can always exploit this sequence of events, varying speed and grain simply by increasing or decreasing the development time.

FILM SPEED RATING SYSTEMS

ASA	16	25	50	64	125	200	400	800	1600
DIN	13	15	18	19	22	24	27	30	33

The table above illustrates the relationship between the two main systems in current use—ASA (American Standards Association) and the German DIN (Deutsche Industrie Norm). Black and white films rated over 250 ASA (25 DIN) are regarded as fast, while those rated below 64ASA (19DIN) are considered slow. Colour films are usually slower than black and white equivalent.

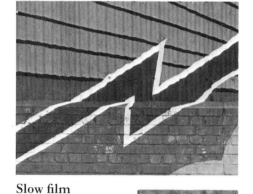

Slow film

Fine, even grain (*right*), high contrast and good definition are characteristic of slow films.
Kodak Panatomic X, rated at 32ASA and developed in Kodak D-76 for 5½ minutes.

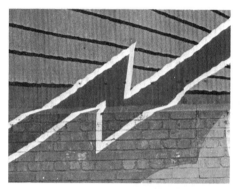

Medium film

The grain of a medium film is usually fine enough, and the definition good enough, for everyday purposes. (*Ilford FP4, 125ASA, developed in Kodak D-76 for 8½ minutes.*)

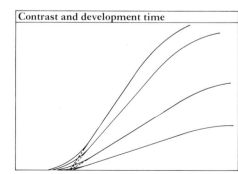

Fast film

With poor light or fast shutter speeds, high-speed film may be necessary despite its coarse grain. (*Kodak 2475 Recording Film, rated at 1000ASA, developed in Kodak DK-50 for 5 minutes.*)

The characteristic curve

Information about how a photosensitive material behaves under given conditions can be represented as a graph called a "characteristic curve", in which density is plotted against the logarithm of the exposure. These curves are commonly provided by manufacturers to give scientific but easily interpreted descriptions of various materials. The curve shows how dense the image will be after development at each level of exposure, and is divided into four sections: 1. the toe; 2. the straight-line portion; 3. the shoulder; 4. the region of solarization or reversal (dark blue zone).

A precise measurement of the contrast of the material can be found by examining the straight-line part of the curve: a steep slope indicates high contrast, while a slight slope means low contrast.

The characteristic curve

The characteristic curve of a film has the elongated S-shape illustrated above. The correctly exposed part of the film is represented by the straight portion; the toe depicts underexposure, the shoulder overexposure.

Contrast and development time

The diagram above shows the effect of varying the development time from 2 to 16 minutes while other conditions remain constant. A series of curves is produced, showing how contrast (the slope) increases with development.

The basic camera

Despite the appearances of some sophisticated models, the camera is fundamentally a simple piece of apparatus—much more simple than the film needed to capture the image. It need comprise only a *light-tight box* and a *lens*: everything else can be considered a luxury. The lens is required to "collect" rays of light from the scene being photographed and focus them into an image; the box must be light-tight to ensure that only light which has been through the lens is allowed to reach the film. Given a suitable photo-sensitive material, reasonable photographs could be made without any other equipment, but a more practical version of the basic box camera would also have a shutter, an aperture control, a focusing mechanism and a simple viewfinder.

The *shutter* is a timing device that opens and shuts to restrict the length of time during which light reaches the film. But the total amount of light is a combination of two factors: the duration of the exposure (controlled by the speed of the shutter) and the intensity or brightness.

This second factor is controlled by the *aperture*, a hole situated just behind the lens itself: the bigger the hole, the brighter the image. Together, the size of the aperture and the speed of the shutter determine the exposure—the amount of light reaching the film. A large aperture and a fast shutter speed can produce the equivalent exposure to a small aperture and a slow shutter speed, but determining the right combination of the two factors for a particular subject is one of the essential techniques of photography.

In its most basic form the *focusing mechanism* need only allow the lens to be moved backwards and forwards in relation to the film. On some cameras the lens is mounted on a kind of thread so that it can be "unscrewed" away from the film, while on others the whole front of the camera holding the lens is moved along a rail, as shown schematically in the abstract model below.

The simplest cameras manage without a focusing mechanism altogether: the lens is set at a fixed distance from the film and objects beyond a few metres away appear reasonably sharp.

Finally, the photographer will want to be able to see what is to be included in the picture and, if possible, to see exactly which part of the picture is in sharpest focus. The simplest *viewfinder* only meets the first of these requirements, while more advanced cameras have viewing systems linked to the focusing mechanism. Different types of camera are generally distinguished by the system of viewfinder they employ.

Parallax error

From its position on the camera the basic viewfinder does not see exactly the same area as the lens—a discrepancy called "parallax". The greater the distance between the viewfinder and the lens, the more severe the error. The view camera and the SLR overcome this problem completely.

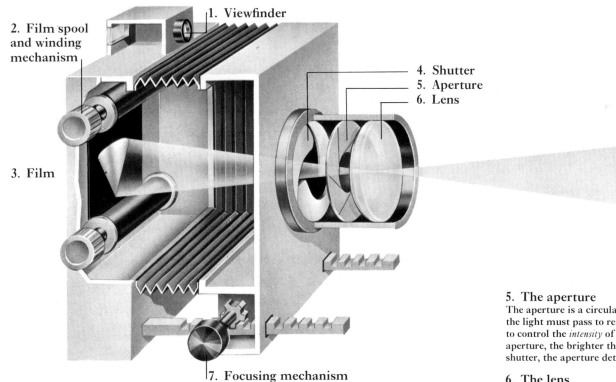

1. Viewfinder

2. Film spool and winding mechanism

3. Film

4. Shutter
5. Aperture
6. Lens

7. Focusing mechanism

1. The viewfinder
The viewfinder enables the photographer to see what will be included in the picture.

2. The film spool and winding mechanism
Flexible film allows a series of exposures to be made without opening the camera to change the film. It is held between two spools, and a winding mechanism moves the film along after each exposure.

3. The film
When the shutter opens, a latent image is recorded on the film. This is later converted into a visible image by the development process.

4. The shutter
The shutter controls the *length of time* during which light reaches the film. Simple cameras have a fixed shutter speed of about $\frac{1}{60}$ second, but more advanced models offer a range of speeds up to $\frac{1}{1000}$ and even $\frac{1}{2000}$ second.

5. The aperture
The aperture is a circular hole through which the light must pass to reach the film. It is used to control the *intensity* of light: the bigger the aperture, the brighter the image. With the shutter, the aperture determines the exposure.

6. The lens
A "positive" lens has the ability to form a real image which can be recorded by the film. A single convex lens can be used, but the image it forms has a number of faults or "aberrations"; these are corrected in sophisticated compound lenses.

7. The focusing mechanism
As the lens is moved backwards and forwards in relation to the film plane, objects at different distances are brought into focus. To control the part of the image that is sharp, a focusing mechanism is included in all but the most basic types of modern camera.

The lens and focusing

Light can be thought of as an infinite number of "rays" emanating or being reflected from every point on an object and travelling from it in straight lines. Because they travel in all directions, rays will not form an image on a screen unless something is used to "control" them, and in a camera this task is performed by the lens.

Like a prism, a lens bends light rays, collecting and redirecting them, but instead of having the flat surfaces of a prism, a lens is curved. Different rays strike its surface at different angles, and as a result some rays are bent more than others. A "positive" lens, which is thicker in the middle than at the edges, causes light to converge; a "negative" lens (thinner in the middle) makes light diverge. Only a positive lens can form a real image that can be projected on to a screen, because it brings all the rays reaching it from one point into focus at another point behind the lens.

Focal length

In general, the thicker and more curved the surfaces of a lens, the greater its ability to bend light. This is usually measured as its "focal length"—the distance from the centre of the lens to the point at which parallel rays entering the lens converge—and the more the light is bent, the shorter the focal length of the lens.

When focused at infinity, a lens is exactly one focal length away from its "focal plane", where the sharp image is formed. The operation of focusing involves moving the lens away from the focal plane to bring nearer objects into focus.

Focal length is also related to the area of the scene reproduced by a lens on the film, its "angle of view". Cameras are usually sold with a normal lens, which has a focal length approximately equal to the diagonal of the negative used by the camera, but various lenses of longer or shorter focal length are used by photographers to change radically the appearance of the final picture. Long-focus lenses see a narrower angle and the negative is filled with a small area of the scene, giving the impression of compressed distance. Conversely, short-focus lenses take in a wide angle of view.

Why a lens?
When light falls on an object it is usually reflected off it in all directions. No image is formed on the screen because the rays overlap: either a pinhole or a lens is needed, and several factors make the lens more suitable.

The pinhole image
A pinhole permits only rays coming directly towards it to pass through, and an inverted image consisting of tiny dots of light will be formed on the screen. The pinhole must be small to produce a sharp image, but if the size is reduced, less light is allowed through and the image becomes very dim.

The lens
The image formed by a lens is much sharper and brighter than that produced by a pinhole, which makes it easier to record on film. The lens "collects" rays over its *whole* surface and bends them in such a way that all the rays reaching it from one point converge at another point.

Focal length
When parallel rays of light enter a positive lens, they meet at a point behind the lens. The distance from this point to the centre of the lens is the "focal length" of that lens. Thin, slightly curved lenses have longer focal lengths than thick, strongly curved ones because they bend light rays less.

Compound lenses
On its own a single positive lens will have several defects or "aberrations". For example, it will have a slightly different focal length for various wavelengths of light, and this will cause each colour to be focused at a slightly different distance from the lens, reducing the sharpness of the image. In a compound lens the light passes through a series of "elements"—positive and negative lenses—which are designed so that their individual defects cancel one another out.

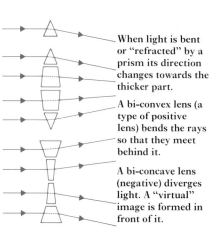

Shapes of lenses
A lens can have one of six different shapes, depending on whether its surfaces are convex or concave. They fall into two basic types—"positive" and "negative". A positive (converging) lens will form a real image behind the lens, while the image formed by a negative (diverging) lens is "virtual" and cannot be projected on to a screen. The reason for this important difference can be understood by imagining a lens as fragments of prisms and considering the paths taken by light rays.

When light is bent or "refracted" by a prism its direction changes towards the thicker part.

A bi-convex lens (a type of positive lens) bends the rays so that they meet behind it.

A bi-concave lens (negative) diverges light. A "virtual" image is formed in front of it.

Wide-angle lens

A lens with a focal length shorter than "normal" will have a wider angle of view. Wide-angle lenses have a large apparent depth of field, allowing both the foreground and far distance to be kept in focus at the same time. Extreme wide-angle lenses ·commonly called "fish-eye" lenses, (shorter than about 21 mm for 35 mm cameras) can produce dramatic distortions, making straight vertical and horizontal lines appear to curve. Because of the technical problems in their manufacture, all types of wide-angle lenses are expensive.

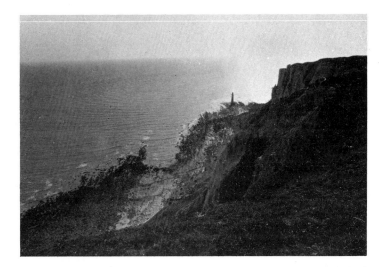

Standard lens

A standard or "normal" lens has an angle of view of 45°–50° (measured across the diagonal) and a focal length about equal to the diagonal of the negative format. In practice a normal lens for a 35 mm camera is more often 50 mm or 55 mm, while for 6 × 6 cm, focal lengths between 75 mm and 80 mm are used. These are the focal lengths generally fitted to fixed-lens cameras, or supplied as standard with inter-changeable-lens cameras. The diagram below the lens shows its various elements.

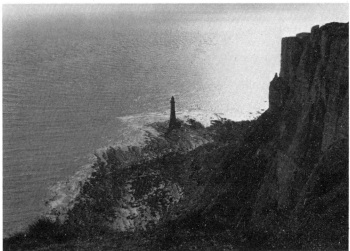

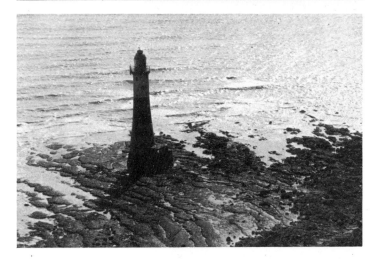

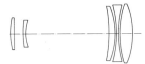

Long-focus lens

Although a true "telephoto" is physically shorter than its focal length, the name is often applied to any longer-than-normal lens. Both have similar qualities (such as shallow depth of field) and allow the photographer to work at a distance—particularly helpful for photojournalism and travel or sports photography. Focal lengths between about 80 and 135 mm are often used with 35 mm cameras in portrait photography for their slightly flattering effect on perspective.

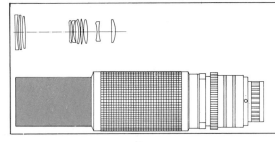

Zoom lens

A zoom lens is one where the focal length can be varied—from 80 mm to 200 mm, for example—without changing its focus; this is done by moving some of its elements in relation to each other. "Variable-focus" lenses are similar, but they require refocusing each time the focal length is altered.

The aperture and exposure

The eye adjusts very rapidly to changes in the intensity of light, and only when moving from one extreme to another (when leaving the darkness of a cinema in the daytime, for example) does the wide range of intensities found every day become obvious. The eye, in fact, has an automatic aperture (the iris), which opens and closes to regulate as far as possible the brightness of the image reaching the retina.

A given photographic film similarly requires a fairly exact amount of light to record a good image, and unless there is some device to reduce or increase the brightness, the camera will be restricted to taking acceptable pictures only if the light itself remains constant.

Several factors affect the amount of light reaching the film—principally the duration of the exposure and the diameter of the aperture. These must be related to each other to ensure a correct exposure for each negative, but control of the variables is essentially simple: the exposure is adjusted by varying the shutter speed (see pages 48–9) and the size of the aperture.

The aperture is calibrated in "f-numbers" or "stops", usually marked in a ring around

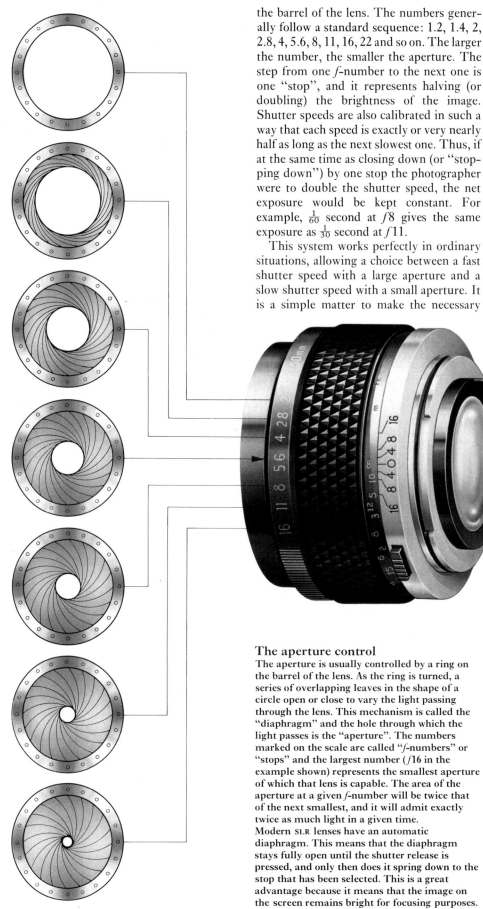

the barrel of the lens. The numbers generally follow a standard sequence: 1.2, 1.4, 2, 2.8, 4, 5.6, 8, 11, 16, 22 and so on. The larger the number, the smaller the aperture. The step from one f-number to the next one is one "stop", and it represents halving (or doubling) the brightness of the image. Shutter speeds are also calibrated in such a way that each speed is exactly or very nearly half as long as the next slowest one. Thus, if at the same time as closing down (or "stopping down") by one stop the photographer were to double the shutter speed, the net exposure would be kept constant. For example, $\frac{1}{60}$ second at $f8$ gives the same exposure as $\frac{1}{30}$ second at $f11$.

This system works perfectly in ordinary situations, allowing a choice between a fast shutter speed with a large aperture and a slow shutter speed with a small aperture. It is a simple matter to make the necessary

The picture above shows the effect of the aperture. A lens (the front panel of a view camera) was set up pointing at a window. With the aperture open at $f5.6$, a bright image was formed on a sheet of paper behind the lens (*top*). The lens was then stopped down to $f32$, and the picture above shows clearly the effect: the image remains the same in size and general appearance, but it is much dimmer.

The aperture control

The aperture is usually controlled by a ring on the barrel of the lens. As the ring is turned, a series of overlapping leaves in the shape of a circle open or close to vary the light passing through the lens. This mechanism is called the "diaphragm" and the hole through which the light passes is the "aperture". The numbers marked on the scale are called "f-numbers" or "stops" and the largest number ($f16$ in the example shown) represents the smallest aperture of which that lens is capable. The area of the aperture at a given f-number will be twice that of the next smallest, and it will admit exactly twice as much light in a given time.
Modern SLR lenses have an automatic diaphragm. This means that the diaphragm stays fully open until the shutter release is pressed, and only then does it spring down to the stop that has been selected. This is a great advantage because it means that the image on the screen remains bright for focusing purposes.

adjustments while keeping the exposure constant since, as far as exposure is concerned, a step down on the aperture scale is the same as a step faster on the shutter speed scale. There are occasions when a fast shutter speed is needed—when photographing moving objects, for instance—and on other occasions a particular aperture may be required. The reasons governing choice of aperture are covered in the next two pages.

Few standard lenses on 35 mm cameras are capable of opening up as far as *f*1.2 or beyond, and those that can tend to be extremely expensive. The aperture control often moves in half-stops, but these are rarely numbered except in cases where the maximum aperture of the lens is a half-stop. A number of lenses have a maximum aperture of *f*3.5, for example, which is halfway between *f*2.8 and *f*4. The maximum aperture a lens is capable of achieving is confus-

ingly called its "speed"—a fast lens is a great asset on an SLR because it provides a bright image on the focusing screen. In general, however, lenses give their optimum performance in the middle range of their aperture settings.

Focal length and *f*-numbers

The *f*-numbers are worked out in a way that saves the practising photographer considerable trouble. One of the additional factors affecting the amount of light reaching the film is the distance between the film and the lens: the greater this distance, the dimmer the image. As explained on pages 42–3, a lens focused at infinity will be one focal length away from the focal plane, and therefore a long lens will transmit less light than a short one with the same aperture when both are focused at infinity. It would, however, be very inconvenient to use a system of *f*-numbers that meant something different

for lenses of all the different lengths.

The exact relationship between distance and intensity is given by the "inverse square law", which states that the intensity of light is inversely proportional to the square of the distance between the source of light and the surface on which it is falling. If this distance is doubled, for example, the intensity will be reduced by a factor of four, because the same amount of light is covering an area four times as large. This principle means that a 50 mm lens would admit four times as much as a 100 mm with the same aperture.

To overcome this problem the *f*-numbers are calculated so that an aperture set at *f*8, for example, will give the same amount of light whatever the length of lens. They are, in fact, related both to the diameter of the aperture and to the focal length of the lens: an *f*-number is the ratio of the diameter of the aperture to the focal length of the lens.

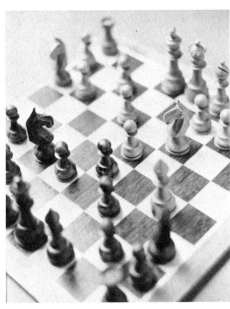

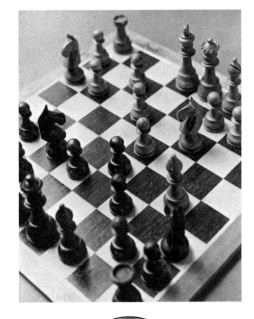

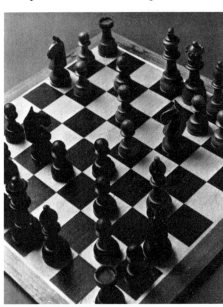

One stop overexposed

This sequence of pictures illustrates the effect of the aperture on the exposure. All three photographs were taken using the same shutter speed ($\frac{1}{30}$ sec). The first picture (*above*), taken with an aperture of *f*5.6, is overexposed, and as a result everything is too light on the final print. Too much light was allowed to reach the film during the time the shutter was open.

Correct exposure

Closing down the aperture by one stop provides a setting of *f*8: half as much light as before is allowed to reach the film during the $\frac{1}{30}$ sec. The resulting photograph is correctly exposed. The increase in sharpness over the area of the picture is due mainly to an increase in the "depth of field", which is fully explained on the next page.

One stop underexposed

At an even smaller aperture, *f*11, the photograph is underexposed. Too little light reached the film, and the picture is too dark. The white pieces are now as dark as the black pieces were in the first photograph. Yet despite the fact that the film in the first photograph received four times as much light (2 stops difference), both recorded tolerable images.

The aperture and depth of field

When a lens is focused on a point a certain distance away, there will be a zone both in front of and behind this point that also appears acceptably sharp on the film: this zone is called the "depth of field".

Depth of field can be controlled because it is affected by changes in the aperture size: with the aperture fully open a lens has a small depth of field, and the further it is stopped down the more the depth of field increases. For the purposes of composing a shot, photographers often select the aperture that gives the depth of field required and then match the shutter speed to produce the correct exposure.

Under difficult conditions the choice may be restricted, making it impossible to use the ideal shutter speed and aperture combination, and a compromise often has to be made. The problems are typified by those that arise when using a telephoto lens: consideration of the depth of field makes a small aperture desirable, since long-focus lenses always have a shallow depth of field. A small aperture will improve this, but a fast shutter speed is needed to reduce the inherent risk of camera shake.

Restrictions on sharpness

It is important to realize that terms such as "sharply focused" and "acceptably sharp" are not absolute. They depend on the degree of enlargement and the distance from which the final picture will be viewed. Moreover, the optimum focus of a poor lens will be considerably less sharp than that of a high-quality one. How sharp the image must be to qualify as "acceptable" depends partly on what can be expected. It is also a subjective judgement, since the eyesight of an individual limits what he sees as sharp. It is possible, however, to quantify these terms quite accurately for the purposes of making meaningful comparisons.

With a 50 mm lens focused at 2 metres, for example, an aperture of ƒ16 will ensure that everything between about 1.5 and 3 metres (5–10 feet) is in focus. An aperture of ƒ2, however, will reduce the depth of field to a fraction of a metre either side of the original 2 metres. All these distances can simply be read off the focusing scale against the appropriate marks. The numbers quoted here refer to a 50 mm lens: as explained on page 42, the longer the focal length, the smaller the depth of field at any given setting. For this reason, extreme wide-angle lenses may require hardly any focusing, with almost everything rendered sharply.

However, two general principles are worth noting. First, the greater the distance the greater the depth of field; thus shallow depth of field becomes an extremely awk-ward problem at very close distances. Second, depth of field tends to be greater behind the main object of focus than in front, although this ceases to hold true when focusing on close objects, when it is about the same in either direction.

Pre-focusing

Depth of field is useful in a number of ways other than for aesthetic effects. It can, for example, enable the lens to be "pre-focused" —a distinct advantage when it is known in advance that there will not be time to focus precisely without missing the shot. Instead, an estimate can be made of the approximate distance and a small aperture selected, so that the depth of field covers the area within which the event is likely to take place. At the critical moment, the photographer can simply aim and shoot—a big asset in sports and reportage photography, where events take place too quickly for fine camera adjustments to be made accurately.

Hyperfocal distance

Because the depth of field cannot extend beyond infinity, a lens focused at infinity will have a depth of field extending only in the direction of the camera, and the distance from the camera to this near limit is called the "hyperfocal distance". To overcome this wastage of some of the potential focusing ability, and to take fullest advantage of the depth of field, the lens should be set so that the depth of field finishes at infinity; this is accomplished by focusing on the

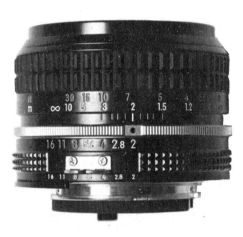

Depth of field scales

The most common kind of depth of field scale reads directly on to the focusing ring. The barrel of the lens has a mark indicating the distance from the camera to the object in optimum focus. On either side is a series of marks representing different aperture settings, the closest to the centre being the large apertures and those farthest from the centre being the smallest.

Some cameras are constructed in a slightly different way, which may require an alternative arrangement of the depth of field scale. A Rolleiflex twin-lens reflex camera, for example, has its depth of field scale marked against the focusing knob at the side of the camera body. Other variations may be encountered, but all work in basically the same way.

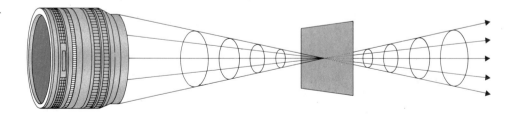

Circles of confusion

The image of an absolute point focused by a lens consists of a disc, which although large enough to be measured is still too small to be perceived by the eye as anything other than a point. Either side of the focal plane the discs increase in size, and objects behind and in front of the principal object in focus will be reproduced as discs of larger sizes. These discs are known as "circles of confusion", and the largest circle that still looks acceptably like a point provides a measurable standard of sharpness for certain viewing conditions. From a distance of 25 cm/10 in, for example, the average human eye cannot distinguish between a true point and a disc of 0.25 mm/0.01 in diameter or smaller. The discs may be larger at a greater distance.

hyperfocal distance. Depth of field then covers the distance from half the hyperfocal distance to infinity. Cameras with fixed-focus lenses are set in this position.

Depth of focus

Depth of focus is sometimes confused with depth of field. The difference is that depth of focus refers to the film side of the lens rather than the object side. The plane in which the image is sharpest (the focal plane) is where the film should be positioned, but there is a zone on either side of the focal plane within which the eye cannot detect any difference in sharpness. This is the depth of focus. Like depth of field, it is increased by stopping down, making the exact positioning of the film less critical.

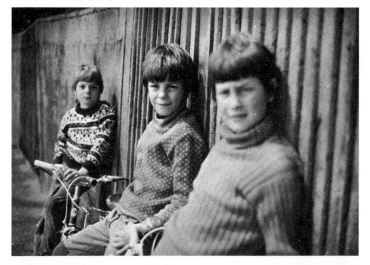

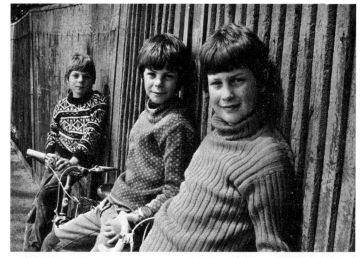

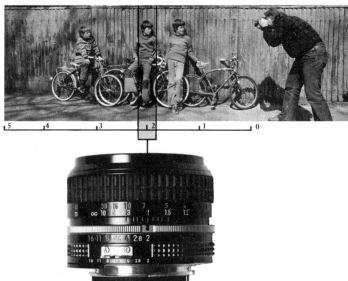

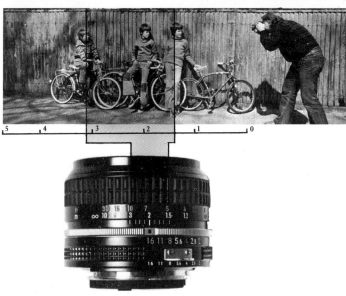

The photograph at the top was taken with a 50 mm lens focused on the middle boy 2 m/6 ft away (the picture below the main photograph shows the arrangement). An aperture of *f*2 gave a depth of field of 1.9–2.1 m/6–7 ft, throwing the other boys out of focus.

With the camera in the same position and focused at the same point, the aperture was stopped down to *f*16. The resulting photograph shows all three boys in focus. From the lens it can be seen that the depth of field extended 1.3–4.5 m/4–15 ft.

The shutter

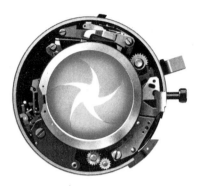

The principal function of the shutter is self-explanatory: while it is closed no light reaches the film, and when the shutter release is pressed it opens (normally for a fraction of a second) to allow the film to be exposed. The longer it remains open, the more light reaches the film.

If the object being photographed moves while the shutter is open, some degree of blurring can occur on the negative, and although this may sometimes be desirable—perhaps to convey a sense of speed—it is more usual to select a shutter speed which will "freeze" the action and render everything as sharp as possible. The shutter speed needed to do this depends on the speed and direction of the object being photographed.

The speeds marked on most modern cameras follow a sequence which, like the sequence of *f*-numbers (see page 44), is based on halving the exposure at each step: 1 second, $\frac{1}{2}$, $\frac{1}{4}$, $\frac{1}{8}$, $\frac{1}{15}$, $\frac{1}{30}$, $\frac{1}{60}$, $\frac{1}{125}$, $\frac{1}{250}$, $\frac{1}{500}$,

Leaf shutter

The leaf or diaphragm shutter (*above*) consists of a system of thin blades positioned as close to the optical centre of the lens as possible (*right*). In general they are quieter than focal plane shutters, but usually have a maximum speed of only $\frac{1}{500}$ sec; and because each lens needs its own shutter, interchangeable lenses are costly.

The row of pictures above illustrates the sequence of events in the action of a leaf shutter. As the blades begin to open, a small amount of light enters the camera.

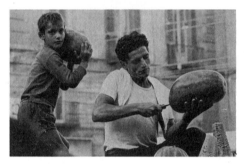

The brightness of the image continues to increase as the blades open further.

Focal plane shutter

A focal plane shutter is situated directly in front of the film and as close to it as possible (*right*). Two blinds move across the film, the slit-shaped gap between them controlling the exposure of the film to the light. Unlike leaf shutters, the mechanism is part of the camera.

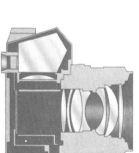

When the shutter is fired, the first blind begins to move across the film, exposing the first section of film.

If the shutter speed selected is faster than $\frac{1}{30}$ sec, the second blind will begin to move before the first has reached the other side.

Focal plane shutter mechanism

A system of blinds and tensioning drums forms the basis of a focal plane shutter. The blinds may be made of special opaque black cloth or, less often, of metal. Some travel vertically from top to bottom of the negative area, but the more common types run horizontally. The leading blind has a rectangular aperture slightly larger than the negative area. The trailing blind is connected to tapes and operates independently of the primary. Unlike the leaf shutter, which must first open and then close, the focal plane shutter does not have to change direction during the exposure. This enables it to reach higher shutter speeds, with $\frac{1}{1000}$ sec not uncommon.

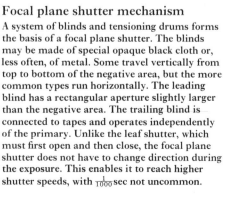

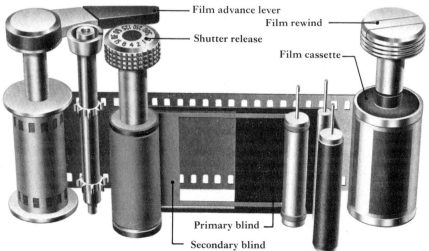

Film advance lever

Film rewind

Shutter release

Film cassette

Primary blind

Secondary blind

$\frac{1}{1000}$ and sometimes $\frac{1}{2000}$ second. The slight irregularities occur because the numbers have been rounded up or down for convenience—$\frac{1}{15}$ instead of $\frac{1}{16}$, for example—but the discrepancies are minimal.

Types of shutter

Modern camera designs make use of two principal types of shutter mechanism—"the focal plane shutter" and the "leaf shutter". The focal plane shutter works by a system of two blinds or curtains that open to form a slit, which moves across the film. The duration of the exposure is determined by the width of the slit: the narrower the slit, the briefer the exposure.

Focal plane shutters are positioned just in front of the film (hence their name) and are used almost exclusively in SLRs. Their main advantage is that because of their position they permit light to pass through the lens and so on to the viewing screen without exposing the film.

Leaf shutters, used in most other types of camera, are positioned either just behind the lens (in the case of a simple lens) or inside the lens close to the diaphragm (in the case of a compound lens). The leaf shutter consists of a system of metal blades, similar to those of the aperture, which are opened and closed by a spring tensioned by the film-winding mechanism. Some SLRs (like the *Hasselblad*) do use leaf shutters, but these require an additional focal plane shutter.

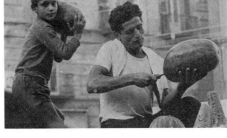

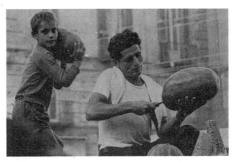

The blades will either remain fully open (for a relatively long exposure) or begin to close again almost immediately. While they are open the image will be at its brightest.

As soon as the shutter begins to close, the image starts to decrease in brightness. Ideally the shutter would reach its fully open position instantaneously, but there is some lag.

The image here is shown just before the blades close completely. The total exposure received by the film will be the sum of all the light that reached it.

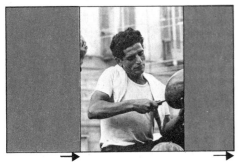

Both curtains continue to travel across the film. The size of the slit increases as the speed of the blinds increases for an even exposure.

The second blind here completes the exposure. The time taken by the slit to cross the area is longer than the actual exposure.

When the film is wound on the shutter is tensioned ready for the next exposure. The two curtains are drawn back in opposite directions.

B and T settings

Two additional settings often appear on the shutter speed dial: B (brief) and T (time). These enable the photographer to use speeds slower than those featured on the dial: when set at B, the shutter will remain open as long as the release button is depressed, while the T setting causes the shutter to open the first time the button is pressed and to remain open until it is pressed a second time. The photographer can thus leave the camera during long exposures.

The table on the right is a guide to the slowest shutter speeds needed to freeze moving subjects. Experience will provide a more precise idea of the actual effects achieved.

SHUTTER SPEEDS FOR ACTION

Subject	Approx. speed	Camera to subject distance	Motion at right angles to camera	Motion at 45° to camera	Motion towards or away from camera
Pedestrian, swimmer.	3–8 kph/ 2–5 mph	5–10 m/15–30 ft 15 m/50 ft 30 m/100 ft	1/125 1/60 1/30	1/60 1/30 1/30	1/30 1/30 1/30
Horse walking, sailing boat.	8–15 kph/ 5–10 mph	5–10 m/15–30 ft 15 m/50 ft 30 m/100 ft	1/250 1/125 1/60	1/125 1/60 1/30	1/60 1/30 1/30
Cyclist, runner.	15–30 kph/ 10–20 mph	5–10 m/15–30 ft 15 m/50 ft 30 m/100 ft	1/500 1/250 1/125	1/250 1/125 1/60	1/125 1/60 1/30
Horse racing, diver.	30–50 kph/ 20–30 mph	5–10 m/15–30 ft 15 m/50 ft 30 m/100 ft	1/1000 1/500 1/250	1/500 1/250 1/125	1/250 1/125 1/60
Skier, train, car.	50–80 kph/ 30–50 mph	5–10 m/15–30 ft 15 m/50 ft 30 m/100 ft	1/1000 1/1000 1/500	1/1000 1/500 1/250	1/500 1/250 1/125

The view camera

View cameras, particularly professional models such as the Sinar, often have a formidable number of controls, but in appearance they still resemble the basic box shape of the most elementary camera. The components are the lens panel at the front, the focusing screen at the back (replaced by a holder containing the film when the exposure is to be made), and the light-tight bellows linking them. The front and back of the camera are usually attached to a monorail, and the whole apparatus requires a tripod or studio stand as a support.

View cameras use large-format sheet film such as 5×4in or 10×8in which, despite the high quality of modern smaller format film emulsions, still produces negatives of superior definition.

The most significant advantage of the view camera is its flexibility and the control it offers over the image; but because the camera is more appropriate to studio work or fairly specialized or technical photography, it is essentially an instrument for the professional or serious amateur.

The basis of the view camera's flexibility is the ability to move its various parts independently of each other, creating changes in the perspective and focus of the image. Under some circumstances they can also be used to achieve a great depth of field—despite the fairly long lenses (over 120mm) normally used with a view camera.

The image
As seen by the photographer the image is upside down and laterally reversed. The image seen is exactly what will be recorded on the film and there is no possibility of parallax error.

Focusing screen
The image is focused on a ground-glass viewing screen at the back of the camera, and unwanted reflections can be eliminated by a black hood. When the picture has been composed and all the necessary adjustments made, the screen is replaced by a film holder with a sliding light-tight panel which protects the film before and after exposure.

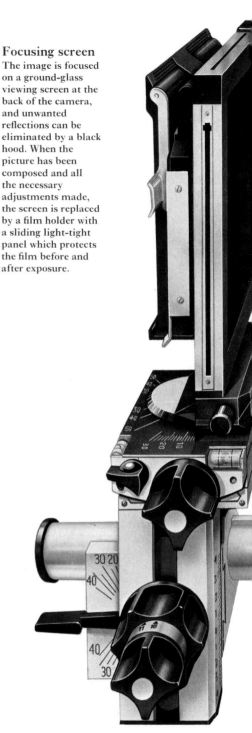

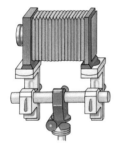

Rise and fall
The camera, set at "zero position", is pointed at a rectangular object. The image seen in the viewfinder is shown on the left.

By lowering the front of the camera (or raising the back) the whole object can be brought into view without affecting its shape, and the vertical sides stay vertical.

Tilt
With the camera again in the zero position, but pointed downwards at the object, the sides of the rectangle converge. The image is inverted.

By tilting the back of the camera away from the object, the sides can be made parallel. At the same time, however, the focus on the lower part deteriorates.

The view camera
Despite its cumbersome appearance, the view camera is an extremely versatile piece of equipment, ideal for professional studio work. The use of large-format equipment is likely to call for an approach rather different from that of the miniature camera; much more time is usually spent making preparations before the camera is loaded with film and the photograph taken. Because of the time needed to set up and adjust the camera, the photographer usually begins with a fairly precise conception of the viewpoint required, rather than moving round the subject experimenting with different angles.

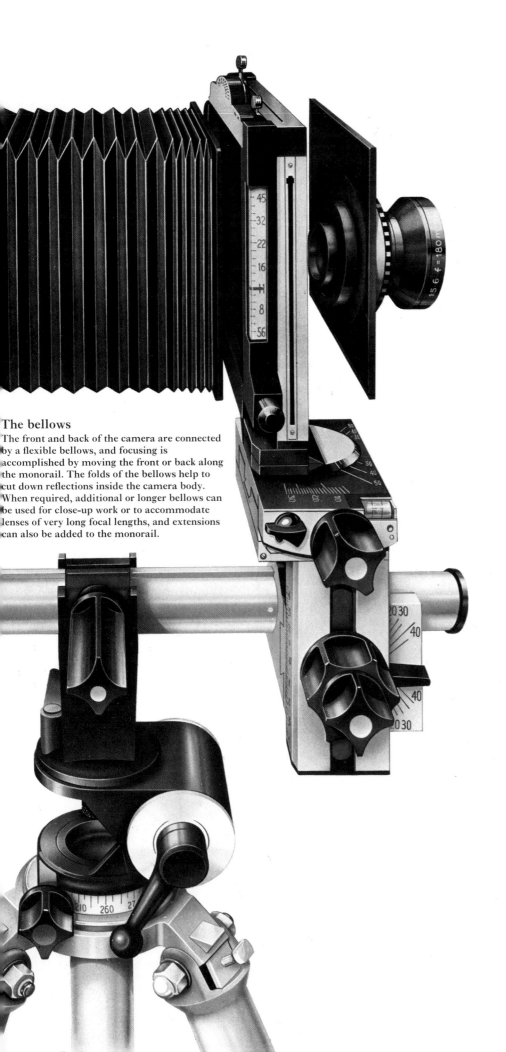

The bellows

The front and back of the camera are connected by a flexible bellows, and focusing is accomplished by moving the front or back along the monorail. The folds of the bellows help to cut down reflections inside the camera body. When required, additional or longer bellows can be used for close-up work or to accommodate lenses of very long focal lengths, and extensions can also be added to the monorail.

The lens

The "normal" lens of a 5 × 4 in camera is over 120 mm and that of larger formats is longer still, but the shallow depth of field of these lenses can often be remedied by the camera movements. A wide range of interchangeable lenses is available, each lens generally having its own leaf shutter (see page 48). The most important asset of view camera lenses, and the feature which distinguishes them from other types, is their greater "covering power"; this ability to produce a high-quality image over a large area of the focal plane permits the fullest use of the camera movements while still producing excellent results.

Swing

The effect of swing—moving the back or front of the camera about a vertical axis—is the same in principle as the tilt movement, but it works sideways instead of from top to bottom. Like tilt, it affects both the shape and the focus of the image, but not its position.

Shift

Movement of one of the parts of the camera from side to side is called shift. It is the horizontal equivalent of rise and fall, and similarly affects the position of the image on the screen rather than its shape.

51

The viewfinder camera

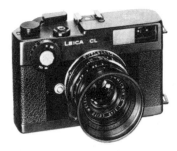

The distance between the lens and viewfinder can give rise to parallax error, in which the image in the viewfinder does not coincide with that captured by the lens. This is more pronounced when the subject is close.

Any camera where the viewing system consists of a small window indicating its field of view comes under the general title of "viewfinder". A "rangefinder" is basically an optical device for measuring distance and, when this is coupled with the standard viewing window, the camera is called a *rangefinder camera*. Since there is very little difference in appearance between the two types the terms, "viewfinder" and "rangefinder" tend to be used indiscriminately.

The camera itself need consist of no more than a box, a fixed-focus lens and a shutter. With only one shutter and aperture setting this would be ideal for holiday snaps, where it is assumed that the weather is fine and the subject matter conventional. At the other end of the scale some rangefinder cameras boast the advanced specifications of other modern cameras, including built-in metering and a complete range of interchangeable lenses. Even when the rangefinder is coupled to the focusing mechanism the design is lighter and often quieter than other designs.

The greatest disadvantage of viewfinder/rangefinder cameras is the problem of parallax. This can result in classic accidents such as a person's head disappearing off the top of the picture. The more sophisticated designs make some correction for this by incorporating in the viewfinder a frame that moves slightly as the camera is focused.

The independence of the viewfinder from the lens also creates problems when changing lenses. The viewfinder can be designed to accommodate a small selection of focal lengths, but a lens not included in this range would require a separate viewfinder of its own, depriving the photographer of the integrated use of the rangefinder.

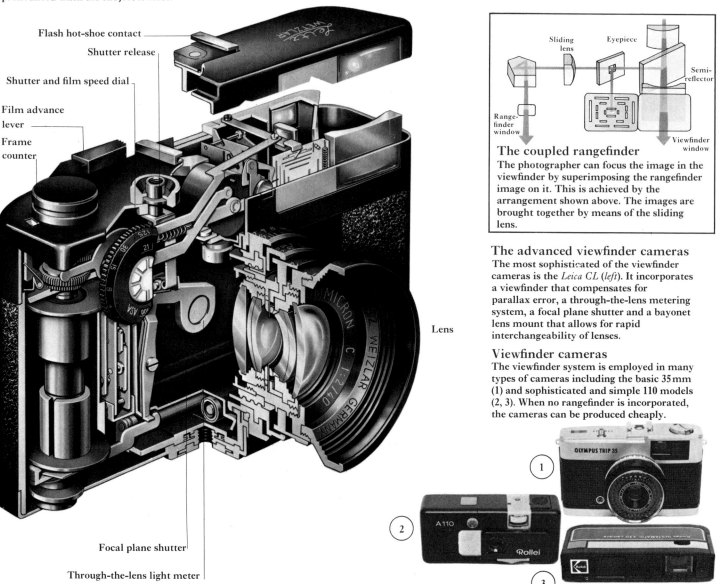

Flash hot-shoe contact

Shutter release

Shutter and film speed dial

Film advance lever

Frame counter

Lens

Focal plane shutter

Through-the-lens light meter

The coupled rangefinder
The photographer can focus the image in the viewfinder by superimposing the rangefinder image on it. This is achieved by the arrangement shown above. The images are brought together by means of the sliding lens.

Sliding lens

Eyepiece

Semi-reflector

Rangefinder window

Viewfinder window

The advanced viewfinder cameras
The most sophisticated of the viewfinder cameras is the *Leica CL* (*left*). It incorporates a viewfinder that compensates for parallax error, a through-the-lens metering system, a focal plane shutter and a bayonet lens mount that allows for rapid interchangeability of lenses.

Viewfinder cameras
The viewfinder system is employed in many types of cameras including the basic 35mm (1) and sophisticated and simple 110 models (2, 3). When no rangefinder is incorporated, the cameras can be produced cheaply.

The twin-lens reflex camera

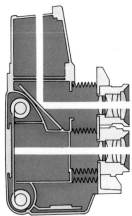

The shape and size of the twin-lens reflex camera or "TLR" give it the appearance of being more complicated than it actually is. Indeed, one of the advantages of this type of camera is that there is relatively little that can go wrong with it mechanically; it is both robust and reliable.

The two lenses do not have to be of the same optical quality. The upper lens plays no part in exposing the film (therefore having no effect on the quality of the final image) and can be of simpler construction, providing its focal length is identical to that of the "taking" lens. The two lenses are close to one another and the parallax error is quite small. Some types, such as the *Mamiya C330*, have a parallax correction dial.

Some professional models do have interchangeable lenses but, since both lenses must be changed at the same time, the cost is high. In addition, the camera uses a leaf shutter, so each lower lens has its own built-in shutter, further increasing the cost of each set of lenses. Like the large-format SLR (see page 54), the TLR takes 120 roll-film giving negatives of $6 \times 6 \, cm / 2\frac{1}{4} \times 2\frac{1}{4}$ in. The square format allows the camera to be held upright for vertical and horizontal compositions.

The viewing lens of the TLR reflects an image of the field of view up to a ground-glass screen, and a magnifying lens mounted above the screen helps to obtain the correct focus. With its square format, the camera can always be held vertically for viewing whatever the shape of the subject.

The image observed on the ground-glass screen is laterally reversed. The size of the screen and the negatives are identical. Since the lenses are slightly apart, there is a small degree of parallax error.

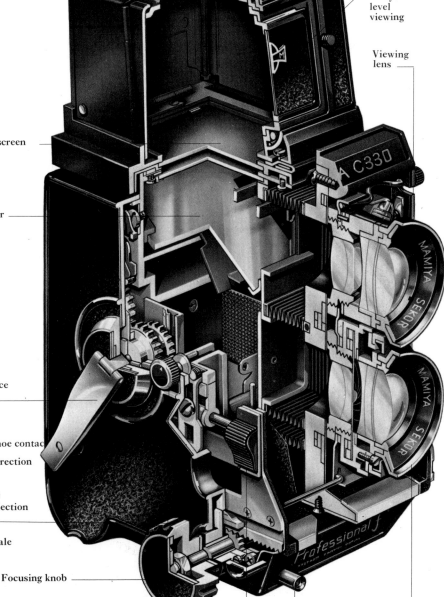

Magnifying lens

Window for eye-level viewing

Viewing lens

Focusing screen

Mirror

Film advance lever

Flash hot-shoe contact

Parallax correction dial

Multi/single exposure selection dial

Distance scale

Focusing knob locking lever

Focusing knob

Shutter release

Taking lens

The single-lens reflex camera

The most versatile and successful design of camera is the single-lens reflex, or "SLR". One lens serves both for viewing and taking the picture, thus overcoming the problem of parallax and, because the viewfinder automatically shows the image exactly as it will be recorded, lenses are easily interchangeable. SLRs can be adapted to almost any task while remaining convenient for everyday work. However, a complex mechanism is needed to make an SLR function, and this brings certain obvious but minor disadvantages.

Most SLRs use 35mm film, but some large-format types, such as the Hasselblad and the Bronica, take roll-film producing 6×6 cm/$2\frac{1}{4} \times 2\frac{1}{4}$ in, 6×7 cm or 6×4.5 cm negatives.

The reflex mechanism consists of a mirror, set at an angle of 45° just behind the lens, which reflects light up to form an image on the focusing screen. A focal plane shutter behind the mirror protects the film while the camera is focused. The image formed on the screen is upright but laterally reversed, and in some models this screen

provides an optional waist-level viewing; for eye-level viewing (standard on most 35mm models) a "pentaprism" housed directly above the screen reflects the image through the eyepiece and reverses it so that it is both upright and laterally correct.

To ensure that the image on the screen is bright enough to allow accurate focusing and clear viewing, nearly all SLRs are fitted with an automatic diaphragm: instead of closing down as soon as the aperture ring is turned, it remains fully open until the

The illustration on this page shows the major working parts of a large-format SLR, the Bronica. With one or two exceptions, this type of camera is at the top of the price range, and is backed up by a full range of lenses and accessories.

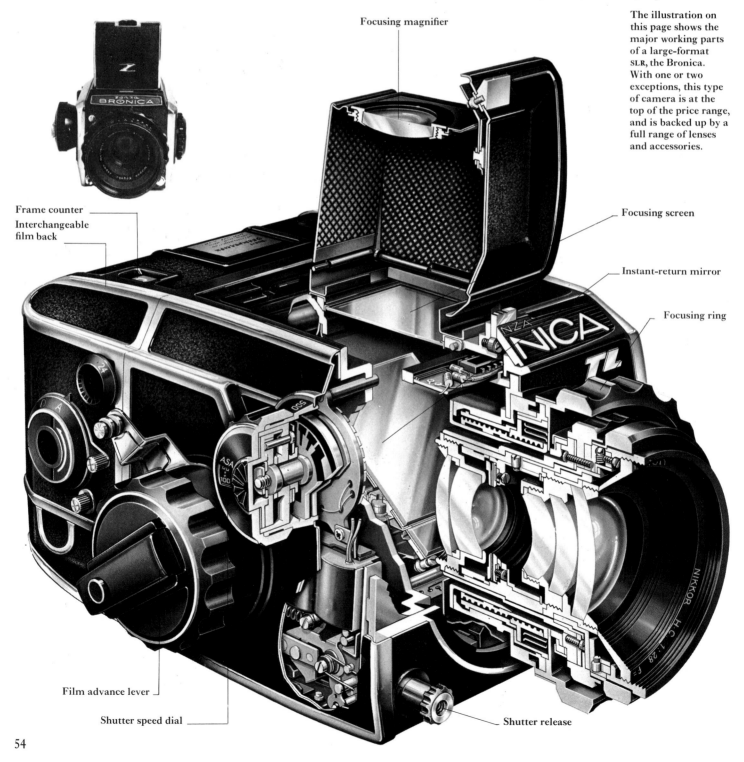

Focusing magnifier

Frame counter

Interchangeable film back

Focusing screen

Instant-return mirror

Focusing ring

Film advance lever

Shutter speed dial

Shutter release

moment the picture is taken.

When the shutter release is pressed the camera performs a complex series of actions. First the diaphragm closes down to the pre-selected aperture; the mirror flips up out of the way, temporarily blacking out the viewing screen; the shutter then exposes the film at the selected speed and finally, in all but a few models, the mirror returns to its original position and the diaphragm re-opens. In older designs the mirror does not return until the film is wound on.

The large-format SLR
The cross-section above shows the light path through a large-format SLR. A focal plane shutter protects the roll-film contained in an interchangeable back, while the moving mirror behind the lens reflects light up to the ground-glass screen for waist-level viewing.

The 35 mm SLR
The basic arrangement of the more common 35 mm SLR is the same as that of the large-format types, but the image is more often viewed at eye-level. This is achieved by the use of a pentaprism above the focusing screen, which reflects the light out through the eyepiece.

This example of the 35 mm SLR (Pentax KX) illustrates the relative positions of the basic components; small variations will be found in different makes. Many SLRs now incorporate automatic metering systems, which monitor the intensity of light passing through the lens (see pages 56–7).

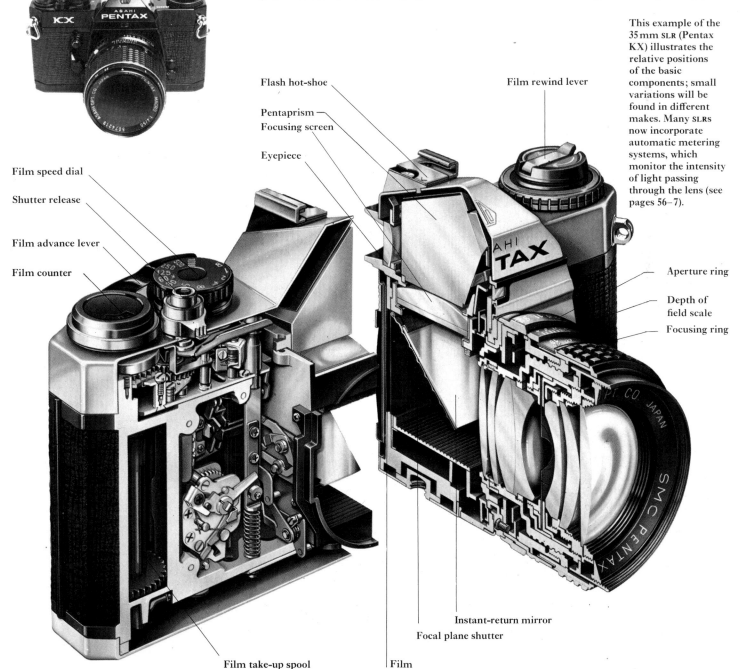

Flash hot-shoe

Pentaprism
Focusing screen

Eyepiece

Film speed dial

Shutter release

Film advance lever

Film counter

Film rewind lever

Aperture ring

Depth of field scale

Focusing ring

Instant-return mirror
Focal plane shutter

Film take-up spool

Film

The light meter and exposure

It is possible, though not recommended, to estimate exposures for black and white using a combination of guesswork and experience: colour films, however, demand a much greater accuracy because the colours become affected by variations in exposure. A device to measure accurately the brightness of the available light is therefore advisable for black and white but essential for colour.

The two materials traditionally used for this purpose are selenium and cadmium sulphide (CdS), but suitable new materials continue to be introduced all the time. An increasing number of cameras now include their own metering systems, the most sophisticated kind being the "through-the-lens" or "TTL" meters (nearly all using CdS or one of the more recent materials), which monitor the brightness of the actual image formed by the lens. Some are directly linked to the shutter and aperture controls to give fully automatic exposure. The TTL system is particularly well adapted to SLRs, allowing the photographer to carry out all the necessary adjustments (focusing, aperture and shutter speed) while looking through the viewfinder.

The alternative to built-in metering is a separate hand-held meter. The best of these do retain a few slight advantages over the average built-in varieties—they are, for example, able to give a reading at lower light levels—but even this advantage is rapidly disappearing as built-in meters become more sensitive.

It is, however, important to realize that light meters can be fooled. The reading given, regardless of type, depends exclusively on where it is pointed. If, say, a large area of sky is included in the scene measured by the meter, the average brightness is likely to be considerably greater than that of the same scene without the sky. The meter will show a shorter exposure than required and the picture will be underexposed.

Designs have been produced that overcome such obvious pitfalls, but these always assume a typical set of conditions. If the actual conditions are not "typical", the meter reading will have to be interpreted in order to achieve the desired result. The "centre-weighted" system, for instance, assumes that the main subject is in the centre of the frame, and that the main subject should be "correctly" exposed.

Many of the difficulties of obtaining technically excellent pictures have been simplified by the advent of reliable light meters, but it is still necessary to understand the equipment to make the best use of it.

The hand-held meter

Some of the more sophisticated hand-held light meters like the Lunasix (*right*) are as expensive as a modest camera. The needle gives a reading of the intensity of light, from which the required exposure can easily be calculated using the dials on top of the meter. A separate scale is used for special low-light readings.

Indicator needle — Shutter speed setting — Aperture setting — Film speed setting — **Lunasix 3** — Scale — Film speed setting — Exposure value — Calculator disc

Reflected and incident light readings

There are two basic ways of using a hand-held meter: to measure reflected light or to measure incident light. The photo-sensitive cell is situated in the centre of the front panel and to read the reflected light the cell is uncovered (1). To prepare the meter for incident light readings a small plastic diffuser slides across the cell (2).

HOW A LIGHT METER WORKS

The principle of the selenium meter is that selenium produces a small but measurable current when exposed to light, with the size of the current proportional to the intensity of light. The meter circuit (*below left*) thus consists of selenium connected to a galvanometer, which measures electric current. No batteries are needed, but the cell

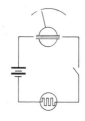

is too large to be incorporated in an integrated circuit.

Cadmium sulphide, like the more recent substances in use, works on a different principle. It is a light-sensitive resistor whose resistance varies with the brightness of the light falling on it. A battery in series with the cell supplies a steady voltage, as shown in the meter circuit (*above right*). The galvanometer then measures the current in the circuit, which is proportional to the resistance of the cell. Because the CdS cell need not be large to ensure high sensitivity, it is better suited to TTL metering systems. The special batteries used in the photo-resistor type continue to supply the same voltage throughout their working life, but will cease to function suddenly.

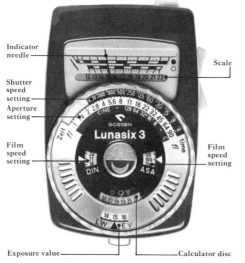

Reflected light

The simplest way of taking a light reading is to point the meter at the subject, thus measuring the intensity of light reflected back to the camera, where the meter is held. One disadvantage of this method, however, is that the reading may be influenced by extreme bright or dark areas in the vicinity of the subject.

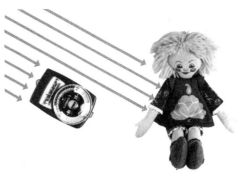

Incident light

Using the diffuser over the cell, the meter can be pointed away from the subject in the direction of the camera to measure the incident light. This method is more accurate, particularly with very dark or light subjects. A black cat, for example, would record grey if the exposure were based on a reflected light reading.

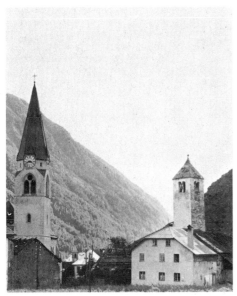

Through-the-lens metering: average reading

For an average reading, two photo-sensitive cells measure the light over most of the area of the focusing screen. The reading thus produced can be misleading when the main subject occupies only part of the frame, the other part being filled with a much brighter or darker area, such as the sky. The meter will recommend an

exposure half-way between the two intensities, causing the subject to be underexposed. The way to overcome this is to point the camera slightly away from the distracting area.

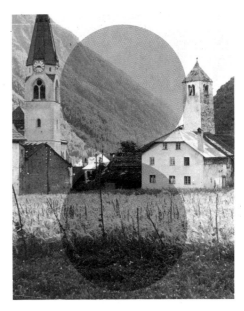

Through-the-lens metering: centre-weighted

A number of SLRS now use a centre-weighted system, in which the reading is biased towards the intensity at the centre of the viewfinder. This avoids many of the errors that may occur with averaging meters, but assumes that the centre of interest is always in the centre of the frame. Like all metering systems, the centre-weighted

meter demands intelligent use to produce perfect exposures every time. In the photograph on the left, for example, the light reading was taken from the foreground.

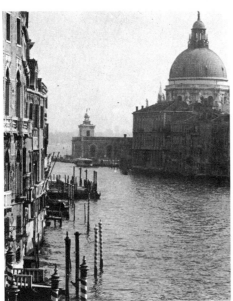

Through-the-lens metering: spot meter

More precise but slightly harder to use, the spot meter reads only a very small area in the centre of the frame, avoiding any distracting influences. The spot must be aimed at a medium-grey tone in the subject for a direct reading, but highlight and shadow readings can also be taken and the

average used for the aperture. The spot meter employs a device for splitting the incoming light beam and allowing part of it to reach the meter with as little disturbance as possible to the image as viewed by the photographer.

Lighting / The equipment

Tungsten lighting

The simplest and cheapest type of artificial lighting for photography is the tungsten filament bulb. The ordinary domestic version does not produce sufficient power for most purposes, but similar bulbs called photofloods yield an appreciably higher output for a much more limited life of between two and six hours. These are relatively inexpensive and, used carefully, can be employed for a considerable number of films. It is also possible to buy high-output bulbs of 1,000 watts and upward with a life of up to 100 hours; these are physically much larger and their lampholders and reflectors are bulky and expensive.

One disadvantage of tungsten filament bulbs is that the output diminishes slightly during their life-span. This causes a change in their colour quality and, when used with colour film, they cannot be considered as a constantly reliable light source. The tungsten halogen lamps, however, largely overcome this problem, and while these bulbs are more expensive than the photoflood type, their longer life, consistent output and constant colour quality make them a worthwhile investment. It must be noted that it is dangerous to run any bulb over 150 watts from ordinary domestic fittings and cables; the special fittings and cables designed for use with these lamps are essential.

A wide variety of light sources and accessories are available. *Floodlights* with built-in reflectors (1) can be obtained in a number of wattages. They are expensive but they eliminate the need for carrying around extra reflectors. *Light boxes* (2) consist of a number of lamps housed behind a translucent panel and are used to give a very diffused light. These can also be used for viewing transparencies, providing they have daylight-matching tubes. *Barn doors* (3) are hinged flaps that attach to a floodlight or a spotlight and prevent stray light from shining into the camera. *Snoots* (4) are conical tubes that slip over the light source and channel the light in a narrow beam.

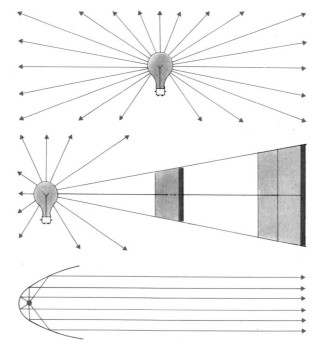

The parabolic reflector is used to send an almost straight beam of light from a bulb to the photographic subject and is the most common type of tungsten lighting. A subject lit by this source will have a great deal of contrast between light and shade and will cast a strong, sharply outlined shadow. Some direct light will spill out at an angle.

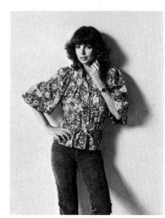

The diffusion reflector is much more shallow and spreads the reflected light out over a wider area. A cap ensures that no direct light from the bulb falls on the subject. The resulting illumination is very soft and diffused with the shadows indistinct and fuzzy-edged. The degree of diffusion depends on the size of the reflector.

The spotlight is a very specialized light source that can be arranged to give a converging pattern of light rays. This is achieved by a reflector and a Fresnel lens—a concentrating lens with a concentric pattern of prisms on the front face. It delivers an intense light to a small area, controlled by a focusing mechanism.

The properties of light

It is important to understand certain basic aspects of the behaviour of light before undertaking any photographic lighting. First, it radiates in all directions from a point and, second, its illuminating effect diminishes the farther it travels from its source. This second fact can be quantified by the inverse square law, which states that the illuminating power of a light source decreases as the square of the distance from that source. In other words a surface 3 m/10 ft from the light source will only receive a quarter of the light received by a surface 1.5 m/5 ft away. In photographic lighting the wasted light must be harnessed by reflectors.

Flash lighting

Flash lighting has largely taken over from tungsten lighting in professional studios. Its advantages are the proportionally high light output for the power consumed, the brief duration of the flash (eliminating the possibility of subject movement), the similarity in colour with daylight—so that the same film can be used—and the constancy of colour quality. The disadvantage for the amateur is the expense, both of the initial equipment and of replacing the bulbs. The choice of reflectors and fittings is much the same as with tungsten equipment; a folding reflector, a large white nylon umbrella into which the flash is directed, is considered standard equipment for studio flash.

The light from a flash is of constant power and duration and the exposure can only be controlled by the distance of the flash from the subject and the aperture used. This poses problems where depth of field is important, as in some still life photography. Exposure can be calculated by a flash meter that plugs into the synchronization socket of the flash head and takes a reading simultaneously with the flash, or by guide numbers which calculate the aperture for the speed of film and the distance of the subject from the flash unit.

The small flashgun designed to fit on to the camera shoe is largely a convenience accessory and, when used in this way, is unlikely to provide an attractive way of lighting the subject, producing the characteristic "red eye" effect. To obtain the best results the background should not be too far behind the subject and the flash not too close to the lens; overexposure, contrasty subjects and smoke-filled rooms should be avoided. Where possible it is preferable to bounce the light from a white wall or ceiling to produce a much softer effect, or to diffuse the flash with a white handkerchief, increasing the exposure as required.

Portable flash equipment comes in many forms and can use light from an expendable bulb or an electronic discharge. The simplest type consists of a bulb in a reflector, and powered by a battery.

A pocket version has a collapsable reflector in the form of a series of leaves that open out like a fan when in use. These simple types are usually triggered by the shutter via a connecting cable.

The flash cube is an arrangement of four expendable bulbs. The cube is turned to engage a fresh bulb before each exposure. Many simple cameras house the firing mechanism and batteries in the body.

The simplest type of electronic flash has a battery housed in its body and is triggered by the camera shutter. The power is supplied by a capacitor that must be charged before the exposure.

A more versatile flash unit has a head that can be tilted to give a "bounced light" from the ceiling. Both of these types are triggered by the shutter either via a cable or by connections in the shoe.

The most sophisticated flash unit has a separate power pack which is carried by means of a shoulder strap. The flash-head may be carried in the hand or can be attached to the camera.

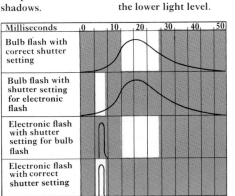 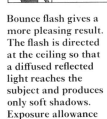 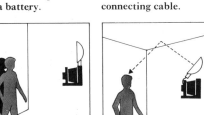

The most convenient way of taking flash photographs is with the flash unit attached to the camera and pointing at the subject. Photographs taken this way are flat and produce harsh shadows.

Bounce flash gives a more pleasing result. The flash is directed at the ceiling so that a diffused reflected light reaches the subject and produces only soft shadows. Exposure allowance should be made for the lower light level.

When the flash is held away from the camera to light the subject from above or from one side, a better effect of relief is obtained and the "red eye" effect can be eliminated. Another flash can fill in the shadows.

An umbrella reflector can be used to control reflected flash. Commercial models are made of reflective material and are mounted on a stand, but a substitute can be made by painting an umbrella white.

Multiple flash

A flash photograph of the interior of a very large building, such as a church, may be made by leaving the camera shutter open in the darkness and discharging successive flashes from behind each of the columns. Care must be taken to ensure that the flash does not shine directly into the lens.

Synchronized flash, where a number of flash units are used, can be achieved by using slave cells. When the master flash on the camera is discharged it is picked up by photo-electric cells on the others and this triggers them at the same time. The advantage of this system is that several flash units may be used without the need for trailing cables.

Flash synchronization

There is a considerable difference between the duration of a bulb flash and an electronic flash, although this may not be discernible to the naked eye. The bulb flash begins to burn slowly until it reaches its peak of brightness and then dies away in about $\frac{1}{20}$ sec. The flash of an electronic device is usually over after $\frac{1}{100}$ sec. Inexpensive cameras are usually synchronized so that the shutter opening coincides with the bulb flash, but more sophisticated cameras have a choice of setting enabling both bulb flash and electronic flash to be accommodated.

Milliseconds	0	10	20	30	40	50
Bulb flash with correct shutter setting						
Bulb flash with shutter setting for electronic flash						
Electronic flash with shutter setting for bulb flash						
Electronic flash with correct shutter setting						

Lighting/The studio

The normal illumination of a room is totally unsuitable for serious formal photography because of the fixed locations of the windows and lights and the low light levels, and is out of the question for any sort of colour work because of the incompatibility of the various light types. Some form of studio set-up is essential for any serious photographer, whether amateur or professional.

The home studio
An amateur's studio need be no more complicated than the temporary conversion of a living room or a bedroom, as shown below. The flexibility of such a system could be greatly increased by the addition of a narrow-angle reflector with barn doors or a snoot, a large diffusion screen consisting of a wooden frame covered with white tracing paper or nylon sheeting, and flat reflectors that could be made of hardboard painted white or covered with aluminium foil, or large sheets of expanded polystyrene, which is very light but quite rigid. These can be simply propped up against chairs or boxes, but a handyman would find it easy to construct a wooden base for them and also provide some means of tilting them.

Early studios
Professional studios are considerably more sophisticated. In the early days when there was no satisfactory form of artificial lighting, a studio was built so that it would be lit by sunlight. Such a studio had a glass roof facing away from the sun and covered with a white curtain to diffuse the light. The wall beneath this was also usually glazed and the lighting was controlled by a complex series of blinds and curtains. Sometimes only one end of the studio was glazed while the other was in shade so that the photographer could focus the image in his camera without the need of a cloth. The advent of artificial lighting did away with the need for the large areas of glass; indeed, once colour photography was established, daylight had to be excluded entirely because of the difference in quality between the two types of illumination. Studio lighting became a totally new and complex art.

The modern professional studio
Although modern studios vary greatly in design and size according to the type of work undertaken, the basic equipment is the same in most of them. Most lights are held in overhead runners or are clamped to poles fixed between the floor and ceiling. The latter are spring-loaded and can be released by disengaging the spring. With their clamps, these constitute a very versatile and stable lighting support system. Additional lights are mounted on heavy duty wheelbase stands or on boom stands, each giving a high degree of freedom of movement. The floor, however, is left as clear as possible to give the photographer room to manoeuvre and to allow for posing the subjects, with cables kept out of the way.

In most professional studios flash lighting has largely replaced tungsten, but where this has happened conventional lamps are still used to judge the effect before the photograph is taken. These are mounted close to the flash units to give similar lighting conditions to those that will be produced by the flash. The advantage of this is that the lamps use very little power and the subject does not suffer under a constant brilliant glare of light while the photograph is being set up. In this way the versatility of tungsten lighting can be combined with the efficiency of flash equipment.

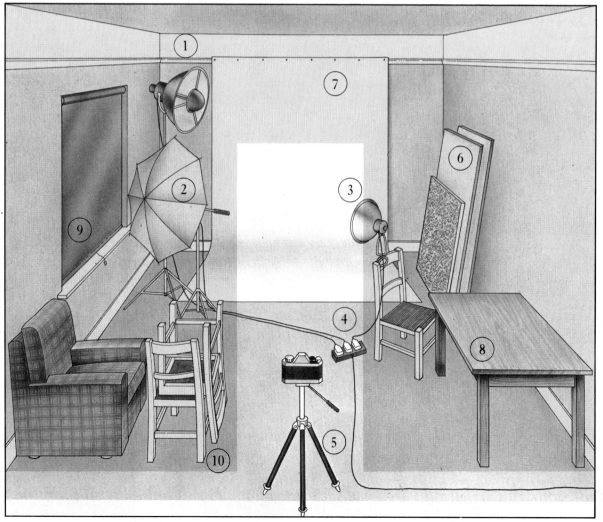

The home studio
A home studio can be improvized from a bedroom or living room. The basic requirements are a minimum of three lights, a backdrop and a sufficient distance between the camera and the subject. Unwanted light should be kept out by covering the windows. The main and backlights should be mounted on fairly tall stands, while the lamps for the fill-in lighting can be clamped to the back of a chair. The camera-to-subject distance can be increased by placing the camera outside the door and shooting to the opposite wall.

1. Back light on stand
2. Main light on stand
3. Fill-in light
4. Junction box
5. Camera outside door
6. Reflectors
7. Backdrop pinned to picture rail
8. Still life table
9. Blacked out window
10. Room furniture

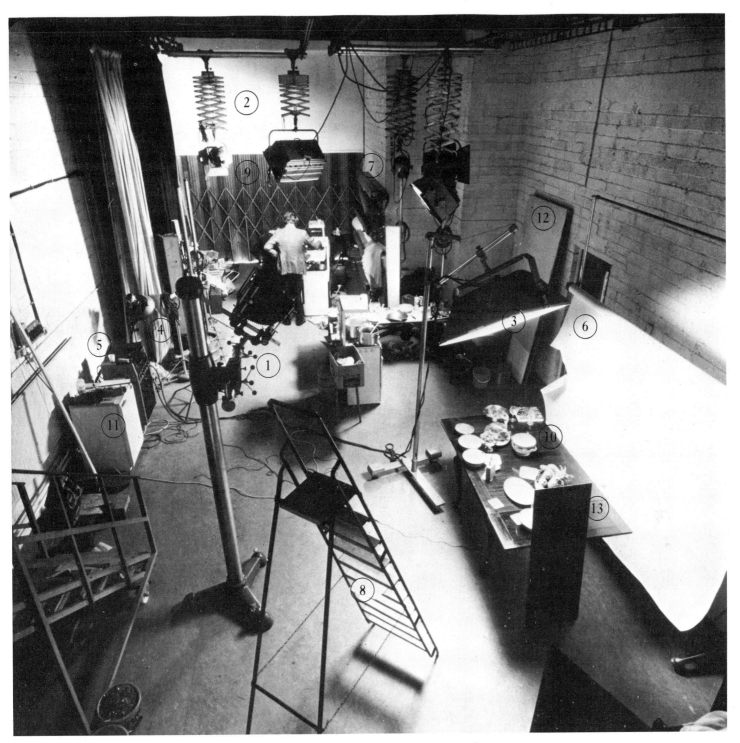

The professional studio

A professional studio has a large floor space to allow as much freedom of movement as possible. The lighting is usually arranged so that the working space is kept fairly clear and the photographer is free to move about. A typical commercial studio will need about **5,000** joules of power for lighting alone—not counting heaters, motors and other electrical equipment —and so a wiring system consisting of particularly heavy cables and metering must be installed. Each piece of equipment has its own individual fuse so that one failure does not inactivate the whole studio.

1. Camera mounted on a wheelbase stand
2. Lights on overhead rails
3. Main light on boom stand (fish fry)
4. Additional lamps on tripod stands
5. Lighting console
6. Background paper
7. Stored background papers
8. Step ladder for additional height
9. Large doors to allow access for heavy equipment or props
10. Subject (still life)
11. Refrigerator for storing films
12. Spare reflectors
13. Mirror reflector

Supporting the camera

In the most common way of holding a camera the left hand supports the weight from beneath and is in position to adjust the focusing and aperture rings.

If it is not practical to use a tripod in conjunction with a long lens, a fast shutter speed must be selected. It also becomes even more necessary to support the weight from underneath.

This position is essentially the same as the previous one, except that it enables both elbows to be held close to the body and thus provides more rigid support. The choice is one of personal preference.

For vertical pictures the camera is again supported by the left hand, leaving the right hand free to make the exposure. This reduces the risk of jogging the camera when pressing the shutter release.

A convenient post or wall can often be used to improve stability, making the body and wall into a tripod. Best results are achieved when the back is straight.

For low-angle shots it can be helpful to adopt the position shown above, in which the knees provide support for both elbows. Some photographers select a rigid equipment case for this purpose.

The problem of shake

One of the most common causes of poor definition is "camera shake", the name given by photographers to their own frailty: in most cases it is the photographer who shakes. The effects of camera shake may not be obvious on contact prints, but enlargements will be ruined. It is particularly frustrating if a large sum of money has been spent on a high-quality lens, since the accurate definition given by the lens will be lost, and the final picture may even be less sharp than one taken with a simple meniscus lens in capable hands.

The slower the shutter speed the greater the risk of camera shake, and anything slower than $\frac{1}{250}$ sec should be regarded as a potential hazard. However, rather than restrict the flexibility of a camera that offers a full range of shutter speeds by never using speeds below $\frac{1}{250}$, it is preferable to learn how to combat camera shake by holding and firing the camera correctly. In any case, fast shutter speeds will not solve the problem if the camera is handled badly.

The other critical factor affecting steadiness is the length of the lens used. Not only are long lenses heavier than normal ones, but they also tend to exaggerate the effects of the slightest movement. This is because the angle of view is so small that a minute change in the angle represents a large proportion of the whole picture: each movement is effectively magnified.

There are a number of attachments designed to improve the steadiness of hand-held cameras, but the best answer is to use a tripod wherever possible. Some indication of the wide range of tripods and grips available and their application is given by the illustrations on these pages. Some of the equipment is more specialized than most amateurs would need, but a general-purpose tripod is a valuable accessory.

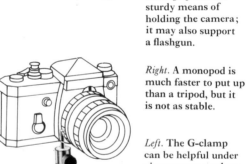

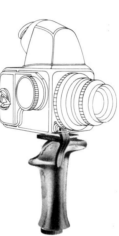

Above. The pistol-grip leaves one hand free to work. It is often used in conjunction with a motor-drive unit.

Above. The detachable hand-grip offers a sturdy means of holding the camera; it may also support a flashgun.

Right. A monopod is much faster to put up than a tripod, but it is not as stable.

Left. The G-clamp can be helpful under circumstances where a tripod is inconvenient or obtrusive.

Left. The rifle-grip. The increased chances of camera shake when using the longest telephoto lenses can be overcome partially by the use of a rifle-grip. It can be home-made.

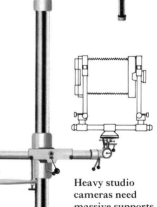

Heavy studio cameras need massive supports. The arm carrying the camera moves up and down the centre column pneumatically and gives a wide range of heights.

Most waist-level viewfinders incorporate a magnifying lens to help accurate focusing. The camera is pressed firmly against the stomach or chest.

With waist-level viewfinders stability can be further improved by pulling the strap taut. This is a particularly helpful feature, since there is no support for the elbows.

This method allows the photographer to focus over the heads of crowds. At sporting events, for instance, it can produce exciting results and the high viewpoint may even enhance the dramatic effect.

Resting the camera on a knee is a simple but effective way of improving steadiness. It is particularly helpful when photographing children with a waist-level viewfinder.

By pressing the camera body firmly against a rigid post or doorway it is possible to take pictures using exposures of up to $\frac{1}{4}$ sec or even $\frac{1}{2}$ sec, though great care is needed to avoid shake.

For very low-angle pictures the photographer can adopt a lying position. Both elbows rest on the ground, sufficiently spread to be comfortable while giving maximum stability.

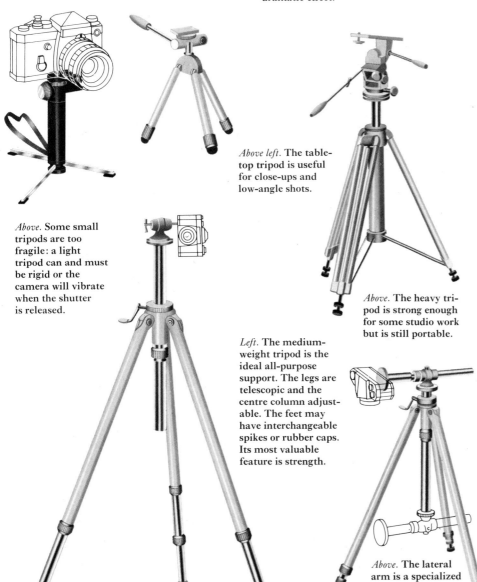

Above. Some small tripods are too fragile: a light tripod can and must be rigid or the camera will vibrate when the shutter is released.

Above left. The table-top tripod is useful for close-ups and low-angle shots.

Left. The medium-weight tripod is the ideal all-purpose support. The legs are telescopic and the centre column adjustable. The feet may have interchangeable spikes or rubber caps. Its most valuable feature is strength.

Above. The heavy tripod is strong enough for some studio work but is still portable.

Above. The lateral arm is a specialized attachment for copying work. The centre column can be reversed for the second position, as shown.

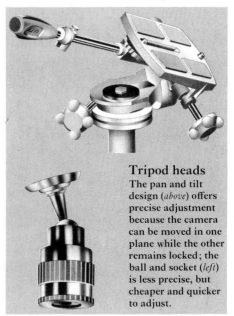

Tripod heads

The pan and tilt design (*above*) offers precise adjustment because the camera can be moved in one plane while the other remains locked; the ball and socket (*left*) is less precise, but cheaper and quicker to adjust.

CABLE RELEASES

Even with a tripod a shutter release should be used, and at very slow speeds it is essential. A pneumatic release works better than a cable release if the extension is to be longer than 30 cm/12 in. Cameras with electronically fired shutters need a special type of release.

Extension tubes and bellows

Most normal lenses are capable of focusing down to less than a metre, which is sufficient for everyday purposes. The rather imprecise term "close-up photography" is usually distinguished by the use of extension tubes or bellows, since these two attachments offer the widest possible scope for this kind of work. But there are alternatives. These include supplementary lenses that fit over the normal lens like a filter, and macro or close-focusing lenses. These differ from normal lenses in having a longer focusing mount, but although they are often called "macro" by their manufacturers, not all are true macro lenses (see glossary).

Extension tubes and bellows, which fit between the lens and the camera body, enable the photographer to use his ordinary lenses to achieve close-ups and they can, if required, give a high degree of magnification. While tubes have to be used either singly or in combination to give an assortment of fixed lengths, bellows have the advantage of being continuously adjustable: in principle this is the only difference between them. Finally, macro lenses can be combined with tubes or bellows and can tolerate a greater extension before the quality of the image deteriorates.

The most suitable camera for use in conjunction with all these attachments is the single-lens reflex, largely because of its complete avoidance of parallax. Depth of field is extremely small at close distances, and the only way of being sure that the subject is in focus is to examine it directly on a focusing screen.

Formulas for exposure calculation

(a) actual exposure = exposure indicated $\times \left(\dfrac{\text{total extension}}{\text{focal length}}\right)^2$

(b) actual exposure = exposure indicated $\times (M+1)^2$
where M is the Magnification.

To use either of these formulas it is first necessary to measure the light available and calculate an exposure time as if for a normal photograph—this is the "exposure indicated".

The first formula, usually the more convenient to use, also requires the extension to be measured (either with a ruler or by reading the distance off the scale on, say, the bellows rail). The second method depends on the "magnification ratio", which is simply the image size divided by the size of the actual object.

Extension tubes
A single tube or a series joined together can be fitted between the camera body and the lens. The greater the extension, the larger the image. More sophisticated tubes retain the use of automatic diaphragm, but with simple tubes it is necessary to stop down manually. The rail is not an integral part of the tubes, but a useful aid for measuring the lens-to-film distance, from which the correction can be calculated.

Supplementary lens
A simple positive lens can be fitted over the normal lens to magnify the image.

Macro lens
Though designed for close-up work, macro lenses can also be used for normal distances.

Extension tubes
These are usually sold in sets of three, each of a different length, giving a wide selection of magnifications when used in combination.

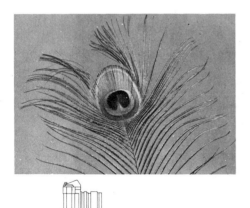

Supplementary lens
A +2 supplementary lens (basically a magnifying glass) was used to take this picture of a peacock feather. Unlike more elaborate equipment, supplementary lenses require no exposure increase and can be fitted even to cameras with fixed lenses. Their strength is measured in diopters (numbers related to their focal length), added to the strength of the lens.

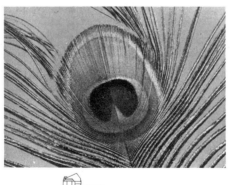

Macro lens
Because the quality of supplementary lenses is limited, a macro lens was used to take this photograph. The macro lens mount indicated a magnification ratio of 1:1.1, i.e. M = 0.9 (reproduced slightly smaller here). An exposure of $\frac{1}{4}$ second at $f16$ was indicated by the meter: using formula (b) the correct exposure was $\frac{1}{4} \times (0.9+1)^2 = 0.9$ seconds (in practice 1 second).

Normal lens with extension tubes
Two extension tubes and a 50 mm lens were used to achieve this life-size image. The total lens-to-image distance was measured at 100 mm and the lighting was as before. Using formula (a), the actual exposure at $f16$ was $\frac{1}{4} \times (\frac{100}{50})^2$, which worked out at exactly 1 second, or four times the measured exposure. This ratio of magnification is very useful for copying slides.

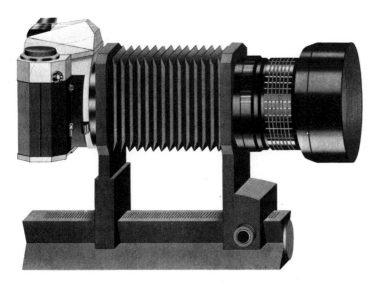

Bellows attachment

The bellows works in exactly the same way as extension tubes, increasing the distance between the lens and the camera body to give larger images than the lens can produce on its own. They are more convenient than tubes in that they can be adjusted continuously, but because they are bulkier and tend to be more expensive they are an investment for the specialist.

Exposure for close-up

The most serious problem confronting the photographer who wants to take close-ups is that the f-numbers on the aperture scale cease to function in the same way. This is because f-numbers are calculated on the assumption that the distance between the lens and film plane is equal or nearly equal to one focal length. However, the brightness of the image decreases as the lens moves away from the focal plane, and this is not accounted for by the aperture number.

At distances within range of the lens without its special attachments the discrepancy is small enough to be ignored, but as the lens is moved farther away from the camera it becomes increasingly significant.

A "through-the-lens" meter overcomes this problem automatically because it reads the actual light, not f-numbers. Without a TTL meter, however, it is quite simple to calculate the correct exposure from an ordinary meter reading, using one of the two formulas provided in the box on the opposite page.

Both formulas will give the same result, but in practice one is often more convenient than the other. When using tubes or bellows it is likely to be easier to measure the length of the extension that relates to the first formula, while a macro lens may have a "scale of magnification", which relates to the second formula.

The attachments here are sophisticated; the beginner can start by reversing the lens and making a cardboard extension.

Reversing ring

A reversing ring is a simple adaptor that enables the lens to be mounted back-to-front. The diagram above shows how this makes it possible to focus closer than normal. Moreover, a reversed lens can often improve the quality of photographs taken at higher magnifications using other extension attachments. This is because many camera lenses are asymmetrical, designed to give their best results when the back elements are used at short range.

Ringflash

It is often difficult to obtain adequate light for close-up photography, particularly when dealing with moving objects, and flash equipment is frequently used to solve the problems. Ringflash, a circular tube that fits round the lens to illuminate close objects from all sides, can help to avoid the harsh shadows that may result from ordinary flash, and can provide even, frontal lighting at very short distances.

Normal lens with bellows

To achieve this magnification of about $1\frac{1}{2}$x, a bellows unit was used. As with extension tubes, focusing at this degree of magnification is best carried out by examining the image through the viewfinder and moving the whole apparatus in relation to the subject; adjustments can then be made. The extension was 120 mm and, using (a); the exposure was $\frac{1}{4} \times (\frac{120}{50})^2 =$ about $1\frac{1}{2}$ seconds.

Macro lens with bellows

A 55 mm macro lens in combination with a bellows unit was chosen for this picture (about $2\frac{1}{2}$x life size) because of the macro lens's high quality in close-up photography. The total extension was 200 mm. Using formula (a), the exposure was $\frac{1}{4} \times (\frac{200}{55})^2 =$ about $3\frac{1}{2}$ seconds. With slow speeds allowance should be made for reciprocity failure, and 5 seconds was used.

Microscope attachment

Photography has become an invaluable aid in science and medicine, particularly in the field of photomicrography, the technique of taking photographs of very small objects through a microscope (outside Britain and the USA, this process is called "microphotography"). Manufacturers of "system cameras" often include microscope attachments.

Filters for black and white

Panchromatic film, as its name implies, is sensitive to all the colours seen by the human eye, although of course in black and white photography the result appears as varying shades of grey. The emulsion does not, however, respond evenly to colours. Compared with the human eye, it is oversensitive to blue and undersensitive to green and red. Thus blue sky, for example, tends to come out too light.

The solution is to use filters—simple pieces of coloured, transparent material that may be fixed temporarily to the front of the lens. An object appears coloured because when white light (containing all colours) falls on it, some of the colours are absorbed; only the remaining colours are reflected and can be seen. Filters work in the same way, allowing some colours to pass through to the film and blocking the others. They are made either of glass or gelatin, the latter being cheaper but more vulnerable to damage.

A filter of any one of the primary colours of light (red, green or blue) will prevent some portion of the other two from reaching the film, and in black and white photography filters enable a great deal of control to be exercised over the response of the film to the subject. An example is a landscape with a blue sky and white clouds: a filter may be necessary to strengthen the contrast of the clouds against the sky. A yellow filter would make the blue sky slightly darker (by absorbing some of the blue before it reaches the film), an orange filter considerably darker, and a red filter would render it very dark.

Filters and exposure

Because the filter prevents some light from reaching the film the exposure must be increased, and the stronger the filter the more exposure will be required in compensation. The degree of increase of exposure is called the filter factor. A filter factor of two, for example, will mean doubling the exposure: thus x2 = 1 stop, x3 = 1½ stops, x4 = 2 stops, x8 = 3 stops. Manufacturers provide precise instructions.

It is not essential to have a large range of filters. For general work a pale yellow and a yellow-green are usually sufficient. Under most conditions the yellow-green will give a colour response very similar to that of the human eye, and the pale yellow, which requires little additional exposure, will produce good skies and can to some extent penetrate haze. An orange or red filter is also very useful for enhancing blue sky.

The need for filters

Colours are rendered as shades of grey in black and white photography. When no filter is used (*far right*) the greens, reds and blues may look too similar, since the human eye responds to colours in a way different from film. Filters can correct this, adjusting the brightness of colours relative to each other.

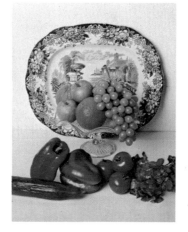

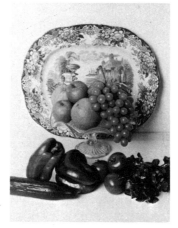

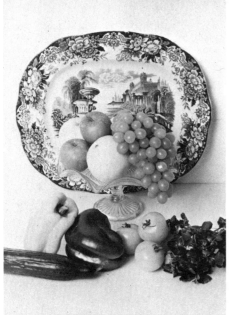

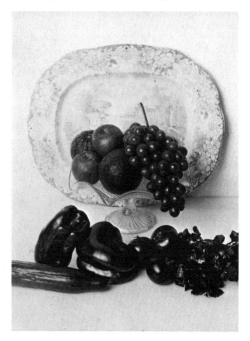

Red filter
Nearly all the blue and green light is absorbed by a red filter, so that the blue on the plate is enhanced while the red pepper and tomatoes are rendered nearly white.

Green filter
With a green filter, red light is blocked but green light admitted; reds then become darker than greens. It is useful for leaves and grass, which can often appear too dark.

Blue filter
A blue filter absorbs red and green, making them appear the same tone. Blue objects come out as white and thus disappear against a white background.

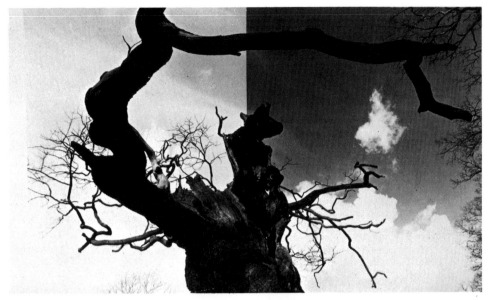

Application of a red filter

The picture on the left demonstrates one of the applications of a red filter. In the half on the far left, taken without a filter, the sky is over-exposed, so that both the blue sky and the white clouds appear an almost uniform white. The effect is pronounced because panchromatic film is particularly sensitive to blue light. With a red filter over the lens (right half) much of the blue light is absorbed by the filter, making the sky appear darker. The clouds, of course, remain white and consequently stand out, giving an effect closer to that seen with the human eye.

Polarizing filter

Light consists of waves which vibrate at all angles, but when it is reflected from non-metallic surfaces some of it is polarized—the waves vibrating at only one angle. A polarizing filter (*above*) can also polarize light, and if set at the correct angle it will block light which has already been polarized, reducing or eliminating the reflections. It is usually necessary to rotate the filter to find this angle. The two pictures on the left illustrate the results: the one on the far left was taken without a filter, the other with one. As well as minimizing unwanted reflections, a polarizing filter will darken sky.

Filter	Result lighter	Result darker	Suggested uses
Yellow	Yellow, green slightly	Blue slightly	Landscapes, sports. Slightly darkens sky, grass appears lighter.
Yellow-green	Yellow and green	Blue	As above, but contrast greater; effect on grass more pronounced.
Green	Green	Red and blue	Subjects with concentrated green, which normally appear too dark.
Orange	Yellow and orange; red slightly	Blue; green slightly	Gives dark sky, accentuates clouds; brings out texture on stone and wood.
Red	Red	Blue and green	Produces dramatic sky; gives lighter brickwork on houses.
Blue	Blue	Red; green slightly	Emphasizes mist.
Ultraviolet	Ultraviolet eliminated		Penetrates haze, particularly near snow or sea. Gives clear distances.
Polarizing			Reduces reflections from non-metallic surfaces such as glass and water.

Black and white film guide

Choice of black and white film is, like choice in many fields of photography, far from an exact science. Fortunately, modern films are so good-natured, each type being able to cope adequately with a wide range of photographic possibilities, subject matter and lighting conditions, that as a result inappropriate choice is rarely a disaster, especially if you play safe and go for a film of medium speed rating.

The main factors governing choice are (1) film speed, (2) format, (3) length (in number of exposures per roll) and (4) brand. Thus a photographer who asks for a "36-exposure 35mm cassette of *FP4*" has specified his need accurately, *FP4* being *Ilford*'s medium-speed film, rated at 125 ASA. Most cameras take only one film format, so the choice there is self-evident.

CHARACTERISTICS OF FILMS
Speed
The choice factor which governs the suitability of a film for the job it has to do is its speed—its sensitivity to light. This will be denoted by a reading, shown on the package, in either ASA or DIN scale figures (often both are shown, e.g. 125 ASA/22 DIN). For the practicalities of choice we can think of black and white general-purpose films as being in three speed bands—slow, medium and fast. Taking for convenience the ASA scale, this would break down roughly into slow films of 20–50 ASA, medium films of 80–125 ASA and fast films of 200–1250 ASA. The widest sold medium films are 125 ASA and those in the fast range 400 ASA.

This speed figure, set on the meter, will play a big part in the way the camera can be set to expose the film correctly. A fast film speed will, under given conditions, allow a higher shutter speed or smaller aperture to be used, which generally makes taking photographs easier. That is not to say that fast films are superior nor, conversely, that slow is surer. The choice should be related where possible to the type of photograph you are looking for.

Film speed has a close relationship to several photographic facts of life—graininess, latitude, contrast and resolving power (the ability to show small detail sharply) and acquaintance with these permutations will help make that choice more objective.
Grain
The faster the film, the coarser the grain. However much manufacturers improve films they cannot escape the physical fact that the size of the individual silver halide grains in the emulsion is smaller in slow films than in fast ones. Both exposure and the degree and type of development influence the clumping

together of these grains, which becomes evident in the print as the mottled effect of the graininess. Hence correct exposure and development can minimize the grain of a fast film, but it starts off with a built-in handicap against a slow film.
Latitude
A film's ability to deliver an acceptable result when the exposure given is greater or less than strictly correct is widest with fast films. Slow films require accurate exposure and development to give of their best; fast films can tolerate underexposure or overexposure of several stops and still yield acceptable prints.
Contrast
Though much influenced by development, contrast is also closely related to film speed, and the contrast of slow films builds up much more quickly than fast ones.
Resolving power
The ability to show fine detail is higher in slow films than in fast ones. Measured scientifically, slow films resolve more lines per millimetre. Since the appearance of sharpness is enhanced by contrast, slow films have a much greater faculty for showing fine detail than fast films.

THE CHOICE OF FILM
Medium film
If there is a film for all seasons and shots for the all-round photographer it is the medium-speed variety. Pictures in clear sunny conditions will call for an exposure of $\frac{1}{250}$ sec at $f11$. Fast action can be arrested easily and coped with confidently even in dull conditions by increasing the aperture. Shots requiring considerable depth of field should not need a shutter speed so slow that a tripod would be needed.

If development is to standard recommendation then grain should be unnoticeable on a print, say, $25 \times 30\,cm/10 \times 12\,in$, and not a problem even if development is prolonged to increase contrast.
Slow film
The photographer looking for maximum image quality for large blow-ups of, say, $40 \times 50\,cm/16 \times 20\,in$ or larger will find a slow film is his best ally. It is excellent for architectural work in which rendering of extra fine detail and texture is important. Technical subjects likely to be examined and close-up work in general benefit from the inherent sharpness qualities, as do subjects showing large expanses of even tone where grain would be obtrusive.

Slow film can be the 35mm user's way of approaching large-format quality. It can also, incidentally, be employed rather as an extra-long-focus lens, since a small part of

the negative may be enlarged while retaining sufficient quality. The potential of slow film to enhance contrast can be useful under flat lighting conditions, such as when shooting landscapes on a dull day.
Fast film
Fast films should not be selected for general use simply as an insurance policy against more careful technique because of their good-natured latitude. Though modern fast films are good enough to produce adequate results in brilliant lighting or of even-toned subjects in flat lighting, for which they are least suited, they are best used to extend the photographer's shooting possibilities when the light is low but a high shutter speed is essential. Obviously they score highest for sporting events, especially indoors, for candid photography in poor light and for use with very long-focus lenses with their restricted depth of field and relatively small maximum aperture.

EXTENDING A FILM'S RANGE, OR "PUSHING"
The nominal speed of a film is that which the manufacturer recommends for processing in a developer that gives optimum results. Processing in the more energetic developers or in those which give finer grain requires amendment either way to the film speed, and effectively extends the film's versatility. Thus the standard developer for *Ilford*'s medium speed *FP4* is *ID11*, giving the nominal 125 ASA, but processing in fine-grain developers such as *Perceptol* requires a one-stop exposure increase rating at 64 ASA, and a $\frac{2}{3}$ stop decrease to 200 ASA in developers with a high speed/grain ratio such as *Microphen*.

This apparent elasticity of film speed is employed most with fast films. Increasing of a film speed, with a corresponding increase in development time, is known as "pushing". As an example *Ilford HP5*, nominally rated at 400 ASA for 7 minutes development in *ID11* (full strength) can be rated at 800 ASA if developed for $8\frac{1}{2}$ minutes, 1600 ASA in the more energetic *Microphen* for 10 minutes and even 3200 ASA (giving an extra 3 stop exposure) for 15 minutes.

Inevitably, "pushed" negatives do not give optimum quality, and the technique really works best with subjects under flat lighting conditions. Most experienced photographers do not change because they have learned how to exploit the qualities and idiosyncrasies of their chosen film by long and patient trial and error. Although the choice may be wide, it is probably worth settling for two or three films of different speeds as quickly as possible.

BLACK AND WHITE FILM

NAME	MANUFACTURER/ DISTRIBUTOR	SPEED (ASA)	SIZES
SLOW FILM			
Efke-Adox KB 14	Frederick Page	20	35 mm/36 exp.; 35 mm cassette reloads; 5 m, 17 m, 30 m bulk lengths
Efke-Adox R 14	,,	20	120 roll film
Efke-Adox KB 17	,,	40	35 mm/36 exp.; 35 mm cassette reloads; 5 m, 17 m, 30 m bulk lengths
Efke-Adox R 17	,,	40	120 roll film
Panatomic-X	Kodak	32	35 mm/36 exp.; 35 mm cassette reloads; 17 m bulk lengths
Panatomic-X Professional	,,	32	120 roll film
Pan F	Ilford	50	35 mm/20 and 36 exp.; 35 mm cassette reload; 5 m, 17 m, 30 m bulk lengths; 120 roll film
MEDIUM SPEED FILM			
Efke-Adox	Frederick Page	100	35 mm/36 exp.; 35 mm reloads; 5 m, 17 m, 30 m bulk lengths
Efke-Adox R 21	,,	100	120 roll film
Boots	Boots	125	126/20 exp.; 127, 35 mm/20 and 36 exp.; 120 roll film
FP4	Ilford	125	126/20 exp.; 35 mm/20 and 36 exp.; 35 mm cassette reloads; 5 m, 17 m, 30 m bulk lengths; 120 and 220 roll film; sheet film
Plus-X Pan	Kodak	125	35 mm/20 and 36 exp.; 35 mm cassette reloads; 5 m, 17 m bulk lengths
Plus-X Pan Professional	,,	125	120 roll film
Plus-X Pan Professional 4147	,,	125	Sheet
Verichrome Pan	,,	125	110/12 exp.; 126/12 and 20 exp.; 127, 620, 120 roll film
FAST FILM			
HP4	Ilford	400	127, 120 and 220 roll film; sheet film
HP5	,,	400	35 mm/20 and 36 exp.; 5 m, 17 m, 30 m bulk lengths
Panchro-Royal 4141	Kodak	400	Sheet
TRI-X Pan	,,	400	35 mm/20 and 36 exp.; 35 mm cassette refills; 5 m, 17 m bulk lengths
TRI-X Pan Professional 4146	,,	320	Sheet
TRI-X Ortho 4163	,,	200	Sheet
Royal-X Pan	,,	1250	120 roll film
Type 2475 Recording Film	,,	1000–1600	35 mm/36 exp.

INSTANT PICTURE FILM BLACK AND WHITE

TYPE	SPEED (ASA)	SIZE/PACKING	IMAGE TYPE
PACK FILM			
Polaroid Type 105	75	3¼ × 4¼ in/8 exp.	Print and negative
Polaroid Type 107C	3000	3¼ × 4¼ in/8 exp.	Print
Polaroid Type 87	3000	3¼ × 3⅜ in/8 exp.	Print
SHEET FILM			
Polaroid Type 51	320	4 × 5 in/20 sheets	Print
Polaroid Type 52	400	4 × 5 in/20 sheets	Print
Polaroid Type 55	50	4 × 5 in/20 sheets	Print and negative
Polaroid Type 57	3000	4 × 5 in/20 sheets	Print
ROLL FILM			
Polaroid Type 20C	3000	2½ × 3¼ in/8 exp.	Print
Polaroid Type 37	3000	2½ × 3¼ in/8 exp.	Print
Polaroid Type 42	200	3¼ × 4¼ in/8 exp.	Print
Polaroid Type 47	3000	3¼ × 4¼ in/8 exp.	Print
Polaroid Type 46L	800	3¼ × 4¼ in/8 exp.	Black and white transparency
Polaroid Type 146L	100	3¼ × 4¼ in/8 exp.	Black and white transparency
Polaroid Type 410	10000	3¼ × 4¼ in/8 exp.	Print

INSTANT PICTURE FILM COLOUR

	SPEED (ASA)	SIZE/PACKING	IMAGE TYPE
PACK FILM			
Polaroid SX-70	80	3¼ × 3¼ in/10 exp.	Integral print
Polacolor 2 Type 88	75	3¼ × 3⅜ in/8 exp.	Print
Polacolor 2 Type 108	75	3¼ × 4¼ in/8 exp.	Print
Kodak PR 10	150	2⅔ × 3 9/16 in/8 exp.	Integral print
SHEET FILM			
Polacolor 58 Professional	75	4 × 5 in/20 sheets	Print

Instant-load cartridges, for both 110 and 126 format, are usually available in either 12-exposure or 20-exposure loadings. The 35 mm cassette holds either a 20- or 36-exposure length. Roll film packing is either 120 with 12 exposures or 220 with 24 exposures, the latter being less common. Some cameras or film packs take 8, 10 or 16 exposures on the 120 format. Roll film is also known as 6 × 6 cm or 2¼ in square film. Sheet film comes in a wide variety of centimetre and inch sizes. Choice is essentially a matter of convenience, availability and economy, larger loadings being cheaper per shot. As in so many areas of consumer selection, brand choice is largely a matter of personal preference. If you like the packaging or are more persuaded by the promotion of any one of the big film manufacturers, it is safe to say that results from that film are more likely to be dependent on the way you expose and process it than on its brand qualities. Colour films of different manufacturers have distinct characteristics, but it is not possible to predict reliably the brand from which a black and white print was made.

Note: the ASA speed ratings are nominal. They vary greatly with change in temperature. The integral print system involves no throw-away elements. The others work on the "peel-apart" principle in which the negative is discarded (except for Polaroid Type 105 and Polaroid Type 55 in which the negative can be treated and reused).

THINKING
IN COLOUR

"The prejudice many photographers have against colour photography comes from not thinking of colour as form. You can say things in colour that cannot be said in black and white."

EDWARD WESTON

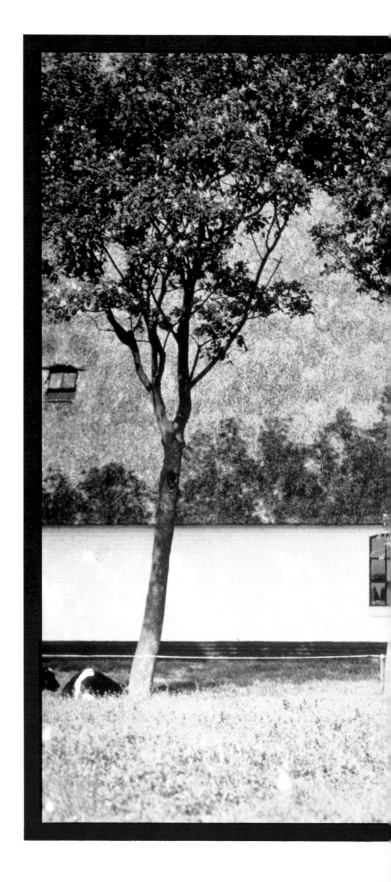

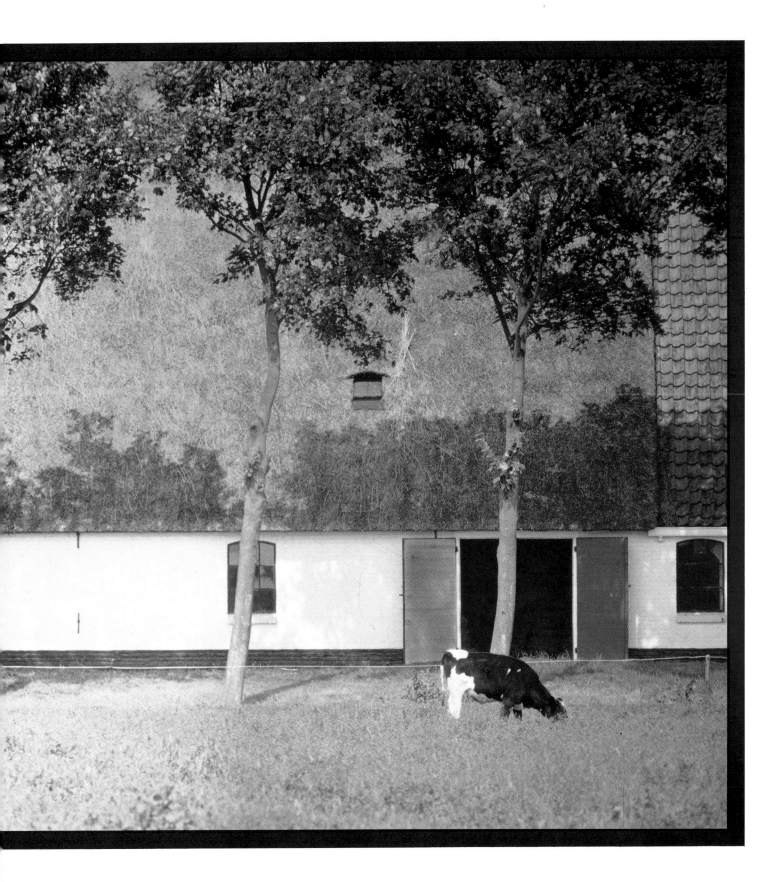

Understanding colour

While an instinctive response to colour is of greater importance to the photographer than an understanding of the physical nature of light, even the most creative artists sometimes show a little curiosity in their medium. Moreover, some small knowledge of theory is essential to anyone who wishes to make his own colour prints.

The basic principle of colour photography is that any colour can be reproduced out of a mixture of only three basic "primary" colours—red, green and blue. White light, consisting of a combination of the three primary colours, can be separated into its components, but can itself be produced by combining red, green and blue lights. These three colours are therefore called the "additive primaries", and the production of multi-coloured images by mixing them together is known as "additive synthesis". However, the method is inconvenient in practice and not used to any great extent in photographic colour systems.

Most practical colour photography employs the method known as "subtractive synthesis". Instead of beginning with three coloured light sources, the subtractive method uses a single white light and creates various colours by filtering out the colours not contained in the desired colour. The filters used in this method are coloured yellow, magenta and cyan and called the "subtractive primaries", because each of these colours has the ability to block or subtract from the light one of the additive primaries. Yellow subtracts blue, magenta subtracts green, and cyan subtracts red.

The colour wheel

Consideration of colour needs to be related to psychology and physiology as well as to physics. The emotional effects of colours in various combinations and juxtapositions depends to a great extent on the individual, and generalizations about which colours "go well together" should be regarded with a certain amount of suspicion. Nevertheless, some explanation of the more obvious dramatic effects can be found in the relationship individual colours have to each other on the "colour wheel": if a colour is placed side by side with its complementary colour the result is likely to be discordant, while colours close to each other tend to blend.

Perhaps the strangest aspect of colour photography is that it is not necessarily the brightest or most colourful scenes that produce the most striking colour photographs. Often a very restricted range of colours with only one dominant primary will give the impression of being highly "colourful", while multi-coloured photographs may appear disappointingly weak.

(see page 42)

The spectrum
A prism can be used to demonstrate that white light is composed of different colours. When a beam of white light passes through the prism, it is not only refracted (bent out of its original path—see page 42), but also split up into its component colours. This happens because the short wavelengths (the blue end of the spectrum) are more strongly refracted than the longer wavelengths (the red end). A second prism can then recombine the colours into a single beam of white light.
(PAUL BRIERLEY)

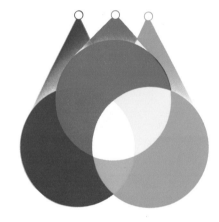

The additive principle
Red, green and blue lights can be added together to produce any other colour, including white. The additive principle was used as the basis of the original demonstration of the possibility of colour photography, conducted by James Clerk Maxwell in 1861. Three negatives were made of the subject—one taken through a red filter, one through a green filter and the last through a blue filter. From these, three positive transparencies were made. Using three projectors, each positive was projected through a filter of the same colour as the one through which it had been taken: the red, green and blue image overlapped to create the first full colour picture.

The subtractive principle
The diagram above illustrates the principle of producing colours by subtraction rather than by addition. A set of coloured filters is used to block varying amounts of the red, green and blue content of a single source of white light. Each of the subtractive primary colours, used for the filters, will block one of the additive primaries: yellow blocks blue, magenta blocks green, and cyan blocks red. Thus each filter will remove one-third of the total spectrum and transmit two-thirds; all three filters together will remove all the colours, and the result will be black. This is the basis of most practical colour printing systems employed today.

Colour and composition

This London barrow-boy seems blissfully unaware that the bold colours on his fruit stall have caught the photographer's eye. The strong horizontal composition, relying on colours from a distinctive section of the colour wheel, is given added force by the lack of rivalry from the neutral tones in the background, the black and white clothes of the boy and the large, muted expanse of green. It should also be noted that if the boy had been looking at the camera he may have detracted from the essential purpose of the picture and stolen the initial interest of the viewer.

Nikon F2 with 80–200 zoom lens at 90 mm; $\frac{1}{60}$ sec at f5.6; Ektachrome X; 81A filter.
(JOHN GARRETT)

The colour wheel

The colour wheel is a schematic way of representing the relationship between colours. Adjacent colours will harmonize fairly readily, while complementary colours (opposite each other) will tend to contrast.

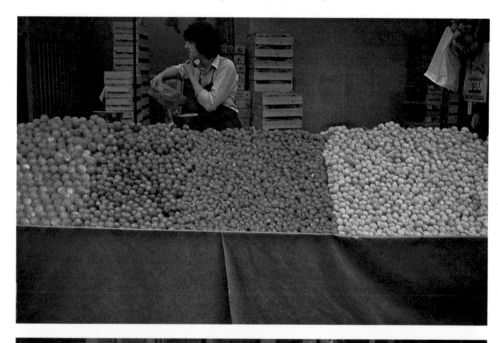

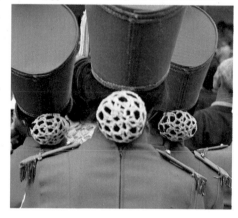

Dominant colour for effect

A back view of girls in a band provides a good example of using one colour for impact. Although the gold is a contrasting colour, it is secondary and soft enough not to clash.

Canon FT with 50 mm lens; $\frac{1}{125}$ sec at f5.6; Kodachrome 25. (NEILL MENNEER)

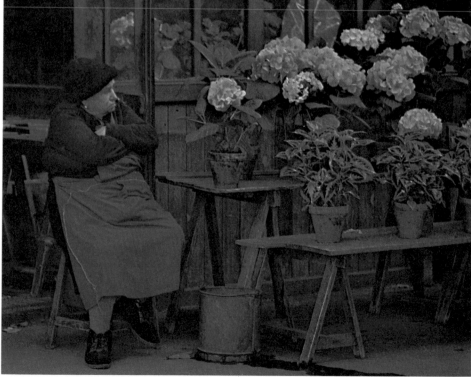

Colour and atmosphere

Red, blue and purple work well together to form a delightful image of a Parisian flower seller. Here the person is an integral part of the composition, her apron picking up the blue flowers and the skin tones blending with the red blooms. As in the top picture, there are no contrasting colours of any strength to ruin the balance and, again, the muted tones of the other elements and the overcast conditions required a generous exposure.

Nikon F with 105 mm lens; $\frac{1}{60}$ sec at f4; Ektachrome X.

Isolating the colour element

Although it is small, the vivid hue of the red towel catches the eye immediately. Its importance can be gauged by putting a thumb over it from the top.

Canon FT with 135 mm lens; $\frac{1}{125}$ sec at f8; Kodachrome 25. (NEILL MENNEER)

The colour process

Although the chemistry of colour photography is a great deal more complicated than that of black and white, the principles are in many respects similar. The idea that a full range of colours can be produced by adding together three primary colours (explained on pages 72–3) leads to the possibility of making colour pictures out of a minimum of three black and white negatives: each negative would have to contain all the information about one of the primary colours in such a way that any other colour could be produced by a combination of the primaries.

Early colour cameras produced three so-called "negatives" by analysing the subject into its red, green and blue components. These were then recorded on three black and white photographic plates, and a special additive viewing system used to recombine the images into a colour picture.

A less cumbersome method is suggested by the subtractive principle. If, instead of additive primaries, the images are produced in the subtractive colour primaries made out of dyes, then the final image can be viewed simply by laying the dye images one on top of the other and viewing the result with a white light. This will work for both prints and transparencies. The image would, for example, look blue where there was a combination of cyan and magenta, because the red and green would be filtered out.

Colour films

Actual colour films (reversal for slides and negative material for prints) consist of three layers of emulsion similar to the emulsion used in black and white film (see page 38). Each layer is converted to a dye image at some stage of the processing, thus arriving at the same effect as three separate images.

The top layer is sensitive to blue light, the second to green and the third to red—the same breakdown as black and white film (see pages 38–9). Light from the subject is recorded on the appropriate layer or layers of emulsion: red light, for example, will affect only the third layer, passing through the others, while yellow light, a combination of red and green, will be recorded on both the second and third layers. Several extra layers such as the acetate base are built into the structure of the film to hold it all together, but the basis of "tripack" film is in the three emulsion layers themselves.

Colour reversal film

The latent images formed on each layer of emulsion when the film is exposed to light are developed in much the same way as for black and white. Exposed silver halides are converted to black metallic silver, giving

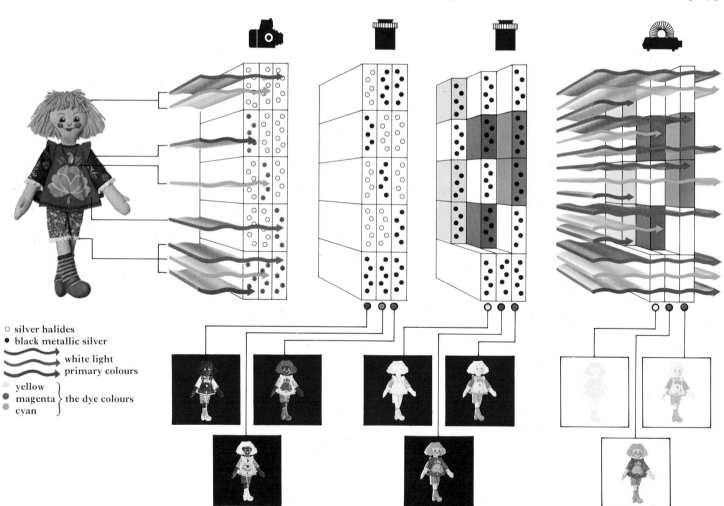

○ silver halides
● black metallic silver
〜〜〜→ white light
〜〜〜→ primary colours
● yellow
● magenta } the dye colours
● cyan

Colour reversal film

Each emulsion layer is sensitive to one-third of the visible spectrum—one of the primary colours. When the film is exposed a latent image is formed in the silver halides of the emulsions. White light forms a latent image on all three layers.

The first developer turns the latent images into black metallic silver. The film is then fogged by exposure to light or chemicals, and a second developer converts the remaining halides to silver, forming the three dye colours at the same time.

The film is finally bleached and fixed to remove the silver, leaving the finished transparency. Each dye filters one of the primaries from white light shining through the slide, so that only the correct colours pass through.

superimposed black and white negatives.

After the first development, the film is exposed a second time to fog the unexposed silver halides. (This may be done by exposing the film to light, or by the use of a chemical agent that achieves the same effect.) The second exposure is necessary to provide a latent "reverse image", to give a positive instead of a negative.

The film is then immersed in a second development bath: this develops the newly exposed halides into metallic silver, and at the same time activates the dye couplers, which are either in the film itself or in the developer. These form three dye images of different colours wherever development of silver is taking place. The blue-sensitive layer becomes yellow, the green-sensitive layer becomes magenta, and the red-sensitive layer becomes cyan. Finally it is

bleached to convert the metallic silver back to silver bromide, then fixed to convert the bromide to a soluble salt.

Where the original subject was blue, the final transparency will now consist of magenta and cyan dye; where it was red, the image will have yellow and magenta; and where it was green, the image will have yellow and cyan.

Colour negative film

Working with colour negatives allows the photographer greater control over the colours of the image because the final picture is produced in two separate steps instead of one, the negative being an intermediate stage; corrections can be made by filtering the image at the printing stage.

The developer performs exactly the same functions as the second developer of the reversal process. It converts the latent image

to black metallic silver, and immediately activates the dye couplers to give the dye colours at the negative stage of development. This time, however, no reversal has taken place, and the colours are therefore "negative". Thus the image formed on the blue-sensitive stage is yellow, that on the green-sensitive layer is magenta, and that on the red-sensitive layer is cyan. Again all the silver is then bleached out and the unexposed, undeveloped halides dissolved away (like fixing a black and white negative —see page 173). Colour negatives are left with an orange cast, called a "mask".

The printing stage then repeats the whole sequence. Dyes are formed in the emulsion layers of the paper in exactly the same way and, because each colour negative is rendered in its complementary colour, the final result is positive.

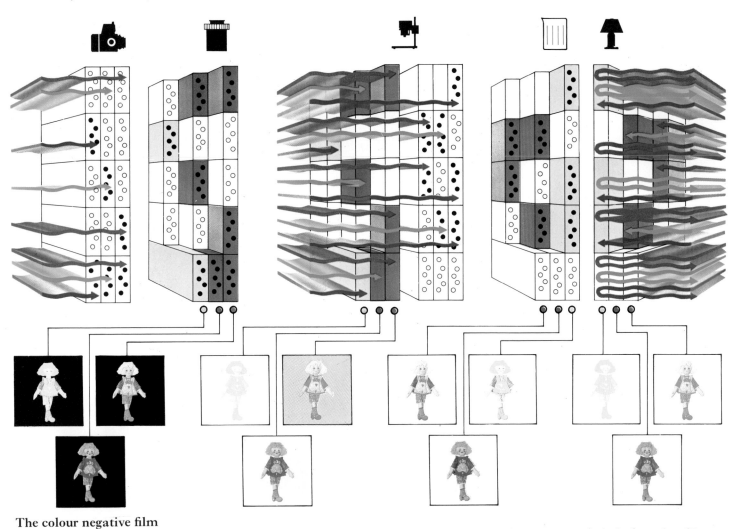

The colour negative film

The latent image is formed in the same way as for reversal film. The colours reflected by the subject are analysed into their primaries, and the latent image recorded on the appropriate layer or layers of emulsion.

The developer activates the dye couplers at the same time as converting the image to black metallic silver. Each primary colour is recorded as its own opposite or "complementary" colour (e.g. yellow dye for blue light).

The silver is bleached and fixed out of the film. At the printing stage, white light from the enlarger shines through the colour negative to form a latent image on the emulsion. The negative filters out the appropriate colours. Development of the paper

results in the formation of dye images, just as for the negative. Now, however, all the dye colours are the complements of those on the negative: when viewed in white light a positive image is seen on the final result—a print.

75

Colour sense

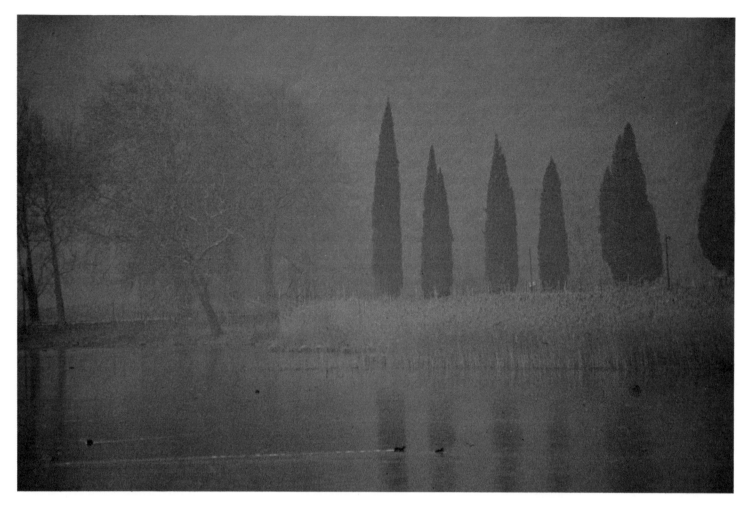

Through tones and hues colour defines form and communicates emotion and mood. Advertising photography is notorious for its control over our responses through its cunning use of colour. These techniques of persuasion are not beyond the ability of the amateur photographer who, rather than wanting to sell a product, wishes to give his picture maximum atmospheric impact.

A common myth about colour photography is that it is an exact reproduction of an image. Since the photographic process involves slight distortion, colours of the result are hardly ever the same as the ones seen by the same person at the moment of exposure (see page 72). Nor does this inaccuracy necessarily matter: as the Impressionist painters realized, colours are continually changing according to the light and their proximity to each other.

Nevertheless, colour enables the photographer to record with a greater degree of accuracy than does black and white. A monochrome photograph is abstract because it leaves out an important visual element. Yet because a photograph is a self-contained work of art rather than mere representation, the black and white photograph has by no

means been eclipsed by colour; it simply offers other qualities.

Colour photography demands a different creative outlook—a visual change of gear. The colour photographer must compose with hue as well as tonal contrasts and values; he must observe the ways in which the temperature and distribution of colour can create space and form; he must be aware of preconceptions about colour, which are sometimes strong enough to blur judgments and lead him to see the grass as being greener than it really is.

Some people appear to have been born with a well-developed colour sense; they choose clothes and furnishings with an apparently instinctive ease. Yet it is possible for most people to develop a sound awareness of colour simply by looking hard and observing the ways in which colours affect each other. If taste can be cultivated through this kind of sensitivity, it has a good chance of becoming personal; otherwise good taste is likely to be dominated by fashion.

Colour theories, based on the structure of the spectrum, offer guidance only within limits. For example, colour harmony can be attained either by using many tones of the

Colour and time of day
The different colours produced by the light at various times of the day can be exploited to convey atmosphere in a unique way. When the sun goes down, for example, landscapes are illuminated only by reflected light and all colours—including the yellow of the reeds and the green of the trees in this picture—take on a blue cast. Here the monochromatic feel has been heightened by the use of a blue filter, emphasizing the peaceful mood.
Nikon F2S with 200mm lens; $\frac{1}{250}$ sec at f4; Ektachrome X; CC10 blue filter.

same colour or colours from any quarter of the colour wheel (see page 73). Having established harmony, however, it may be necessary to liven up the picture with a dash of discord. Colours from opposite sides of the wheel, known as complementaries, can sometimes enhance each other by contrast.

Neither bright colours nor subdued ones are automatic formulas for success. Contrasting and fully saturated colours can create too many focal points, all fighting for the viewer's attention. A large flower bed in full bloom might appear an inviting subject, but the finished photograph may be a jumble of competing hues with no point on which the eye can rest. In such cases it is preferable to select and simplify.

Contrasting colour
The red shiny body of a cardinal beetle contrasts strongly with the matt green of the rose leaves over which it crawls. Part of the bush was carried inside with the beetle aboard to take the shot under controlled conditions. *Pentax S2 with 100 mm macro lens and three extension tubes; f16 and flash; Kodachrome 25.* (ROBIN FLETCHER)

Colour and texture
The muted pastel shades in this detail of brick, stone and wood are brought out by the soft, hazy light. Here colour and texture work closely together to form the image, illustrating that colour must always be seen in conjunction with the basic elements of photography. *Nikon F2S with 105 mm lens; $\frac{1}{250}$ sec at f5.6; Ektachrome X.*

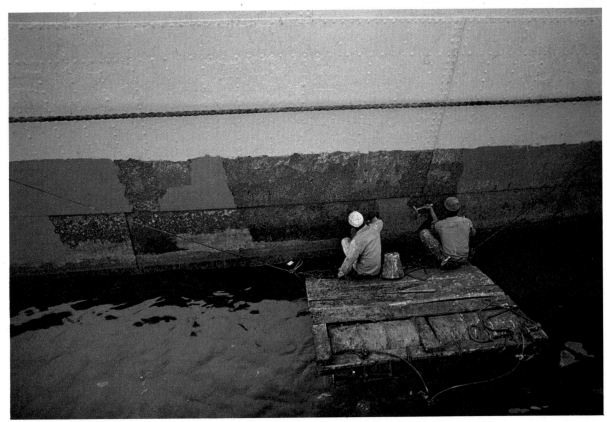

Using colour as a foil
Colours from the same area of the wheel (see page 73) stand out in the pale façade of a Paris street hit by the strong light of noon. They are brought closer together—both in terms of colour and composition—by the green of the tree. This living element does not compete because the focusing deliberately employs its soft tracery as a foil to the dominant background.
Pentax with 135 mm lens; $\frac{1}{250}$ sec at f11; Ektachrome X.

Colour in composition
Three dominant bands of colour are broken by the human element of the men on the pontoon. The blue shirt acts as a compositional catalyst, linking the grey and the turquoise.
Nikon F with 50 mm lens; $\frac{1}{125}$ sec at f5.6; Kodachrome II.

Colour and mood

Of all the formal elements in a photograph, it is colour that makes the most direct impact. In order to have control over the image, the photographer must be aware of the ways in which colour generates mood and atmosphere. A pink rose may endorse that flower's intimation of peace and gentleness; a dark crimson one may contradict it.

There is no generally accepted view as to why specific colours inspire certain feelings; nor are the same feelings universally applied to the same colours. European mourners traditionally wear black and brides wear white, but in India Hindus attend funerals in white and girls are married in scarlet. Danger seems to be the only situation which is symbolized by the same colour (red) in almost every culture.

Some emotional reactions to colour may be conditioned by colours in nature. White, symbol of purity, recalls freshly fallen snow; black, a colour of gloom, is associated with the absence of light and warmth at night; greens and blues suggest the tranquillity to be found among woods, hills, lakes and fields; yellows and oranges, colours of sun and fire, create an impression of warmth, brightness and happiness.

To the photographer the quality of a colour depends not only on its name but also on its tone, its "temperature" (see page 82), the area which it covers and, most important in a visual sense, the colours against which it is seen and photographed.

The 19th-century painter Delacroix said that he could paint the flesh of Venus convincingly in mud provided he controlled the colour against which it was juxtaposed. Since colours change and are changed by each other, the photographer must see each one in relation to the picture as a whole. The yellow of an armchair, which might appear soothing and happy in an expanse of green—its neighbour on the colour wheel—might look discordant and shrill if placed next to violet, its complementary colour.

Since light is the source of colour it affects the mood of an image. The photographer must be aware of more than just the dramatic changes in lighting, and must register the hues, tones and temperatures of a colour, which can fluctuate according to the weather and the time of day. Colours are very different under overcast skies from the way they appear in harsh sunlight, in the mellow afternoon glow or in the warm light of dusk.

Isolating colour
One colour can be a striking element when used in a neutral setting. Here the reds of the chairs, table-cloths and jacket provide the only colour in an image dominated by greys and blacks. The photograph was underexposed by a stop to emphasize the contrast.
Pentax S2 with 55 mm lens; ¹⁄₁₂₅ sec at f5.6; Ektachrome X. (PATRICK THURSTON)

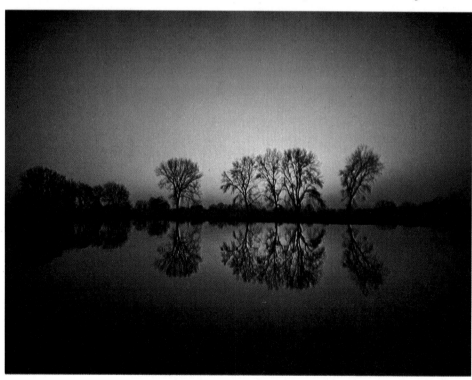

The reflected image
Tranquillity is the central theme of this wide-angle shot of the River Thames flowing through the Berkshire countryside. The almost perfect reflection and soft gentle colours of dusk give the picture a timeless quality. As with most sunsets, a long exposure was necessary in the poor light.
Nikkormat EL with 18 mm lens; ¹⁄₁₅ sec at f5.6; Kodachrome 25. (RICHARD HAUGHTON)

Colour for emotion
Blue is traditionally a colour of sadness and depression, and the mood of this concierge at the uninviting entrance to a Parisian house (*above right*) seems to match his uniform.
Pentax with 135 mm lens; ¹⁄₂₅₀ sec at f4; Ektachrome X.

Using the view camera for effect
A view camera evokes the richness of country life with fine foreground detail and saturated colour (*right*), despite the dull autumnal light conditions. Note the enormous depth of field acquired with the wide-angle lens and the small aperture.
Sinar 10 × 8 in with 165 mm lens; 4 seconds at f32; Ektachrome Daylight. (ROGER PHILLIPS)

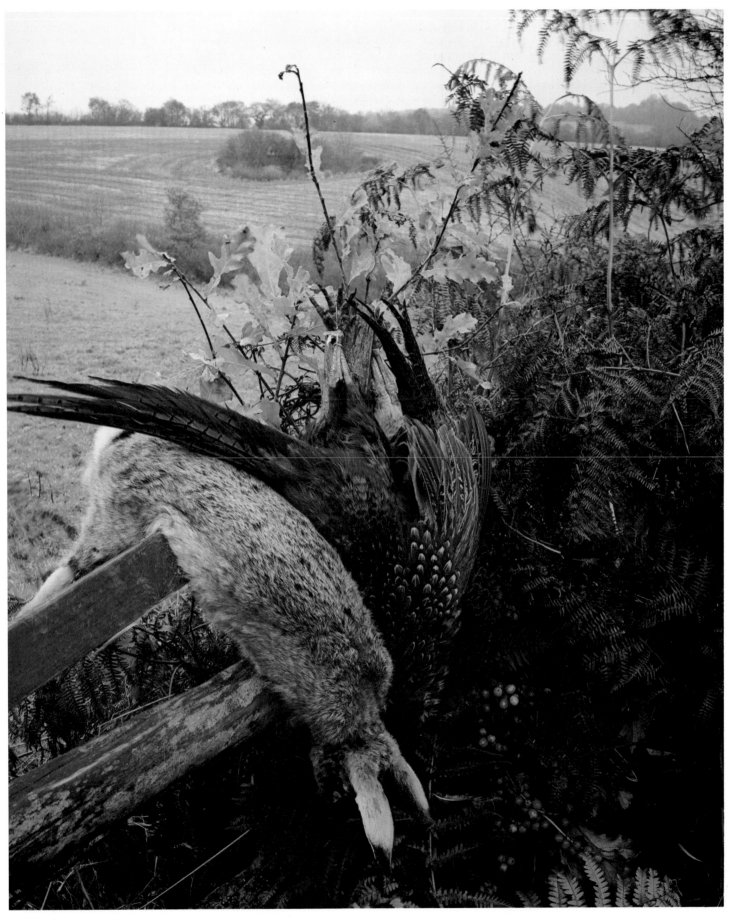

An eye for detail

The observant photographer can find pictures within pictures indefinitely. He might begin by photographing a building, then a section, and then select a detail of one window before isolating a figure framed by that window. Often it is the detail which says more about a subject than the whole.

This awareness enables the photographer to find an inexhaustible wealth of subject matter all around him. Many situations which are conventionally dismissed as having little visual interest incorporate details which only need to be taken out of their original context to become dramatic or decorative images or striking patterns. Areas of colour, isolated from the object to which they belong, have powerful abstract potential.

An eye for detail is too often limited by a connoisseur's prejudice and a reliance on details of historic or artistic importance. Gargoyles, stained-glass panels and medieval turrets are undoubtedly fascinating, yet no more so to the detail hunter than things of less aesthetic significance. A broken and discarded house brick may have no intrinsic artistic appeal, but a close-up of its surface, revealing texture and colour, could make as interesting a composition as any detail of ornamentation. To most people a scrapyard is a chaotic conglomeration of rubbish, devoid of any visual harmony or interest, but to the photographer it can provide innumerable opportunities for selective detail. Ernst Haas, a photographer who has recorded the surfaces of decaying walls and squashed metal cans, maintains that the "final stage of photography is transforming an object from what it is into what you want it to be".

The photographer should not overlook the human or animate details that overlap the static ones. Details of human life may mean anything from a shot of an insignificant face in a crowd to a revealing close-up of wrinkled skin or a part of the body.

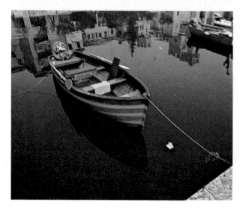

Changing the emphasis
A slight change of viewpoint and a tighter approach can overcome both aesthetic reservations and practical problems. The boat in the harbour is a pleasant image, framed by the reflection of the buildings, but a closer shot from a lower viewpoint produces a totally different composition. It is not necessarily better: it merely serves to illustrate that the photographer can create his own changes in feel. In this case, too, it has a more pragmatic purpose, ridding the frame of the unattractive flotsam floating in the foreground.
Nikon F2S with 105 mm lens; $\frac{1}{250}$ sec at f11; Ektachrome X.

Abstraction through close-up
The materials from which an object is made can often be of more interest or significance than the object itself. Here it is irrelevant whether the iron and wood are part of a boat, a house or a wall; the hard directional light has cast strong shadows and revealed unusual textures to form a striking abstract composition. Areas of strong colour, isolated from the object or scene to which they belong, also have powerful abstract potential for the alert photographer.
Nikon F2S with 85 mm lens; $\frac{1}{250}$ sec at f5.6; Kodachrome 25.

Pictures within pictures
There is an element of the voyeur in every good photographer. It would be easy to walk past this converted houseboat acting as a swimming pool on the Seine, but the instinctive awareness of the compulsive photographer gives him an intriguing "detail within a detail". The exposure was made for the boys, who are in direct sunlight; the exact colour quality of the wood was less significant.
Canon FT with 50mm lens; $\frac{1}{125}$ sec at f11; Kodachrome 25.
(NEILL MENNEER)

Light and colour

Many optical illusions are based on the fact that the brain interprets what is seen by the eye rather than accepting the information literally. This applies to colours as well as to shapes. The knowledge that an object is white, for example, can cause the brain to disregard colours reflected by the object, so that it continues to appear white even when viewed under a strongly coloured light such as candle-light, which is a warm yellow. Consequently the brain does not normally notice quite dramatic changes in colour, such as the difference between candle-light and daylight. Colour film, on the other hand, records colours literally, making no allowance for an overall blue or red cast which may be characteristic of the light source. Many photographs, even though correctly exposed, have been spoiled by the presence of an unexpected colour for which the brain corrects but the film does not.

Colour temperature

"White light" can thus mean a whole range of different colours. It is possible, however, to measure the colour of light, using the fact that when something becomes very hot it starts to emit light: first it glows red, then white, and eventually, if it becomes hot enough, blue. The temperature in degrees Kelvin to which a hypothetical black object must be heated in order to produce a certain

Colour temperature

The illustration below compares the colour temperature of various common light sources. (The actual colours shown are only an approximation and should not be taken literally.) The colour temperature for which daylight film is balanced is 5,500°K, the temperature of "standard noon daylight". This means that a hypothetical black object would have to be heated to a temperature of 5,500°K (5,227°C) to emit light of the same colour as daylight.

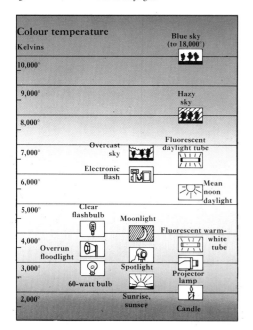

Colour temperature	
Kelvins	Blue sky (to 18,000°)
10,000°	
9,000°	Hazy sky
8,000°	
7,000°	Overcast sky / Fluorescent daylight tube
6,000°	Electronic flash
	Mean noon daylight
5,000°	Clear flashbulb
	Moonlight
4,000°	Overrun floodlight / Fluorescent warm-white tube
3,000°	Spotlight
	60-watt bulb / Projector lamp
2,000°	Sunrise, sunset / Candle

Daylight with daylight film

Daylight with tungsten film

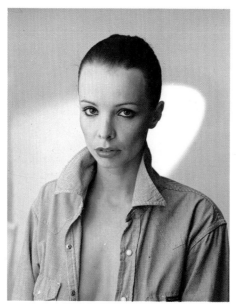

Artificial light with tungsten film

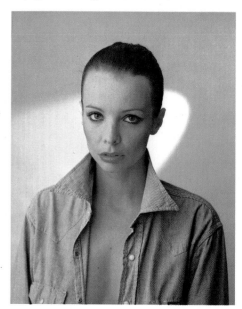

Artificial light with daylight film

Balancing colour film

While the brain interprets through experience a wide variation of colour seen by the eye, film records colours in a literal way, making no allowance for a cast which may be characteristic of the light source. The colour balance of a film must thus be matched to the colour temperature of the light source being employed in order to give the "correct" result. In the two examples above left, the correct film has been used for the conditions—daylight film (*Ektachrome X*) in daylight and tungsten film (*High-Speed Ektachrome B*) for artificial light—while the two pictures above right show the result when the film was not matched.

In the case of tungsten film with daylight, the result would appear "normal" without terms of reference. The strong blue cast produces a technically incorrect picture, but it may be acceptable and even useful for particular effects. In the picture

taken on daylight film with artificial light the result is tolerable because, although the eye has common reference for skin tones, they remain acceptable when erring towards red. If the same photograph erred towards blue to the same degree as the incorrect one above it, it would almost certainly appear abnormal. It should be noted that the colour temperature of the light can be raised or lowered with the use of the appropriate colour conversion filter (see pages 86 and 209). This enables the photographer to work in both natural and artificial light without changing film and can save both time and money.

To summarize, a film designed to produce "natural" colours when used in one kind of light will usually produce unattractive results if used under the wrong conditions. Daylight film should be used with natural light and tungsten film with artificial light in order to obtain the correct balance. Alternatively, the appropriate conversion filter will solve the problem.

colour is called its "colour temperature".

This scale provides a way of checking the colour of daylight (which changes constantly) or of comparing daylight with candle-light used in the example earlier. To colour film, the difference between a reddish white and a bluish white is critical: every colour film is balanced for a particular colour temperature, the basic division being between daylight (relatively blue) and artificial light (relatively red). A film designed to produce "natural" colours when used in one kind of light will usually produce unpleasant results if used under the wrong conditions. It is possible, however, to use coloured filters to raise or lower the colour temperature of the light so that it matches the balance of the film. A pale blue filter, for example, will raise the colour temperature of ordinary indoor lighting, making it suitable for daylight film.

It is ironic that in terms of scientific colour temperature, those colours generally associated with warmth—reds, oranges and yellows—are cool, while blues and greens, normally referred to as cool colours, are hot. However, since the psychological responses provoked by certain colours have little to do with the system devised to measure colour, the difference in terminology rarely causes confusion among photographers.

Colour cast

The picture of the boy below, who was standing near a red garage door, illustrates how colours can give a cast to the subject. The most common example of this is on bright sunny days when deep shadows—whether on a face or on the ground—appear blue. They can be remedied with a strong correction filter, but the natural colour in the unaffected areas will then also tend to be lost. The safe solution is to avoid areas or images with dense shadows.
Nikon F2S with 50mm lens; $\frac{1}{125}$ sec at f8; Ektachrome X.

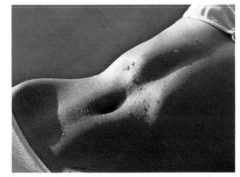

Light and skin tones

The difference between these two photographs is due to the nature of the light being used. The girl on the left was taken in early evening, when the sunlight with a high yellow content gives the skin warm, rich tones. The girl below was shot by window light with a high blue content. Its strong, hard qualities, which would "kill" everything on one side, was diffused and softened by the double net curtains. The exposure was determined by the light shade on the flesh tones.
Left: Pentax 6×7cm with 150mm lens; $\frac{1}{125}$ sec at f8; Ektachrome X.
Below: Canon FT with 50mm lens; $\frac{1}{125}$ sec at f4; Kodachrome 25. (NEILL MENNEER)

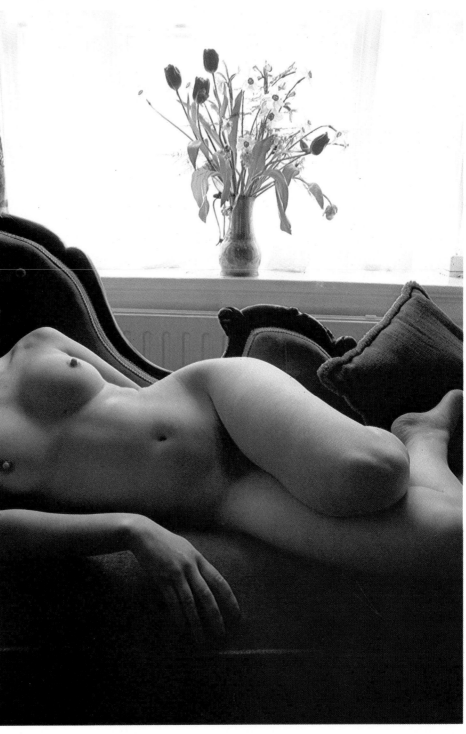

Exposure for colour

In principle, the exposure for colour film is calculated in the same way as for black and white. However, there are a number of important differences to be considered.

A slight under- or overexposure will still provide a usable black and white negative, but the same departure for a colour transparency will have a dramatic effect on the quality of the result. Even half a stop difference will produce a significant change and, to be able to predict the resulting quality, it is important to understand the effect that exposure has on colour film. The latitude of colour negative film is somewhat greater and small variations in exposure can be corrected in the printing, but not to the same extent as in monochrome.

As with black and white film, over-exposure of transparency film will result in increased detail in shadow areas, burning-out of highlight detail and, usually, a decrease in the contrast range. In addition, the saturation or density of the colours will be considerably decreased, resulting in pale, washed-out tones.

Underexposure will have the effect of reducing detail in shadow areas, increasing the range of tones and detail in highlight areas and, usually, increasing the contrast. The effect on the colour quality will be to increase the colour saturation, giving richer and stronger hues than are apparent in the subject to the human eye.

Exposure tolerance

There is no such thing as correct exposure —only one which gives the required effect. Both overexposure and underexposure can be deliberately employed to achieve a particular result or to convey a mood.

Almost all manufacturers and processing laboratories work to an exposure tolerance of a third of a stop. Thus the exposure index of a film may vary as much as two-thirds of a stop from that indicated on the packet, and it is often necessary to make preliminary tests before making the final exposure.

Clip testing involves shooting a whole roll of film, usually at slightly less than the calculated exposure, and then having just one frame cut off the end and processed first. After assessment the remainder of the film can be processed with a modified development time to adjust the density of the transparencies (see pages 182–3). Some films, like *High-Speed Ektachrome*, can be "pushed" up to three stops faster than the manufacturer's indicated speed and, although there is a corresponding loss in image quality, they can make photography possible at quite low light levels.

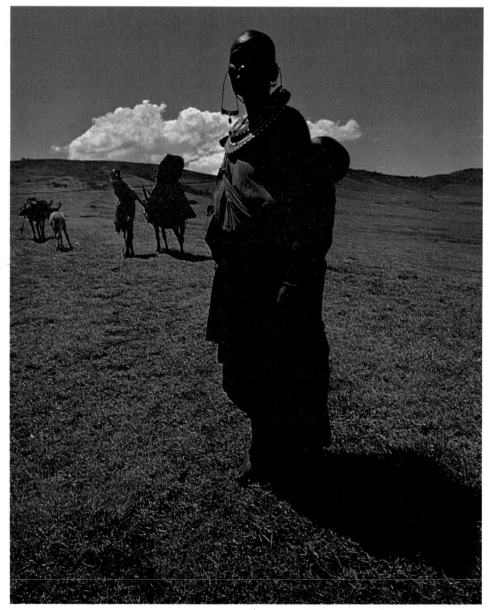

Bracketing the exposure
A satisfactory way of guaranteeing a particular effect is by bracketing—taking three exposures, one at the calculated aperture, one a stop (or half-stop) above and one a stop (or half-stop) below. For this photograph the calculated aperture was f 8 at $\frac{1}{250}$ sec (*centre*); the others were taken at f 5.6 (*top*) and f 11 (*bottom*), giving three from which to make the final choice.
Nikon F2S with 105 mm lens; Ektachrome X.

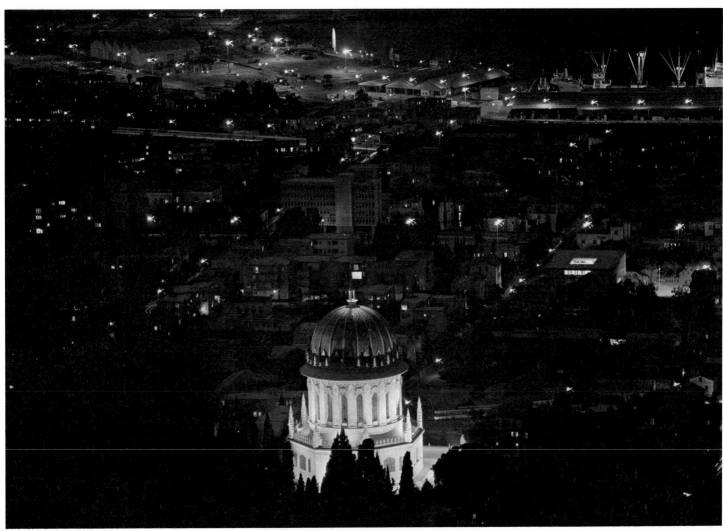

Long exposures

When a film is given appreciably more or less exposure than that for which it is intended, both its response to exposure and to colour will deviate considerably from the expected norm. This photograph of the Bahai Temple in Haifa shows the colour bias produced by the extremely long exposure necessary to produce an image using exceedingly low levels of available light. The effect can be rectified by using a colour conversion filter (see page 88), but the only way of ensuring that the result is the one desired is by taking a preliminary test photograph.
Hasselblad 500C with 150 mm lens; 1 minute at f 11;
Ektachrome Daylight.

Varying the exposure for effect

Underexposure and overexposure can often be used for effect. To emphasize the dark strength of a Masai woman standing against a green plain (*left*) this backlit picture was underexposed by a stop—*f*8 instead of the calculated *f*5.6. A soft effect was sought for the picture of the girl (*right*) and it was over-exposed by one stop (*f*4 instead of the calculated *f*5.6) to desaturate the colours.
Left: Nikon F with 24 mm lens; $\frac{1}{250}$ sec at f8;
Kodachrome II. (JOHN GARRETT)
Right: Pentax 6 × 7 cm with 150 mm lens; $\frac{1}{250}$ sec at f4;
Ektachrome X.

Filters for colour

A great deal of control can be exercised over the colour quality of photographs by the use of filters. Many manufacturers supply complete ranges of filters together with detailed information about the effects achieved (see table on page 208).

There are filters that convert daylight film for use with tungsten lighting and vice versa (see page 84), filters to reduce the effect of ultraviolet light on film in high altitudes and hazy conditions, filters that compensate for excess blue in daylight on cloudy days, filters that adjust for the red content in late afternoon sunlight, colour correction filters which correct for the colour bias of a batch of film, graduated filters and polarizing filters. There are also neutral density filters, which are grey and do not affect colour, and are used when the camera is loaded with a fast film and a wide aperture setting is required. A fog filter has a milky appearance and creates a degree of flare within the image with the effect of reducing the contrast and colour saturation of a transparency (see page 89).

Good quality glass filters are best if they are to be used frequently. However, gelatin filters are much less expensive and, although vulnerable to dust and finger marks, they can be used many times if they are handled and stored carefully. These are usually supplied as squares, but can be cut into discs to fit an ordinary filter mount. Alternatively a gelatin filter mount can be bought to fit over most lenses.

Because most filters prevent some of the light reaching the film, some additional exposure will be required. This "filter factor" will be clearly indicated in the manufacturer's instructions.

Coloured filters
Coloured gelatin filters can be used for quite subtle effects on black and white film (see page 66), but the same filters used on colour film cut out all the colour except that of the filter. The result may be dramatic, as when using red, blue and yellow filters for a photograph of water, but their unconsidered use could be disastrous.

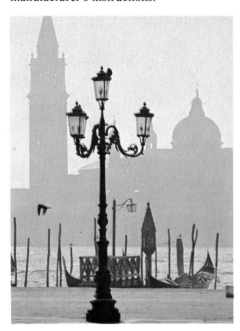

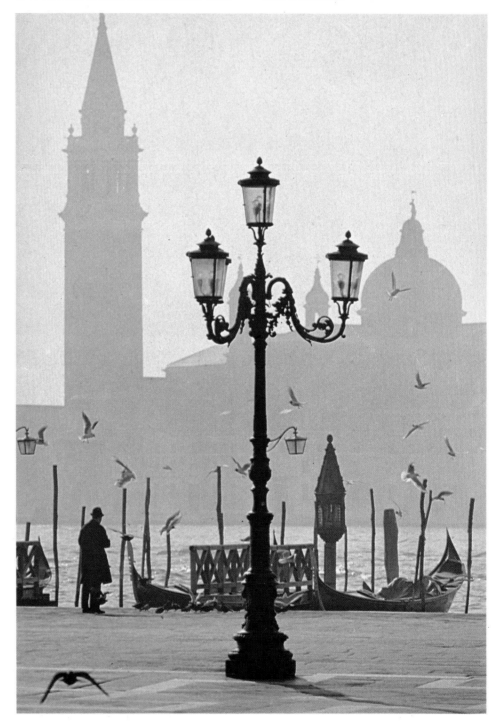

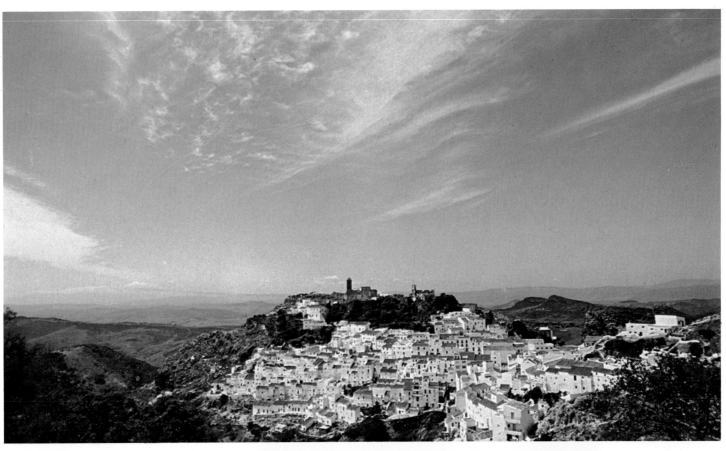

Polarizing filter

The polarizing filter has no effect on the colour quality of the subject; it only cuts down the light that has been polarized by reflection from a surface (see page 67). Thus the glare from blue skies (where light is reflected from water particles), water surfaces and windows is eliminated, and the colours of reflective surfaces, such as leaves, are brought out. The polarization of reflected light from a blue sky is dependent on the angle of the sun, and the polarizing filter is rotated in its mount until the polarization stops as much of this light as is necessary. Water reflects horizontally polarized light, and so the filter must be polarized vertically to eliminate this.
Nikon F2S with 24 mm lens; $\frac{1}{250}$ sec at f8; Ektachrome X.

Compensating filters

Colour casts produced by atmospheric conditions can be overcome by using the appropriate colour compensating filter. It is possible to buy a complete range of these, comprising yellow, blue, red, green, cyan and magenta; they are also available in a range of strengths. They can be mixed to achieve a variety of effects. In this photograph of Venice (*left*) the filter used was quite strong (20 magenta) but the effect was not as marked as it could have been because of the light tones in an essentially high-key picture (*far left*). A shot with a more normal tonal range would give a more striking effect with the same filter. An increase in exposure is advisable for the stronger filters and at least a stop essential for a very strong blue (CC50B).
Nikon F2S with 20 mm lens; $\frac{1}{250}$ sec at f8; Ektachrome X.

Graduated filters

The atmosphere of a picture can be enhanced by using a graduated filter. To produce a sombre effect on this landscape (*left*) a filter graded from brown at the top to clear at the bottom was used (*below left*). Such filters are available in a number of colours and strengths to give dramatic or subtle effects, or in a neutral grey to enable the sky to be darkened without affecting the foreground elements. No change in exposure is required; a TTL metering system will indicate an unrequired increase in exposure and should be overridden.
Nikon F2S with 50 mm lens; $\frac{1}{250}$ sec at f8; Ektachrome X; Chromofilter T2.

Creative colour / Filtering the image

Colour opens up a world of experiment for the photographer, a world that does not exist in black and white. Numerous techniques can be used to enhanced an image, many of them involving neither expense nor complicated equipment and procedures. Indeed, the excitement of creating images derives from the element of experiment.

Filters

Most modern camera lenses are of such high quality that the detail they record can sometimes detract from the effect of the photograph. A good example of this is the type of portrait used in beauty and cosmetic photography, when the merciless scrutiny of the camera reveals normally unseen blemishes and lines in even the most flawless skin. On many occasions more interesting pictures can be obtained by leaving something to the imagination, and a number of home-made and commercial devices can be employed to achieve this end.

There are several methods of producing a soft focus or diffused image. Simply taking a photograph out of focus is rarely satisfactory but makeshift arrangements can be used, such as stretching clear adhesive tape across the lens hood, smearing a piece of thin glass with petroleum jelly or coating it with hair spray and holding it in front of the lens. The effect of these will be reduced if the lens is stopped down.

Commercial devices include filters with concentric circles engraved on them, star filters, fog filters and split prism filters. With some of these attachments the effect will be rather hit and miss, and it is always best to use an SLR camera so that the effect of any filter placed on the lens can be viewed directly and the photographer can judge exactly how the result will look. There will also be some effect on the exposure and it may be necessary to use a larger aperture than normal. The degree of alteration is the filter factor (see table on page 209).

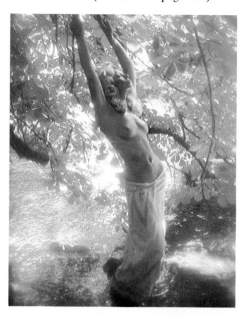

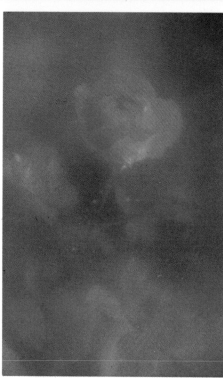

Increasing grain
The grainy effect of the late evening shot above was achieved by using a very fast film, uprating it and "pushing" it during processing. *Nikon F2S with 50mm lens; $\frac{1}{125}$ sec at f8; GAF 500, rated at 1000 ASA.*

Soft focus: magnifying glass
For this rose a lens from an old magnifying glass was mounted in the end of a 150mm/ 6in cardboard tube attached to the camera body. The indicated exposure was $\frac{1}{60}$ sec at f11, but to calculate the exact exposure the length of the tube was divided by the aperture of the "lens" (40mm), giving a figure of f3.7. *Pentax 6×7cm with 150mm lens; $\frac{1}{500}$ sec at f3.7; Ektachrome X.*

Soft focus: special filter
Here a commercial filter was used for a specific effect—to make the girl glow. The *Softar* gives a sparkle to the backlit areas and smooths the skin. A snoot on the light from behind the girl creates the halo, and the extra filters add warmth to the flesh tones. The front light was softened by fibreglass. *Nikon F2 with 80–200 zoom lens at 150mm; f16 and electronic flash; Ektachrome X; Hasselblad Softar filter, 5R and 81B filters.* (JOHN GARRETT)

Soft focus: covering the lens

Merely taking a photograph out of focus to achieve a diffused image is rarely effective and some special material, whether bought or home-made, is required For this effect (*below left*), strips of adhesive tape were fixed horizontally and vertically across the lens, leaving a small hole in the centre. The size of the hole depends on the degree of softness required, the aperture being used and the focal length of the lens. If no hole is made the result will be too exaggerated. Other home-made devices—net, stocking and muslin are often used—tend to need a wide aperture to produce the right effect.

Transparent jellies or creams, such as *Vaseline*, can be used for a similar result, but it is often difficult to control highlights. The simplest method of all is to mist the lens by breathing on it. This technique is most effective when the rear surface of the lens is misted and replaced quickly so that the moisture is retained longer inside the camera body, but is at best an unpredictable approach.

Nikon F2S with 50 mm lens; $\frac{1}{125}$ sec at f4; Ektachrome X.

Split prism filter

This shot of Jochen Maas' *Martini Porsche*—the car which won the Le Mans 24-hour race in 1977—was taken with a filter that divides the image into a "static" half and a "moving" half, and is particularly useful for conveying an impression of speed.

Nikon F2 with 80–200 zoom lens at 90 mm; $\frac{1}{250}$ sec at f5.6; Kodachrome 64; B + W Prism Six filter.
(JULIAN CALDER)

Star filter

Though something of a photographic cliché, the star filter can produce beautiful and dramatic effects, especially when it is used to pick up the highlights on water. Because it can create a strong pattern it is usually best employed providing a contributory element rather than the dominant one.

Nikkormat EL with 80–200 zoom lens at 150 mm; $\frac{1}{250}$ sec at f11; Ektachrome X; star filter.
(JOHN GARRETT)

Fog filter

Unlike the soft focus devices and techniques, which soften definition, fog filters have little effect on definition but reduce contrast and desaturate colour by creating a degree of flare in the optical system. They are available in two strengths, the more pronounced version being used for this shot.

Nikon F2S with 105 mm lens; $\frac{1}{250}$ sec at f5.6; Ektachrome X; fog filter 2.

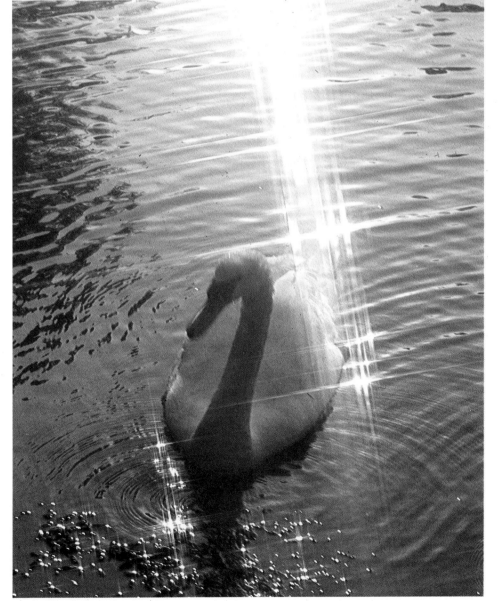

Creative colour / The multiple image -1

There are several ways of making a multiple photographic image, including multiple exposure in the camera, the use of prisms and mirrors, projection on to a screen, montage in the darkroom and montage by hand.

One of the simplest techniques involves holding a small mirror close to the camera lens at approximately right angles to it. This produces a split image with one half a reversed view of the other.

A projector can be used in three ways to produce a multiple image. Back projection enables a background to be provided by a transparency projected on to a translucent screen behind the main subject (see page 195). The two elements are photographed separately on the same frame, the foreground with the background screen covered with a black cloth and then the background image with the foreground in silhouette against it, ensuring that the exposure is correct for each element.

In front projection, the background element is projected from the front along the camera lens axis with the aid of a two-way mirror. The screen is made of a highly reflective material ensuring that there is enough light from it to enable the photograph to be taken at an exposure suitable for both elements.

A third method is by projecting a slide directly on to the subject—a landscape projected on to a nude, for instance.

Multiple exposure with high-speed flash
An example of very advanced multiple image photography is provided by this shot of a green lacewing fly taking off from a hawthorn leaf. To take it the photographer had to develop an electronic shutter with an opening time of $\frac{1}{450}$ sec linked to an array of electronic flashes that would give three images of the insect frozen in flight during this brief period. About 900 exposures had to be taken before a satisfactory photograph was made, since the very small depth of field involved meant that there was a great deal of difficulty in ensuring that the subject remained in focus during all three exposures.
Leicaflex SL with 100 mm lens; three exposures in $\frac{1}{450}$ sec at f16; Kodachrome II. (STEPHEN DALTON)

The repeated image
A symmetrical, repetitive effect can be produced by means of a special prism in a lens mount or, as in this case, by a sheet of plastic embossed with a number of small "lenses" and held in front of the camera. The prisms can be supplied in mounts to fit most cameras and are usually designed to give a ring of images, with or without one in the centre. The mount can often be rotated so that the images move in a circle—an effect often used in cinematography. The prisms have a small number of facets, usually three, five or six. The embossed plastic sheet is cheaper and can give a larger number of images more randomly spaced. No change in exposure is needed.
Nikon F with 105 mm lens, $\frac{1}{250}$ sec at f8; Kodachrome II. (LEE BATTAGLIA)

Photomontage

Although the multiple photographic image can be accomplished in numerous ways—by mirrors and prisms, multiple exposure, back and front projections, projected images and stroboscope— perhaps the most rewarding technique is montage, which tests both visual imagination and technical ability while using existing material. It can be done either in the enlarger, as with the picture on the right, or by hand, as in the image below. Producing combined images in the enlarger is not just a matter of selection. Skill in judging fit and exposure and patience in achieving the right balance are also required. Here three colour images—a girl, trees and clouds—were used. The transparencies are projected, one at a time, through the enlarger on to a sheet of duplicating film. Each transparency must be sized up and tested individually for colour balance and exposure, adjusting the exposure and adding colour filters for the required result before any attempt is made to montage them. In this picture the fact that one element is significantly more grainy than the others adds to the impact. For black and white photomontage see page 189.

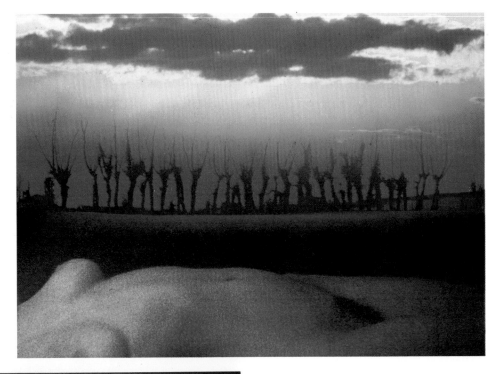

Montage by hand

Composite prints, whether in colour or black and white, can be both exciting and inventive, though strictly speaking they are divorced from the basic photographic process. This method of montage is sometimes also called collage, particularly if it does not involve rephotographing after the prints have been aligned. A darkroom is usually essential because the biggest problem—one which becomes increasingly important the greater the number of images used—is that of scale. In this example of seven different images (the sky, armchair, postcard, bottles and cans, skull and two prints of the same girl) only the sky and the chair had to be resized to fit. All the original pictures were shot in black and white with a *Pentax* 6 × 7 in camera, but none was taken with the intention of combining them; the composition emerged afterwards. The prints were cut roughly to size with a scalpel, wetted and the highlights bleached in. The various colours were washed on with a swab or applied with an airbrush (see page 189). After drying in a flat-bed dryer, each print was sand-papered round the edges for the exact fit, backed with mounting tissue and dry mounted in position (see page 192). The complete image was then rephoto-graphed with a 5 × 4 in camera to produce a tighter result. (BOB CARLOS CLARKE)

Creative colour / The multiple image - 2

Creative colour / The multiple image - 2

The projected image

A basic projector and a screen are all that is required to combine two images by projection, a technique commonly used to marry the human figure with inanimate objects. Here a slide of a girl taken against a black background was projected on to a screen draped with silk ribbons arranged in sweeping diagonals, and given a long exposure to compensate for the weak light emitted by the projector. It is possible, of course, to project images on to a model; the choice will depend on which of the two components needs to be the more flexible. For back and front projection, see text on page 90 and box on page 195. *Hasselblad 500C with 150mm lens; $\frac{1}{4}$ sec at f8; High-Speed Ektachrome Professional Type B.* (ROGER PHILLIPS)

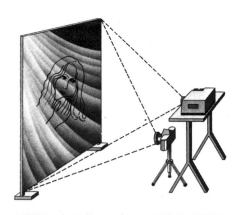

Utilizing the large format

Making accurate multiple exposures is not easy with 35 mm cameras. It is difficult to tell exactly where the first image was on the film when the second is taken, and while it is usually possible to bypass the fact that the film must be wound on to cock the shutter (by depressing the rewind button), this does not apply to all SLRs. In this case the only alternative is to run the film through twice—a risky and wasteful enterprise. The safest answer is to use a view camera, where size and construction provide the opportunity to make an exact trace of the first picture on the screen for positioning the subsequent images. The photograph on the left, although a montage rather than a genuine simple multiple exposure, illustrates the range of the studio camera. This preconceived image was composed by aligning four separate pictures—a 10 × 8 in studio

shot of the girl and three pictures of wolves. These were taken with flash in a wood at a zoo on 35 mm and then copied on to 5 × 4 in before being aligned with the larger format. In both cases the picture was mounted on a flash-head, which was used as the light source for copying. The overlapping of the blacks and any unwanted blemishes were standardized with liquid opaque—a technique also employed on the background of the projected image in the photograph above. *Girl: Sinar 10 × 8 in with 240 mm Schneider-Kreuznach f5.6 lens and Hasselblad No. 3 Softar filter attached with tape; $\frac{1}{100}$ sec at f16; Ektachrome Daylight. Wolves: Nikkormat with 250 mm lens; $\frac{1}{60}$ sec at f5.6; High-Speed Ektachrome.* (ROGER PHILLIPS)

Creative colour / Infra-red

Because objects do not reflect the same amount of infra-red as they do visible radiation (see page 39), infra-red film alters colours, often with bizarre results, and a wide variety of novel and exciting photographic opportunities become available.

Most 35 mm cameras can take infra-red pictures, but cameras with plastic or wooden bodies, shutters made of plastic, rubber, or rubberized cloth (and some types of bellows) may transmit infra-red, resulting in strange fog patterns on the photograph. The problem can be overcome by wrapping the camera in aluminium foil, leaving holes for the lens, viewfinder and shutter release.

As with normal colour film, colour infra-red film has three layers, but they are sensitized to green, red and infra-red. Because all the layers are sensitive to blue light, an overall bluish effect will result unless a yellow filter is used to compensate. The effect on most common colours, such as green, can usually be predicted reasonably well, but a mixture of colours, as in a flower garden, will provide a kaleidoscope of strange and unexpected shades.

Although camera lenses do not focus infra-red rays in the same way as visible light rays, this is not a consideration unless taking close-ups or pictures in dull conditions. Some cameras have a red dot on the focusing scale to give an average correction for infra-red photography, but if this is not present the solution is to focus on the front edge of the main subject. No correction will be necessary in the majority of cases if the aperture being employed is f11 or smaller.

The best results are usually obtained in fairly bright daylight. Since clouds absorb infra-red, exposure times must be longer in overcast conditions. The safest all-round artificial light source is probably electronic flash, where the colour quality is similar to that of daylight.

Infra-red film is more sensitive to heat than ordinary film and must be kept at a low temperature. Unopened film can be safely stored in a domestic refrigerator, provided the temperature is 13°C/55°F or lower; for long periods of storage the temperature should be −18°C/0°F or below. Film should be taken out of the refrigerator two hours or so before use to return it to normal room temperature.

The effects of infra-red film are best illustrated by starting with a normal picture (*above*) containing a wide range of common colours—shades of green, blue, yellow and brown—and hair and skin tones.

The use of infra-red without a filter (*below*) turns green to purple, brown to blue and red to yellow, as in the lipstick. The darker the original hue the darker will be its "new" colour, but the results are unpredictable.

The addition of the recommended *Kodak Wratten 12* filter (*above*) moderates extreme colours such as flesh tones and the colour of the eyes, lips and hair. The purple remains almost unchanged.

Filters can also create bizarre effects. A red filter (*below*) has turned light green to orange, deep green to bright red (the button on the dress) and eliminated blue. The dark hair takes on blonde highlights.

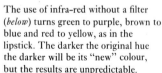

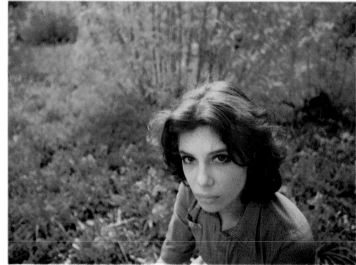

Moving the camera: rotation
Unusual and often beautiful photographs can be obtained by shooting while the camera is actually in motion. A rotary movement here keeps the central leaves in focus but creates a swirling impression around the edges. To be effective, it is essential to establish a slow steady rhythm by rotating the camera several times before releasing the shutter. A slow shutter speed is vital.
Nikon F with 50mm lens; ⅛ sec at f16; Ektachrome X.

Moving the camera: vertical
An alternative effect can be achieved by moving the camera slowly up and down, again shooting while in steady motion. As with circular movements, it is necessary to practise before making the exposure. The effect will be enhanced if there are strong vertical lines in the image, preferably in silhouette. A similar approach, of course, can be used for various horizontal subjects.
Nikon F with 105mm lens; ½ sec at f22; Ektachrome X.

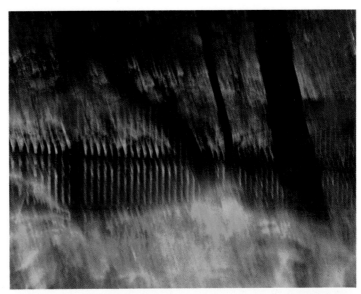

Colour at night
Night photography in cities, with its own special brand of neon colour, is always appealing, but the timing is important. Pictures taken in the deep of night will result in loss of detail and inky darkness, and the trick is to shoot just before nightfall or just after sunrise. This shot of Admiralty Arch in London was taken at dusk. Use of the T setting (see page 49) allowed a long, controlled exposure to bring out the colour of the trees and the strange patterns formed by the head-lights and tail-lights of numerous vehicles. A tripod is vital for stability. For other aspects of night photo-graphy, see page 135.
Nikon F2 with 500mm mirror lens; 4 minutes at f5.6; Kodachrome 64; tripod.
(PATRICK THURSTON)

Colour film guide

All modern colour films are multi-layered coatings of very thin emulsions, each of which is selectively sensitive to a particular part of the spectrum. The relative sensitivities of these emulsions have been adjusted to record a particular colour accurately under stated illumination and to reproduce it faithfully. Thus colour films are balanced for exposure in daylight or tungsten lighting. A notable exception is infra-red film, which is sensitive to a part of the spectrum the human eye cannot detect.

Whether the colour film is of the reversal type, which is processed to colour transparencies, or negative type, which is an intermediate stage to producing colour prints, the basic principles for the tri-pack emulsion have not radically altered since the first commercially viable colour film in 1935.

The introduction of very small cameras demanded a fine-grain emulsion and new lens technology to produce acceptably sharp pictures which, in turn, suggested new processing methods and finer grain definition.

Because it is three layers of film in one, the tri-pack emulsion uses more silver than black and white and the consumption of this valuable and limited resource is a subject of intense exploration for alternative light-sensitive emulsions. Efforts are also being made for recycling through silver recovery units economically viable for even the modest processor.

This revolution in colour film technology will in its turn point to new horizons with different opportunities and problems; but for today's photographer the scope for recreation and pleasure is reflected in the extensive range of films available.

Colour principle

Agfa — Agfacolor principle— i.e. dye couplers immobilized by long-chain hydrocarbon residue to prevent diffusion.

Ektachrome — Ektachrome principle— i.e. substantive resin-protected dye couplers dispersed in emulsion.

Kodachrome — Kodachrome principle— i.e. non-substantive dye couplers in processing solutions.

* tungsten

COLOUR REVERSAL FILMS (for transparencies)

FILM	MANUFACTURER/ DISTRIBUTOR	SIZES	DAYLIGHT SPEED (ASA)	COLOUR PRINCIPLE
Agfachrome 50L Professional	Agfa-Gevaert, West Germany	120, 135, sheet, 35 mm bulk film	50*	Agfa
Agfachrome 50S Professional	Agfa-Gevaert, West Germany	120, 135, sheet 70 mm, 35 mm bulk film	50	Agfa
Agfachrome 64	Honeywell, USA	126, 135	64	Agfa
Agfachrome Pocket Special	Agfa-Gevaert, West Germany	110	64	Agfa
Agfacolor CT 18	Agfa-Gevaert, West Germany	120, 127, 135, Rapid	50	Agfa
Agfacolor CT 21	Agfa-Gevaert, West Germany	135	100	Agfa
Agfacolor CT-PAK	Agfa-Gevaert, West Germany	126	64	Agfa
Alfochrome DC21	Ringfoto, West Germany	135	100	Ektachrome
Boots Colourslide	Boots, England	135	64	Ektachrome
Cilchrome	Lumière, France	135	125	Ektachrome
Diachrome SL 18	Foto-Porst, West Germany	135	50	Agfa
Diachrome SL 20	Foto-Porst, West Germany	126	80	Ektachrome
Diachrome SL 21	Foto-Porst, West Germany	135	100	Ektachrome
Ektachrome Aero Infrared	Kodak	120, 135	125	Ektachrome
Ektachrome 64	Kodak	110, 126, 135	64	Ektachrome
Ektachrome 200	Kodak	135	200	Ektachrome
Ektachrome 160 Tungsten	Kodak	135	160*	Ektachrome
Ektachrome 64 Professional	Kodak	120, 135, 220, 70 mm	64	Ektachrome
Ektachrome 50 Professional	Kodak	120, 135	50*	Ektachrome
Ektachrome 200 Professional	Kodak	120, 135, 35 mm bulk film	200	Ektachrome
Ektachrome 160 Professional	Kodak	120, 135, 35 mm bulk film	160*	Ektachrome
Ektachrome Slide Duplicating Film 5071	Kodak	35 mm bulk film	3*	Ektachrome
Ektachrome Duplicating film 6121	Kodak	Sheet	3*	Ektachrome
Ektachrome 64 Professional Film 6117	Kodak	Sheet	64	Ektachrome
Ektachrome 50 Professional Film 6118	Kodak	Sheet	50*	Ektachrome
FK Color RD-17	Fotokemika, Yugoslavia	135	40	Agfa
Fujichrome R100	Fuji, Japan	120, 135	100	Ektachrome
Fujichrome RK	Fuji, Japan	126	100	Ektachrome
Fujichrome Professional Type D	Fuji, Japan	120	100	Ektachrome
Fujicolor R100	Fuji, Japan	120, 135	100	Ektachrome
Fujicolor Professional Type D	Fuji, Japan	Sheet	50	Ektachrome
Fujicolor Professional Type T	Fuji, Japan	Sheet	32*	Ektachrome
GAF Color Slide 64	GAF, USA	120, 126, 135	64	Agfa
GAF Color Slide T/100	GAF, USA	135	100*	Agfa
GAF Color Slide 200	GAF, USA	135	200	Agfa
GAF Color Slide 500	GAF, USA	135	500	Agfa
GAF 1000 Blue Insensitive Color	GAF, USA	135, bulk film	1000	Agfa
Gratispool Colour	Gratispool, Britain	126, 135	64	Ektachrome
Kodachrome 25	Kodak	135	25	Kodachrome
Kodachrome II Type A	Kodak	135	40*	Kodachrome
Kodachrome 64	Kodak	110, 126, 135	64	Kodachrome
Kodak Photomicrography Color 2483	Kodak	135	16	Ektachrome
Orwochrom UT 18	VEB Filmfabrik Wolfen, East Germany	120, 135, sheet	50	Agfa

Orwochrom UT 21	VEB Filmfabrik	in preparation	100	Agfa
Orwochrom UK 17	VEB Filmfabrik Wolfen, East Germany	120, 135, sheet	40*	Agfa
Orwochrom Professional Type S	VEB Filmfabrik Wolfen, East Germany	120, sheet	40	Agfa
Peruchrome C 19	Perutz, West Germany	126, 135	64	Agfa
Prinzcolor Slide Film	Dixons, England	135	100	Ektachrome
Sakuracolor R100	Konishiroku, Japan	120, 126, 135	100	Ektachrome
Sears Color Slide	Sears, Roebuck, USA	126, 135	64	Ektachrome
3M Color Slide Film	3M, Italy	110, 126	64	Ektachrome
3M Color Slide Film	3M, Italy	135	100	Ektachrome
Technicolor Slide	Technicolor, USA	126, 135	64	Agfa

COLOUR NEGATIVE FILMS (for prints)

FILM	MANUFACTURER/ DISTRIBUTOR	SIZES	DAYLIGHT SPEED (ASA)	COLOUR PRINCIPLE
Agfacolor CNS 2	Agfa-Gevaert, West Germany	120, 126, 127, 135	80	Agfa
Agfacolor Pocket Special	Agfa-Gevaert, West Germany	110	80	Agfa
Agfacolor 80S Professional	Agfa-Gevaert, West Germany	120, 135, sheet	80	Agfa
Berkeycolor	Berkey, USA	126	80	Agfa
Boots Colourprint II	Boots, England	110, 126, 135	100	Kodak
Cilcolor	Lumière, France	110, 126, 135	100	Kodak
Dixons Colourprint II	Dixons, England	110, 126, 135, 120	80	Kodak
Ektacolor ID Copy Film	Kodak	135, sheet	100	Kodak
Fujicolor F-II	Fuji, Japan	110, 120, 126, 135	100	Kodak
Fujicolor F-II 400	Fuji, Japan	110, 135, 120	400	Kodak
Fujicolor Professional Type L	Fuji, Japan	120, sheet	50*	Kodak
Fujicolor Professional Type S	Fuji, Japan	120, sheet	100	Kodak
GAF Color Print	GAF, USA	110, 135, 70 mm 120, 126, 127	80	Kodak
Gratispool Colour	Gratispool, Great Britain	120, 126, 127, 135	80	Kodak
Hanimex-Color CNS 80	Hanimex, Australia	126, 135	80	Agfa
Kodacolor II	Kodak	110, 120, 126, 127, 135	80	Kodak
Kodacolor 400	Kodak	110, 135	400	Kodak
Kodak Instant Picture Film PR-10	Kodak	Film pack (6.7 × 9 cm)	150	Dye release
Pacific Prestige	Pacific Film Laboratories, Australia	110, 135	80	Agfa
Perucolor	Perutz, West Germany	110, 126, 135	80	Agfa
Polacolor Type 58	Polaroid, USA	Sheet	75	Polaroid
Polacolor 2 Type 88	Polaroid, USA	Film pack (8.2 × 8.6 cm)	75	Polaroid
Polacolor 2 Type 108	Polaroid, USA	Film pack (8.5 × 10.5 cm)	75	Polaroid
Polaroid SX-70 Land Film	Polaroid, USA	Film pack (8 × 8 cm)	80	Polaroid
Prinzcolor Print	Dixons, England	126, 135	80	Kodak
Revuecolor 3000	Foto-Quelle, West Germany	110, 120, 126, 135	80	Kodak
Sakuracolor II N 100	Konishiroku, Japan	110, 120, 126, 135	100	Kodak
Sakuracolor 400	Konishiroku, Japan	110, 135	400	Kodak
Sakuracolor Professional Type L	Konishiroku, Japan	4 × 5 in sheet	32*	Kodak
Sakuracolor Professional Type S	Konishiroku, Japan	4 × 5 in sheet	80	Kodak
Sears Color Print	Sears Roebuck, USA	120, 126, 127, 135	80	Agfa
Technicolor Print	Technicolor, USA	126, 135	80	Agfa
3M Color Print	3M, Italy	110, 126, 135	80	Kodak
TriFCA Colourprint	FCA, England/USA	110, 126, 135	80	Kodak
Valcolor	Valca, Spain	126, 135	100	Kodak
Vericolor II Professional Type L	Kodak	120, 135, 220 sheets	80*	Kodak
Vericolor II Professional Type S	Kodak	120, 135, 220, 35 mm, 46 mm, 70 mm	100	Kodak

Colour principle

Agfa Agfacolor principle—i.e. dye couplers are immobilized by long-chain hydrocarbon residue to prevent diffusion.

Kodak Ektachrome principle—i.e. resin-protected dye couplers are dispersed in emulsion.

Polaroid Polaroid dye-diffusion principle for instant picture photography (Polacolor and Polacolor 2 films are of the two-sheet type, whereas SX-70 film is a monosheet material).

* tungsten

THE GREAT THEMES

"We photographers deal in things which are continually vanishing, and when they have vanished there is no contrivance on earth can make them come back again. We cannot develop and print a memory."

HENRI CARTIER-BRESSON

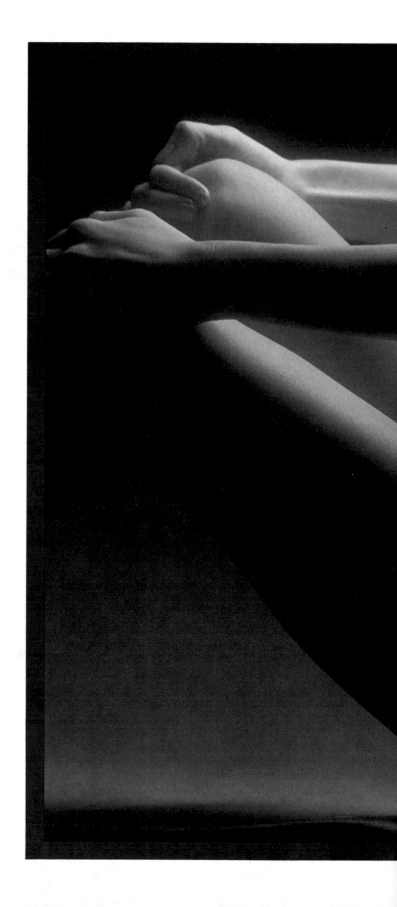

People / The formal portrait

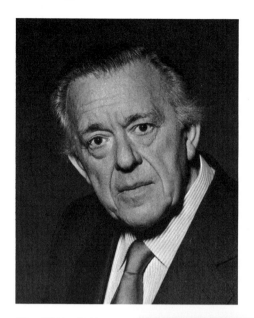

The simplest way of lighting a portrait is obviously to use only one lamp, but when this is applied to the sitter from the front it produces an unattractive glare and shows little of the form, texture or character of a face. The light needs to be angled and softened for a more telling effect.

When the lamp is moved to an angle of about 45° and the light softened by a screen, the strongly directional but diffused light reveals more about the form and texture in the face. It does, however, create dense shadows and excessive contrast, giving an unbalanced feel to the portrait.

The addition of a blue filter (*right*) will intensify the texture of the skin, although it will mean an exposure increase of 2–3 stops. Care must be taken with the nose and eyes in all facial portraits; the nose can cast awkward shadows across the cheek and it is usually essential for the eyes to be lit so that they are not shaded by the nose or eyebrows.

Indoor portraits can be taken without lighting equipment by using available light. The danger here is that with all the light on one side there will be excessive contrast. This can be reduced with a reflector. A cloudy day with good light will probably give the best effect, but if the light is harsh it can be softened by placing a sheet over the window.

Technical proficiency and visual sensitivity are not enough in portrait photography. Two human beings are involved in the creative process and its success ultimately depends on their relationship. The celebrated theatrical photographer Angus McBean has written: "You have at your mercy that tender thing—a human being—with a lot of light on its most tender point, its personal appearance . . . Do everything you can to make them unselfconscious."

To establish a rapport with his subject the photographer should himself be relaxed and confident; an appearance of uncertainty is inevitably infectious. There are no rules for relaxation, however; conversation may help the sitter to forget about the camera, or it may seem as disturbingly artificial as the soft music played to soothe the nerves of anxious air travellers.

As with all aspects of photography, it is essential to understand the purpose of a particular portrait. If it is taken at the request of the sitter, an element of flattery may be necessary; if taken for the photographer's own satisfaction, the emphasis may be on revealing or exaggerating character. Most of the best portraits are not merely likenesses: they are interpretations of personality and character. The great American photographer Irving Penn sees portraiture as "a kind of surgery; you cut an incision into people's lives".

The difficult task of choosing which facial features to emphasize and which to subdue depends to what extent and in what way the photographer wishes either to flatter or to reveal the personality of his sitter. As a general rule, features that indicate or betray character—age wrinkles, laughter-lines and

dimples—should be retained, while features that tell little of character, such as skin blemishes or protruding ears, should be played down. In many outstanding portraits the face is almost eliminated or hidden in shadow, while others are given added impact by including the entire figure.

If the portrait is full or three-quarter length, careful attention must be given to the hands; their form and position can reveal almost as much about the subject and the background as can the face.

The type of lighting employed must suit the face in question: the best light for the main source is soft and directional, achieved either by bouncing light from a large white reflector or by using a white translucent screen between the lamp and the model. The effects of different lighting arrangements are illustrated on these pages.

The dense shadows and excessive contrast range can be relieved by the addition of a reflector on the "blind" side of the sitter. A reflector is preferable to the use of another direct light, since this may produce cross-shadows and conflicting lighting. The effect of the reflector can be boosted by directing an extra light on to it to further relieve shadows and reduce contrast.

More textural detail and highlights emerge by placing a second lamp behind the subject and using a snoot to direct the new light. Using two lamps of differing strengths—one for the main lighting and one for shadows—will often give good results. If lamps of the same power are used they should be placed at different distances from the model.

The outdoor portrait

The principles of portrait lighting in the studio or home are also applicable in daylight with the rather obvious difference that, since the light source cannot be moved, the sitter must be the portable element. Hard directional sunlight is rarely the best light: shadows are dense and sharply defined, the model will tend to squint and skin texture may be exaggerated. While this is not a rigid rule—a white reflector can relieve the shadows—the soft directional light of a dull day will usually prove more suitable.

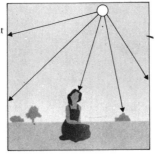

When the sun is high in the sky there is a great danger of shadows being thrown beneath the eyes and chin and of facial lines being accentuated (*above left and diagram left*). This can be rectified by positioning the model under a tree or by a house, the shadows of which will eliminate much of the top lighting (*above and diagram right*). In bright sunlight, backlighting can be used to create a softer effect on the face and highlights in the hair, but care must be taken not to underexpose; again, a reflector can be used to strengthen the light.

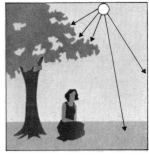

People / The informal portrait

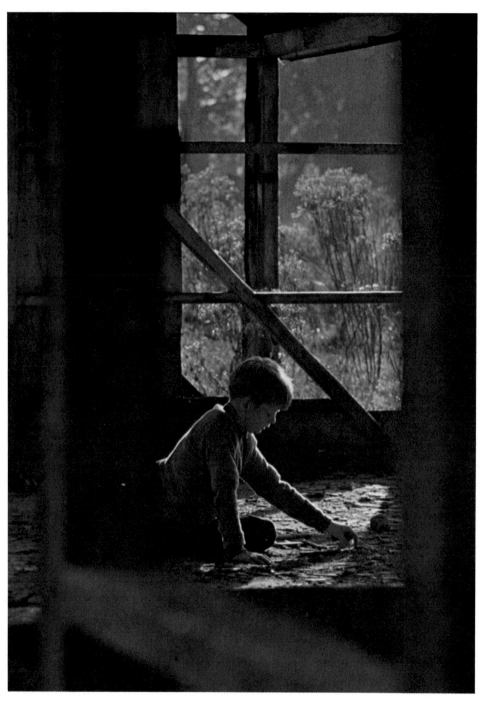

Most amateur and much professional photography falls under the umbrella heading of informal portraiture—a title which covers anything from children giggling at the camera to Buddhist monks absorbed in meditation. Any photographic portrait which has not in a sense been posed in the studio or home can be called informal.

Although less contrived, informal portraiture demands no less skill. The photographer has to be constantly on the alert to make instant decisions and catch a pose before it vanishes.

In the case of a genuine informal "portrait", where the subject is totally aware of the situation, he or she should be made to do something, such as reading a book or just pretending to sleep in a chair.

The background, which is usually subordinate to the modern studio portrait, is a telling part of the informal picture. Any unsuitable setting will destroy mood and composition. Unless deliberately integrated, the subject should be separated from it by ensuring that the background is either less sharp or in strong contrast, or by photographing the figure against the sky. Backgrounds must never overwhelm or confuse the picture. A choice of viewpoint and lighting that separates the model from the surroundings helps to avoid this pitfall. A wide-angle lens enables the camera to be fairly close to the subject without severely limiting the area of visible background.

Creating the picture
Though this boy had been put into the disused room and the photographer had to wait until he relaxed, he was rewarded with a natural looking picture of a child in his favourite hiding place. The informal portrait can vary from constructed and planned shots of a relation or friend, such as this one, to a genuine spontaneous snap of a stranger in the street, in the park or on the beach. The key is the lack of formality, using natural light in everyday situations.
Nikon F with 105 mm lens; $\frac{1}{250}$ sec at f5.6; High-Speed Ektachrome.

Framing the subject
A woman selling national lottery tickets from a booth in a Paris street forms a perfect, framed image. Though in a sense she is trapped, with no escape from being put on film, the photographer will get a much better result if he politely asks her permission. When language is a problem, a smile and a gesture with the camera is usually enough to elicit a co-operative response from the potential subject.
Nikon F with 105 mm lens; $\frac{1}{125}$ sec at f4: Ektachrome X.

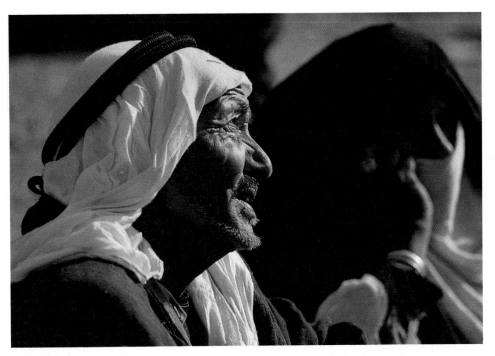

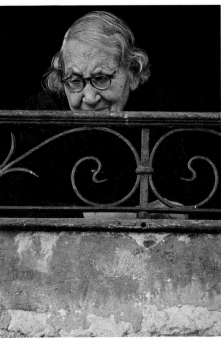

Using the profile for effect
While a profile will often provide insufficient information about the subject for a meaningful portrait, it can sometimes prove the best angle to capture the essence of a face. The picture above of a Bedouin in the camel market at Bethsheba brings out the curve of the nose and the strength of the chin, while the harsh sun adds emphasis. Profiles present no problem of depth, and a wide aperture was used here with a slow film.
Nikon F with 105 mm lens; $\frac{1}{250}$ sec at f5.6; Kodachrome II.

Setting for mood
The strange light of evening picks out two women on a park bench in Heidelberg, West Germany. The dark, sombre background, relieved only by the empty benches, gives a rather mysterious, even menacing feel to an otherwise tranquil image.
Canon FT with 28 mm lens; $\frac{1}{60}$ sec at f8; Kodachrome 25. (NEILL MENNEER)

Seeing the portrait
Awareness is a vital prerequisite for the photo-journalistic type of informal portrait. Most people walking down a narrow Lisbon alley would not have seen this lady peering from her second-floor window. The wall was retained to convey the feeling of constriction. A slow exposure was essential to obtain a good picture in the dark conditions.
Canon FT with 135 mm lens; $\frac{1}{30}$ sec at f4; Kodachrome 25. (NEILL MENNEER)

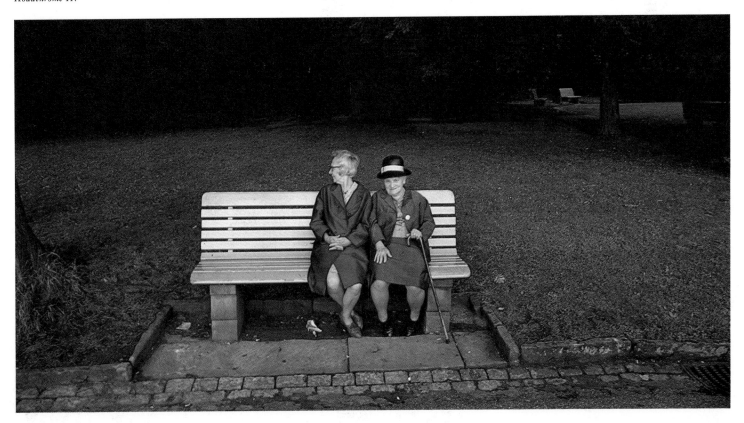

People/ Bringing out character

Hard rules are difficult to lay down in portraiture because no two faces are the same. There are, however, some general guidelines. The position of the head is crucial. A frontal view is usually unflattering and conveys an air of formality, while a profile can often give insufficient information about the sitter—although it will, of course, emphasize nose and chin lines. A three-quarter view, using lighting that provides some shadow to avoid broadening of features, often looks most natural.

The level of the head is also important. If it is raised and the camera is shooting slightly up, the face will appear broader and rounder; pointing the camera slightly downwards will emphasize the forehead and tend to make the face narrower. The normal height for the camera is level with the eyes. A model appears relaxed if leaning slightly forward, aloof if leaning back.

Revealing the model's personality is essentially a matter of observing mannerisms and characteristic expressions. The eyes and the mouth are the most emotionally expressive features and must be watched carefully for clues to the model's mood. Lines around the eyes and mouth are also helpful pointers to the habitual expression of the sitter's face.

Classical symmetry in the human form is rare: if an imaginary line were drawn from the hairline to the tip of the chin, it would be found that in most cases the two sides of the face were not identical. While these discrepancies are usually minimal and not evident at a casual glance, the camera will record them pitilessly. Most people have a better side to their face, which should be identified by the photographer.

Flattering the subject

"Ah no, ma'am, photography cannot flatter" replied a court painter when asked by Queen Victoria if the new boom in photography would ruin his livelihood. As these two pictures show, he was incorrect. The first, taken with soft 45° floodlighting and a reflector to fill in, has a happy, natural feel, but it does not capture the girl's best aspects. With the second, the face is turned towards the light and the heavy shadows disappear; the shoulders, now without the constricting sweater, are changed from a front shot almost to a profile; a slightly higher camera angle

makes the round face taper and gives prominence to the eyes; the addition of a light with a snoot catches the highlights in the hair; and the smile, while remaining natural, is not now creating the slit-eyed effect of the first shot. This last improvement can often be effected by asking the model to pronounce a short word—preferably not cheese, but one with a crisp sound to it. These adjustments—without any extra make-up, styling or major lighting changes—produce a totally different image.
Nikon F2S with 105 mm lens; f11 and flash; Ilford FP4.

Capturing personality

Three pictures of Sir John Betjeman, Britain's Poet Laureate, illustrate the value and advantage of creating a relaxed atmosphere with the sitter. The session started with a serious attempt to convey the dignity and stature of the subject, but his ebullient personality soon began to pierce the decorum. While the first shot would suit the cover of a programme for an evening of poetry reading, the third is far nearer the real charm and humour of the man. "It is the mind and the soul of the personality before my camera that interests me most," explained Yousuf Karsh, perhaps the greatest of all portrait photographers, "and the greater the mind and the soul the greater my interest."
Hasselblad 500C with 80 mm lens; f16 and Balcar Strobes; Ilford FP4. (JOHN GARRETT)

Playing off the image
This shot of Britain's controversial right-wing politician Enoch Powell puts into cruel juxtaposition the real and the paper image of a public figure. The low viewpoint, looking up into his campaign vehicle, enhances the feeling of superiority and exaggerates the difference between the two "portraits".
Nikon F with 24 mm lens; $\frac{1}{60}$ sec at f8; Ilford FP4. (JOHN GARRETT)

Lighting for a particular effect
A single photo-flood with a reflector was sufficient to produce this striking image. The head raised towards the light brings out the strong texture of the man's face, and the carefully placed hand holding a rolled cigarette adds a final if muted element to the very formal composition.
Rolleicord 5B; $\frac{1}{125}$ sec at f5.6; Ilford FP3.

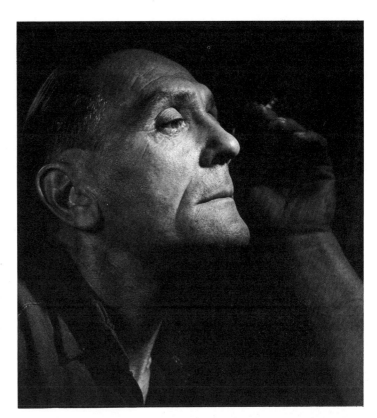

Emphasizing contrast
The casual, confident air of this little girl is deceptive: she is in fact in a state of slight shock after seeing her sister hit on the head with a bottle outside their high-rise home. The dark background, which does much to increase the power of the portrait, was blackened further at the print stage.
Nikkormat EL with 50 mm lens; $\frac{1}{125}$ sec at f8; Ilford FP4.
(RICHARD HAUGHTON)

Accentuating a feature
All-in wrestlers are supposed to be menacing, and this subject certainly plays the part. Two flash heads reflected the light off the ceiling and the background, producing very strong shadow effects on the face. This, allied to the crop at the top, helps to make the piercing left eye an even more striking part of the picture. The raised viewpoint gives the impression of the man leaning or coming towards the viewer.
Hasselblad 500C with 50 mm lens; $\frac{1}{125}$ sec at f22; Kodak Tri-X. (ROGER PHILLIPS)

People / Work and play

Victorian photographers loved to arrange their models against studio backgrounds of misty landscapes, intended to tell the spectator more about the sitter. In this case "more" usually meant a romantic suggestion of rustic harmony, simplicity and happiness. The modern preference for honest realism leads photographers to seek out subjects in their own environments. Rather than imposing on people theatrical, idealized settings, the photographer wishes to catch them at their own pursuits complete with familiar surroundings.

The movement and vitality of people at work and play are obviously fertile sources of photographic subject matter. The self-consciousness which blights so many portraits is often absent from casual pictures of people who are absorbed in their pleasures and duties or—a happy coincidence—both together. The sculptor considering his chunks of stone, the rock climber negotiating an overhang and the child leaping to catch a ball are unlikely to be concerned with the presence of a sensible photographer; he can thus freely intrude on a scene of unmasked fear, pleasure, exasperation, anger or even embarrassment—provided the embarrassment is not caused by the camera.

The subject may be fully aware of this intrusive eye, but because he is anchored to an activity, and especially to a familiar one, the subsequent self-consciousness leads less easily to the distortions of shyness. The boatman hauling on a rope may be looking into the lens, but his movements are automatic and he is confident about his role. There will be nothing artificial or contrived about his pose. This approach also helps define something of the personality, frequently the off-guard personality, of the subject. His response to his work or pastime is more interesting than the mere facts of it, however, and cannot help but be revelatory in a photograph. Sometimes, too, revealing human pictures can be taken of people watching those at work, such as a group engrossed by workers on a demolition site.

It is easy enough to watch people at play, and some "slice of life" photographers are satisfied with taking pictures of people at work in the local market or the nearest building site. Unusual subject matter does not necessarily make a good photograph, but it can inspire one. The photographer who wants to explore the theme of people at work should be ambitious enough to try to find his way into hotel kitchens, down mine shafts, on to an assembly line or into an operating theatre; permission will sometimes be forthcoming, and the keen photographer can but try to obtain it.

Using the wide-angle lens
The skyscrapers of Manhattan form a backdrop for New Yorkers taking advantage of a cold spell to skate in Central Park. The muted colours secured by the deliberate underexposure combine with the wide-angle lens to produce an image reminiscent of a Lowry painting. Although the people are small and depersonalized, they still comprise the most vital element, converting what is basically an urban landscape into a human picture.
Nikkormat EL with 20mm lens; $\frac{1}{250}$ sec at f5.6; Ektachrome X; 81A filter. (JOHN GARRETT)

Using the telephoto lens
The telephoto lens is a great asset for the informal shot, particularly when the photographer is obliged to remain at a distance. Here a 1000mm lens had to be employed in order to capture a frontal view of hitter, catcher and umpire without intruding on the baseball game enjoyed by expatriate Americans in London's Hyde Park. The low viewpoint, chosen to put the figures against a dark, contrasting background, also adds to the photojournalistic feel of the shot.
Nikon F2 with 1000mm lens; $\frac{1}{250}$ sec at f11; Ektachrome X; tripod. (JULIAN CALDER)

Judging the mood

Deciding whether to pose people or take them naturally is often a difficult task. The French shepherd, with plenty of time to spare, seems only too willing to pose with his trusty dog and anonymous flock, but the fisherman, working on a fish-farm in Israel, is best taken in the throes of his work as he nets his golden carp.
Far left: Nikon F2 with 105 mm lens; $\frac{1}{250}$ sec at f8; Ektachrome X.
Left: Nikon F2 with 105 mm lens; $\frac{1}{250}$ sec at f5.6; Kodachrome II.

Anticipating the picture

The photographer had already been impressed by the strong composition of the light catching these Roman pillars when he saw the nuns approaching; by waiting for them to cross to the square he obtained a far more arresting image, while also more accurately conveying to the viewer the size of the structure.
Canon FT with 135 mm lens; $\frac{1}{125}$ sec at f8; Kodachrome 25. (NEILL MENNEER)

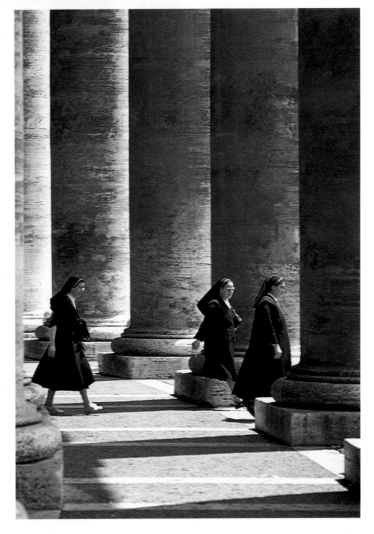

People / Children

Children's moods change rapidly, tears giving way to grins, shyness to exuberance. For this reason a formal studio portrait is seldom satisfactory: the child will all too often appear strained and inhibited.

Informal portraits have a much greater chance of success. Children are usually concerned with the presence of the camera for only a short time; the photographer can load film and accustom them to the strange clicking device until the children return to their own pursuits and once again behave more naturally. The key to successful child pictures is a willingness to expose a generous amount of film, although haphazard snapping is obviously not good enough and judgment and control are needed to capture the fleeting expressions and gestures; some of the best photographs of children look as if the subjects were caught unaware. At the same time the child's response to the camera can also make an interesting portrait.

Children are usually good subjects to be photographed in groups. Adults pose problems in this respect: it is not easy to group them in a way that does not look stiff and posed. Children, on the other hand, will play unselfconsciously together, making ideal subjects for an informal group portrait.

The group picture
Language proved no problem in persuading these Neapolitan children to pose for a group shot. The gestures are exaggerated yet natural; the expressions run from happiness to anxiety, from aggression to indifference. The high viewpoint accentuates their smallness and vulnerability.
Nikon F with 24 mm lens; $\frac{1}{125}$ sec at f 5.6; Ilford FP4.

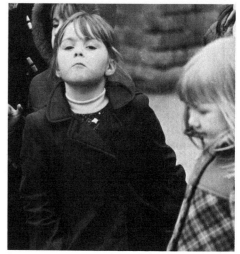

Isolating the subject
The three pictures above come from a series taken as the photographer wandered around a school playground. After initial curiosity and, in some cases, shyness and embarrassment, the children returned to their normal pursuits and he was able to isolate this

girl and capture a variety of expressions. Such a sequence of natural shots will often reveal character and personality more effectively than a conventional studio portrait.
Nikon F2S with 105 mm lens; $\frac{1}{250}$ sec at f 8; Kodak Tri-X.

The child as an element
On some occasions (*right*) the child is only part of a story. This little boy's stance and expression tell a tale in themselves as he waits for his mother.
Nikon F with 105 mm lens; $\frac{1}{250}$ sec at f 5.6; Kodak Tri-X.

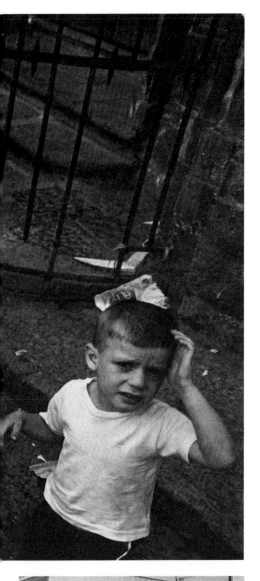

The natural actors
Photographing children is made easier by the fact that all of them are natural actors and that most love a challenge. In both these cases (*right*) the kids were asked to pull a face, and both subjects were only too willing to oblige. (ROGER PHILLIPS)

The natural approach
Most people understandably wish photographs of their own children to be "nice". But a far more accurate appraisal (*left*) can result from a natural approach, shooting when something quite normal is happening—like a change of nappy. This baby boy will have a more realistic view of the way he looked when he was two days old than if the approach had been purely sentimental.
Pentax with 55 mm lens; $\frac{1}{125}$ sec at f4.5; Kodak Tri-X. (JOHN BIGG)

The natural response
While a little imagination can produce rewarding results with most portraiture, this is especially true of children. The photographer realized that by standing these two boys against a wall or sitting them on chairs they would almost certainly be strained, inhibited and unnatural. Instead he decided to lay them on a dark carpet and stand over them. During the sequence of pictures the cat walked between the boys; both instinctively grabbed her and the result was a happy, spontaneous and natural photograph. The exclusive use of available light from a window helped to reinforce the casual atmosphere. The two essentials in the success of this shot, as with nearly all child photography, were a relaxed approach and a willingness to expose a good deal of film to ensure a few satisfying pictures.
Pentax with 55 mm lens; $\frac{1}{125}$ sec at f5.6; Kodak Plus-X Pan. (JOHN BIGG)

People / The group

The formal group
Tradition and function often demand that the formal group is a conventional composition, as this picture of Manchester United clearly demonstrates. While it obeys all the basic rules —the tiers give each member equal prominence, the tall goalkeepers are in the middle—it affords the photographer little scope to exercise his imagination.

Using viewpoint for effect
A far more arresting group shot has been created below with the Vienna Boys Choir. The photographer has resisted the temptation to position the whole choir on some steps and by the combination of several factors—choosing only a few members, arranging them in a semi-circle, adopting a low viewpoint and employing a wide-angle lens—he has produced a much more meaningful and moody image. The use of the chandelier as a central compositional element reinforces the feel of the rarefied classical atmosphere in which the boys live. This was the only light available for the picture.
Nikon F with 24mm lens; $\frac{1}{15}$ sec at f5.6; Ektachrome X; tripod. (PATRICK THURSTON)

THE FORMAL GROUP

The formal group portrait can provide an acid test of the photographer's skill and imagination. The group must be attractively arranged and the attention of every member caught at the same moment. Although composition and lighting impose certain restrictions, an effort should be made to avoid the regimented monotony of the conventional formal line-up. Lighting cannot, of course, be adjusted to suit merely a few of the members; it must in some way attempt to create a group mood. The bigger the group the more exposures are required

to ensure that nobody is blinking, frowning or looking away at the crucial moment.

A line of more than three or four people looks awkward and should usually be split up into rows. It is advisable to put the tallest people farthest from the camera and in the centre. A third row should make itself taller or shorter by standing on benches at the back or sitting or kneeling in front. Where possible, natural supports— steps or an incline—can be used to achieve this vertical, staggered effect.

If kneeling figures look inappropriate— outside the church at a wedding, for example

—the conventional solution is an arrangement of two lines with the faces of the taller members in the back row showing between the heads of those in front. Members of the group stand close together and the camera should be positioned fairly high. The composition can look more interesting if the ends of the rows are slightly curved towards the camera. Whatever the group arrangement, a tripod is essential since the photographer needs to move backwards and forwards between the group and the camera while making adjustments and checking the effect through the viewfinder.

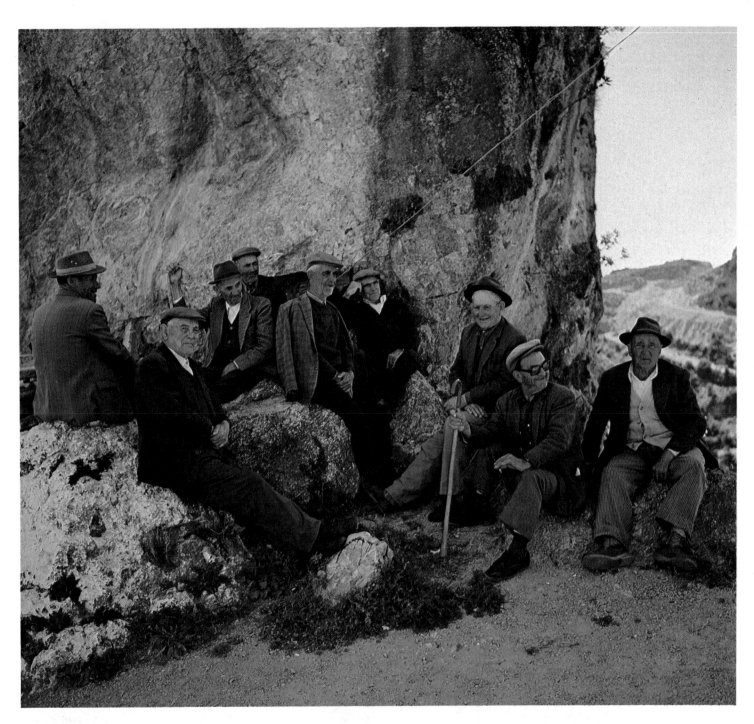

THE INFORMAL GROUP

Informal group photography gives the amateur a chance to compete with the professional. In formal group photography expertise will tell; in the informal setting it will be less apparent because the intention is to take relaxed and spontaneous-looking studies. The amateur, who is also likely to be a friend of the group, has an opportunity to capture its members under virtually ideal conditions.

In this type of photograph it is not necessary for people to be looking at, or to be aware of, the camera. Even formal occasions are opportunities for informal portraits. While the professional is arranging the set group portrait, the amateur has a superlative chance to capture those interludes which can provide the most lifelike records of the occasion. Better results are often obtained by moving around with a camera and photographing people in natural situations rather than lining them up in front of the lens. Guidelines for such informal pictures are simple: select a viewpoint where the lighting is suitable; wait for an attractive composition; watch for the right expressions and actions; and use a fast shutter speed.

The informal group
The routine in one day of the life of an Andalusian village is captured as these old or out-of-work men gather at their favourite meeting place to while away the hot Spanish afternoon. The essence of a good informal group photograph is keeping a natural feel, and although several faces here are looking at the camera, the overall effect remains casual and unposed. The shadows and strong blue cast caused by the harsh sunlight are in sharp contrast to the warm tones generated by weather-beaten faces and hands.
Pentax 6 × 7 cm with 55 mm lens; $\frac{1}{125}$ sec at f5.6; Ektachrome X.

The human form / Lighting the nude -1

The human body is a landscape of even texture and continually changing contours. The way in which its forms are defined or contribute to the mood of the photograph depends largely on the direction and quality of the lighting.

Lighting in the studio

Harsh directional lighting—sunlight or diffused studio lighting—will almost certainly be unflattering because it exaggerates skin texture and blemishes, limits the range of skin tones and causes powerful shadows that destroy softness. Diffused light is preferable when subtlety and roundness are required. Created in the studio by reflecting light from large white sheets or umbrellas, or by diffusing it with translucent plastic or fabric, it can be applied very directionally to reveal form and texture to the maximum, or evenly to minimize this sculptural effect and allow the outline and position of the body to dominate.

Even slight movements of the figure alter the effect of strongly directional lighting, and the photographer must be continually aware of changing highlights and shadows. It is easier to control the adjustment of this type of lighting by moving the model rather than the light source itself. With very soft overall lighting, however, the model can change position quite freely without drastically altering its effect.

Using natural light

The same principles apply to both studio and natural light. Dull daylight is usually sympathetic to the form, tone and texture of flesh, but direct sunlight should be avoided and use made of any shade afforded by trees and buildings, which will soften the glare. By late afternoon the sun can create rich textures and soft contours, but the unrelenting light of noon and early afternoon is usually too sharp to be attractive, especially when directed at pale skin. Natural light indoors can be effective as long as the figure is protected from direct sunlight, but even then it may be necessary to use white reflectors to modify tonal contrasts (see also page 100).

Aspects of the body

As in other areas of photography, parts of the body can appear more interesting than the whole. Shapes, forms and textures of the body can be interesting in their own right, independent of facial beauty or even physical identity. This concentration on form for its own sake may just mean cropping the head of the model, thus depersonalizing her, or it may be more extreme. A small area of curves and creases can become an abstract image almost unrecognizable as a part of the human body.

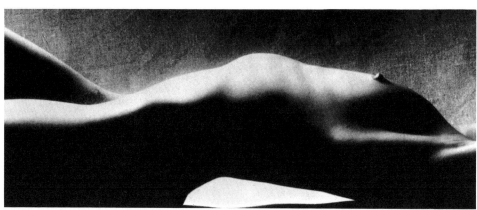

The lighting in these three photographs emphasizes both the contours and skin texture of the body, while a slow, fine-grain film keeps the tones soft. A strip light, powered by a 5,000-joule *Cecil Strobe* console, is diffused through an opalescent plastic screen to heighten the softened effect. When the light is angled mainly towards the backdrop, it bounces back on to the figure to create a continual highlight along the stomach, breast, neck and arms. These, and the pool formed in the arch, contrast strongly with the deep shadows along the side and the underpart of the body. This is very different from the effect evident in the similar pose on pages 114–15, where a reflector has been used to open up the shadow areas.
Mamiya RB 67 with 180 mm lens; $\frac{1}{60}$ sec at f8; Kodak Panatomic X.

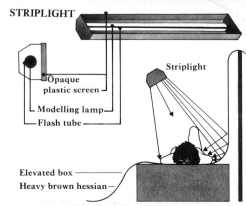

STRIPLIGHT

Opaque plastic screen
Modelling lamp
Flash tube
Striplight
Elevated box
Heavy brown hessian

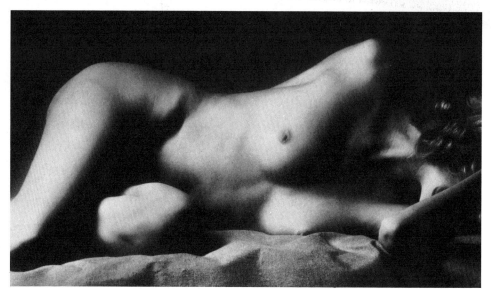

When the model turns on her side and the light source is placed directly above her, the light is directed straight on to the body to cast shadows that accentuate the contours of the undulating pose. The darkness of the background establishes a sense of secrecy and intimacy, but at the same time the legs and the lighting have been arranged to camouflage the crutch in deep shadow.
Mamiya RB 67 with 360 mm lens; $\frac{1}{60}$ sec at f11; Kodak Panatomic X.

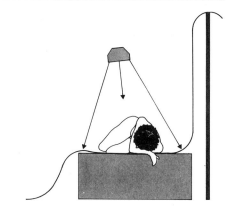

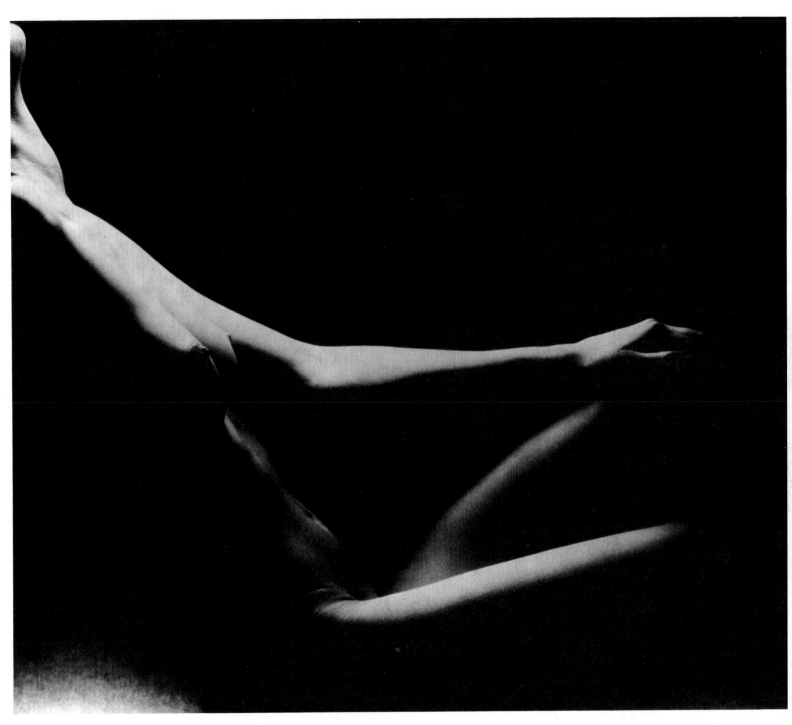

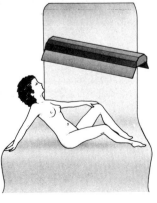

The model's breasts, arms and thighs contrast dramatically with the background and the rest of the body to take on an almost abstract form in this taut pose. The tonal difference is created by restricting the spill of light and moving the source nearer the model. To control the width of the beam "barn doors" (see page 58) were fitted to the striplight. In all these pictures the head was cropped or the face turned away in order not to detract from the functional purpose of the series—to illustrate various aspects of the body and how to use lighting for them.

Mamiya RB67 with 180 mm lens; $\frac{1}{60}$ sec at f8; Kodak Panatomic X.
(All photographs by NARU INUI)

The human form / Lighting the nude - 2

The female form is one of the most common subjects at all levels of photography. Yet it is one of the most difficult subjects to photograph, because it either elicits several conflicting responses or merely looks "unnatural" naked. The nude can be many things—an imitation of another art form, a vulnerable human being, a sex object, a manifestation of beauty; the viewer's reaction depends on which ways and to what extent the body is any one of these things or a mixture of a number of them.

The painted figure, further removed from reality than the photographic one, is less likely to look plainly or shockingly naked, as opposed to self-confidently and discreetly nude. In an attempt to create art out of nakedness, 19th- and early 20th-century photographers posed their models according to classical paintings and sculptures. This was no real solution—the models looked either cold and statuesque or over-sentimental—and acceptance of the erotic in photography and the exploration of form for its own sake have subsequently made nude pictures more real and successful.

Sensuality and eroticism

It is difficult to imagine a photograph of a nude which would leave the viewer unaware of sexual content or induce an asexual response. If a selection of first-class portraits and landscapes were displayed with some third-rate nude photographs, the attention of even the most visually aware spectators would be directed first to the nudes. For a nude photograph to sustain interest, however, it must have qualities other than purely sexual ones, and the photographer must be aware of the extent to which he wants the sexual content to dominate his subject.

The degree to which a nude photograph is erotic depends not only on the viewer and the body itself but also on the pose, the facial expression, the lighting and the environment. Eroticism should not be confused with nudity; some of the most seductive photographs reveal surprisingly little of the naked body. As in portraiture, the eyes are a dominant factor; when they are directed at the camera the feeling between the model and the spectator immediately becomes more personal and intimate. Even when the pose is in no way provocative the expression in the eyes can heighten the sexual aspect.

Perhaps more than in any other branch of photography, discretion and judgment are critical; the erotic picture can so easily be as coy or as coarse as the most pathetic kind of pornography. To a large extent sensuality is more effectively achieved by implication and suggestion than by bald statement of physical fact.

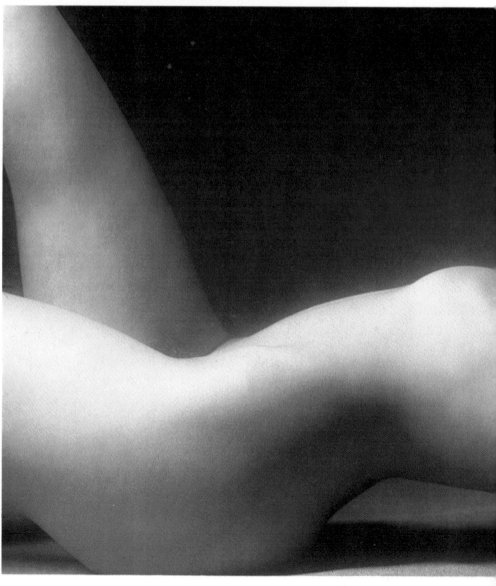

The figure on the left is arranged as a formal composition of curves and angles undistorted by overpowering shadows. The photographer diffused the direct light and gave the model's pale skin an opalescent warm glow covering the lens with a double layer of stocking. This picture illustrates the need for great care on the part of the photographer: the veins in the model's arm, caused by her leaning on it for too long, can be eradicated by shooting soon after adopting the pose, or breaking for a moment. *Mamiya RB67 with 360 mm lens; $\frac{1}{60}$ sec at f11; Ektachrome Daylight 120.*

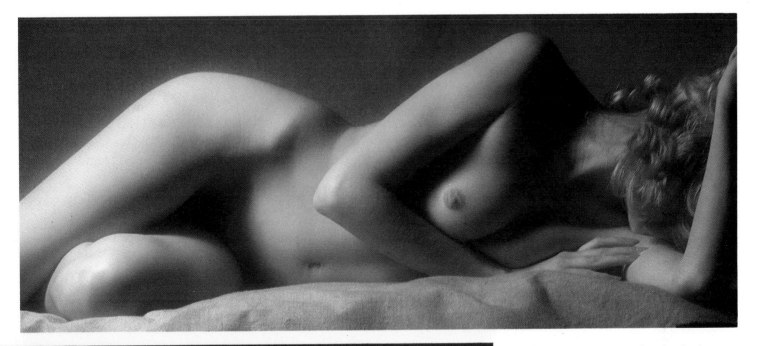

The relaxed, curvaceous pose above is seductive, yet the figure and surroundings are impersonal. The light, spilling on to the upper part of the figure but leaving the background even in tone, emphasizes the extremes of contour in the body—the roundness of breast and hip, the angle of elbow and pelvis. Again, the lighting is angled towards modesty, with the crutch disguised in shadow. The flaring of the highlights produced by the double layer of stocking—an effect evident in all three photographs—is particularly pronounced on the thigh. The inclusion of the canvas sheet creates an interesting textural contrast to the skin; texture is an important element in photographing nudes, adding a tactile quality to basic shapes, forms, tones and colours.

Mamiya RB67 with 180mm lens; $\frac{1}{60}$ sec at f8; Ektachrome Daylight 120.

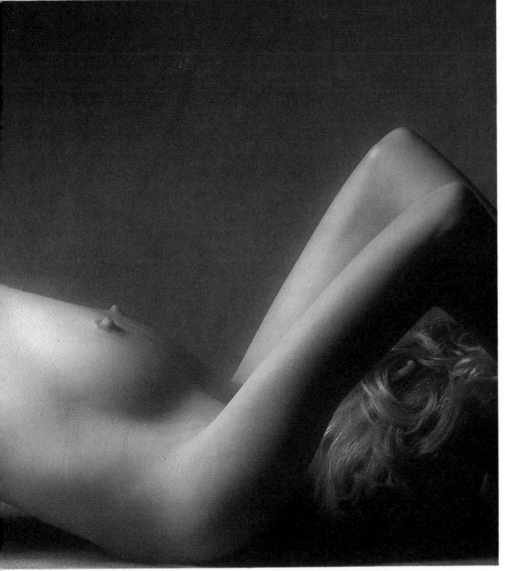

This stretched pose shows off the rounded sinuousness of the body, while the lighting suits its tautness and tension. The overall tonal effect is created by directing most of the light at the background and using a white reflector to open up the shadow areas. The backdrop is valuable here, retaining a tonal blend and lending further warmth to the skin tones. The picture also illustrates a theme endlessly reiterated in fashion magazines and advertisements, where the photographer exploits the textures and tones of skin, hair, cloth, water and sand to intensify the sensuality of the picture.

Mamiya RB67 with 180mm lens; $\frac{1}{60}$ sec at f8; Ektachrome Daylight 120.
(All photographs by NARU INUI*)*

The human form / Style and mood-1

Between pin-ups and formal studies of the naked figure is a wide area of erotic chic much used in fashion photography. To a large extent it is generated by settings and clothes which help create a personality for the model and the mood for the photograph. A nude against a plain studio background can look alluring, but a sexually stylish or glamorous image can usually only be created by a special environment or by props. The nature of these "extras" may depend on being a step ahead of or in line with fashion; thus the photographer has to be aware of fashion trends, such as silk replacing denim or vice versa. The kind of glamour that money can buy has never died out, although it goes out of fashion periodically and photographers may put their models on bicycles, not in sports cars.

Most of this kind of photography swings between two extremes—the hard and the soft sort of elegance. The hard style idolizes the inhuman woman—poised, flawless and rich; the soft, innocent style favours the candid country girl who lies in the meadow rather than in the apartment.

The setting

If its relationship with the figure is right, virtually any environment can be used to create style and glamour. Much depends on the model's type of looks as well as on the ingenuity of the photographer. It is his job, however, to discover new sources of sensual imagery or else make good use of the clichés. Photographers who take pictures of sleek or stylish models in building sites or scrap yards know how useful contrast can be in emphasizing the beauty or sexuality of a figure. An absurd setting also suits the deadpan style of modern fashion photography, which must not appear to take itself too seriously. The desert, the zoo or the motorway are all suitable settings for the bored, disdainful, self-mocking modern model.

The model

The photographer may choose the theme or setting for his picture, but his model must be able to relate to it and relax within it. She must be as confident as possible for the success of the photograph depends on her looking good—and knowing it. Shyness is rarely glamorous and the self-conscious model who cannot project personality is not likely to be an object of fascination to others.

The professional photographer has the advantage of working mostly with experienced models who are paid to be extrovert and who know how to adopt poses to please the public. Their expertise, however, brings with it a tendency to rely on a repertoire of stereotyped positions and movements; the amateur can sometimes offer a fresh appeal.

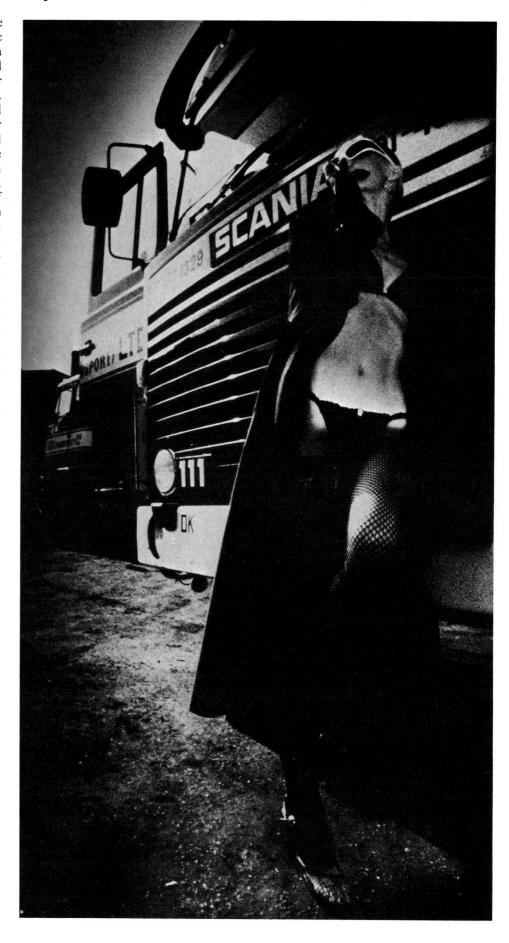

Creating impact
The unexpected combination of a streamlined truck and a scantily-clad female makes a strangely effective contrast. The model has been deliberately posed against the sun and a mirror used to bounce light back on to her body. The mirror's harsh, glaring reflections give emphasis to the intended role of space-age vamp. A low viewpoint elongates her figure, while the wide-angle lens exaggerates the lines along the radiator grille.
Nikon F2 with 24 mm lens; $\frac{1}{60}$ sec at f8; Kodak Tri-X.
(NARU INUI)

Using available light
Interesting images and effects can often be captured indoors without any special equipment. Window-light coming through Venetian blinds (*right*) casts hard shadows which take on the forms of the objects they hit and scatter themselves in geometric patterns across the floor. The bands of light and shade accentuate the roundness of the model's leg, arms and breasts, though their hard-edged quality suits the angular pose. The boots, stockings and exposed crutch, together with the shaded face, convey an atmosphere of provocative if impersonal sexuality.
Nikon F2 with 24 mm lens; $\frac{1}{60}$ sec at f4; Ilford FP4. (NARU INUI)

The human form / Style and mood-2

Softening the image

Pretty girls, fresh air and frilly cotton dresses
epitomize the innocent, natural look of much modern
fashion photography. In both photographs a double
layer of stocking was used over the lens to reduce
contrast, modify colour and create an effect of hazy
softness. The two pictures also demonstrate the results
of different angles of light on tone and colour. The
sun behind the models (*top*) highlights the edges of
the blonde heads while casting an even, muted light
over the rest of their bodies. In the photograph using
frontal lighting (*above*), with the girls looking into the
sun, the light strengthens colour and tone, although
the general effect remains subdued. The parasol is
functional as well as pretty, helping to shade the eyes
and avoid frowning. The inexperienced photographer
should begin experimenting with softening the image
in a gentle way, learning the techniques gradually.
*Nikon F2 with 80–200 zoom lens at 180mm; $\frac{1}{250}$ sec at
f5.6 (top) and at f8 (above); GAF 500.* (NARU INUI)

Creating a mood

A slower, finer-grained film was used (*right*) to record
the sharp contrasts, hard edges and fine detail produced
by the strong noon sunlight. The focal point, a girl
who is modest enough to hide her face but blasé
enough to reveal her breasts, adds a touch of wit
which accentuates the photograph's air of casual
indifference. A weak blue chromofilter was used to
darken the sky.
*Nikon F2 with 24mm lens; $\frac{1}{60}$ sec at f8; Ektachrome
X; blue chromofilter.* (NARU INUI)

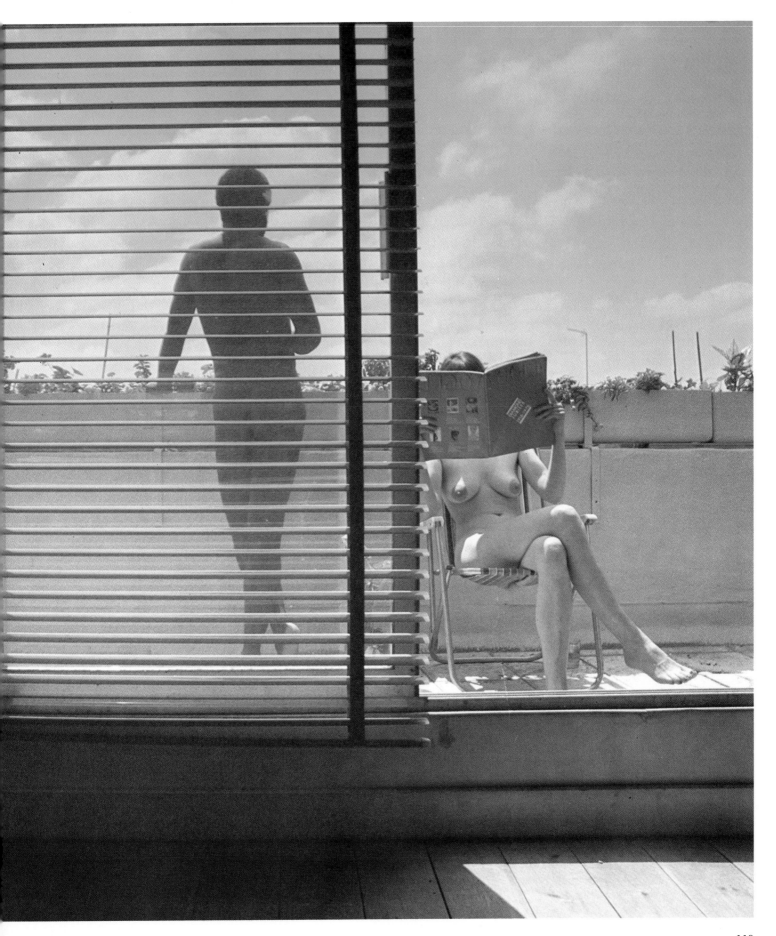

The human form / The body and movement

The strength, grace and vitality of the moving figure is an irresistible subject for a photographer concerned with either the human form or human behaviour. Self-consciousness, so often present in static poses, is rarely a problem in pictures of the figure in action; the individual is too involved and preoccupied to be concerned with personal appearances. The activity usually takes care of the aesthetics.

To arrest movement, the unique prerogative of the camera, the photographer must obviously be as sensitive to physical change as possible. The speed of sport or dancing, however, is such that he cannot always anticipate results and must be prepared to expose a generous amount of film from which to select the telling picture of an energetic figure. The most intense moments of action can appear lame when reproduced from an uninteresting angle or without the necessary stress of a tight composition.

Movement exists in time but the photographer, who cannot use time-space factors like the dramatist or the strip cartoonist, must imply it through a static image. Facial expression helps because the face registers tension, surprise, joy or whatever emotions the activity arouses. Composition is also crucial in conveying movement; in a carefully composed picture the eye is led along planned routes by shapes, lines and colours so that the suggestion of movement is accentuated by the movement of the eye within the picture. Several methods can be employed to convey the impression of movement and speed—blurring, zooming, motor drive, multiple exposure and so on—and these are explained on pages 152–5.

Stylized movement
Choreography presents the action of the body at its most stylized and graceful (*right*). The rapid succession of apparently effortless movements that comprise a ballet can be visually dismantled by the photographer and studied as a sequence of carefully controlled poses to express the strength, beauty and vitality of the human figure. Dancing a *pas de deux* are Gloria Gorrin and Arthur Mitchell of the New York City Ballet; the contrasting poses enhance each other, the ballerina a counterpoint to the powerful vertical stance of her partner. Soft, grainy effect and relative lack of contrast (alleviated by the dancers' clothes) are the result of using a fast film in poor lighting conditions.
Nikon F with 50mm lens; $\frac{1}{125}$ sec at f4; Ilford HP4. (ZOE DOMINIC)

The abstract figure
The semi-silhouette (*left*) simplifies form to accentuate the abstract quality of the figure. The black shape, appearing almost two-dimensional against the stark white background, is only recognizable as a figure through areas of tonal modelling on the feet, neck and back. The shadows, created by the 45° flash and intended as a soft contrast to the outline of the figure, provide depth.
Nikkormat with 35mm lens; $\frac{1}{125}$ sec at f11; Kodak Tri-X. (SUSANNAH HALL)

Accentuating movement
A frieze of leaping, twisting figures (*below*) records spontaneous, as opposed to formalized, movement. The linear, two-dimensional aspect of the body, produced by the absence of the floor level (and by the removal of shadows by retouching at the print stage), gives an almost calligraphic quality, emphasizing shape rather than solidity and mass. The black tunic absorbs light and reduces tonal contrast, thus contributing to the silhouette effect.
Nikkormat with 35mm lens; $\frac{1}{250}$ sec at f16; Kodak Tri-X. (SUSANNAH HALL)

Landscape / The changing light

Little remains constant in a landscape. The continual process of change brought about by the light, the time of day and the seasons of the year combine to produce an endless variety of pictorial opportunities. Landscape work is thus one of the most exciting aspects of photography; it is also one of the most difficult. Ansel Adams, one of its greatest masters, has succinctly described it as "the supreme test of the photographer—and often the supreme disappointment".

It is common to see in a scene a compelling image, which, when revisited a few hours later, will have altered or perhaps even disappeared altogether. Similarly, a sudden change in the weather or light can reveal a superb view in what had previously been an uninspiring scene. There can be a special type of spontaneity in landscape work that can be almost on a par with sports or reportage photography.

In addition there are the wider but more predictable changes wrought by the seasons. The sky changes continuously, at one time brilliant with summer sunshine, at another tempestuous with winter storm clouds. Snow gives way to lush grass, bare branches become green with foliage, flowers of different hues bloom and fade. No two weeks are the same, and a scene that is ordinary for the greater part of the year can suddenly produce inspiring textures, compositions or colour.

Assessing the light

Lighting technique in landscape photography is divided into three factors—direction, quality and colour—but it is impossible to generalize about lighting since each pictorial possibility and each desired effect presents different requirements. No photographer, of course, should automatically accept the first "favourable" lighting situation. If it is possible, the scene should be studied under differing light conditions and shot only when the light is best suited for the result sought. Although many landscape photographers prefer to work mostly in early morning or late afternoon—at those times sunlight is quite hard and strongly directional, revealing a high degree of form and texture—other times of day can also produce compelling results. Bright sunlight is by no means essential: the soft light of a dull overcast day can yield atmospheric images of delicate tones and colours. Rain, snow, mist and fog can, with careful thought and proper use of equipment, actually enhance or dramatize a scene. The important factor is awareness. It is easy to become oblivious of the potential in landscapes or to be too impatient to wait for the right conditions.

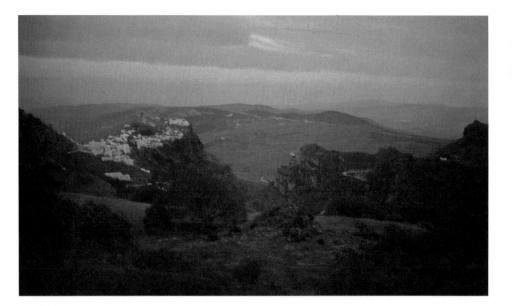

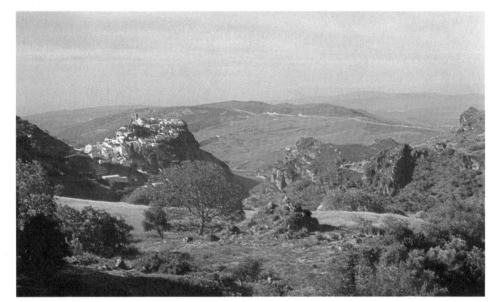

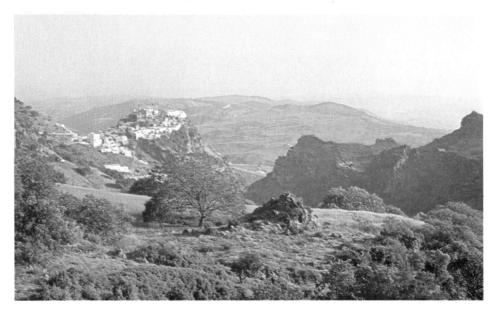

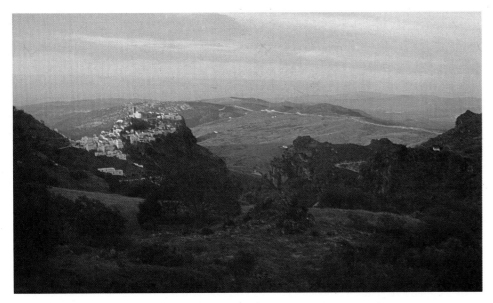

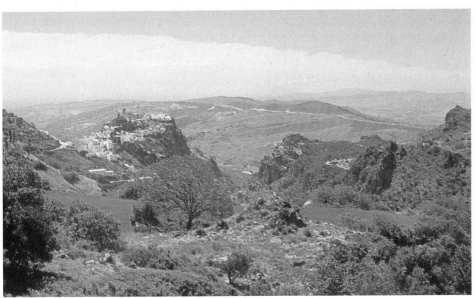

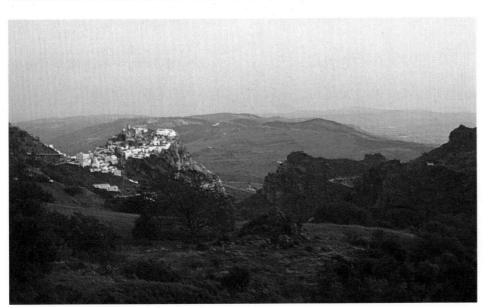

Time of day

These six photographs of a landscape in southern Spain were taken in late spring from precisely the same south-facing viewpoint to illustrate the changes in lighting effects during the course of a day. The first picture (*far left*) was shot at dawn. With no direct sunlight the tones are extremely soft and tend to merge; the colours are pale and desaturated. Because light from the sky is much more blue than light from the sun, there is a distinctive blue cast, particularly evident on white objects ($\frac{1}{4}$ *sec at f2.8*).

The second picture (*left*) was taken as the first rays of the sun were felt in early morning. The light is now more yellow, removing the blue cast and producing a warmer colour quality. With the sun very low on the horizon, the shadows are both long and dense. An extreme instance of this is the foreground, which is in deep shadow because the sun has not yet risen high enough to illuminate it ($\frac{1}{125}$ *sec at f4*).

The colour of light at mid-morning (*far left*) is now much more "normal" in the sense that it is approaching the colour temperature of noon sunlight, for which most daylight colour films are balanced. Though the changes in the quality of light are not fully apparent to the human eye, they are fairly accurately recorded on film. The sun is now high enough to illuminate the foreground, but the shadows are still fairly long and dense, while form and texture in the distance remain quite strong ($\frac{1}{250}$ *sec at f8*).

The photograph taken at noon (*left*) with the sun almost overhead shows the most dramatic change of the day: shadows are at their shortest and lighting at its most flat. The sun moves through an angle of 15° relative to the earth every hour, and if part of a landscape is in shadow at, say, 10 a.m., it is easy to estimate when the sun will have moved round for it to be in sunlight ($\frac{1}{250}$ *sec at f11*).

By late afternoon (*far left*) the shadows have lengthened in the opposite direction to those of the early morning. Here the tonal variation between the foreground, mid-distance and far distance is probably at its greatest. Sunlight is yellow and warm at the start of the day; by noon it has become "normal" white, giving a faithful rendition of colours; and by late afternoon it has again developed warmth due to its lower colour temperature ($\frac{1}{250}$ *sec at f11*).

The final picture (*left*) was taken in late evening. The light, even more warm and mellow, now illuminates only a small part of the landscape, creating strong contrast and detail where it strikes. The rest of the scene is now rather dark and soft in tone. The most popular times of the day with landscape photographers are usually the early morning and late afternoon, which afford the maximum rendition of form and texture ($\frac{1}{250}$ *sec at f4*).

All photographs taken with a Nikon F2S and a 50mm lens on Ektachrome X.

Landscape/Horizon, depth and scale

The position of the horizon—the line where the earth and sky appear to meet—is nearly always a dominant factor in landscape photography. It divides the picture into two distinct areas, and the relative proportions of these areas will help govern the composition, balance and mood of the photograph. If the horizon appears nearer the top of the photograph than the bottom, the land will be the main point of interest; if it is in the lower half, the sky will tend to dominate.

For this reason it should seldom run exactly across the middle of the picture, except when the composition and purpose of the picture is dependent on symmetry. If, for example, the foreground were the dominant feature and the sky devoid of interest, having the horizon running through the centre of the image would probably throw it out of balance. In such a case it would almost certainly be a better composition if the horizon were two-thirds or three-quarters of the way up the image—the most common proportions in landscape photography. The proportion of sky shown will also have an effect on the feeling of space; at its most extreme, when the horizon is omitted the scene will appear enclosed.

The position of the horizon can be adjusted by tilting the camera. Although this will introduce some distortion of perspective, it is usually insufficient to be a serious consideration. A view camera will let the horizon be altered without tilting.

The line of the horizon is usually broken by trees and buildings, and these will in turn affect the position and the balance of the image. As a general rule, the line should be interrupted before it meets the edge of the picture by selecting a viewpoint that includes an object to mask some part of it.

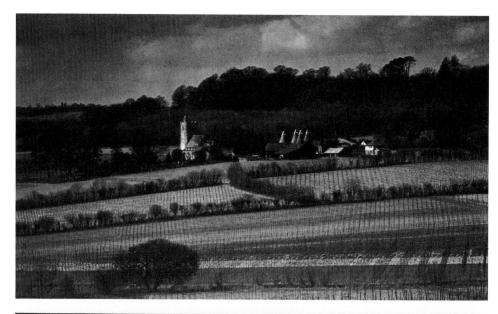

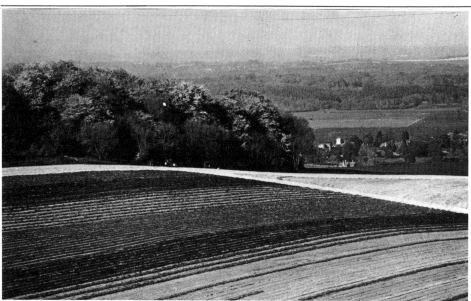

Depth and scale

Perspective affects both the feeling of depth in a picture and the relative scale of objects within it. A distant scene will show objects in proportion to their actual relative sizes, but the introduction of foreground, while increasing the feeling of depth, will also falsify the relative sizes of the near and distant objects. This dual function means that a decision has to be made in landscape photography as to which of the two qualities—depth or true relative scale—is the more important.

The amount included in the foreground will be determined by the viewpoint. A low viewpoint will accentuate the size of close objects; a high viewpoint will tend to exclude objects in the foreground, but will provide a panoramic view over the middle and far distance.

The choice of lens is another factor when considering the rival claims of scale and

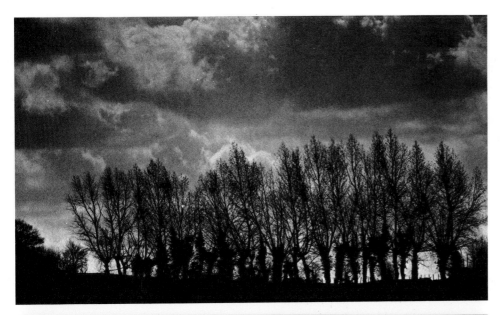

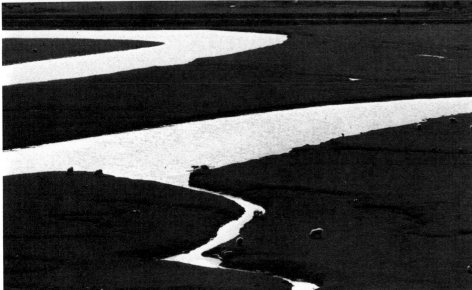

High horizon
With a high horizon (*far left*), the eye travels between the middle distance, where there are oast-houses and a church, and the detail of the hop fields in the foreground—the two main centres of interest. The sky and its cloud formations are of little importance: their main purpose, apart from minor considerations of composition, is to act as a frame, preventing the eye from being drawn from the important images.
Nikon F2S with 200 mm lens; $\frac{1}{250}$ sec at f5.6; Ilford FP4; red filter.

Low horizon
The sky will tend to dominate when the horizon is in the lower half of a landscape (*left*). The trees break the domination to a certain extent, but this would be more pronounced (and reduce the role of the sky) if they were leafy and formed a solid block. Powerful though sparse cloud formations frame the image; without these the scene would be out of balance and need a different horizon level.
Nikon F2S with 200 mm lens; $\frac{1}{250}$ sec at f5.6; Ilford FP4; red filter.

Central horizon
The most difficult horizon level to compose satisfactorily is one that runs through the centre of a picture; here (*far left*) a sense of symmetry was needed to give the impression of space and emptiness. The impact depends, however, on the severe perspective and on the components of the scene: if there were no vehicle in the centre of the far distance, and if the sky were cloudless, the image would be without interest. As it is, the truck appears to be on some strange, unending journey.
Nikon F2 with 35 mm lens; $\frac{1}{250}$ sec at f8; Ilford FP4; red filter. (JOHN GARRETT)

Absence of horizon
With no horizon at all a picture gives a confined impression. Although this is an extensive view, given both depth and scale by the sheep and other recognizable foreground objects, the lack of an horizon encourages the viewer to dwell on detail. The strong lateral lines of the river divide the picture in much the same way as would a horizon.
Nikon F2S with 200 mm lens; $\frac{1}{250}$ sec at f8; Ilford FP4.

depth. A wide-angle lens, covering 60° or more (*right*), allows the inclusion of foreground elements close to the camera position in the picture, offers greater depth of field, increases the impression of depth and, of course, enables a wider angle of view to be shown. It will, however, alter the apparent scale of objects. The long-focus, or telephoto lens, on the other hand (*left*), allows a more distant viewpoint and elements of the scene to be isolated; it reflects a more truthful relationship between the size of objects in the picture, although the effect of depth is considerably reduced.
Left: Nikon F2S with 200 mm lens; $\frac{1}{250}$ sec at f5.6; Ilford HP5; red filter.
Right: Nikon F with 24 mm lens; $\frac{1}{125}$ sec at f5.6; Kodak Tri-X.

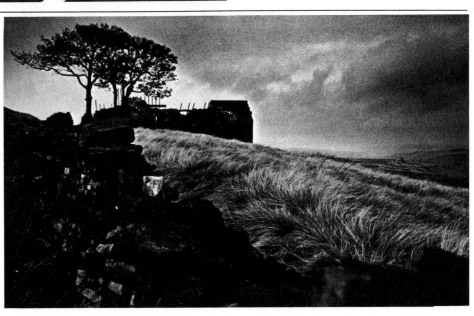

Landscape / The sky

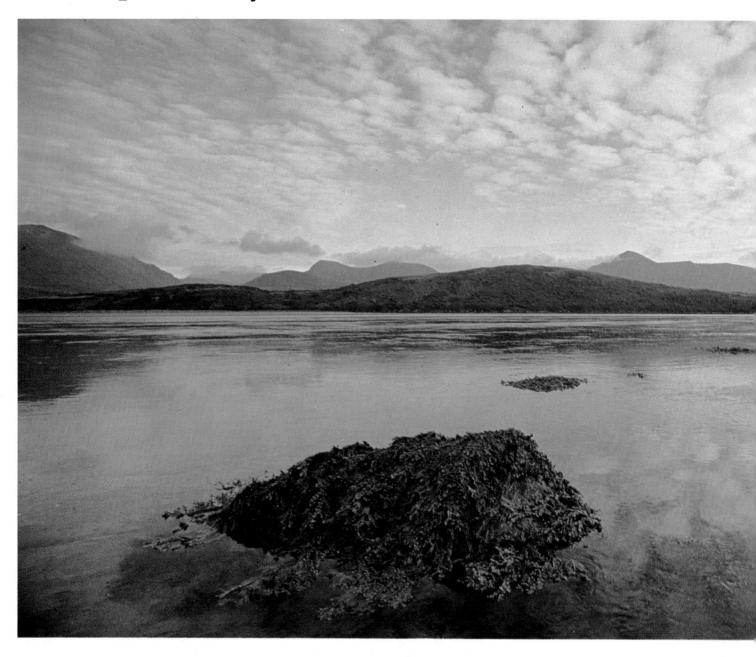

The sky can be a dominant feature in a landscape photograph—or it can be totally irrelevant. There is little that can be done about a sky when it is devoid of interest, except to minimize its role in the image or to exclude it altogether; there are, however, a number of considerations involved in making the most of detail and dramatic effect when they do exist.

The sky is one of the changing aspects of a scene. While houses, trees and fields remain essentially the same, the sky (like the light itself) can alter continually and make striking differences to landscapes.

Because the sky acts as a reflector it is part of the light source and the exposure calculated for foreground detail tends to make the sky overexposed, reducing its detail and tonal range. Thus it is important when the sky is a significant element in the composition of a picture to keep exposures to the minimum required for adequate shadow detail. In black and white photography, a great deal of control can be exercised at the printing stage by shading and printing-up sky areas (see page 179) and, to a certain extent, when making colour prints from negatives. With colour transparency materials this cannot be done and the control must therefore come from exposure and the use of filters.

It is possible to buy graduated filters, both in neutral density and in a range of colours. These affect only half of the image and can be used to reduce the exposure of the sky without affecting the foreground. When the sky is blue and the photographer is shooting away from the sun, a polarizing filter can be used with colour film to darken the tone of the sky without affecting the quality of the other colours (see pages 86–7). With black and white photography blue skies and the contrast of the clouds can be more effectively controlled by the use of yellow, orange and red filters—yellow having a subtle effect, orange somewhat stronger (rendering the blue sky a mid-grey) and the red filter producing a dramatic impact, converting the blue sky into a dark grey with the white clouds in strong contrast (see pages 66–7). It is always worthwhile experimenting at dawn and dusk, since success depends on the sky's mood and atmosphere and they are often best revealed at those times.

Sunsets
Perhaps the most common cause of disappointing results with sunsets is overexposure. Unfortunately the exposure needed to give detail and rich colour will usually provide little more than a silhouette in foreground subjects, and if these are important a compromise must be made.

Graduated filters can be used to control density in a sunset (see page 86), and these can also contribute to the effect by making the colours richer and stronger. Over-filtering may, however, lead to unconvincing, heavy results. Once the sun is low in the sky its intensity diminishes rapidly, and exposures can change two or three stops in as many minutes.

If the sun itself is included (*left*) it should usually be veiled by foreground objects or haze; it would otherwise be so bright that no detail could be seen and even its own shape would be lost. Foreground objects should partly be chosen for the interest of their shape (*below*) since their silhouette is all that will be seen.

Left: Nikon F2 with 500 mm mirror lens; $\frac{1}{250}$ sec at f8; Ektachrome X. (JOHN GARRETT)

Below: Pentax 6 × 7 cm with 200 mm lens; $\frac{1}{250}$ sec at f11; Ektachrome X.

Sky and water
The sky in this study of the Irish coast derives its impact not only from the striking cloud formation but also from the reflective quality of water. The feeling of depth has been emphasized with a wide-angle lens to produce a strong perspective; this was helped by the inclusion of a large rock detail in the foreground and the selection of a viewpoint from which the mountains are partly masked by the hill in the middle distance.

Nikkormat EL with 18 mm lens; $\frac{1}{30}$ sec at f16; Kodachrome 25. (RICHARD HAUGHTON)

Landscape / The urban scene

The urban landscape
The backs of interwar houses look down on ugly
monuments to Victorian enterprise in the Colne
Valley, part of England's northern industrial belt.
Here house and factory live cheek-by-jowl in a grey,
claustrophobic environment. Although there is a
distinct feeling of dereliction—heightened by the
waste ground and the clocks showing completely
different times—the factory was in full production
and the houses all occupied. The urban landscape
provides a great opportunity for the photographer
to use a large canvas for social comment.
Nikon F2S with 200 mm lens; $\frac{1}{250}$ sec at f11;
Kodak Tri-X.

The word landscape conjures up a romantic picture of inland scenery with hills, trees, rivers and fields. There is an alternative landscape, however, one equally worthy of the photographer's attention. Created by man and composed of houses, factories, offices, warehouses, schools, churches, roads, canals and railways, the urban landscape may seem even more beautiful or more dramatic than the conventionally rural one.

In any case, attractive or interesting subject matter, whether it is a chemical plant or a view of a mountain range, is not always the essence of a successful photograph. The talented photographer can often create a powerful atmosphere or an arresting design out of the most mundane scene, no matter how unphotogenic it may appear.

As with all aspects of photography, the key to success is visual sensitivity. The photographer must be an acute observer of changing patterns—those which occur independently and those which he can effect by examining a building or a piece of industrial machinery from unusual angles.

Urban landscapes, usually a hotchpotch of various architectural styles and functions, provide the photographer with a wealth of visual contrasts and comparisons. A picture of a church dwarfed by modern offices neatly contrasts style, function, scale and historical period. The hard-edged nature of much modern architecture lends itself well to semi-abstract compositions. A simple image of a soaring tower block, for example, may emphasize the stark beauty of glass, metal and concrete, while the skeletal silhouette of a bridge can often inspire an interesting linear composition.

The juxtaposition of man-made and natural scenery can give an added force to the picture. The comparison may be as simple as clouds above a row of houses; it can be a "clever" shot of buildings reflected in a puddle or canal; or it can be obviously dramatic—the sun sinking behind an industrial wasteland, or clouds and blue sky seen through a broken window pane.

The time of year, time of day, the weather and the light obviously affect the urban as much as the rural landscape. The weather is useful to reinforce a mood—gloomy sky over grimy cotton mills—or contradict it: try showing the same view in brilliant sunshine. The unexpected is always intriguing and, depending on the quality of light and the angle from which the picture is taken, the un-prepossessing building could take on the grandeur of greater architecture.

Man and his environment

The urban landscape also affords an opportunity for a photographer to make a social comment by emphasizing the beauty or ugliness of towns and the excitement and sadness of living in them. The relationship between man and his environment is an obvious theme for the urban photographer. The human figure, so often out of place in the rurality of a conventional landscape, is a natural element in scenes of street life.

Cities often look their best at night. The glare of artificial lights against blackness presents a dramatic picture, and the modern metropolis offers unlimited scope for abstract patterns (see pages 95 and 135). Again, the early hours of morning, before the town stirs, can look exciting because it is not how most of us usually see the urban environment.

The aerial photograph
A view from a helicopter of downtown Toronto produces a more glamorous version of the urban landscape. The ultra-modern design of the CN television tower (the tallest in the world on its completion in 1975), the light catching the skyscrapers and the feeling of depth all combine to form a reasonable advertisement for today's urban scene. Distance also lends enchantment to the view, and the industry which so governs the image above is here put into a wider perspective. An orange filter was used to darken the sky.
Nikon F2 with 80–200 mm zoom lens; $\frac{1}{250}$ sec at f8; Kodak Plus X; orange filter. (PAOLO KOCH)

Landscape / Water

Lakes, rivers and the sea are important elements in landscape work because their reflective quality contributes a rich variety of tone and colour to pictures. The role of water in a photograph can vary from dominance in a seascape to the minor contribution of a stream or pool, but it will always tend to catch the eye.

The visual quality of water is largely dependent on three factors. The most important is sky, which gives water much of its colour. The blue of a sea is intense when the sky is very blue, while the same sea with a grey sky can be almost devoid of colour.

The second factor is reflection. In addition to reflecting the sky, water will also mirror other tones and shapes around it and, depending on the degree of movement, these can produce a wide range of effects.

The third factor is movement itself. Water is compelling when it scintillates in the sun, but when it is without motion it can lose its interest. A still canal may produce a mirror-like image of buildings overlooking it, and sometimes this is the desired effect; but a slight degree of movement (easily achieved by casting a stone to create ripples) can change the image to a more abstract one while still retaining a faithful rendition of tones and colours.

There are two ways of photographing rapidly moving water: a slow shutter speed blurs the movement, giving an impression of speed and power, while a fast shutter speed will "freeze" it. The approach is dictated as much by the combination of light conditions, lens and film as much as it is by personal preference.

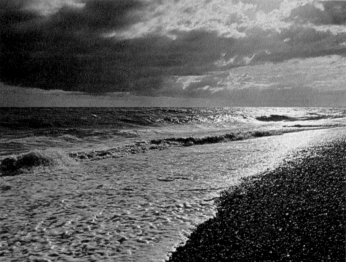

Seascapes
These two photographs, taken from the same viewpoint, produced very different results. The first, almost excluding the sky, captures the movement in the foreground as two waves break on to the shore, using a fast shutter speed to freeze the moment.
In the second shot, taken only minutes later, the motion of the sea was not the main consideration. The use of a wide-angle lens, showing the curving sweep of the beach and including the sky, creates a more sombre mood with an extended range of colours and tones.
Top: Nikon with 105 mm lens; $\frac{1}{500}$ sec at f8; Ektachrome X.
Left: Nikon F with 24 mm lens; $\frac{1}{250}$ sec at f11; Ektachrome X.

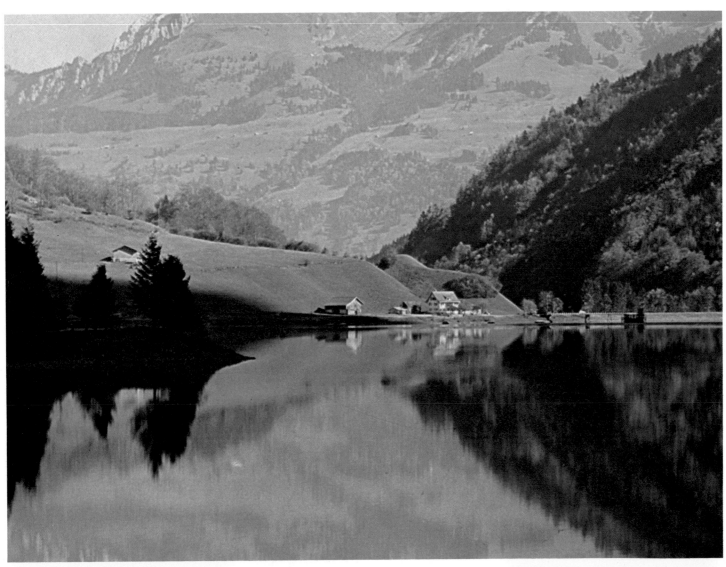

Reflection in still water
The tranquillity of the water in this Alpine lake
makes it highly reflective. To enhance the effect, the
photograph was taken when the sun was shining
strongly on the distant mountains, and maximum
light was reflected back to the water.
*Nikon F with 105 mm lens; $\frac{1}{250}$ sec at f11;
Ektachrome X.*

Capturing atmosphere
Strong, warm colour was captured on the surface of a
Venetian canal (*right*) by shooting at the building
when it was bathed in the golden light of evening.
The water glitters because it was photographed
towards the light source. The abrupt definition of the
illuminated area increases the impression of a narrow,
dark passage, while the presence of the figures helps
to indicate the true scale of the buildings.
*Nikon F2S with 105 mm lens; $\frac{1}{250}$ sec at f5.6;
Ektachrome X.*

Abstraction with water
A close-up of water in an Amsterdam canal (*left*)
reveals the dislocated reflection of adjacent buildings.
Here the water becomes a photographer's tool, a
canvas on which to create a natural abstract image.
*Nikon F2S with 105 mm lens; $\frac{1}{250}$ sec at f8;
Ektachrome X.*

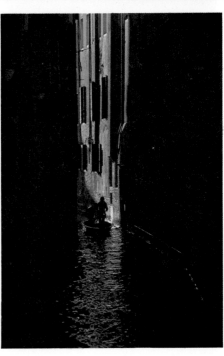

Architecture / Verticals and perspective

Photography and architecture have much in common. Both are concerned with the expression of line, form and texture; both are concerned with the influence of light on the final result. When the two art forms are in unison, a superb opportunity exists for controlled photography.

The amateur generally takes pictures of buildings for one of two reasons: either the building is of personal significance to him or it is of historical or architectural importance.

It is not difficult to obtain passable pictures of famous buildings. All a photographer need do is to buy a good postcard and shoot from the same viewpoint with similar lighting conditions. Much more thought is required if the picture is to have impact as a personal interpretation.

Studying the subject

If possible the building should be studied from several viewpoints and under various lighting conditions during the day. It is generally safest to view first from a straightforward aspect, and then move around it, closer in and farther away, seeking unusual or dramatic angles and views. It may seem a truism that buildings were designed to serve a specific purpose—houses were built to live in, churches to worship in, factories to work in—but keeping this in mind is an important aid in creating the right mood. Often, too, the inclusion of trees or foliage introduces a balancing element to the hard outlines of the building.

With most historical buildings a knowledge of architectural styles, even a rudimentary one, will also be of great help. Each period has its own distinctive features and an appreciation of this will enable the photographer to search out and find the best aspects and most interesting details. As Ansel Adams expressed it in *Camera and Lens*: "When confronted with good architecture or works of art, the photographer has a certain obligation to respect the forms already created." Nor should photographers ever disdain the use of the better kinds of guidebooks, since these will often indicate interesting aspects of a building that might otherwise have been overlooked.

A detail may often be effective as an architectural record, particularly when used in conjunction with two or three larger views employed as establishing shots. Door knockers, choir stalls and diminutive carved figures can reveal so much more of tradition and workmanship than a full picture, and make delightful images in their own right. The texture of the building—stonework or timber in old buildings, glass, steel and concrete in modern ones—will also come across more strongly if taken as a detail.

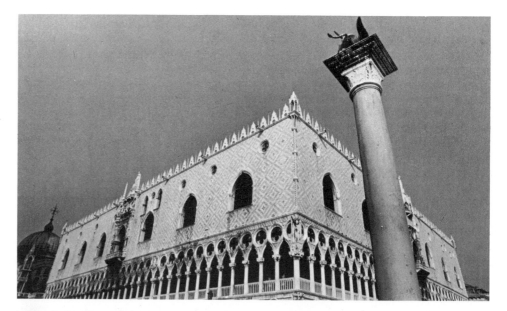

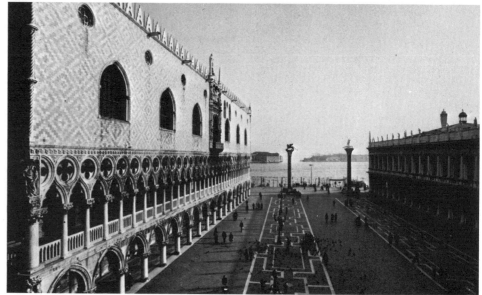

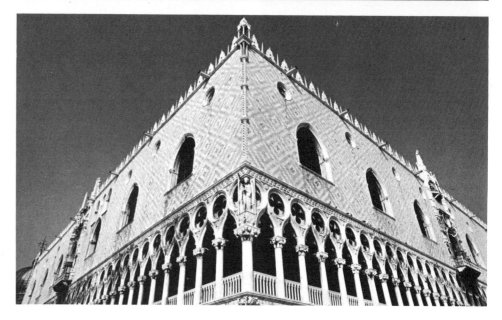

Problems of perspective

One of the main difficulties in architectural photography is to obtain a truthful rendering of perspective, since converging verticals occur when the camera is tilted to include the topmost point of a building (*above left*). This can be corrected in one of three basic ways.

The first solution is to photograph the building from an adequate distance (*above*): unless a long lens is used, this will mean a large foreground area, but this can sometimes be filled with objects of interest or the picture can be cropped at the print stage. The second answer (*centre left*) is physically to raise the viewpoint to a position half-way up the building—although this is, of course, only possible when there is a building opposite to which access is allowed. Finally, the rising front capacity of a view camera (*right*) will enable the whole structure to fill the frame—here the Temple of Jupiter at Baalbek in the Lebanon—while still retaining the correct vertical lines and perspective.

If the photographer has neither the equipment nor the viewpoint to eliminate converging verticals, it is often better to make a virtue of necessity (*below left*) and let the converging verticals add a sense of drama to the picture. Simply pointing a camera up at the face of a building, however, will make it look as if it is falling over; a better approach is to exclude the base of the building when tilting the camera.

Above and left: Nikon F2S with 24 mm lens; $\frac{1}{250}$ sec at f11; Ilford FP4.

Right: Linhof Super Technika V 6 × 9 cm with 100 mm Symmar f5.6 lens; maximum rising front (25 mm of shift); $\frac{1}{60}$ sec at f16; Ilford FP4 120; red filter; heavy tripod. (ANGELO HORNAK)

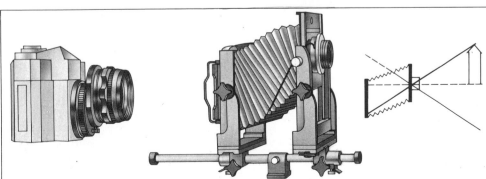

CONVERGING VERTICALS

When a camera is tilted to include the whole of a building, the top will be farther from it than the bottom and the verticals will converge. With a view camera (*left*), the front can be raised to include the top of a building while keeping the film plane parallel with it. With an SLR camera, the problem can often be overcome by the use of a perspective control lens (*far left*). A limited degree of correction can also be exercised at the printing stage by tilting the baseboard, provided that the film plane and/or lens plane are also altered (see page **176**).

Architecture/Interiors

The problems of adequate lighting make interiors far more difficult to photograph than exteriors. Unless the photographer is prepared to carry around and set up bulky lighting equipment, interiors of any size will necessarily be dependent on available light. This can nevertheless be highly effective and, provided a good tripod is used, long exposure will enable all but the very darkest interiors to be photographed. Ordinary flash will be almost useless.

Interior photography is usually easiest when the weather outside is bright but not too sunny. There will be no startling patches of sunlight or dense shadows and the illumination will be much more even.

The contrast may still be excessive, however, so that highlights such as windows will be burnt out or the shadows heavy and lacking in detail. A sensible choice of viewpoint will often eradicate these unwelcome extremes of contrast.

With black and white material it is a help to develop the negative to a low contrast, and skilful printing on soft paper can even out the highlights and shadows. With colour there is no such possibility and additional lighting may be needed, although the larger the interior being photographed the less effective this will become.

Not all colour films are suitable for the long exposures needed to take photographs by available light. Most daylight films are designed for short exposures and using them at several seconds will not produce satisfactory colour (see pages 82 and 96).

Using perspective for effect
This view of the Palace of Queluz near Lisbon, taken by available light from the windows, illustrates one way of compensating for a lack of specialized equipment in architectural photography. The straight, symmetrical composition exaggerates the size of the room and emphasizes the strong geometrical feel of the simple design.
Nikon F2 with 35 mm lens; ⅛ sec at f8; Kodachrome II. (JULIAN CALDER)

Photographing small rooms
A confined space (in this case the breakfast-room of the Sir John Soane's Museum, London) dictates the use of a very wide-angle lens, while the choice of a viewpoint half-way up the room removes the problem of converging verticals. The scene is lit entirely by available light, and the inclusion of the skylight in the picture conveys an impression of the lighting effect planned by the architect—Soane himself. The exposure was gauged to hold detail in both the shadows and the highlights.
Linhof Super Technika V 6 × 9 cm with 47 mm Super Angulon f8 lens; 1 minute at f22; Ektachrome Professional Type B; Kodak Wratten 85B filter; heavy tripod. (ANGELO HORNAK)

Capturing architectural style

To do justice to the San Carlino in Rome (*left*), where Borromini contrived to create an illusion of space on a very small site, effect is more important than mere technical record. The wide-angle lens reinforces the vertical perspective and conveys the essence of Baroque architecture.

There is hardly a right-angle in New York's Guggenheim Museum (*above*), so the photographer has none of the usual problems of converging verticals and can shoot from almost any appealing viewpoint. A wide-angle lens is essential to illustrate the spiral design of the museum. In both these cases, a 35 mm camera with a wide-angle lens and the same exposure would produce a similar result.

Linhof Super Technika V 6 × 9 cm with 47 mm Super Angulon f8 lens; 1 minute at f22 (left) and 20 seconds at f16 (above); Ektachrome Professional Type B; Kodak Wratten 85B filter; heavy tripod. (ANGELO HORNAK)

Buildings at night

When the subject is floodlit, night photography is often the best way of isolating an old building such as St Paul's Cathedral in London from its modern environment. The use of a view camera will result in correct vertical lines (*above*), and the tungsten film closely matches the colour quality of the floodlighting.

The more conventional approach (*right*) uses a longer view. While the architectural detail is lost, this angle puts the 17th-century cathedral in its broader setting by the Thames and hints at its gradual enclosure.

Above: Linhof Super Technika V 6 × 9 cm with 65 mm Super Angulon f8 lens; 1 minute at f16; Ektachrome Professional Type B; maximum rising front (25 mm of shift); heavy tripod. (ANGELO HORNAK)
Right: Nikon F2S with 50 mm lens; 1/30 sec at f2.8; High-Speed Ektachrome Daylight; tripod.

Architecture / Using setting

A building's setting is often almost as important as the building itself. This is particularly true of old structures, which were usually designed with their setting in mind. A Spanish castle, for example, would be far less interesting without a glimpse of the rugged landscape it was built to defend; cathedrals were usually built on elevated ground, visible from all directions.

Weather is one of the most important factors in architectural photography, and styles evolved partly to meet different climatic conditions. Classical architecture, designed for regions of bright sunshine, rarely looks good on dull, overcast days, but Perpendicular Gothic, conceived for the damp misty conditions of northern Europe, can be at its most dramatic in poor weather. But light and shade are essential to architectural photography; usually directional light gives best results.

With old buildings, a background of snow or storm clouds will often better evoke a medieval atmosphere than the bright light of a summer afternoon. Ultra-modern buildings, with their reflective glass and steel surfaces, can appear at their most attractive in sunlight, especially at sunrise and sunset, when they take on the colours of the sky. Rain, too, can enhance a picture with its reflective quality. It is also an aid in setting mood—for example, with rows of slate-roofed urban dwellings.

Creating mood with setting
A straightforward daytime view of this Danish house could easily be mundane, but by photographing it in silhouette and framing it with leafless trees it has been given a haunting, eerie quality. The effect of the storm-laden sky was further enhanced by considerable burning-in at the print stage.
Nikon F with 24mm lens; $\frac{1}{250}$ sec at f8; Kodak Tri-X.

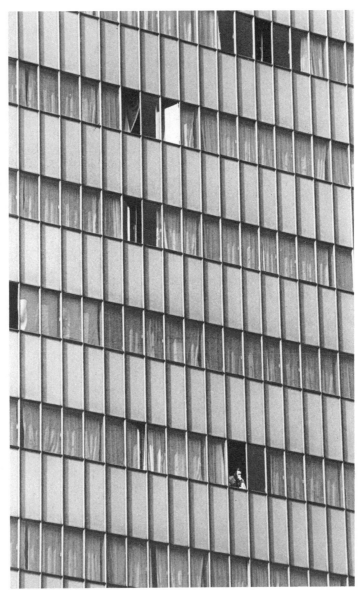

Utilizing pattern
Office and apartment
blocks afford an
opportunity for
isolating and exploring
pattern, but run the risk
of dullness. Interest has
been given to this
composition by the
inclusion of a single,
pensive figure at one
window. His presence
also helps to give an
impression of the size
of the structure and
its components.
*Nikon F with 200 mm
lens; $\frac{1}{250}$ sec at f8;
Kodak Tri-X.*

Figures for scale
The inclusion of human
figures is one of the
safest ways to establish
scale in a picture. The
buildings on the Mount
of Olives in Jerusalem
(*below*) would be of
uncertain dimensions to
the viewer without the
two monks in the
foreground. Care must
be taken, however, not
to overemphasize the
human element: as a
general rule, if it is
possible to read the
expression on the face
of someone in a picture,
then that person may
easily become the main
subject at the expense of
the scene or building.
*Nikon F with 200 mm
lens; $\frac{1}{250}$ sec at f5.6;
Ilford FP4.*

Isolating detail
Two views of Torrigiano's gilded bronze effigies of
Henry VII and Elizabeth of York in Westminster
Abbey illustrate the most rewarding ways of taking
pictures of sculpture. The piece can be
photographed either in its entirety, showing
something of its setting (*far left*), or as a telling detail
(*left*). With a detail, particular attention must be given
to depth of field; in this example a shallow depth
serves to bring the king's head and hands into sharp
relief. One advantage of concentrating on a small
element is that an area with adequate natural lighting
can be chosen; this is usually preferable to flash,
which, unless skilfully used, gives hard, flat results.
*Far left: Linhof Super Technika V with 65 mm Super
Angulon f8 lens; 1 minute at f16; Ilford FP4; heavy
tripod.* (ANGELO HORNAK)
*Left: Linhof Super Technika V with 100 mm Symmar
f5.6 lens; 15 seconds at f8; Ilford FP4; heavy tripod.*
(ANGELO HORNAK)

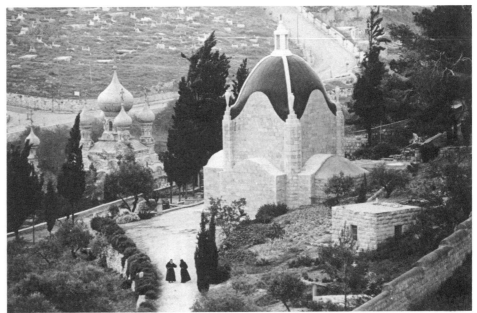

Still life / Simplicity in design

There are two types of still life pictures: "planned" still life, arrangements deliberately created by a photographer, and "discovered" still life, arrangements that the photographer merely comes across.

Planned still life—the positioning of shapes in a satisfying, self-contained manner —is one of the few areas of photography where all the elements of the picture can be completely under the control of the photographer, and it offers exciting opportunities for experiments in lighting, colour arrangement and composition. A wide variety of effects can be achieved in a limited space— without specialized or expensive equipment —and an exposure need not be made until the photographer is satisfied that the components are placed to the best effect. Even then, further attempts can be made under identical conditions if the results are not completely satisfactory. Finally, still life is one of the applications of photography where a knowledge and understanding of composition and lighting for form and texture can be exploited to the full by both amateur and professional.

Visual considerations

Many still life photographers depend not only on the variety of forms and textures in the objects themselves but also on the use of various props and backgrounds—a roll of coloured cartridge paper, a textured surface or a piece of furniture—to create mood and atmosphere. It is equally possible, of course, to produce arresting images with simple objects, backgrounds and lighting, and in this case the element of design must be the dominant influence, with the juxtaposition of the still life objects themselves the crucial factor.

Added impact can be given by a surprise element or a contrast between the objects and their background. It is largely a matter of the photographer's own imagination, for it is by no means necessary for there to be a "story" behind the picture. In fact, logic can sometimes be an undesirable quality, destroying the surprise element on which a picture may depend.

Screening the object

Softening the still life image can produce an artistic, ethereal quality particularly suitable for delicate objects. In this case it was achieved by using white muslin stretched over a wooden frame; this was placed as close as possible to the vase of flowers to retain definition and avoid a soft-focus effect. An undiffused light was directed from above the objects on the left, almost at a right angle, and a second source with a snoot created the pool of light behind the subject. This helped to accentuate the flowers and play down the vase. A small aperture was used to keep both screen and flowers in focus.

Pentax 6 × 7 cm with 150 mm lens: f16; Ektachrome X; two 750-joule flash units.

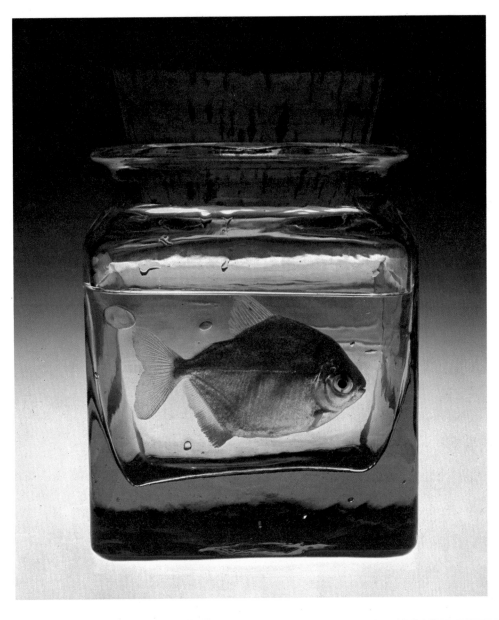

Combining animate and inanimate objects

To illuminate this live fish (*left*) with the maximum clarity, the bottle was placed on a large sheet of opalescent thermoplastic and lit from beneath. The glass transmitted just enough light to reach the cork and reveal its form and texture before fading into the background. The background itself is an important component of the picture, changing from light at the base to dark at the top in conjunction with the object. Partially filling the bottle with water helped to convey the image of a live rather than dead fish. The picture again illustrates how the careful choice of simple subjects, allied with good arrangement and subtle lighting, can result in strong still life design.
Sinar 10 × 8 in with 300 mm Symmar lens ; $\frac{1}{125}$ sec synchronized to electronic flash and f22 ; Ektachrome Professional EPB. (STEVE BICKNELL)

Lighting from below

Striking still life photographs can be obtained with the simplest of raw materials; this "outer space" effect was produced by breaking an egg on to a sheet of transparent thermoplastic available from any hardware store. The sheet, supported by two trestles, was bent slightly to prevent the egg-white running too far. The lighting was also simple—a 750-joule flash placed underneath the plastic sheet.
Pentax 6 × 7 cm with 80 mm lens and extension ring ; f11 ; Ektachrome X.
(SIMON DE COURCY WHEELER)

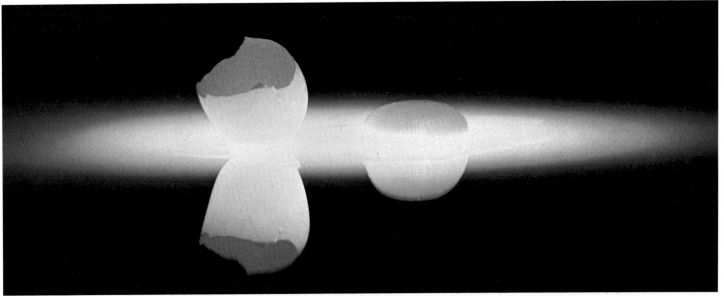

Still life / Composition and lighting

COMPOSITION FOR STILL LIFE

When arranging the objects in a still life it is invariably best to begin with the most dominant one—whether it is strongest because of its size, shape, colour or texture—placing it at first on the background. This must then be viewed through the camera. Further components can be added, arranged and rearranged until all are in the most advantageous relationship. The photographer should never hesitate to change his mind and experiment with different positions, both with the objects and the camera, and it must be remembered that the viewpoint—the height of the camera and its distance from the subject—can greatly influence the feeling of depth and the relative scale of objects in a picture.

During the arranging process it is also important to be constantly aware of the juxtaposition of tones and colours, detail and mass, highlights and shadows. The fine detail of flowers, for example, may be lost or at best confused if placed in front of an object with a strong pattern or texture of its own, such as a colourful print.

There is probably no better way of gaining an understanding of the art of composition than by selecting a group of simple objects of varying shapes and sizes and experimenting with them to produce a variety of arrangements, setting a target of, say, ten shots. "Good composition is only the strongest way of seeing the subject," Edward Weston once observed in an article in *The Complete Photographer*. "It cannot be taught because, like all creative effort, it is a matter of personal growth."

Arranging a few simple objects for the camera can be an effective way of learning about composition. This obvious permutation is logical but unimaginative.

By placing the objects at 45° and slightly overlapping them, a feeling of depth is introduced and the image is more unified. The dark face of the cube at the back helps to "hold" the picture.

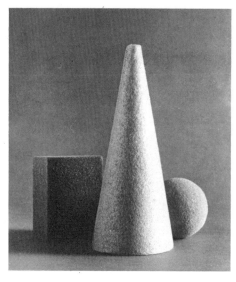

Here the depth is retained, but the dominance of the cone becomes more pronounced by placing it in the central foreground, partially masking the secondary objects behind it.

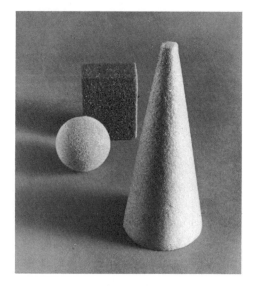

Although the cone remains in the foreground, a higher viewpoint puts more emphasis on the two smaller objects and creates a different feel and balance in the arrangement.

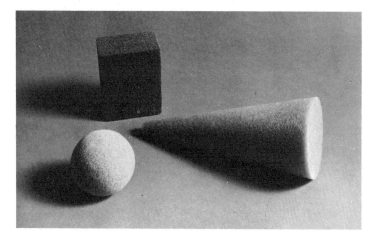

Another shape is given by retaining the higher viewpoint but using the cone in a new way—to lead the eye to the ball and cube. Here the three elements are fairly evenly balanced.

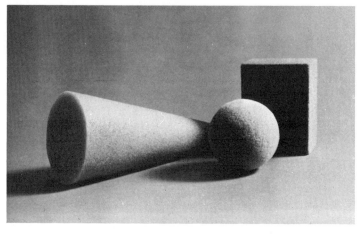

The viewpoint is dropped again but another overall shape emerges. The ball, now central, assumes a new prominence, helped by the cone leading the eye to it and the strong contrast with the cube.

LIGHTING FOR STILL LIFE

Lighting is a crucial factor in still life, and success can depend on understanding how and where to use it. During the arranging sequence the lighting can be approximate, but once the objects have been finally placed it should be adjusted to complete the creative process begun with the composition.

The way an arrangement is lit will be governed largely by the nature of the objects and the effect desired. An arrangement of finely detailed porcelain, for example, would need a soft frontal light to avoid unwanted reflections; on the other hand, a still life comprising objects with interesting textures and forms would need a more directional light to reveal these qualities.

The type of lighting used will also have a strong effect on the mood and feel of a particular still life image. A soft, frontal light, for example, giving few shadows and little modelling, will tend to create a cool, clinical feel; low, strongly directional lighting, on the other hand, provides large areas of shadow and can be used to enhance the mood and atmosphere of the shot where appropriate, such as with old books or furniture.

Shadows and strong highlights can themselves become important elements in a composition. But their position and effect must always be considered carefully, for an unwanted shadow or highlight can detract from the main point of interest. When extra highlights are required and additional lighting is either inconvenient or not available, a simple but effective solution is to position small hand mirrors either just outside the picture area or hidden behind objects larger than themselves. Mirrors can also be used to lighten shadow areas and can be held firm and upright quite easily by wedging them into small pieces of modelling clay.

The basic tools of lighting (see pages 58–9) are few: a spotlight (giving a hard, narrow beam of light), floodlight (providing a soft, general light), and light reflectors (to reflect diffused light on to the subject). While the arrangement of this equipment can produce a wide variety of effects, it does not follow that employing complicated lighting will result in a better picture. Because several lights from different angles can cause conflicting and confusing shadows which detract from the subject, the general rule should be to keep the lighting as simple and functional as the particular situation permits.

A hard frontal light indicates the shapes of the objects but almost obliterates form and texture. The uninformed might be forgiven for assuming that banana skins have no "edges" and that pears are flat.

Strongly directional light, softened by the use of a screen, reveals form and texture—the form being particularly evident on the banana. This approach, however, produces dense shadows.

By adding a reflector the dense shadow on the far side of the objects is relieved; the form of the pear is now more apparent. The picture still lacks highlights.

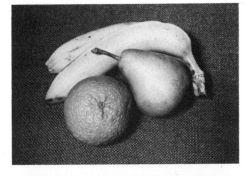

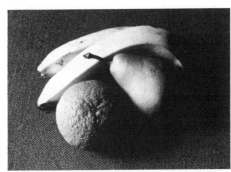

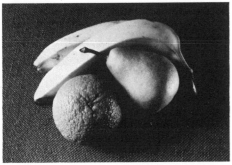

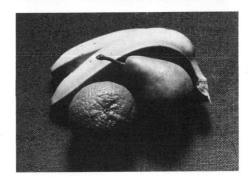

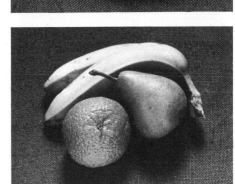

Replacing the reflector with a mirror produces a more directional backlight (like a miniature spotlight) and creates highlights. This extra sparkle rids the image of its rather flat feel.

When the objects are lit directly from behind with a screen, both form and texture are revealed but, as in the example above, dense shadows appear on the near side.

Again, adding a reflector gives a much more full and natural appearance to the image, filling in the areas hidden by shadow, this time in the foreground.

Still life / Special problems

Reflected light, diffused by a screen, illustrates the reflective quality and natural sheen of the glass by creating highlights.

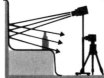

Transmitted light, directed over the top and bounced back off the curved backdrop, emphasizes the translucence of glass.

Combined lighting, the most common technique, uses both reflected and direct light; it shows form and provides depth.

LIGHTING FOR GLASS

The properties of glass enable it both to transmit and reflect light. In order to achieve effective photographic images of glass objects, the lighting must reveal one or both of these attributes.

There are essentially three ways of lighting glass—with reflected light, with transmitted light and with a combination of the two. The translucent nature of glass can best be caught by the use of a light-toned background at which the source of light is directed and reflected back through the glass. When lit only from the front or the side with a soft or diffused source, glass will reveal its sheen and reflective quality.

Either of these methods on its own can produce interesting and effective images. Transmitted light can result in strong graphic shapes with edges and corners boldly defined in dark tones, while reflected light alone can be used for quite delicate images with soft highlights revealing the natural lustre of the glass. The two methods are, of course, often combined.

Good examples of lighting glass can be seen in shots for beer and spirits advertising and it is worthwhile studying the effects achieved by the lighting in this type of professional photography.

Introducing colour
One of the obvious problems with glass and ice is that both lack natural colour. Here a glass was set in ice and, after the ice had been chipped away, filled with whisky. A white curved background was used, but matt black screens placed at the sides helped to accentuate facets and give the ice form.
De Vere 8½ × 6½ in with 210mm Symmar f5.6 lens; f64.
(ROGER PHILLIPS)

Enhancing jewellery
Diamonds, such as these photographed for Cartier, the international jewellers, are not only highly reflective but also generally cut to a number of surfaces. Sparkle is therefore the paramount effect required, and contrast will always enhance this quality; black velvet, for example, makes an ideal background. Here the effect is accentuated by dark skin and a dark choker, and is given additional impact with the diffused sidelighting; this was provided by a single lamp only 1m/3ft from the model, and using a thermoplastic sheet as the diffuser. *Sinar 10 × 8 in with 300 mm Symmar lens; $\frac{1}{125}$ sec synchronized to electronic flash and f22; Ektachrome Professional Type B.* (STEVE BICKNELL)

LIGHTING REFLECTIVE SURFACES

Highly reflective surfaces, such as silver, brass or chrome, pose special problems for the photographer. Silver is a prime example, for its quality is largely dependent on its ability to reflect light. Revealing this quality in a photograph is almost wholly a matter of lighting techniques.

The shiny surfaces of highly polished metal objects accentuate highlights and pick up confusing reflections. The most effective way of preventing this is to use a "tent"—an arrangement of seamless, translucent white paper or white cloth that totally surrounds the subject. A small aperture must then be cut out and the camera lens pointed through it to take a shot.

The tent serves two important purposes: it acts as a "bounce" surface to give soft lighting that will avoid excessive highlights,

and it prevents the metal object from catching reflections of objects in the vicinity. With rounded objects reflections and glare spots may persist, even with the most careful lighting. They can always be toned down, if not eliminated, by dabs from a ball of putty or with photographic dulling spray.

Light is directed on to the tent to create a soft and even illumination over the subject area, eliminating any specular highlights. Small pieces of grey or black card can be positioned within the tent to reflect darker tones into the object and accentuate detail and form, if and where required.

When the object consists largely of flat surfaces it is often possible to dispense with the tent and simply position reflectors at angles to the surfaces and bounce the light off these. A spotlight can be used to add controlled highlights that will give the subject extra sparkle.

A photography tent will eliminate reflections on silver or glassware. Tents can be bought from photographic suppliers, but a handyman might prefer to make his own. A short length of black, non-reflective wire is formed into a circle for the top and another, larger circle for the bottom. These are then joined by three supporting strands and the resulting frame covered with white muslin or tracing paper.

Nature / Zoos and birds

Using surroundings
In captivity, the limits of an animal's territory are defined by the safety barrier. Since only its keeper enters this space, and the animal has no need to defend it, zoo creatures are more relaxed than if the photographer were at the same distance from them in the wild. Placid animals, however, make dull studies unless the photographer is prepared to wait for an interesting moment or uses their surroundings. Here the giraffes, their attention momentarily drawn in the same direction, make an interesting and witty composition. *Nikon F2S with 200mm lens; $\frac{1}{250}$ sec at f8; Ilford HP5.*

ANIMALS IN ZOOS

Many of the problems of photographing animals in captivity are closer to those found with domestic pets than those encountered with their own species in the wild. They are easy to locate, they cannot stalk or endanger the photographer, and they are usually good healthy specimens of their kind.

As with domestic pets, most caged animals are restless as feeding time approaches but placid after eating. More exciting pictures will result if the animal's routine is watched to learn what to expect at different times of the day, and it is always advisable to consult keepers before photographing zoo animals; not only will they give helpful advice, but they will also know what is allowed. A flash, for example, should never be used without permission; if one were fired in a reptile house, snakes might strike instinctively and could damage themselves against the glass of their enclosures.

Quite simple cameras will take adequate photographs of animals in zoos, but a single-lens reflex has the great advantage of versatility. Not only do animals differ in size: their behaviour, surroundings, speed of movement and their distance from the camera are equally diverse. A range of good lenses is desirable for zoo work, an ideal combination being a normal, a wide-angle and, perhaps most important, a reasonably long lens.

The decisive moment
The key to all animal photography is patience and willingness to expose a good deal of film, since the photographer has no control over the animals. Feeding time often offers the best chance of a good shot because most animals, like this sea-lion, are particularly lively then. *Nikon F2S with 200mm lens; $\frac{1}{500}$ sec at f11; Ilford HP5.*

Anticipating movement
Elephants are slow, easy-to-photograph animals, but unless a particular feature or characteristic is emphasized (such as the texture of their hides), the results are likely to be very ordinary, merely giving an impression of grey and motionless bulk. Better pictures will be obtained by waiting until the elephant makes some movement or trumpets. *Nikon F2S with 200mm lens; $\frac{1}{500}$ sec at f11; Ilford HP5.*

PHOTOGRAPHING BIRDS

Of all nature's creatures birds are perhaps the most rewarding, though perhaps the most frustrating, to photograph. The variation in birdlife is enormous. Some are brilliantly coloured, others drab; some hunt by day, others by night, yet all birds have one common characteristic: they are creatures of habit. They will constantly alight near their nests at the same spot and, excepting marauding birds, will usually feed from the same patch. This gives a photographer the opportunity to predict a bird's movements and take pictures at exactly the right moment. Nevertheless, a sound knowledge of a species is needed for anything more than a garden or local woodland environment.

Birds are easiest to photograph when they are busy at their nests, but even then silence and stillness are essential. This is true of all animal photography, but must be particularly stressed with birds; once alarmed, they may never return to their nesting sites.

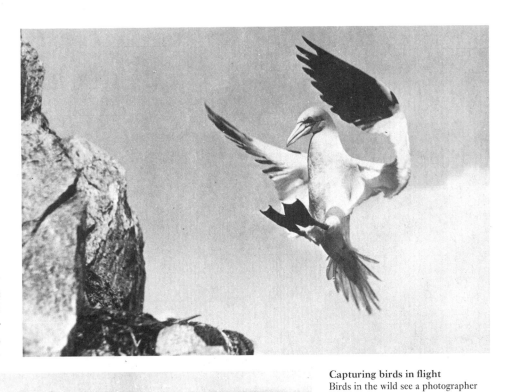

A "hide" conceals the photographer and allows him to see through a peep hole. This cliffside version was erected to take pictures of golden eagles in Western Scotland, and was assembled over six separate sessions of 40 minutes so that the birds would not be disturbed or alarmed.

Capturing birds in flight
Birds in the wild see a photographer long before he is in "shooting" range. Some birds, however, such as this gannet coming in to land on its nest, are unperturbed and a hide can be dispensed with. A fast shutter speed is essential to capture most birds in flight. *Contessa-Nettel 9×12 cm; $\frac{1}{1000}$ sec at f8.* (NIALL RANKIN)

Photographing from a hide
Birds are nervous and alert when feeding their young, and with owls a hide is virtually essential. This photograph of a female snowy owl alighting by her offspring was one of the first ever taken in Britain of a breeding pair. *Contarex with 250 mm lens; $\frac{1}{500}$ sec at f5.6; Kodak Tri-X.* (ERIC HOSKING)

Eliminating fences and bars
Cage bars or wire fences at zoos can be eliminated either by poking the lens between them or by going close and using a wide aperture. This is often difficult or impossible, and a long lens can be the answer. With a normal lens near the wire (*left*) the toucan is masked by the fence; by moving in and using a long lens with the widest possible aperture (*right*) the wire goes out of focus to produce a more "natural" picture. This technique is increasingly effective the further the subject is from the wire. *Left: Nikon F2S with 50 mm lens; $\frac{1}{250}$ sec at f11; Ilford HP5. Right: Nikon F2S with 105 mm lens; $\frac{1}{1000}$ sec at f5.6; Ilford HP5.*

Nature / Pets and wildlife

Excellent photographs of animals are rare. Most animals are highly unpredictable and cannot readily be controlled. It is no more possible to direct the right pose by verbal command than it is with children. The photographer must usually do something to attract the animal's attention for a "portrait", but even then the expression or position will probably be held only for a brief moment.

There are, of course, ways of increasing the chances of a good picture. One method is to be fully aware of the animal's physical appearance, build, movements and habits. A long-nosed dog will always look at its most handsome in profile or three-quarter view; a horse jumping a fence will appear best when taking off or when half-way across a hurdle, but looks at its least elegant when landing and regaining its stride.

The animal's coat is also an important consideration. Dark fur, for example, absorbs light to a surprising degree, so that when photographing dark-coated animals it may be necessary to open up a stop or two more than usual. Background, too, is always important: unless camouflage is the essence of the picture, contrast is essential.

Finally, animal photographs can be ruined if sentimentality is allowed to intrude too far. Appealing shots of kittens in baskets of knitting wool with ribbons around their necks may help to sell boxes of chocolates, but they do little to reveal an animal's individual personality.

The controlled situation

Fish and other aquatic animals, such as the one female and two male frogs apparently enjoying their mating, present little difficulty when photographed under controlled conditions. They will make sudden, swift movements, but this hazard can be greatly reduced by penning them into a narrow space in the tank by inserting a sheet of glass. The glass at the sides of the tank should be polished to prevent optical distortion, and any water-weed and stones should be thoroughly cleaned so that the movement of the animals does not disturb the dirt.
Hasselblad with 120mm lens; f22; two Braun 700 flash-heads; Ektachrome X. (ERIC HOSKING)

Pictures of pets

Like all animals, domestic pets vary to a marked degree; a picture of a cat and another of a dog would result in uninteresting and untypical results if they were taken in precisely the same way. While cats will provide the photographer with good poses and actions, an exciting picture of a dog is largely a matter of its facial expression. Cats are small animals and only long-focus lenses or close-up lenses will give really satisfactory pictures. This shot of a lilac-point Siamese, which the photographer followed into the garden, illustrates the value of patience and of taking a pet in a "natural setting". Care was taken to ensure the subject was separated from the background.
Nikon F2S with 105mm lens; $\frac{1}{125}$ sec at f8; Kodachrome 25.

In some ways animals are easier to photograph in the wild than in captivity, since there are no distracting bars or buildings. The chief problem, of course, is to locate the animal, for most creatures keep themselves, and especially their young, out of sight and many species are endowed with keen noses that can detect a human long before he is within "shooting" range. Smaller animals, such as mice, remain hidden most of the time, while others are nocturnal and almost impossible to pho graph naturally.

Some animals are aggressive and cannot be approached; others, and these include nearly all reptiles, are difficult to identify since their colouring is usually very similar to their natural surroundings. Once located, however, the free animal offers the photographer many more exciting opportunities than the captive one.

Using the long lens
The dangers of photographing the big-cat family can be overcome with a long-focus lens or by waiting until the animal has eaten and is in a lazy, contented mood. Taken from the roof of a *Land-Rover* in the middle of the day, this picture of a leopard required heavy filtering to retain the rich colour; this can easily be bleached out in the sort of light conditions found in the savannah. *Nikon F2 with 300 mm lens; $\frac{1}{250}$ sec at f5.6; Kodachrome 64; 81B and ultraviolet filters.* (JULIAN CALDER)

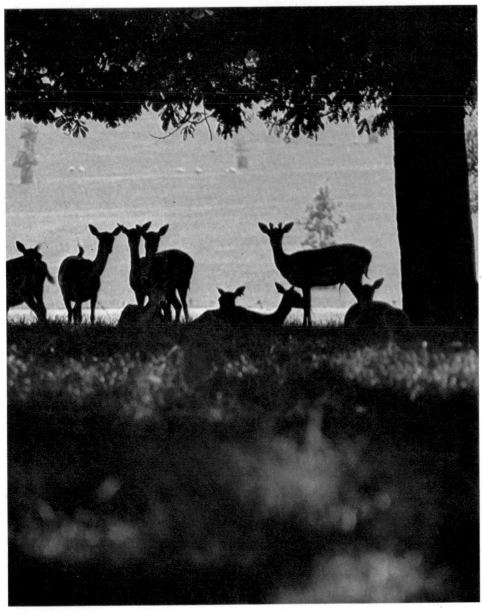

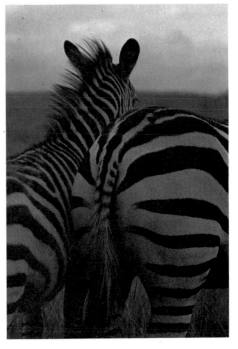

Capturing the distinctive feature
The less "wild" animals in large wildlife parks have become reasonably accustomed to man and are neither aggressive nor frightened except at very close range. It is often possible to walk around them to find a viewpoint that will make the best composition or dramatize their most characteristic feature—in this case the zebra's striped markings. Here the effect has been muted by shooting almost at dusk.
Pentax SPII with 55 mm lens; $\frac{1}{125}$ sec at f8; Kodachrome X. (LYN CAWLEY)

Distance for effect
Deer are among the most graceful of animals but, because they are so timorous and can pick up human scent at long range, they are often difficult to photograph. Here the eye is drawn to them by framing the animals with trees and silhouetting them against the "hot" background.
Nikon F2 with 80–200 mm zoom lens; $\frac{1}{250}$ sec at f5.6; Ektachrome X. (JULIAN CALDER)

Nature / Parks and gardens

Parks and gardens of all sizes provide a rich source for photographers. The key consideration is viewpoint. Landscaped gardens were designed to be seen from certain angles and it is first necessary to locate these. A vista will in any case afford a more attractive composition than an attempt at conveying the size of a large garden, since size alone almost always results in extensive areas of uninteresting foreground.

In a small domestic garden, too, certain views will be more suitable than others. The main features—clumps of flowers, rockeries, lily ponds and so on—are usually on a modest scale that is easier for the normal-angle lens to handle. If there is no natural centre of interest, one can always be created by including a wheelbarrow or mower. Some gardens are best seen from the house, shooting through an open window or door. Another effective angle, especially to capture the whole of a small garden, is to photograph from an upstairs window. In general, however, the feel and character of a garden will come across better if one particular aspect is selected.

Because of their size, trees will nearly always be a centre of interest. They offer unlimited variation and scope, not only as part of a garden, park or landscape but as studies in themselves, varying from fine examples of perfect symmetry to unnatural and perhaps grotesque configurations.

In landscape composition trees can serve a number of purposes; the foreground use of branches can mask an uninteresting, cloudless sky, or frame a picture or help to give an impression of depth or space.

Flowers are probably the most attractive manifestation of nature and abound in a multitude of forms in almost all parts of the world. Apart from their obvious colourful contribution to a garden composition, there are essentially three ways of photographing them. A close-up will reveal the heart and detail of a flower. Second, selective focusing can help to isolate a bloom against a blurred background and capture the "character" of the flower; here it is usually better to photograph the flower against a plain, contrasting colour, such as grass or rich earth, rather than against other, and perhaps conflicting, flowers. Third, flowers can be photographed in bunches or *en masse*, where detail will be of less importance than the strong impression of colour.

The best time to photograph flowers is early morning, when the light from a soft, hazy sun gives sufficient contrast to show form and detail but does not "burn out" the softer colours. Flowers are also at their most fresh at that time: the dew has evaporated but they have yet to feel the full effect of strong sunlight.

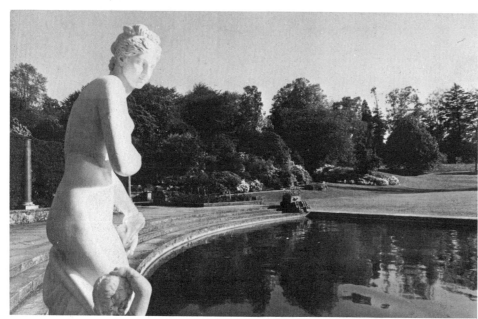

Capturing the elements of a garden
The essence of great landscaped gardens, as in this formal Italian example, is "contrived" nature, usually enhanced by expanses of still water. By using a wide-angle lens and by including a statue in the foreground to serve both as a mask and as a foil to the scene, the picture has been given a feeling of depth and scale in keeping with the artist's intention.
Nikon F2S with 24mm lens; 1/250 sec at f8; Ilford FP4.

Using depth and light
The presence of the Golden Steps, part of Anne Boleyn's walk in the grounds of Hever Castle, Kent, betrays the fact that this essentially woodland scene is in reality part of a planned garden setting; the view looks natural but is clearly landscaped. Trees dominate and are given added prominence by being backlit, casting irregular shadows and highlights.
Nikon F2S with 24mm lens; 1/125 sec at f4; Ilford FP4.

Nature / Close-up photography

In most aspects of photography it is man, his works and possessions, that are the dominant theme. The one area where man is of little importance, or absent altogether, is nature. This field is so wide that no one photographer could ever explore and master all the necessary techniques and, if a high standard is to be achieved, it is wise to isolate areas of particular interest and concentrate on those. One possibility, fascinating but often overlooked by the amateur, is to go for close-ups.

Insects, for example, make extremely exciting subjects since they not only vary greatly in shape but many possess brilliantly coloured markings. Their diminutive size, however, presents the photographer with particular problems. One difficulty is that many of them move at great speed—the cicada-killer wasp, for example, propels itself by beating its wings an astonishing 682 times a second. In the open, insects seldom remain long in one place; and to make matters worse, there is often enough wind to create movement. The subject will not "pose" for long, nor is it likely to do so against a suitable background. The assistance of a naturalist is always helpful, particularly in locating the creatures, since many are camouflaged by their surroundings. For the same reason it is sometimes best to have a very small depth of field to isolate the insect from its background, while a long lens may reduce the risk of disturbing it. Unless the photographer enjoys "stalking" them, however, it is usually easier to obtain good results by first capturing the subject and then bringing it indoors to photograph under controlled conditions.

Flowers, leaves and buds, on the other hand, are generally most easily and effectively photographed in their normal habitat. One problem is movement, but this can often be overcome by supporting the flower on a hidden wire or by shielding it with a three-cornered box.

A cable release is virtually essential equipment for almost all types of close-up in nature work: not only does it prevent camera shake, but insects and small creatures will not be alarmed by the immediate proximity of the human hand.

Eliminating distracting background
A close-up of lilac buds trapped in ice (*above*), taken on a heavy, overcast day using existing light, has been given added clarity of outline and detail by being shot against a large sheet of black felt, placed about 0.7 m/2 ft behind it. The attachments produced a magnification ratio of 1:3.
Nikon F2 with Novoflex 105 mm f4 auto-bellows lens and Nikon PB4 bellows; 1 second at f22; 81A filter; Kodachrome 25; heavy tripod. (ROBERT CARR)

Using a detail
By going right into the heart of the flower, a Harry Wheatcroft Peace Rose (*above right*) gains an almost abstract, artificial form and delicacy of texture, developing hues reminiscent of subtle hand-colouring.
Nikkormat EL with 50 mm lens and extension tube; $\frac{1}{250}$ sec at f5.6; Fujichrome R100.
(RICHARD HAUGHTON)

Exploiting weather conditions
A simple leaf (*right*), one of the most common sights in nature, is given a different feel when backlit and shot early on a winter morning, with its pattern of veins framed by an edge of glittering frost.
Nikon F2S with 105 mm lens and extension tube; $\frac{1}{60}$ sec at f5.6; Kodak Photomicrography Film 2483.

Emphasizing nature's colours
These common seven-spot ladybirds were
photographed at their actual size while hibernating in
a London garden. The macro lens and tubes also
helped to lessen the chance of disturbing them in their
winter home. The three contrasting colours—black
spots, red wings and green leaves—form a compelling
colour composition.
*Pentax S2 with 100mm lens and three extension tubes;
flash and f16; Kodachrome 25.* (ROBIN FLETCHER)

Sport / Timing the action

Because of its ability to freeze movement and capture brief moments of time, the camera is ideally suited to the specialized field of sports and action photography, compelling us to look afresh at a scene or incident that we know to be fact, often making us see it in a new way. Many of the photographs reproduced in the sports pages of newspapers and magazines illustrate the point perfectly, the camera having been used as a tool to isolate the decisive moment of a unique incident.

The camera can also be used as a visual instrument to study human and mechanical movements and, taken to its extreme development, record the precise finishing order at race-tracks and important sporting events.

Sports journalism, whether amateur or professional, relies essentially on four basic requirements: knowledge of the sport, fast reflexes and anticipation, reliable equipment that can be operated instinctively, and a little luck to be in the right place at the right time.

Camera and lens

Most cameras with a shutter capable of at least $\frac{1}{500}$ sec (preferably $\frac{1}{1000}$ sec) can be used for sport, but the most practical and widely used camera system is the 35mm SLR; its portability, ease of use and comprehensive range of lenses make it the most versatile for the various demands and range of sports that the photographer may meet. When used with a motor drive attachment—a device that automatically fires the shutter and advances the film to the next frame, allowing the photographer to keep his eye fixed on his subject in the viewfinder—the SLR becomes an unbeatable system.

The long-focus lens has obvious advantages, although it is generally safer to work with a normal lens close to the subject if possible. Whatever lens is used, it must have an aperture of $f4.5$ or larger so that fast shutter speeds can be used, even in poor light. Filters are rarely used because they demand an increase in exposure—either a slower speed or wider aperture—and both are undesirable for action.

Film and speed

Sports and action photography rely heavily on fast shutter speeds and generally "slow" telephoto lenses, and these factors, coupled with the low levels of light often encountered, make the use of fast film standard practice. Although the normal range is the 400 ASA monochrome emulsions and 200–500 ASA colour reversal films, in many cases these basic ratings are "pushed" (up-rated beyond their stated speed) sometimes as much as $2\frac{1}{2}$ stops, giving an increased exposure index of 2000 ASA for black and white and 1000 ASA for colour. While quality suffers in the increased grain, results are acceptable.

The decisive moment
Tom Watson's caddie shares his master's elation as he sinks the putt which gave him the lead in the 1975 British Open Championship at Carnoustie. Taking the actual stroke would have had little impact; often in sport it is the triumph of success and the despair of failure which most accurately convey the mood and atmosphere of an event—whether an international tournament or a local club handicap.
Nikon F2 with 80–200 zoom lens at 200mm; $\frac{1}{1000}$ sec at f5.6; Kodak Tri-X. (STEWART FRASER)

Anticipating the picture
Knowledge of the subject is always an asset in photography, and this is particularly true of sport, where quick reflexes are essential. The photographer, aware of Jimmy Connors' dramatic two-fisted backhand, was able to pre-focus and wait for the sort of positioning which would really make the young American stretch to provide the perfect balance and composition.
Olympus OM1 with Novoflex 400mm lens; $\frac{1}{500}$ sec at f5.6; Kodak Tri-X. (LEO MASON)

The aware photographer
It is not always the battle for the lead and the winners that provide he best pictures. Though this field of cyclists had passed, the photographer remained aware and alert, prepared for the unexpected. In this case his quick reflexes earned an unusually humorous shot as a back marker apparently decided that the sports page of the local newspaper was more interesting than the race. *Nikon F2 with 80–200 zoom lens at 150mm; $\frac{1}{500}$ sec at f8; Kodak Tri-X. (LEO MASON)*

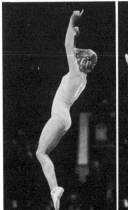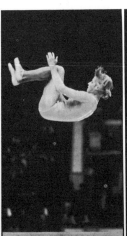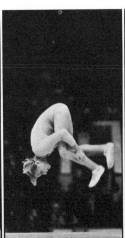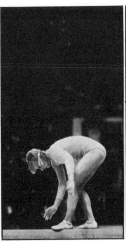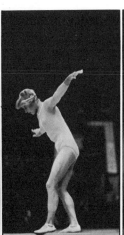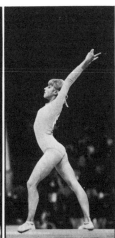

Motor drive
Probably the most valuable asset in sports photography after the telephoto lens is the motor drive. Not only does it increase the possibility of capturing the decisive moment, but it can also provide action sequences valid in their own right, particularly in areas where the action is condensed—athletics,

diving, gymnastics. Here Olympic champion Olga Korbut demonstrates her once-unique back somersault; although the sequence gives the impression of lateral movement, she in fact remains in the same place (*left*). Most motor drives can be set to take up to four or five shots a second (see also page 206), though faster ones are available.

Because film can soon be used up at such rates the serious enthusiast may wish to buy a special magazine, the biggest of which give 750 exposures. No change in exposure is required with motor drive.
Nikon F2 with Nikon Motor Drive and 85mm lens; $\frac{1}{500}$ sec at f2.8; Kodak Tri-X, rated at 800 ASA. (TONY DUFFY)

Sport / Capturing movement

PANNING THE CAMERA

Moving the camera with the subject is usually essential if the subject is going faster than about 40 kph/30 mph. In these three pictures the cars were all travelling at approximately the same speed (about 195 kph/120 mph) and at the same angle to the camera (about 60°). For the top photograph a fast shutter speed ($\frac{1}{1000}$ sec) and panning were necessary to "freeze" the car. This produces a rather artificial, if accurate, shot—the car could almost be stationary. The centre picture goes to the other extreme, panning with a slow speed ($\frac{1}{30}$ sec) to create blur. The last shot is a compromise: panning with a medium shutter speed produces sufficient definition to read the numbers on the cars but enough blur to give an impression of speed. To blur the static section of the image but retain sharpness in the moving element, the "pan" should be continued after the shutter is released. Note the changes made in aperture to provide a constant exposure. A basic guide to speeds for movement is set out on page 49. *Nikon F2S with 105 mm lens; $\frac{1}{1000}$ sec at f4 (top), $\frac{1}{30}$ sec at f22 (centre), $\frac{1}{125}$ sec at f11 (bottom); Ektachrome X.*

A moving person or subject can be recorded by the camera in two different ways. The first is by using either fast shutter speeds of $\frac{1}{250}$ sec upwards (see table on page 49) or electronic flash. These literally freeze the action, generally resulting in pin-sharp images; but these can seem artificial, lacking any real feeling of action. A second group of techniques involves the use of slow shutter speeds (anything from $\frac{1}{15}$ sec upwards), panning, zooming and calculated degrees of blur; all these, used to varying extents, will

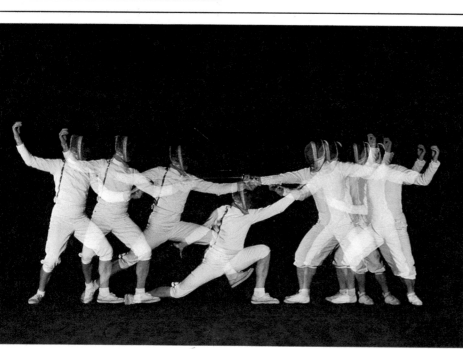

Multi-exposure

Commonly called "strobe", the multiple exposure technique that makes use of a bank of synchronized flash units is particularly suited to sport. The restrictions of the automatic set-up, which employs pre-set intervals and is difficult to align exactly with movements, can be overcome by making a manual type. Comprising any number of equal flash units, it is simply a flat panel about 25 × 20 cm/10 × 8 in with a separate plug for each firing lead mounted on it. A wire from each socket goes to a brass-headed nut and bolt sunk in an arc on the panel, one bolt for each socket. The other wire from each socket goes to a common earth ending at a brass-headed screw on the arm; as the arm is moved manually across the face

of the panel it touches each of the bolt-heads in sequence. This manual apparatus requires a camera with a shutter that can be held open, a number of flash units and a non-reflective black background. While it is essentially a studio technique, it can also be utilized on a theatre stage (as with this picture) or with a moonless night sky on the top of a treeless hill. The procedure is straightforward: rig the lights, plug in the leads, open the shutter, fire the flash sequences with the action and then close the shutter. It is advisable to take a black and white shot first with an instant print camera to establish the light coverage. The fencing picture above was taken on 5 × 4 in at f8 on *Ektachrome* with four 1,000-joule units. (RON STARTUP)

help to convey the impression of speed.

Fast shutter speeds, the primary consideration for the sports photographer, are governed by the prevailing light, the choice of lens and the selective use of depth of field. Most professionals "pre-focus" or "follow-focus", allowing them to work at maximum aperture using the highest shutter speeds and to isolate their subject.

Some degree of panning is required, however, when the subject is moving quickly. Panning is best executed by 'picking up' the subject early on as it moves across the angle of view and then releasing the shutter in one flowing action—but remembering to continue the pan after the release.

"Strobe" photography is an advanced studio technique where a bank of electronic flash guns are synchronized into a control box that regulates the duration and frequency of the amount of light falling on the subject. It has obvious advantages in capturing the body's movements, but usually needs the controlled facilities of a studio.

The zoom technique

In still photography the zoom lens has two main applications. First, it can take the place of several lenses, and while the quality is marginally inferior to those of fixed focal length, it can be a great asset in saving both time and trouble at fast-changing events. The other use is for the "explosion" shot. This can be employed to introduce drama into a static situation, such as a rugby scrum, or to accentuate the impression of speed in a moving subject. The easiest method is to mount the lens on a tripod and zoom in or out using a relatively slow shutter speed.

Nikon F2 with 80–200mm zoom lens; $\frac{1}{125}$ sec at f8; Kodachrome 64; tripod. (LEO MASON)

Sport / Choosing the viewpoint

The successful sports or action photograph is often dependent on good camera positions, and the amateur photographer who is not afforded any special facilities at major sporting events may find it difficult from his limited spectator's position to produce anything more exciting than a reasonable record of the event. Though some big sports give the amateur fairly easy access to good camera positions—motor racing is a good example, where a telephoto lens from a well-known spot can produce "professional" results—it is usually difficult trying to operate from the spectator's conventional viewpoint.

The keen sports photographer may well consider the advantages of the local venues, where restrictions are far less and he is usually free to wander where he likes. The atmosphere may not be quite the same and the "stars" may be missing, but it is likely that the opportunities for dramatic pictures will still present themselves.

This possibility will be heightened if the photographer concentrates on close-ups and special techniques rather than on all-embracing pictures. Close-ups will capture the essence of the sport while eliminating what might be an "amateur" or distracting background; a slight blur or a zoom technique for an explosion shot can work as well at the local tennis club as it does at Wimbledon.

The frontal viewpoint

Horses are ungainly when they land and, whether taken from the front, the side or from a three-quarter angle, are usually most attractive taking off. This picture, the kind any spectator could take with a good telephoto lens, was given added impact by the way the rider peers between the ears of his horse. *Nikon F2 with 400mm lens; $\frac{1}{500}$ sec at f8; Kodak Tri-X.* (STEWART FRASER)

The lateral viewpoint

Ludmilla Tourischeva, the 1972 Olympic overall champion, is caught during mid-performance at an exhibition in London in 1975. The shot not only captures the grace and beauty of a magnificent gymnast; it also conveys the staggering restriction of the beam on which she works (10cm/4in). Although the hands look posed, they are continually on the move during the routine, and the photographer was totally aware of the exact moment he was going to take this particular picture. The film was pushed to its limits to overcome the poor lighting conditions encountered in the hall. *Nikon F2 with 400mm lens; $\frac{1}{250}$ sec at f4.5; Kodak Tri-X, rated at 3500ASA.* (STEWART FRASER)

Looking for the unusual viewpoint

The spectacular shot of a ski-jumper was taken from a position any determined photographer could have adopted—underneath the take-off point on the side of a mountain at Innsbruck. With the less prestigious events in the sporting calendar (this was Three Hills competition at the beginning of the season), it is possible for the amateur to obtain professional results using standard equipment. *Nikon F2 with 50mm lens; $\frac{1}{1000}$ sec at f8; Kodak Tri-X.* (STEWART FRASER)

Viewpoint for atmosphere
The essence of many sports is the struggle between two individuals. Here a low viewpoint conveys the gladiatorial, hothouse nature of squash with Australia's Ken Hiscoe and Qamar Zaman of Pakistan during a world championship game. The expert was in a privileged position, shooting through a glass plate from a special dug-out beneath the "tin".
Olympus OM1 with 85 mm lens; $\frac{1}{500}$ sec at f2.8; Kodak Tri-X; rated at 1000 ASA. (LEO MASON)

Viewpoint and composition
With a little patience and observation, the amateur soon learns the positions to adopt at various sports for the appropriate results, whether for accuracy or impact. The most rewarding viewpoint at track sports—horse racing, athletics, motor sports—is often the bends, where the field turns and appears to bunch and compositions like this can emerge.
Nikon F2 with 500 mm mirror lens; $\frac{1}{500}$ sec at f8; Kodak Tri-X. (LEO MASON)

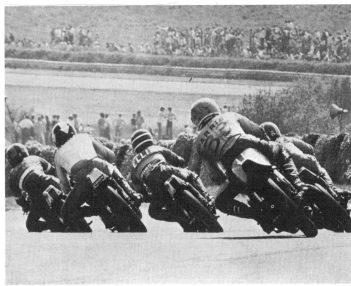

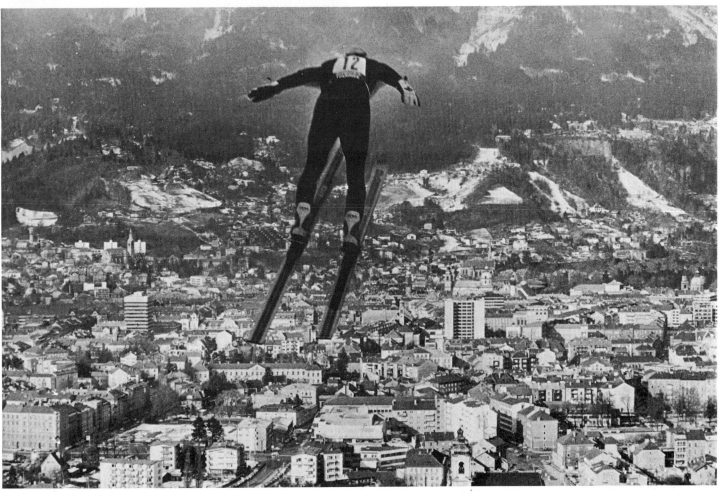

Special techniques/Underwater and close-up

UNDERWATER PHOTOGRAPHY

In more than one sense, underwater photography is a different world, requiring a real commitment. Apart from the obvious prerequisites of being fit and able to swim and dive well, the photographer must be prepared, if using a standard camera, to spend time and money in preparing it for a subaquatic environment. There are sophisticated (and expensive) cameras specially designed for underwater work, but most divers use a standard camera enclosed in some form of waterproof housing; these are serviceable to a depth of about 9 m/30 ft.

Although there are three types of housing —pressure-resistant, pressure-compensating and internally pressurized—the most common is pressure-resistant, a rigid box capable of withstanding the considerable pressures encountered underwater.

The number of controls necessary to operate an adapted camera should be as few as possible, not only because of expense but because they have to operate through watertight glands in the case and these are possible sources of leakage. A small camera with a coupled exposure meter and a mechanism that automatically advances film and cocks the shutter is better than a larger model requiring more manipulations to operate the same number of controls. A wide range of 35 mm single-lens reflex cameras meet the essential requirements and are those most generally used.

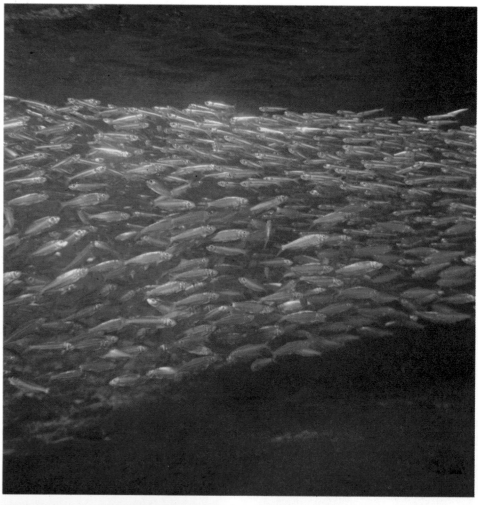

The underwater light

Fish will take fright if a diver makes vigorous movements, but most are inquisitive creatures and, as with this shoal of silverside and herring, will swim quite close if the photographer remains still. An important consideration in underwater photography is visibility: it is usually no more than about 35 m/120 ft, which is the equivalent of very foggy conditions on land. There are also variations in colour balance. At 1 m/3 ft below the surface almost half the red is filtered out; at 5 m/16 ft all the red has gone; at 10 m/33 ft all orange and at 20 m/66 ft all yellow and violet are lost; at 30 m/100 ft everything looks blue-grey. Flash will, of course, reveal a full range of colours under water.
Rolleimarine with 75 mm lens; $\frac{1}{125}$ sec at f 11; Ektachrome X; PFIB bulb. (ALLAN POWER)

Underwater close-up photography

The only sure approach to photographing small subjects underwater, such as this sunshine coral taken at a depth of 22 m/72 ft off Rottnest Island, Western Australia, is to shoot at very close range. Working at a distance with a long lens is rarely satisfactory because of the murkiness of most water and the problems of judging distance, refraction making objects appear closer than they really are. Since the lens of a camera behaves in a manner similar to the lens of the eye, it must be focused at the apparent and not at the real distance of the subject.
Rolleiflex SL 66 in thermoplastic housing with 80 mm lens; $\frac{1}{30}$ sec at f 22; Ektachrome X; blue bulb AG6B. (NEVILLE COLEMAN)

CLOSE-UP IN COLOUR

Any camera will serve for close-up photography provided it has a detachable lens so that the distance between camera body and lens can be extended (see pages 64–5). A very shallow depth of field is inevitable, but in almost all cases this will enhance the photograph since the human brain is attuned to seeing small objects sharply defined but with the edges beginning to blur. The same effect in close-up will thus reinforce the viewer's impression.

The scope for close-up photography is limitless, both with animate and inanimate subjects, but fascinating subjects can be easily manufactured. If, for example, a nail is partly driven into a piece of reasonably hard wood and a close-up shot taken of its point of entry, a pattern emerges in the wood virtually identical to that made by a ship ploughing through the water. Such innovations can be experimented with at home, particularly by adding colour.

Creating colour in close-up
Rewarding possibilities for close-up photography can often be found in unlikely places and situations. In this case it was a peel strength test on the gripping power of a commercial adhesive bond between aluminium plate and melamine laminate. A fixed weight was applied to the free end of the plate, which was pivoted on its fixed end by means of a knife-edge arrangement. The restraining adhesive was slowly revealed as the two surfaces were prized apart. The fascinating colours were introduced by using blue reflective foil on the spotlight in front, and an orange filter on the floodlight behind.
Rolleiflex SL 66 with Zeiss-Planar 80 mm lens; $\frac{1}{60}$ sec at f11; Ektachrome High-Speed 120; 80B and polarizing filters. (PAUL BRIERLEY)

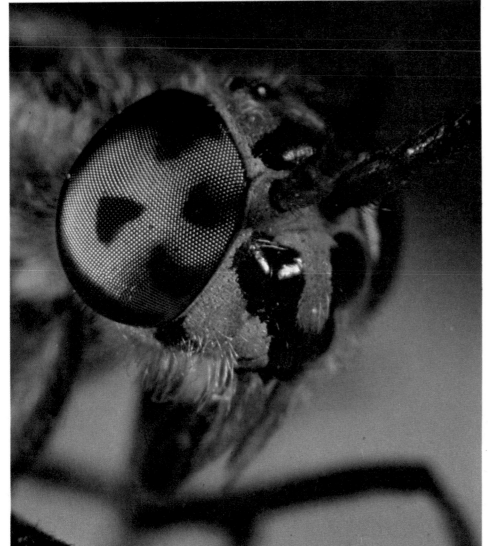

Discovering hidden colour
Modern, reasonable-priced equipment enables the amateur photographer to take close-ups of details far too small for the human eye to detect, and it is often helpful to have some knowledge of the subject to gauge the likely results. A deerfly appears a dull brown insect, but when a detail of the head is magnified six times life size the brilliant colouring of its eyes becomes evident.
Nikon F with 50 mm macro lens and PB4 bellows; f16 and single flash; Kodachrome II.
(ROBERT CARR)

Special techniques/Flash

The combination of flash and daylight can be used as a remedial technique, the flash "filling in" shadows where there is an imbalance in lighting contrast, or purely for effect. This is usually achieved by altering the natural balance of lighting between foreground and background. A very strong flash will light the foreground and render the background or sky much darker, giving the impression of night, or it can be used to create highlights in dull daylight.

Calculating exposure is simple, provided it is borne in mind that it is in effect the condensing into one of two measured exposures. A between-lens shutter is the most suitable for flash and daylight as the flash will synchronize over a much wider range of shutter speeds. First, the normal exposure is taken, say, $\frac{1}{30}$ sec at $f11$. Then the normal exposure for flash must be gauged, using the guide number method— this will be about one stop lower for daylight. We can suppose that the distance at which the flash is to be used dictates $f8$.

If the purpose is to fill in shadows, the combination of $\frac{1}{30}$ sec at $f11$ would be about right, for the daylight would mean that the flash exposure was one stop underexposed, adding "natural" light to the shadows.

Where flash is used to create an effect, however, the flash exposure should be normal and the daylight exposure underexposed. This could be achieved by first resetting the aperture to $f8$ to give the correct flash exposure. Normally this would require the shutter to be reset to $\frac{1}{60}$ sec to compensate, but since the daylight exposure is to be underexposed it will be necessary to use $\frac{1}{125}$ or even $\frac{1}{250}$ sec.

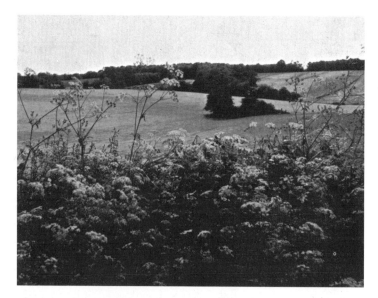

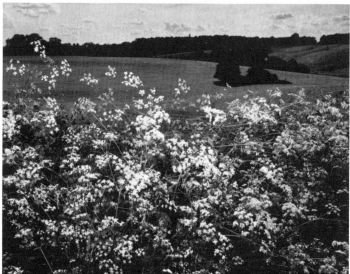

Flash with daylight
Without a flash (*left*) foreground objects lack definition; with flash (*below left*) they gain highlights, revealing their shape and tone, while the clouds stand out against the sky. *Nikon F2 with 24mm lens; $\frac{1}{125}$ sec at $f5.6$ (left), $\frac{1}{60}$ sec at $f16$ (below left); Ilford FP4; red filter.*

Infra-red film
The visible spectrum ranges from violet through blue and green to red, but beyond the deepest red is an invisible region known as infra-red (see page 39). If pictures are to be taken in infra-red (*below*), film which is sensitive to this region is necessary. No other specialized equipment is needed and pictures can be taken in both black and white and colour (see page 94). Infra-red photography allows the special film to "see" what the eye cannot, enabling the photographer to take pictures in the dark and through haze and to produce dramatic changes. *Nikon F2 with 28mm lens; $\frac{1}{60}$ sec at $f4$; Kodak High-Speed Infra-red film.* (SIMON DE COURCY WHEELER)

High-speed flash
Harold Edgerton, one of the most famous pioneers of high-speed photography, used a special strobe lamp operating from 16,000 volts and an exposure of less than a microsecond to "stop" this .22 bullet as it tore into a playing card, thrusting the splinters forward faster than itself. The film was overdeveloped to produce contrast.

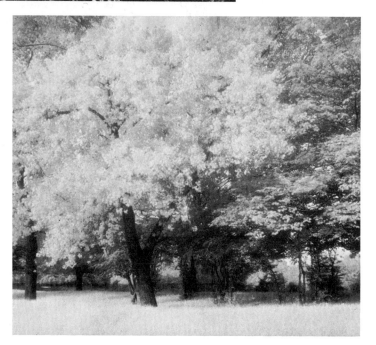

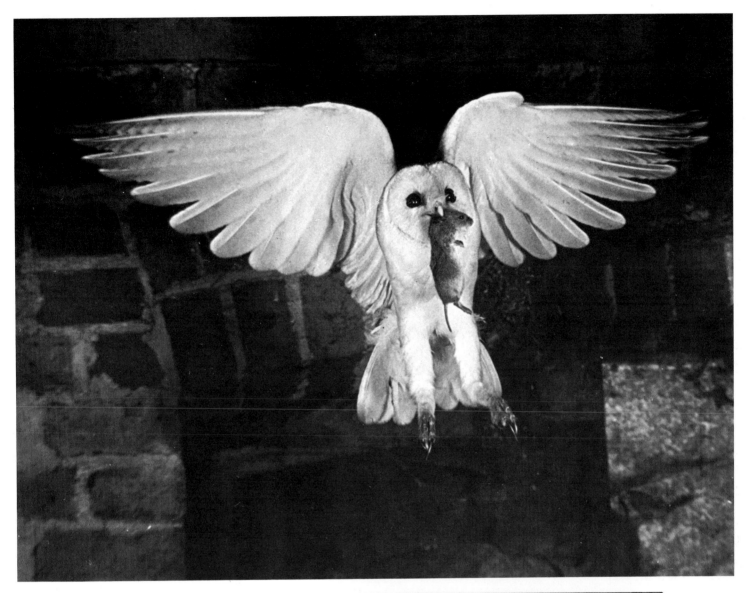

Photo-electric cell

One of the most important recent additions to wildlife photography has been the advent of high-speed flash, which enables photographs to be taken of rapidly moving animals at close range. Birds in flight move so fast that the human eye, brain and hands cannot co-ordinate and function quickly enough to photograph the subject as it passes. The solution is to use a photo-electric cell. This works on the same principle as automatic doors: a narrow beam of light is aimed from a lamp unit on to a photo-electric cell, and when the beam is broken the shutter is released and the flash fired.

The skilful part is the ability to locate the bird and its nest and set up the hide and other equipment in such a way that the bird will accept it. The diagram (*left*) shows a barn owl's nest that was found in a box, the owl entering and leaving the barn by a broken window. The hide was erected so that the owl had to fly over it to reach its nest, triggering the flash and exposing film to take the picture of the owl and captured vole (*above*). This was taken in 1946, before the invention of the motor drive, which automatically winds on film so that the photographer no longer has to return to the hide to set up each picture.

Sanderson 9 × 12 cm field camera with 210 mm Zeiss-Tessar f 6.3 lens; $\frac{1}{10,000}$ sec at f 16. (ERIC HOSKING)

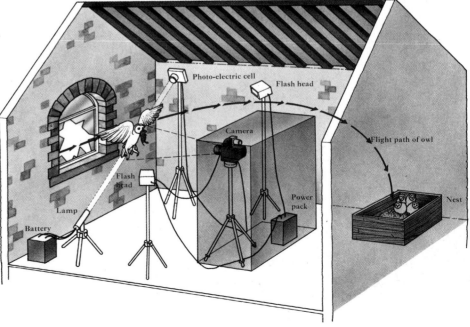

Special techniques / The wide angle

Apart from the wide-angle lens, which produces distortion when it is of a focal length shorter than about 20 mm, there are essentially two ways of obtaining photographic images greater in scope than that seen by the human eye—panoramic montage and extreme wide-angle cameras.

The first, which can be used for pictures of up to the full 360°, normally entails standing in exactly the same spot while moving the camera in an arc or circle to take the required number of shots. The problems here are obvious: the exposure and printing have to be consistent, the movements must be steady and well planned, and the juxtapositioning and alignment of the prints must be accurate. The same principle and prerequisites can be applied to the side of a street or a city square, but here the photographer physically moves his viewpoint to obtain the semi-panoramic effect, making sure that both the distance between shots and the distance between the camera and the buildings remain constant. This method can also be applied to very slow moving objects, such as a ship easing out of a harbour, except that here it is the subject that moves while the photographer remains stationary. The same criteria and basic rules apply as for the panorama of buildings.

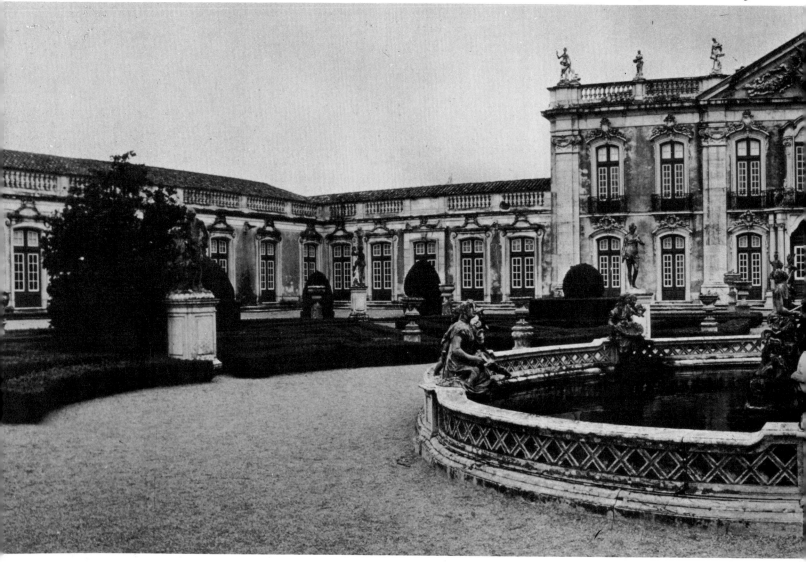

The panorama

A 270° vista of London illustrates how photographic prints can be aligned to form a panoramic picture—in this case ten separate 35mm prints. It is essential to allow a generous overlap on each shot—as much as 25% each side. Do not tilt the camera, and avoid the use of a wide-angle lens unless the verticals are absolutely straight. The exposure must be standardized on an average reading, and the printing should also be constant. It is best to align along natural vertical lines wherever possible. (JULIAN CALDER)

The wide-angle camera

The inevitable circular distortion resulting with very wide-angle lenses can be overcome only by panorama or the use of wide-angle cameras. These either have an external revolving lens and shutter or, as below, a special (and expensive) wide optical system. This picture of the Palace of Queluz near Lisbon shows their usefulness for architectural work, though they are also a great advantage in landscapes (see page 11) and large groups.

Widelux with fixed 28mm lens; $\frac{1}{15}$ sec at f5.6; Kodak Panatomic X. (JULIAN CALDER)

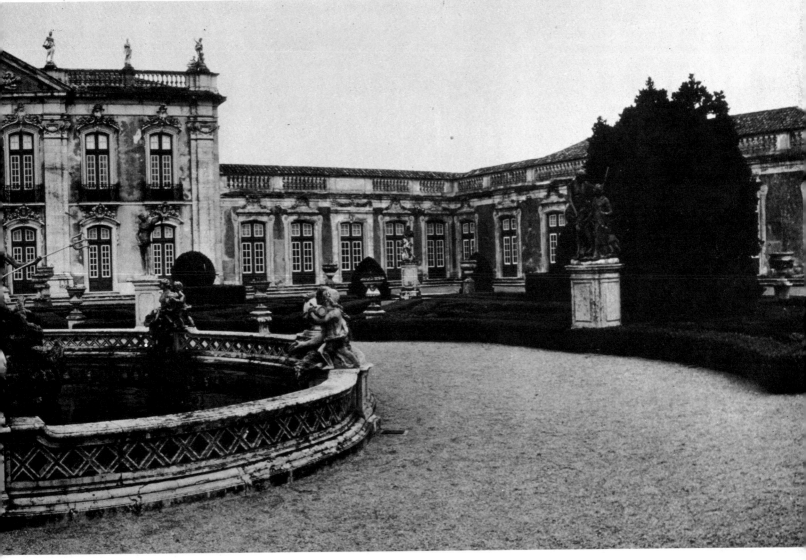

Photojournalism / The decisive moment

The term photojournalism, or reportage, is an umbrella title that covers a wide range of photographic subjects from the launching of a ship to a local dog show, from a burning building to a military parade. Essentially, photojournalism falls into two classifications: either the picture is a record of a single moment, whether anticipated or spontaneous, newsworthy or casual, or it is one of a series to make a story. Within these two categories lies a wide range of possibilities, from a newspaper assignment to a casual informal portrait.

Maximizing control

There is nevertheless one thing common to all pure photojournalism: it records facts without setting-up, manipulating or posing people or events. It is natural and informal. The photographer's only contribution, apart from his talent and expertise, is to choose exactly which moment to record.

The diminished control which the photographer has over his subject matter inevitably places even greater importance on the controls he does possess. Thus lighting and composition can sometimes be as important to a photojournalist as they are to a still life photographer. When it is possible to prepare for a photojournalistic shot by selecting a subject and viewpoint, the photographer must wait for what Henri Cartier-Bresson, one of its greatest exponents, called "the decisive moment". This is the point at which all the available factors that the photographer is powerless to manoeuvre coalesce to the best effect. It could simply be the turn of a head, the flicker of a smile or a hint of a tear which adds the magic ingredient; or it could be something much more dramatic—the exact moment a crashing plane bursts into flame.

Familiarity with equipment

It is essential for the aspiring photojournalist to be completely familiar with his camera, so that there is no unnecessary delay while changing exposure or focusing; indeed, it is always advisable to set the focus, aperture and shutter speed in advance whenever possible. Cartier-Bresson, who says that the camera should become an extension of the eye, claims that he can set exposures while the camera is in his raincoat pocket.

There are many situations where the presence of a photographer will adversely affect the situations he wishes to record, since people often stop behaving naturally if they know they may be photographed. Familiarity with the camera is a great asset on such occasions, and the less it is handled and displayed the better. A long-focus lens obviously helps in this respect, providing distance between camera and subject.

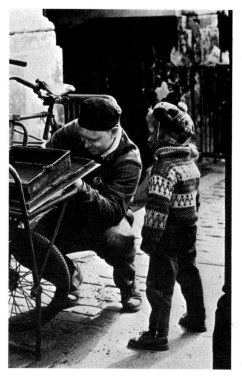
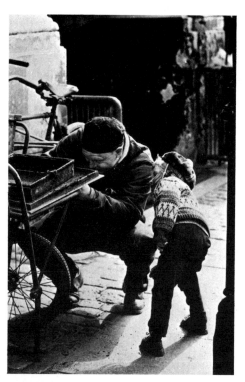
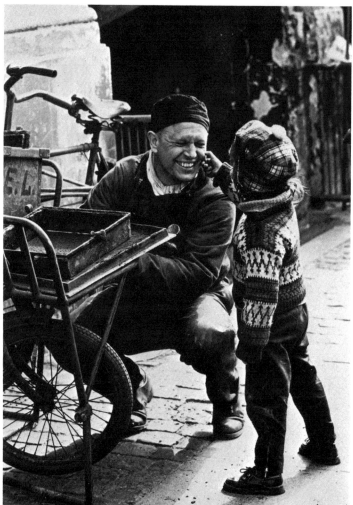

The picture sequence
Often a photographer will come across a scene or situation which, although ordinary or merely pleasant in itself, is likely to produce a "decisive moment". A Danish child shows interest as her father mends his delivery vehicle (*above left*); he makes an adjustment and the child leans forward, her interest and anticipation increasing (*above*); the task successfully completed, the child makes a spontaneous gesture of affection (*left*). In this case, although the final shot has a natural and happy mood, the story is best conveyed in a series of photographs.
Nikon F with 105 mm lens; $\frac{1}{250}$ sec at f 8; Kodak Tri-X.

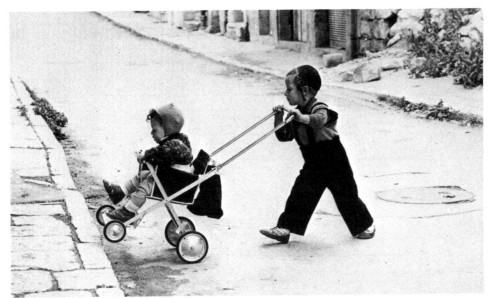

Anticipating the moment

The aware and experienced photographer will often find that he has a few seconds for preparation before the decisive moment occurs. As an Israeli boy pushes his sister across a street in her pram (*left*), the photographer realizes that the child will have to negotiate the kerb and takes the picture at that precise instant, capturing both the concentration of the intrepid young driver and the mild apprehension of the girl.
Nikon F with 105 mm lens; $\frac{1}{250}$ sec at f8; Kodak Tri-X.

The moment of truth

The horror of war, where human emotions, strengths and frailties are revealed at their starkest, is a sphere for the specialist. Here a Venezuelan soldier, badly wounded by rebelling marines in 1962, is comforted in the streets of Puerto Cabello by a navy chaplain. Seconds later, a burst of machine-gun fire drove the chaplain back and the soldier was killed as he crawled for cover. The brilliance of the picture lies in the fact that it tells the entire story in itself; words can merely add supporting facts and figures. (HECTOR RONDON)

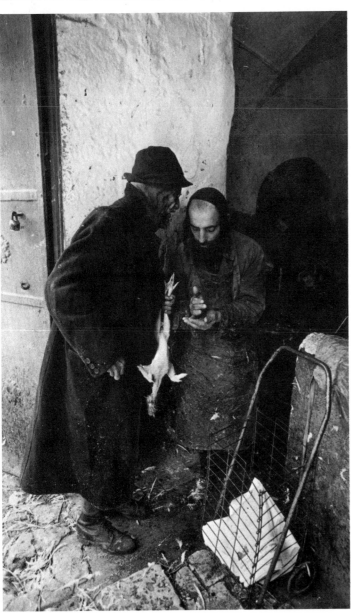

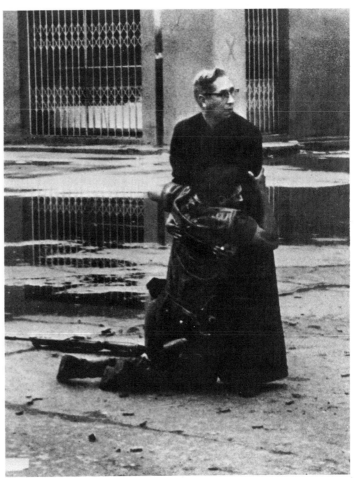

Observing the vital element

The decisive moment is frequently encapsulated within a small part of the total image, as with these two men negotiating in Jerusalem's Mea Shearim. The position of the hands counting the money, and the juxtaposition of the scrawny chicken, which was the subject of the deal, enable the unobtrusive photographer to tell the whole story of the bargain.
Nikon F with 50 mm lens; $\frac{1}{250}$ sec at f4; Kodak Tri-X.

Photojournalism / Making a statement

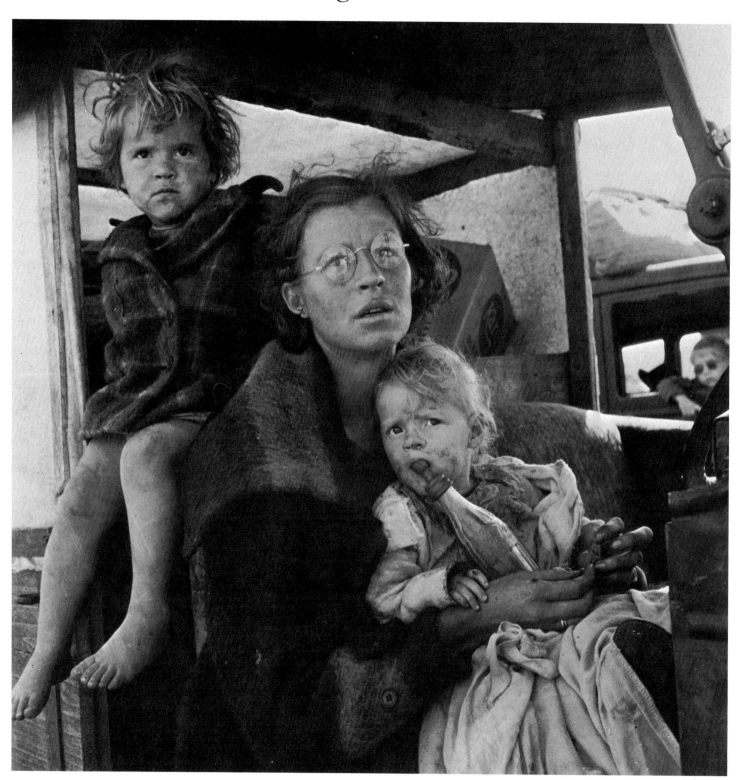

The concerned photographer
Dorothea Lange's photographs of migrants from the American "dustbowl" of the 1930s, making their way in old cars and on foot towards the promised land of California, made photojournalism a real political force in America for the first time. Her theme—exhaustion of the soil and of the people—brought home to the public in a way that nothing else could the social and ecological disaster that four years of drought had wrought in the heart of the most prosperous nation on earth. This was called "Heading West".

Retaining the natural feel
Photojournalism does not allow manipulation. The three boys (*right*) were caught in a completely natural pose in the streets of Haight Ashbury in San Francisco by allowing them to indulge their play-acting without any attempt at control. Any such interference would have changed their mood and expressions and the essential spontaneity may well have been lost.
Nikon F with 35mm lens; $\frac{1}{250}$ sec at f8; Kodak Tri-X.
(JULIAN CALDER)

Photojournalism does more than merely record a moment in time; it also makes some kind of statement. For all the tempting belief that the camera is a passionless recorder of events, precisely the opposite is true. It could hardly be otherwise; it is photographers, not cameras, who take pictures. It is the photographer's decisions about what to take, and when, where and how to take it that will determine the effectiveness of the final image.

Suppose, for example, that pictures were taken of a team climbing a mountain. The shot selected for a newspaper or magazine might be of a triumphant climber plunging a flag into the conquered summit; or it may reveal the courage and ordeal of the climbers in their slow and painful ascent; or it might record an accident on the way, commentating on the folly and waste of some aspects of human endeavour and achievement.

In many cases making a statement is a deliberate act. Adolf Hitler, it has been said, was the most skilful manipulator of the camera in history. Endless photographs of party rallies, autobahns being built, athletic young blonds giving gymnastic displays and all the symptoms of a resurgent Germany gained massive support for the Nazi cause. At the other extreme, concerned photographers have used their skill to expose corruption, injustice and deprivation.

Different photographers can make different statements on the same subject. Emigration to the United States in the early years of this century provided some photographers with an opportunity to see the land of promise and freedom beckoning the hungry and homeless of Europe; to others, such as Lewis W. Hine in a series of photographs in 1908, it was an opportunity to show how in reality millions of immigrants ended up living in overcrowded slums in New York, Chicago and Philadelphia, eking out pitiful wages at enslaving jobs. "If I could tell the story in words," he once explained in a letter to Paul Kellogg, "I wouldn't need to lug a camera." The two approaches to, and interpretations of, the role of the immigrants illustrate the central issue the photojournalist must use his skill and influence with responsibility.

The amateur photojournalist, of course, may not wish to become so deeply involved or indeed to sell his work for publication. But every picture he takes will reveal his view of a situation—his statement—and an appreciation of the inherent subjective nature of photography is an essential ingredient for success.

Personifying the statement

When photographing people in a crowd it is often worthwhile searching among the faces to find one that will personify and epitomize the statement the photographer is attempting to make. In this crowd of ecstatic devotees of Guru Maharishi Jai, the impression of great numbers has been retained but the image of devotion sharpened by using a long lens to isolate and emphasize one particular face, a man totally engrossed.
Nikon F with 300 mm lens; $\frac{1}{250}$ sec at f4.5; Ilford HP4 rated at 800 ASA. (JOHN GARRETT)

Every picture tells a story

An elderly English lady at a graveside (*below*) is not an uncommon sight, and this shot is an example of photojournalism where the full impact depends to a degree on written explanation. The lady was visiting the grave of her parents, next to whom she wishes one day to be buried. The churchyard, however, is now part of an army training area and relatives are allowed to visit it only one day a year. As she was a little blind and slightly lame, and made her way only slowly to the church, the photographer had time to prepare for the right emotional moment without intruding on the woman's privacy and grief.
Nikon F with 105 mm lens; $\frac{1}{125}$ sec at f8; Kodak Tri-X. (JULIAN CALDER)

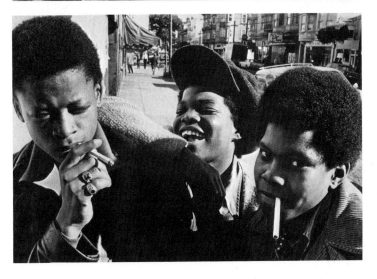

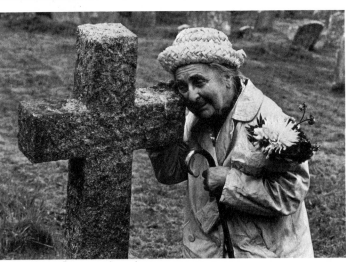

HOME PROCESSING

" We do not use the full scope of photographic technique until we get down to it in the darkroom. That is where our pictures come to life."

OTTO ROMAN CROY

The darkroom

To the inexperienced amateur, setting up a darkroom can seem a daunting and expensive prospect. It need be neither. Most of the essential photographic processes can be carried out with few facilities and little difficulty, and while an elaborate darkroom may be more convenient there is no reason why top-quality results should not be produced with a simple, temporary arrangement such as a converted bathroom.

Ideally, of course, the darkroom should be permanent. If there is sufficient space for this—a spare room, attic or basement, or even a garage—it is advisable to spend some time planning a layout on paper. Photographers spend a good deal of time in their darkrooms and a comfortable, convenient layout will add to the pleasure of working in it.

Keeping out the light

The first task is to make sure that the room is made light-tight. Light-proofed blinds for the window areas can be bought in various sizes from photographic suppliers, but an alternative is to construct a softwood frame slightly smaller than the inside measurements of the window recess and cover

it with hardboard. The edges of the frame should be covered with black felt or other thick fabric that will provide a tight fit and a light-trap around the edges of the shutter.

The door will probably be the only other source of a light leak. This can easily be overcome by hanging two rolls of thick curtain, overlapping and a few feet apart, or by constructing overlapping doors of hardboard.

To test the light-proofing the photographer should sit in the room with the lights off for about ten minutes. It takes that amount of time for the eyes to become adjusted to the dark, and any other leakages of light will then be detectable. This test should be done with all the exterior lights on.

Provided the room is adequately light-proofed, there is no advantage in having dark walls or a dark ceiling. The area behind the enlarger should be matt black, but if the safelight filter is correct for the materials being used (the manufacturers indicate this on their information leaflet) and the recommended wattage of the bulb is not exceeded, it is a positive advantage to have the walls and the ceiling matt white because the safelight will then cast an even light throughout the room.

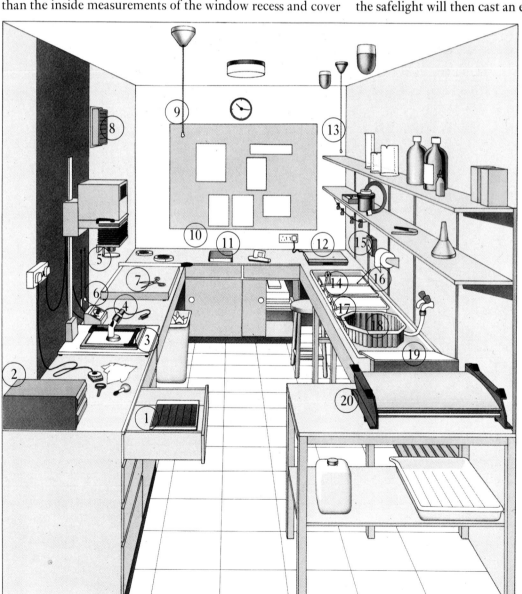

The model darkroom

1. Contact printing frame (kept in drawer)
2. Light-tight box for photographic paper
3. Masking frame
4. Focus finder
5. Enlarger
6. Enlarger timer
7. Guillotine for cutting paper
8. Ventilator/extractor fan
9. White-light switch
10. Pinboard
11. Negative file
12. Dish warmer
13. Safelight switch
14. Tongs
15. Timer
16. Towels
17. Dishes
18. Wash bowl
19. Draining board
20. Print dryer

Other items needed in the dry area include a lens brush and a silicone (anti-static) cloth, an enlarger exposure meter, dodging and burning-in devices and transparent and masking tape. For the wet area a squeegee will be needed, together with measuring cylinders, bottles for diluted chemicals, a developing tank, a funnel and weighted film clips. A waste-bin, stool, clock and scissors are the other necessities.

Several additions can be made to make home processing as labour-saving as possible. These include lever taps that can be operated with an elbow when the hands are full; safelights wired into the enlarger timer so that they are extinguished when the paper is being exposed; wooden slats to raise the dishes off the sink surface; a hot-water supply (especially useful for colour processing); and a drying cabinet.

The safelight enables the photographer to see what he is doing without harming the materials in use—except, of course, during the process of loading exposed film and putting it in the developer tank, when total darkness is essential. In the temporary darkroom the normal bulb can simply be replaced by a special coloured bulb; the more established amateur will change the filter in the safelight to suit a particular process or stage. In a large darkroom (anything bigger than about $3 \times 2\frac{1}{2}$ m/10×8 ft) it is desirable to have more than one safelight, with one positioned near the centre of the ceiling and the other over the sink.

It is helpful if the white-light switch in the darkroom can be reached from both the enlarger position and the fix dish. This can easily be achieved by using a pull-cord switch to the light fitting and connecting this to a cord stretched across the darkroom about 30 cm/12 in above head height.

Organization in the darkroom

One of the most important rules of darkroom procedure is to keep the wet and dry areas apart. The wet side should be reserved for chemical solutions, the dry side for the enlarger and its subsidiary items. This saves time and effort in the sequence of work and prevents contamination of materials.

In a custom-built darkroom it is helpful to have as a wet bench a rectangular sink, long and wide enough to accommodate three or four large dishes and deep enough to prevent splashing and spillage. These can be bought in various sizes from suppliers in moulded plastic or stainless steel.

Because the darkroom operator may need to find something urgently when the lights are off, he should be familiar with the location of all his materials and ensure that they are always kept tidily in the same place. Small strips of luminous tape on shelf edges, light switches and tank lids can prevent frustration. A pinboard is also useful to keep leaflets, manufacturers' information, development times and records of the number of films and papers put through the developer and fix.

There is virtually no limit to the comfort and convenience that can be introduced into a permanent darkroom, but many items are merely refinements. Excellent results can be obtained with simple, basic facilities.

The temporary darkroom

The bare essentials for a temporary darkroom (*right*) are few. Provided it is adequately light-proofed, the only necessities are (1) a bench or work surface; (2) a safelight; (3) developing equipment—chemicals, tank, dishes and thermometer; (4) an enlarger and its support.
A bathroom is certainly the best room for this purpose. There is usually a relatively small area of window space to be blacked out and running water, although not essential, is undoubtedly an asset. The door can be rendered light-proof by making a curtain of heavy fabric larger than the door, long enough to provide a roll at the base. If a light-proofed blind is not suitable for the window it is simple to construct a frame as described in the text on the opposite page.
The bath itself can provide support for a bench for the dishes and chemical containers. Tinted safelight bulbs can be fitted into the normal holder, but it is better to buy a separate darkroom safelight. This can be positioned according to the layout of the darkroom and the screen or filter can be changed to suit the materials being used. A table or chest of drawers is needed to provide firm and stable support for the enlarger, with enough space for negatives and printing papers.

DO-IT-YOURSELF IN THE DARKROOM

Ventilation
Ventilation will be necessary if a temporary darkroom is used for any length of time. Cut a hole in the hardboard cover of the light-tight window frame. Behind this construct a double right-angled channel of wood.

Constructing a work-bench
Cut a piece of blockboard large enough to cover the top of the bath while allowing easy access to the taps. Fit a rim of softwood about 3–4 cm/1–$1\frac{1}{2}$ in deep around the edge to prevent stray chemicals from dripping on to the floor or sides of the bath. The board should be propped at a slight angle and holes drilled in it so that spilt chemicals will fall into the bath.

Developing black and white film

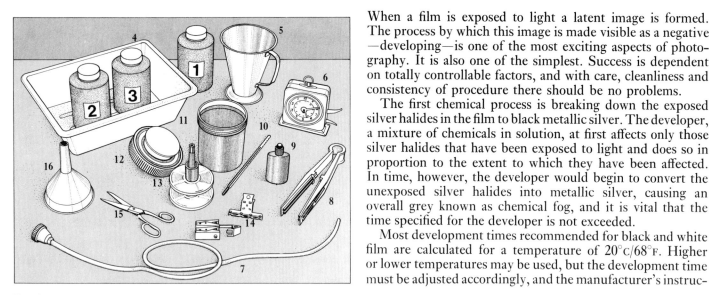

When a film is exposed to light a latent image is formed. The process by which this image is made visible as a negative —developing—is one of the most exciting aspects of photography. It is also one of the simplest. Success is dependent on totally controllable factors, and with care, cleanliness and consistency of procedure there should be no problems.

The first chemical process is breaking down the exposed silver halides in the film to black metallic silver. The developer, a mixture of chemicals in solution, at first affects only those silver halides that have been exposed to light and does so in proportion to the extent to which they have been affected. In time, however, the developer would begin to convert the unexposed silver halides into metallic silver, causing an overall grey known as chemical fog, and it is vital that the time specified for the developer is not exceeded.

Most development times recommended for black and white film are calculated for a temperature of 20°C/68°F. Higher or lower temperatures may be used, but the development time must be adjusted accordingly, and the manufacturer's instruc-

Equipment for developing black and white film

1. Developer solution
2. Stop solution
3. Fixer solution
4. Temperature control bath
5. Measuring jug
6. Timer
7. Hose
8. Squeegee
9. Wetting agent
10. Thermometer
11. Developing tank
12. Developing tank lid
13. Plastic reel
14. Clips for hanging film
15. Scissors
16. Funnel

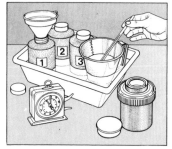

1. Check that the developer, stop bath and fixer solutions are at 20°C/68°F. Place them in the temperature control bath with the water (also at 20°C) covering at least half of each bottle. Water at 20°C should also be put into the developing tank. The temperature of the chemicals can be stabilized by adding water to the bath.
Film subjected to violent changes of temperature may show reticulation.

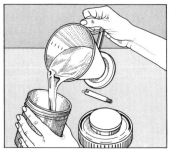

2. Pour out the 20°C water from the tank. Then pour in the developer until the tank is almost full. Do not replace the lid of the tank, but put it in a safe place (it will have to be found later in the dark). Replace the lid on the bottle and return it to the temperature control bath.
A measuring jug may be used for pouring if preferred.

3. Set (but do not start) the timer for the developing time specified by the film manufacturer. It will then be easy to start the timer in darkness the moment the film is placed in the tank. The vital preliminaries are now completed and the darkroom light should be switched off.
Accuracy in timing is essential; without it the negatives will either be too thin and flat or too dense and harsh.

8. Place the reel into the developing tank smoothly but as quickly as possible, and start the pre-set timer immediately.
It is possible to load the film into the tank and close the lid before pouring in the developer, which can then be done with the lights on. The sequence is largely a matter of personal preference.

9. Put the light-tight cover (complete with its cap) on to the developing tank and remove it from its shallow temperature control bath. The lights may now be switched on. Lightly tap the tank to disperse air bubbles.
Air bubbles cause clear spots on the negative and after printing these would appear as dark spots.

10. The next step is immediately to agitate the tank for about 15 seconds. This can be done either with the agitator rod or by inverting the tank like a cocktail shaker (as above). Agitation must be repeated once every minute during the developing period.
Agitation is a vital part of the developing process, bringing fresh portions of the solution on to the film surface.

11. Just before the development is due to be completed, remove the lid of the developer bottle. The moment the timer rings, remove the cap (but not the tank cover) of the tank and pour the fluid back into its bottle for later use. A funnel should be used to avoid spillage. Return the empty tank to its temperature control dish, and replace the lid of the bottle.

tions will indicate these variations. Photographers can quite easily make up their own chemicals, but the manufactured products are inexpensive and save time.

The moment the developing time has been completed the development must be halted, either by a brief rinse in water or by use of a stop bath. The "stop", a mildly acidic solution, immediately checks the action of the alkaline developer and is thus more efficient than running water. It also helps to prevent the fixing solution, the third chemical, from being unnecessarily contaminated with developer.

The next chemical in the process is the fixer. This solution renders the unconverted light-sensitive chemicals in the emulsion soluble in water and enables them to be washed away in running water. Though it is quite safe to expose the film to light after a few minutes in the fixer solution, the negatives cannot be regarded as permanently safe until these remaining chemicals have been removed by the washing process. With water at 20°C/68°F this stage, the last before drying the film, takes about 30 minutes.

REELS AND LOADING

An alternative to a plastic reel is one made of stainless steel (*above*). This is slightly more expensive and a little more difficult to load, but it is easier to clean and is less likely to contaminate film. Instructions must be followed with care. Another method is an automatic loader (*above*). Once the film has been fed into the stainless-steel reel it is wound on by a handle.

4. Open the cassette and remove the spool of film. Fold back an edge of the film (about 6mm/¼ in) to aid loading. Plastic reels can be adjusted to accommodate both roll and 35mm film.
Because the process of loading film on to a reel must be done in darkness, beginners should practise loading with an old roll of film with the light on, and then a few times with the eyes closed until it can be done with confidence.

5. The entry slots of the reel must be aligned and the reel held so that the two indentations in the sides are at the top. Hold the film by its edges and introduce it into the entry slots.
When loading it is essential not to touch the emulsion side of the film and advisable not to touch the back (the shiny or convex side of its curl).

6. Once the film is securely attached to the reel it can be wound on by rotating each side of the reel in opposing directions.
The unwound portion of the film may dangle loose and it is crucial that it does not fall on a dusty surface.

7. When the film has been loaded the end should be cut from the spool. The reel may now be transferred to the developing tank.
Delay and confusion will be avoided if the scissors, as with all "dark" equipment, are kept permanently in a handy position.

12. Pour the stop bath fluid into the tank through the pouring opening until it overflows. Again, do not remove the tank cover. Some tanks have a light baffle so placed that the tank must be held at a slight angle when pouring in liquids. Replace the cap and agitate for about 15 seconds.
This sequence should be done briskly so that the stop solution will start halting development immediately.

13. Return the stop solution to its bottle. Set the timer for 5–10 minutes, according to the manufacturer's instructions. Pour the fixer solution into the tank to overflowing. Replace the cap and start the timer. Agitate for 15 seconds every minute during the advised time. At the timer signal, remove the cap and pour the liquid back into its bottle. The film is no longer sensitive to light.

14. With the tank lid removed, put the tank in a sink or bath. Into its core place a hose—either a double-ended hose connected to both hot and cold taps or a single one attached to a mixer tap—and adjust water temperature to 20°C. Run the water through the tank for about 30 minutes. When washing is complete, it is advisable to put in a drop of wetting agent. Then agitate for about 10 seconds.

15. Unwind the film from the reel for drying. Attach a clip to one end of the film and hang it for up to two hours at an even temperature, with a further clip attached to the other end as a weight. Excess water can be removed by a squeegee.
Bottles should be marked to indicate the number of films processed, and the negatives, when dry, cut into lengths (6 for 35 mm, 4 for 6 × 6cm/2¼ × 2¼ in) and filed in protective envelopes.

Printing black and white

While developing negatives is essentially a routine process requiring care and accuracy but very little skill, it is at the printing stage that photography becomes a craft.

The basic methods of producing a print are nevertheless simple; the importance of the darkroom lies in the degree of control that the photographer can exert over his work. The following pages describe the fundamental techniques of printing in a logical sequence, and there is no reason why a novice should not be successful first time.

A good-quality print is one that faithfully reproduces the range of tones recorded on a good-quality negative. It will exhibit areas of deep black where the negative is clear as well as clean white where the negative is opaque, while at the same time showing all the detail that appears on the negative. This is the goal, but in the early stages the only guide is trial and error. The "perfect" print is achieved by the correct combination of paper, exposure time and development time.

Different grades of paper vary the contrast of the picture and can be used to compensate for variations that occur between negatives—a technique explained more fully on page 178. The other critical factor is exposure, and the test strip (explained on page 177) is the best method to select the most suitable exposure time.

Making the print

To make a positive print from a negative transparency, light is projected through the negative on to special paper coated with a light-sensitive emulsion. The paper is then developed in the same way as film, using a slightly modified developer but the same stop bath and the same fixer. The paper is washed to remove all the unwanted chemicals and then dried. The resulting picture is the positive.

The emulsion on photographic paper is essentially the same as that on ordinary film, except that it is only sensitive to a small part of the colour spectrum, and this allows the use of a safelight. The paper is therefore processed in open dishes instead of the light-tight tank used for films, and the image can be watched as it appears when the paper is developed.

Dry area
1. Enlarger
2. Masking frame
3. Timer
4. Photographic paper
5. Anti-static cloth
6. Focus finder

Wet area
1. Developer
2. Stop bath
3. Fix
4. Three processing dishes
5. Measuring jug
6. Tongs
7. Timer
8. Roller or squeegee
9. Blotter
10. Thermometer

1. Chemical solutions should be prepared and arranged in three dishes in the order in which they will be used—developer, stop bath and fix. They must be brought down or raised to the correct temperature (about 20°C/68°F) and there should be enough of each to give a depth of 5cm/2in.
Temperature is less critical here than during film developing as the image can be watched as it appears.

2. The film should be cut into strips so that all will fit on to a single sheet of 10×8in paper. Clean the negatives and the sheet of glass with an anti-static cloth. Then switch off the white light and switch on the safelight.
Care should be taken throughout not to scratch the surface of the negatives.

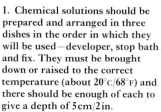

7. When the paper has been in the developer for about 30 seconds the image should begin to appear and it will continue to darken for about two minutes. Agitate the paper gently during this period by rocking the dish or moving the paper about carefully with the tongs.
Take care not to scratch the surface with the tongs: the emulsion is particularly sensitive when wet.

8. After the prescribed time the image reaches a stage where there is little further change in its density. At this point, remove the sheet from the developer and let the liquid drain off.
It is always safer to time the development rather than just remove the sheet when it "looks" developed.

CONTACT PRINTING

Although it is tempting to start making enlargements once the developed negatives are dry, it is better to first produce a contact print—a same-size print of all the negatives of a film side by side on a single sheet of photographic paper. This method (illustrated on these pages) makes it easier to select which pictures merit enlarging and saves the photographer the expense and disappointment of enlarging inferior shots.

The normal printing process applies in making contact prints from negatives. First, light must shine through the negatives to expose the sensitized photographic paper; then the paper must be developed to reveal the positive prints. For the first stage 10 × 8 in printing paper is required and either a printing frame or a blemish-free sheet of glass a little larger than the paper. The negatives are sandwiched next to the paper in contact with the emulsion—hence the name contact printing—while the light from the enlarger shines through the negative on to the paper. The resulting positives are exactly the same size as the negatives.

3. The enlarger is a convenient light source. The height of the head should be adjusted so that its beam illuminates an area slightly larger than the sheet of glass being used. Stop down to ƒ8 and cover the lens with the safe filter.
The further the enlarger head is from the baseboard the longer the exposure will have to be.

4. Take a sheet of printing paper and lay it, emulsion (glossy) side up, in position under the enlarger. It will not, of course, be affected by the filtered light from the enlarger. Lay the negatives, emulsion (matt) side down, on top of the paper and cover them with the sheet of glass to hold them in place.
Be sure to close the box containing the paper the moment a sheet has been taken: it is easy to forget later.

5. Switch off the enlarger and then move the safe filter away from the lens. Switch on the enlarger again and expose the paper for 10 seconds. This should be accurate to within about one second.
It is tempting to expose the paper by simply moving the safe filter, but this can expose one side of the paper for significantly longer than the other.

6. Take the exposed photographic paper from under the glass and slide it into the developer dish, emulsion side up.
It is important to get the whole sheet into the solution quickly. One method is for the photographer to tilt the dish away from him, then slide the far edge of the paper into the chemical and allow a wave of developer to cover the whole sheet. A little practice may be needed.

9. When the developer solution has drained off the paper, take the second pair of tongs and transfer it to the stop for 15–30 seconds.
Do not use the developer tongs for this purpose: if they touch the stop bath the developer could become contaminated.

10. Transfer the print from the stop bath to the fixer. After about a minute the white light may be switched on and the print can be examined.
Contact prints are usually made for convenience, not for display, and a perfect print at this stage is seldom required. If the print is too light or too dark, however, it is possible to try again, starting by increasing or reducing the exposure time by five seconds.

11. The print should now be transferred to the wash and kept there face down for 30 minutes, or at least twice as long for double-weight paper. In the case of resin-coated paper it need only be for five minutes
Running water must be allowed to circulate all around the print: it is no use leaving a print for one hour or even more in still water.

12. The finished print should now be dried. If a squeegee roller or photographic blotting paper is used to remove excess water care should be taken not to get dust on to the surface, which will remain tacky until the print is dry.
Prints sometimes have a tendency to curl—some types of paper are more prone to this than others—but they can later be flattened under a stack of books or other heavy objects.

The enlarger

The best and safest way of determining the exposure time needed to produce a good-quality print is to make a test strip. This is basically a refinement of trial and error: instead of experimenting with different exposure times on several sheets of paper until one of them gives a good result, it is much more efficient to use one small strip of paper and give it several different exposures.

This is done by cutting off a strip of the photographic paper you are going to use and exposing it in sections so that each receives a slightly different exposure. Then, if the section at one end comes out too dark, and the section at the other end too light, there will obviously be one step somewhere between the two which is right. If necessary the accuracy can be narrowed even further by repeating the process with shorter intervals, but one experiment is usually enough once you have learned where to start.

Once the correct exposure has been established from the test strip, the final print can be made. It is important to remember that the degree of enlargement greatly affects the exposure time, so if the enlarger head is adjusted a new test strip will have to be made. The step-by-step sequence on the opposite page explains how to set about making a test strip in practice.

It may seem wasteful and extravagant to cut up a whole sheet of paper, but in reality it is wasteful *not* to use test strips because more paper is wasted without them.

By reversing the mirror inside the condenser head and illuminating the baseboard, the enlarger acts as a copying camera. The image is then focused on the screen.

The enlarger
The function of the enlarger is to provide light to illuminate the negative and a lens to focus it on the photographic paper. In its basic form it would not include the mirror arrangement shown left, but the mirror has the advantage of reflecting nearly all the light but only a small proportion of the heat. Two flat-convex lenses, called a condenser, ensure the light is parallel and uniform.

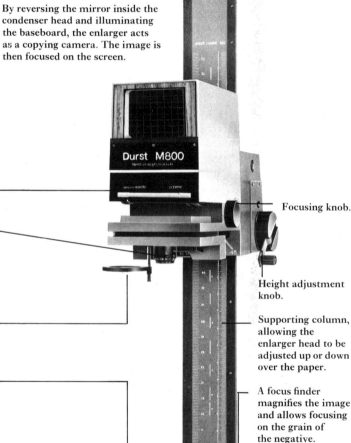

The condenser system distributes light evenly over the negatives.

An enlarging lens must be of a focal length appropriate to the size of negative used: e.g. 50/55 mm for 35 mm negatives. If the same enlarger is to be used for a range of negative sizes, interchangeable lenses will be necessary.

The safe filter enables the enlarger light to be on without affecting sensitized paper; when not required it can be moved aside.

When in place in the enlarger head, the negative carrier holds the negatives flat, level and firm between the light source and the focusing lens.

Wired into the enlarger circuit, the enlarger timer exposes the paper automatically, leaving the operator free for other tasks.

Blower brush and aerosol blower.

Focusing knob.

Height adjustment knob.

Supporting column, allowing the enlarger head to be adjusted up or down over the paper.

A focus finder magnifies the image and allows focusing on the grain of the negative.

The adjustable masking frame alters the area of photographic paper being exposed.

Perspective control
The enlarger can provide some of the flexibility of a view camera. By tilting the masking frame, a geometrically distorted negative image can be corrected, but the film and lens planes must also be tilted to keep the image in focus.

Giant enlargements
The height of the column limits the size of enlargement; for greater enlargements, it can be projected on to a wall (*above, inset*).

Making a test strip

1. Prepare the chemicals in exactly the same way as for contact printing. Then ensure the negatives and negative carrier glasses are free from dust and finger marks.

2. Place the negatives in the carrier, emulsion (matt) side down. If you are using a negative carrier which does not have glass to hold the negative flat, make sure it is held securely at the edges to prevent it bulging at the centre. Some models have small masking blades built into the carrier, and these should be adjusted to cut out extraneous light around the edges.

3. Place the negative carrier in position in the enlarger head. Enlargers are rarely very efficiently light-proof, so do not be alarmed if there is a leak around the negative carrier: as long as there are no shiny or reflective surfaces near, a small light leak is unlikely to have any damaging effect.
If using an automatic timer, set it to five seconds.

4. With the white light off and the safelight on, adjust the height of the enlarger head so that the image projected is roughly the size required. Then adjust the size of the masking frame.
The frame will indicate the size quite accurately, but it may help to use a sheet of photographic paper. This allows focusing to take into account the thickness of the paper.

5. Focus the image with the diaphragm fully open. The height of the head will probably have to be adjusted again.
If a focus finder is employed, it should be stood on a sheet of paper of the same thickness as the paper being used. The extra degree of accuracy this provides is more important with the thicker types of paper.

6. Stop down the lens to ƒ8 or ƒ11. The purpose of this is twofold: to improve the focus of the image and to ensure a suitably long exposure time, ideally between 10 and 20 seconds. Then cover the lens with the safe filter. The preliminaries are now complete and the test strip can be made.

7. Take a sheet of photographic paper and place it in position under the enlarger, emulsion (glossy) side up. Switch off enlarger light and move away the safe filter.
It is not necessary to use a whole sheet —a strip about 5 cm/2 in wide will do.

8. Cover all but ⅕ of the strip with a sheet of cardboard. Start the timer and enlarger lamp. After the first exposure, uncover another ⅕ of the sheet and repeat the exposure for another 5 seconds. Repeat this every 5 seconds, moving the card across the paper until 5 sections at 5-second intervals have been exposed.

9. While the last section receives a short exposure of 5 seconds, the first section will of course receive the maximum of 25 seconds.
The test strip is fundamentally a trial-and-error method of finding the optimum exposure time, so it should not be expected to produce a perfect result first time.

10. Develop the test strip fully in the same way as when making contact prints. If the whole strip is the wrong density, another test strip must be made covering a different range of exposures; if the strip is too dark, stop down . further for the next attempt.
Do not make a final enlargement until a test strip has been correctly exposed.

11. Continue with the normal processing. When the test strip has been in the fixer for one minute, switch on the white light and examine it. If the test strip is in the correct range, one of the sections will be the right density. Calculate what exposure this satisfactory section received.
Make sure hands are clean and dry before beginning the final print.

12. With the lights off and the safelight on, refocus the enlarger— the negative tends to expand slightly under the heat of the lamp and its position in relation to the lens may have altered. Expose a fresh sheet of paper as before, but this time giving the whole area the same exposure as the correct section on the test. Process it in the same way as a contact print.

Control printing

Photographic paper can vary in a number of ways. There are differences not only in the physical quality of the paper that supports the emulsion but, more important, also in the chemistry of the emulsion itself. The paper is described in terms of size, weight and surface, the emulsion in terms of grade, which refers to the degree of contrast it will give.

The difference in grades is a crucial factor in processing since paper, by correcting or modifying the contrast of an image as it appears on the negative, is the primary means of controlling print quality in the darkroom.

Grades of paper range from 1 to 5 (with occasionally 0 or 6 in addition), representing a scale of contrast from soft to hard in which grade 2 is normal contrast. Thus the most common grades are 1, 2 and 3, while grade 5 is usually used only for deliberately exaggerated effects or very thin negatives.

Grade 4 is useful when grade 3 is insufficiently hard. The illustrations below show how the different grades of paper can be employed as a means of quality control.

The other variables are self-explanatory. Weight refers to "airmail", single-weight or double-weight, a thicker card useful for large prints which would be vulnerable to damage on single-weight paper. Surfaces other than the standard glossy include matt, lustre, stipple, velvet, silk and high gloss.

In addition to these traditional variants, and papers with a tinted base, there is a choice between ordinary fibre paper and resin-coated paper. The latter is quicker to process because it does not soak up chemicals into the paper itself and so less time has to be spent washing and fixing prints. It also has less tendency to curl. Despite these advantages, the final quality of fibre-based paper is generally regarded as superior.

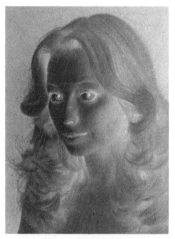

Corrective paper for a soft negative

The soft negative (*far left*) produced a pale, dull picture when printed on normal, that is grade 2, paper (*centre*). The result consists of shades of grey, having no pure white and no rich black; overall detail is visible but not sharp. For the correct print (*left*), grade 4 paper was used because a low-contrast negative and a high-contrast paper effectively balance each other.

 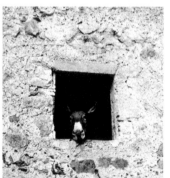

Hard negative

The dense negative (*far left*) suffers from excessive contrast. When printed on normal paper (*centre*) it develops strong black shadows and the highlights are bleached out. A soft grade of paper can be used to spread the greys over a wider range (*left*). This print shows the result with grade 1 paper.

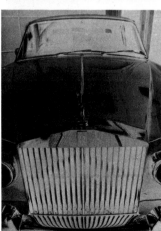 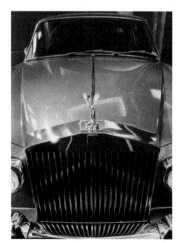 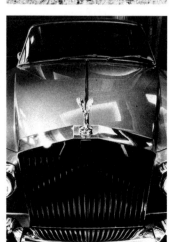

Normal negative

A negative with a good, fairly "normal" range of tones (*far left*) need not necessarily be printed on normal contrast paper. Different effects can be obtained by printing on soft paper (*centre*) or harder paper (*left*), which exaggerates contrast and emphasizes texture but eliminates unwanted detail.

PRINT CONTROL

The information provided by a test strip is not, unfortunately, a complete solution to all exposure problems. A test strip should determine the best exposure time for the print as a whole, but in practice it will be found that some areas of the picture ideally require exposures considerably different from that given to the main subject.

A common example is the sky in landscape pictures, where the sky on the negative is so dense that it needs twice or three times the exposure given to the rest of the picture; without correction it appears an uninteresting area of white.

In cases such as this the solution is simply to extend the exposure time where it is needed while covering up the rest—a technique known as "burning-in", which brings out detail in excessively bright highlights. "Dodging" (or shading, as it is often called) is the same process in reverse: holding back shadows so that they receive less than full exposure.

The only difficulty in applying the idea of controlled local exposures is avoiding sharp lines around the area that has been covered up. This is overcome first by holding the masking device away from the paper so that the shadow it casts is blurred, and also by keeping it moving continuously. A range of masking devices for shading can be made from pieces of cardboard taped to short lengths of black wire (shiny wire will give off reflections) and special shapes can be cut out when required. For burning-in, a hole is cut in a large sheet of cardboard instead. In most cases, however, it is perfectly acceptable to use the hands instead of cardboard, which is only really necessary for precise detailed work.

Burning-in and dodging can be applied to the same print if necessary. The vignette and reversed vignette are the creative extensions of the same kind of corrective techniques.

Burning-in
After the print has been given the normal exposure an extra exposure can be given to highlights through a hole in a mask. It is vital to keep the mask moving.

Dodging
Areas of shadow can be held back during part of the regular exposure period to prevent them becoming too black. Ideally, detailed tests should be made.

Normal vignette
The vignette is produced in much the same way as the "burnt-in" highlight, but a large hole is used and the mask held in position throughout the exposure.

Reversed vignette
To produce a vignette effect with a black surround instead of white, the edges of the paper are fogged with white light after the central image has been exposed.

Black surrounds the subject in a reversed vignette, giving an impression of depth.

The image in a normal vignette is surrounded by white, with the effect of bringing the subject forward towards the viewer. If an abrupt contrast is required, the card or hands must be held still during exposure. This is an early example of the technique, used by Henry Peach Robinson in 1857.

Colour processing

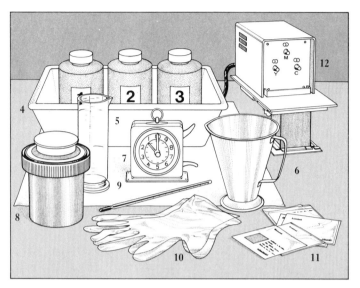

Processing colour film need be no more difficult than black and white. There is a wide range of colour films available, most of them suitable for home processing, but since each type of film has its own chemicals, it is essential that the chemicals should be compatible with the type of film used.

Colour negative and transparency film processing follows a general pattern common to all makes, although the particular formula, times, and the number of intermediary baths varies. The principal steps are development (including colour development in negative film), stop bath, wash, colour development (in transparency film only), bleach, wash, fix, final wash and final rinse in a wetting agent to inhibit the formation of drying marks.

It is important to stress consistency and accuracy of time, temperature control and agitation. Provided these are carefully watched, processing colour at home will give the satisfaction that comes with a growing sense of craftsmanship—and it is much cheaper. Errors can be virtually eliminated by following manufacturers' recommendations.

1. Developer
2. Stop bath
3. Fixer
4. Temperature bath
5. Measuring cylinder
6. Mixing jug
7. Timer
8. Developing tank
9. Thermometer
10. Protective gloves
11. Filters
12. Colour mixing head

Technically accurate colour processing begins with disciplined working habits and clean equipment. A reliable thermometer and timer are essential, and a water bath must be used to keep the chemicals at the required temperature. Stainless steel tanks and reels should be used if much colour processing is to be done.

1. The freshly-mixed or well-stored chemicals are brought to the correct temperature. The tank should also be warmed by filling with water at this temperature. Set the timer for the first bath.
Temperature is critical. Good colours cannot be produced by extending the developer time to compensate for chemicals used at lower than recommended temperature.

2. Empty the water from the developer tank and fill with developer. The lid and cover should be located where it can be conveniently and safely found in the dark.
The developer's activity is continuous, and a constant watch must be kept against both under- and overdevelopment. Other chemicals work to completion and the only error is one of insufficiency.

3. Switch off the room light and load the film on to the reel. Quickly and carefully immerse the film into the developer tank (see captions 8 and 9, page 172).
This provides an immediate and complete contact of film and developer—an important factor in colour processing as times are far more critical than in black and white and there is much less latitude for error.

4. Agitate (see caption 10, page 173). After an initial agitation that starts the process, intermittent agitation ensures the dispersal of fresh chemical to the emulsion.
This procedure is the most difficult to standardize in colour and varies with the type of film. The draining of the chemical is included in the processing time of the film. More processing faults are the result of inadequate agitation and washing than any other reason.

5. When a negative film has been developed the process is halted by a stop bath. Transparency films, however, need a re-exposure to a 500-watt lamp at 1 m/3 ft to reverse the image.
Enough re-exposure is needed to ensure that the middle layer of emulsion in the tri-pack film receives sufficient light. In many modern films the re-exposure has been replaced by an extra chemical bath.

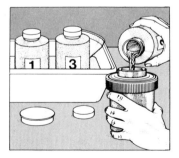

6. The next stage in processing a negative film is bleaching and fixing, but for reversal films it is another colour development. This is followed by the bleach, wash and fix baths.
While subsequent chemical bath times vary with the type of colour film used, the need for consistent and accurate temperature and agitation control remains essential.

7. Complete the process by washing the film in the tank, as with black and white films (see caption 14, page 173). The temperature of the water must be adjusted to the level recommended for the type of colour film being processed. After 30 minutes remove the film from the spool and hang it up to dry.
Do not wipe the film; allow it to dry naturally.

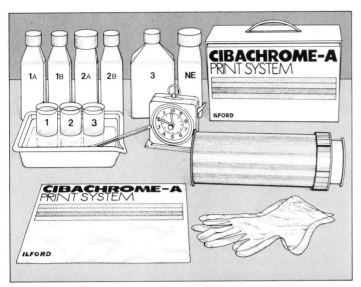

PRINTS FROM TRANSPARENCIES

Prints can be made from slides as well as from negatives. *Kodak Ektachrome* reversal paper follows the same principle of dye coupling as with the standard reversal film process. The *Ilford Cibachrome* system, described below, is unusual in that it involves a unique process of dye destruction which enhances print sharpness and guarantees long-lasting prints.

As alternative systems to the more common method of printing from negative described on the next page, both methods considerably simplify the problems of filtration assessment. They are, however, more expensive.

The *Cibachrome* system is different from others in that the dyes are not generated in the emulsion during development; they are already in the emulsion and are selectively bleached out during the processing. The *Cibachrome* kit includes (1) the developer made up to two parts, (2) the bleach made up of a powder and a liquid concentrate, and (3) the fixer. A neutralizer in powder form (NE) is also included to render the chemicals harmless after use.

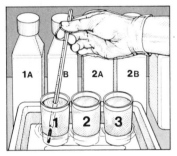

1. Mix the developer, bleach and fixer in their appropriate beakers according to the manufacturer's instructions and stand them in a tray of water to keep them at a constant temperature within 1.5c°/3f° of 24°c/75°f.
The developer contains an irritant and the bleach is strongly acidic. Care must be taken in handling them and protective gloves should be worn.

2. In total darkness make the exposure from the slide. Use as few filters as possible to find the correct colour balance and select the best exposure. As with other enlarging techniques, a test strip should be made first.
Cibachrome "paper" has a plastic base and care must be taken to distinguish the two sides as they have a similar feel. The emulsion side has a dark colour, but this is only obvious in light from enlarger.

3. With the darkroom lights still off, roll the exposed print, emulsion side inwards, and place it inside the developing drum. Screw the cap on tightly. The print is now protected from the light and the darkroom lights may be switched on for the rest of the operation.
The Cibachrome drum is large enough to take a print 25 × 20 cm/10 × 8 in.

4. Pour 90 cc of the developer, already prepared in beaker 1 and kept at the correct temperature, into the drum.
The developer contains hydroquinone which is an irritant and may cause dermatitis. Repeated skin contact should be avoided and any splashes washed away with plenty of clean water. Gloves should be used at this stage of the operation.

5. Place the cap on the drum and roll the drum back and forth for two minutes to agitate the developer. The drums should be rolled through 180° to ensure that the developer reaches all parts of the print to produce an even development.
The developing time is important; two minutes is correct when the solution is at a temperature of 24°c/75°f.

6. Pour away the developer and let the drum drain for about 15 seconds. If the drum is not well drained the next stage may be contaminated and unpleasant odours can eventually build up.
The used developer should be poured into a container with a quantity of neutralizing powder to render the fluid inactive and harmless before it goes down the drain.

7. Repeat the procedure with 90 cc of bleach prepared in beaker 2, agitating the drum for at least four minutes. A shorter bleaching time may produce stains on the print. Pour the bleach into the neutralizing container and let the drum drain for 15 seconds. Pour in 90 cc of fixer from beaker 3, agitate and pour away.
The bleaching is the most important stage of the process.

8. Remove the picture from the drum and wash it in a flat dish under running water for three minutes. At this stage the emulsion surface is very delicate and should not be touched. The print should dry at room temperature in two hours, or it can be dried by an electric fan in five to ten minutes. It can then be mounted and presented in any of the conventional ways.

Controlling colour prints

Despite increasing standardization, small variations still occur in the manufacturing of colour negative film emulsions and coatings. These are further compounded by the chemical process, disparities in the colour paper emulsion itself and in its own chemical activity. The goal in colour printing is to bring into balance these variations to recreate as faithfully as possible the original scene.

In order to compensate for the inability of manufacturers to provide colour emulsions and chemicals of absolute consistency, a methodical approach and routine discipline are required for reliable results. Using a small notepad to record filtration and exposure should become as habitual as systematic and consistent adherence to manufacturer's recommendations in processing.

All manufacturers "aim" their print material to give correct colour balance somewhere in the middle of the red range of filtration. This means that almost all colour printing will be produced with a final filtration using both yellow and magenta $(Y+M=R)$ filters slightly above or below the middle of the range (i.e. a first test should be with 60Y and 60M filters).

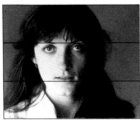

Yellow

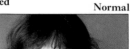

Red

Normal

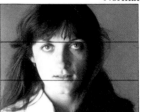

Magenta

Each colour on this chart is the complement of the one opposite: yellow, for example, is the complement of blue. Learning to think of colours in complementary terms is essential in understanding the mechanics of colour processing.

Each photograph has 20 units too much of a particular colour, at correct exposure, under-exposure and overexposure. A comparison of a test strip with this series of pictures will indicate what correction of colour and exposure is necessary before the final print is made.

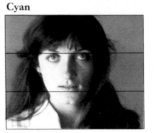

Green

Cyan

Blue

The additive and subtractive colour principles (see page 72) can be used in colour enlarging, but the easier subtractive method is the more common.

Condenser enlarger
This focuses an even area of light on the negative by means of the condenser lenses, and the image is projected on to the base-board by the enlarger lens. Most black and white enlargers work on this principle and they can be adapted to colour work by inserting a filter drawer between the condensers and the negative carrier. The filters produce the correct colour of light for the negative.

Diffusion enlarger
This was developed for use with colour negatives and the even area of light needed to illuminate the negative is mixed in a diffusion chamber. The filters may be gradually introduced into the light beam, the area of the filter caught being proportional to the percentage of that colour in the final beam after mixing. The percentages are provided by calibrated dials.

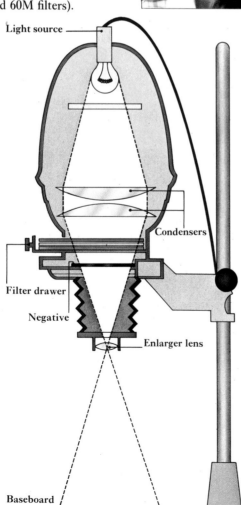

Light source

Condensers

Filter drawer

Negative

Enlarger lens

Baseboard

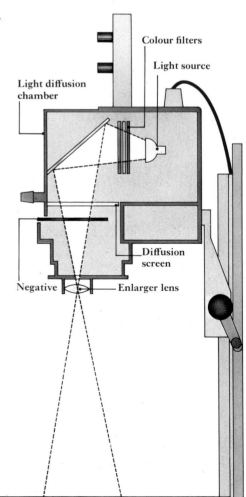

Colour filters

Light source

Light diffusion chamber

Diffusion screen

Negative

Enlarger lens

Baseboard

MAKING A TEST STRIP

Test strips must be prepared, as in black and white printing, before a satisfactory print can be made. A range of exposures is necessary to establish the correct overall density of the final print. It is unlikely that the first test strip will be correct for colour balance. The main difficulty in viewing a colour print test strip for the first time will be to identify and evaluate the overall colour cast present, since wet colour prints look slightly darker than dry prints and they have a very slight bluish cast, particularly in the shadow areas.

The chart on the opposite page is intended to assist in this evaluation. The six pictures all have an overall cast of 20 units of colour and are divided into overexposed, normal and underexposed sections. The picture with correct colour balance and correct exposure is also shown for easy comparison.

Filtration and exposure information is normally recorded in columns on a notepad. The sequence of columns shown—yellow, magenta, cyan, f-stop and exposure time—should be the same for every print. In this way a routine is quickly developed.

The test strip should be from a part of the negative that is representative of the whole picture, and include both highlight and shadow. It should be matched as closely as possible to one of the reference pictures to determine the necessary correction. The first step is to establish the closest exposure density on the strip; the next is to determine the bias of colour in that density.

A slight red colour cast can look deceptively heavy in an overexposed area of the test strip. Conversely, a strong red cast may not look like much in an underexposed one. In practice, a test that seems too red is corrected by adding equal units of both yellow and magenta to the filters. A clear understanding of the substractive colour synthesis and how dyes are formed in colour paper emulsions (see pages 72–5) will also show why, if the test strip seems too cyan, it is corrected by reducing equal units of yellow and magenta.

Corrections for colour are as follows. If the colour is too:
blue—reduce yellow;
yellow—increase yellow;
magenta—increase magenta;
green—reduce magenta;
red—increase yellow and magenta;
cyan—reduce yellow and magenta.

A useful rule of thumb is to over-correct the colour on the test strips (if there seems to be a need for a correction of 20 units of a particular colour, for example, correct it with 30 units). Although colour discrimination and judgment will quickly develop with experience from the first few colour prints, this needs to be sensitized by the familiarity with the equipment and materials that will come with over-correcting on the early attempts.

Increasing or reducing the filtration will affect the amount of light reaching the paper, and exposure compensation will be necessary. This will vary with the particular filter used, but these figures will act as a guide: 20Y will need a 5% exposure compensation; 20M will need a 20% compensation; 20C will need a 10% compensation.

Knowing how much correction is "too much" means a third filtration and exposure test can then be assessed before the final print is made.

Although paper is sensitive to all but a very narrow part of the spectrum and must be handled only in complete darkness, an increasing familiarity with handling colour paper, methodical procedures with the enlarger and consistent processing habits following the manufacturer's recommendations all soon combine to eliminate any initial awkwardness.

Drum processors can be used for the development as in the *Cibachrome* process (see page 181) and once the final print is developed it is washed, dried and mounted.

First test

Second test

Third test

First test

Second test

Final print

Special effects -1

The darkroom can be a playground as well as a laboratory, providing its own kind of fascinating entertainment. Moreover, in order to make the most of his materials, the photographer should know how they behave under unusual as well as normal conditions, and he can learn much from these effects about the nature of photographic materials.

All the special effects described on the six following pages are well established and there is no longer anything experimental about them—though they can be combined in many new ways. In themselves they belong to the repertoire of familiar corrective techniques like dodging and burning-in (see page 179), and at various times in the history of photography it has been the opinion of some purists that all such "tampering" should be abandoned altogether. Instead, exciting effects continue to be discovered by both professionals and amateurs.

In general, the more bizarre the result, the more limited the usefulness of a special process. The effects which tend to dominate the image are the ones which most quickly degenerate into clichés, while the more subtle variations continue to be used interestingly. The most sensible way to approach special effects is to learn the methods but aim for different results: experimental photography should go beyond repeating old experiments.

The first techniques involve adjustments within the normal framework of the printing process, using such accessories as reducers, toners, texture screens and soft focus. The next degree of sophistication involves creating intermediate negatives and positives on film, paper or specially sensitized materials, so that the original negative comes to be regarded as merely the starting point in a series of steps which eventually result in a picture. Ultimately the photographer may set out to manufacture a preconceived image in the darkroom—the montage.

Increasing grain

In the majority of pictures grain is merely a nuisance, distracting the eye from the main subject, and as a result photographers and manufacturers devote a great deal of effort to keeping grain to a minimum. There are nevertheless occasions when general principles can be broken and grain deliberately sought. Grain can be exaggerated by applying all the usual rules in reverse. The fastest suitable film, overexposure, overdeveloped negatives, hard paper and massive enlargements—all these factors can be employed to give varying degrees of increased grain size and texture in the final print. In addition (*right*) a special speed-increasing developer can be employed instead of the normal film developer. This picture, for example, was taken on *Ilford HP5* (400 ASA) rated at 1600 ASA and developed in *Paterson Accuspeed FX-20*. It should be noted, however, that highly uprated film exhibits other characteristics, particularly high contrast and loss of detail.

Photogram

Requiring neither camera nor lens, the photogram is the simplest way of creating pictures with photographic materials. Unlike a print made from a negative (the image of an object), the photogram records the object itself. They are capable of surprising subtlety and artistry—both Man Ray and László Moholy-Nagy used the idea and developed its application—and the complexity can be increased by combining photogram images with more familiar photographic techniques. To make a photogram, place an object or objects on a sheet of photographic paper and expose it to light. When the paper is developed a negative shadow silhouette will appear. The enlarger can be used, but less conventional light sources, such as a torch or match, may be introduced to vary the effect. Any object can be used to produce a photogram, and it will work on film or any other light-sensitive material as well as paper. Though remarkably simple, the photogram is the basic principle on which the X-ray used in medicine is based.

Reducing the print

After a print has been processed there is little that can be done to increase its density, but it can be reduced by the use of Farmer's reducer (*right*). This is a chemical solution which, diluted and applied to the wet print with a brush or swab of cotton wool, will bleach away the silver image. The surface of the print should be flooded with water to prevent definable and sudden changes in tone, and after use the print must be fixed again and washed. A slightly muddy or overexposed print can be totally immersed in this solution to brighten the highlights, but it is important to note that it will affect the lighter tones of the print first and most drastically, and for this reason tends to increase the contrast where applied. Used carefully and sparingly, it can often enhance the effect where shading would be less successful.

The Sabattier effect (pseudo-solarization)

This technique (*below*) which involves re-exposing and fogging a negative part of the way through the development and then continuing normally, produces an image which is partially reversed in some areas. It is largely a matter of trial and error with several variables but, as a basis for experiment, the beginner could first try re-exposing half-way through development for one second to a 100-watt lamp about $2\,m/6\frac{1}{2}\,ft$ away when using a film of 100 ASA. The same method can be applied to prints, but the overall effect will be very dark. Though this technique is sometimes known as solarization, true solarization is achieved by massive overexposure when making the negative (about 1,000 times the exposure needed to give a "normal" result).

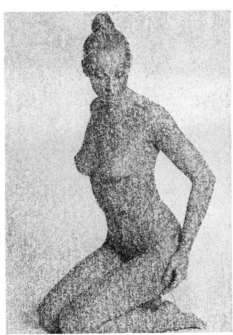

Texture screening

A number of simple techniques can be employed to alter the effect given by printing a negative in the normal way. It is possible to create a soft focus appearance, for example, by placing a piece of diffusing fabric, such as a nylon stocking, over the enlarger lens. This has a rather different effect from the one given by diffusing the camera lens (for colour examples see page 88) because, instead of the highlights spreading into the shadows, the reverse happens—the shadows spread into the highlights. A similar result can be obtained from texture screening (*above*), where the negative can be printed while sandwiched in contact with a texture screen; these are available from photographic suppliers or can be made. The example shown was produced by sandwiching the negative in contact with a piece of translucent paper used to make storage bags for negatives. A pseudo-grainy effect can also be produced by making a greatly enlarged high-contrast print from a piece of evenly fogged or exposed film and then rephotographing it on to a negative the same size as the intended print. These are then placed together in contact in the negative carrier and printed together.

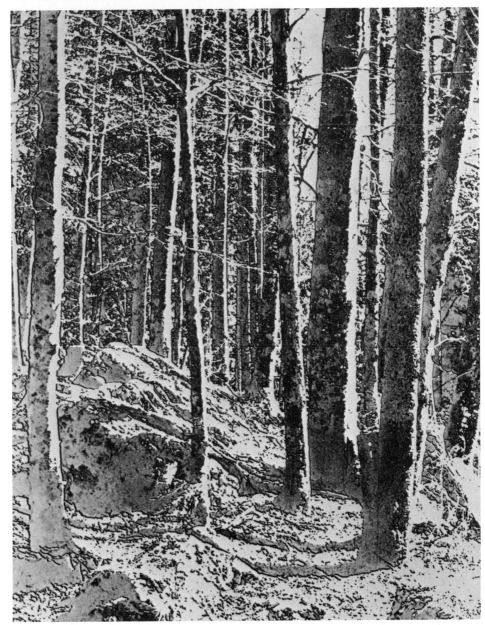

Special effects-2

COLOUR PICTURES FROM BLACK AND WHITE

The various techniques described and represented here all provide means of producing coloured pictures from black and white material. Technically they belong to the realm of black and white and, just as a coloured drawing is not the same thing as painting, they should not be regarded as less sophisticated substitutes for colour photography. If they are the results are likely to be disappointing. On the other hand, colours can be used to pick out or to dramatize the essential or graphic elements of a monochrome photograph.

Toning and hand-tinting are relatively controllable ways of introducing colour, and a little experimentation should produce the required effect. Making colour prints directly from black and white negatives, however, is fairly unpredictable, though it is this random element that often gives the technique its appeal.

Sepia toning

A range of colours can be added to a print after normal processing, sepia (*right*) being the most common. Various recipes are available (a few of them in prepared form) but the principle they use is generally the same. Two stages are involved, normally requiring two separate baths—the first to bleach out the existing silver image, the second to form a new image out of a coloured compound (silver sulphide or silver selenide in the case of sepia). Processing document lith paper in special developer will also produce a stained, toned quality. (NARU INUI)

Hand-colouring

Both prints (*above*) and large transparencies (*left*) can be tinted by hand using an airbrush or a good quality paintbrush. The clown (*left*) was first photographed in black and white and, after initial retouching, such as the removal of unwanted lines, the print was photographed on colour film and colour tints put on the transparency. The advantage of this method is that scalpel marks, which might be visible on a transparency, are not evident if executed on a print.

Various special dyes and tinting inks are available for hand-colouring, but ordinary water-colours can also be used for prints. The most serious disadvantage is that results are less permanent, but this may be a distinct advantage to the beginner since mistakes can be corrected. A clear idea of the qualities of the original makes it easier to create the right effect. Details about techniques and materials are given on page 190.
(*Above*: NARU INUI; *Left*: STEVE BICKNELL)

Posterization

This striking landscape by the late Walter Marynowicz demonstrates the effect of colour posterization, an extension of the monochrome posterization process of flattening and separating tonal areas of a photograph. For monochrome four-tone separation, an original negative is printed on to three separate sheets of high-contrast lith film and exposed for a different time in each case to produce positives of strong, weak and intermediate density. The shadow separation is underexposed so that highlights and mid-tones are clear and only shadows are black; the mid-tone separation is correctly exposed so that deeper greys and blacks merge while

highlights and light greys are clear; the highlight separation is overexposed, leaving only the highlights clear. The three positives are printed one at a time, for exactly the same time and in precise register, on continuous tone film. This forms a master negative of four distinct tones, including white, which is then printed on normal grade paper.

In colour posterization the tone-separated negatives are printed through colour filters, enabling the photographer to produce an abstract colour print from a black and white original. A master positive, made from the original negative, is copied on to lith film with varying exposure levels to produce negatives of progressively increasing solid tones. From the

negatives high-contrast positives are made, from which are derived a second set of negatives. Each positive is printed through a colour filter, with each secondary negative acting as a mask for its positive equivalent when the subsequent positive is printed through a different colour.

Registering the various coloured images on the printing paper is crucial and the stud method is recommended: the negatives and positives are physically linked by pairs of holes punched along one edge of the films. A contact printer with appropriately spaced studs is necessary for making the films and a negative carrier with identical studs for making the prints.

Special effects/3

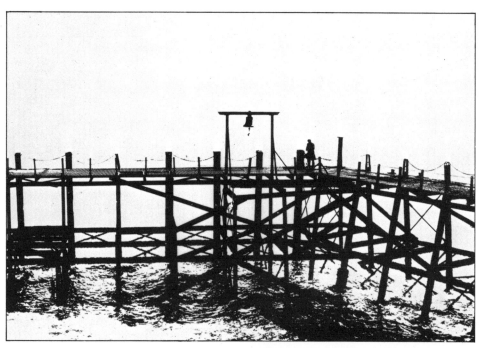

In its most familiar form black and white photography depends heavily on tones, the gradations of grey which separate pure black from pure white. It is these tones, as much as the accurate shapes of the objects, that are the cause of a photograph's illusion of reality: belief in a photograph is sustained by its tones even when the image is wildly improbable, like the montage picture on the opposite page. Conversely, a straightforward image can lose its commonplace associations and acquire novelty and interest as its tones become eliminated.

The photographer can exercise a limited amount of control over the tones of his print by using different grades of paper (page 178) and various kinds of reducers (page 184). But to exert complete control over tone, eliminating it so that all that remains is a semi-abstract image consisting of simple black and white areas, it is necessary to employ more radical techniques. This departure from realism is marked by

Tone elimination

The illustration above is an example of tone elimination—a picture consisting only of pure black and pure white. The simplest way of achieving this effect is with "lith" film, a special high-contrast film (usually ortho-chromatic) requiring its own developer. The image is first enlarged on to lith film, and the resulting positive recopied on to lith or normal film by contact printing. The final negative can be printed or enlarged in the usual way.

Tone separation/Posterization

Sometimes known as posterization, tone separation is similar in principle to tone elimination. Three positives are made on lith film, but in each case a different exposure is used. This produces three positive transparencies that are all equally dense but in which different proportions of the original negative have turned black. When dry, these three positives are re-copied, one at a time, on to a single sheet of ordinary continuous tone film. The exposure is made so that the first image gives a light grey; the second, exposed for an equal time, gives a greater density where it overlaps with the first; and the third, again exposed for the same time, gives a maximum black density where all three overlap. The negative is developed and printed as normal.

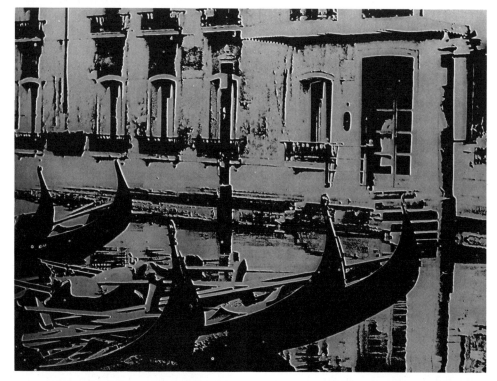

an important step in procedure, namely the introduction of intermediate negative/positive stages that successively alter the original negative. Thus instead of one negative the photographer can have at his disposal any number of transparent images, all as different from each other as he likes to make them, but all nevertheless made from the same original. The number of permutations in the way the picture can be printed is greatly increased, and the basic purpose of these two pages is to suggest how different combinations can be used to produce various effects.

Once the idea of intermediate stages has been grasped, however, photography begins to lose its completely distinct character, since techniques belonging to other methods of printing can be introduced, such as silkscreen or lithography, leaving photography merely a part of an overall process. But the scope of this book is necessarily limited to "pure" photography.

The illusion of a picture "carved" into the paper like a sculptural bas-relief is produced by sandwiching two transparencies, one negative and the other positive, slightly out of register. It is possible to make the positive on ordinary film, or on high-contrast lith film to combine this effect with tone separation. The two transparencies can be sandwiched in the enlarger, and this allows adjustment to the direction of misalignment (which alters the effect) before making the final print.

Multiple image printing

Photomontage (*right*) combines two or more negatives (*above*) in a single picture. Care and patience are required, particularly if it is to appear as though the photograph has not been manipulated. The difficulties increase with the number of negatives being used. One method is to cut out different prints, paste them all together, and simply photograph the result. With less detailed work, however, it is possible to blend the images directly while making the enlargement, making a different test strip for each negative. The print must be shaded carefully during each exposure to control overprinting – some overlap is often desirable to blur the borders of the join. The trick in fitting the images together is to trace the outline of the main image from the enlarger on to a sheet of ordinary paper and use this drawing as a guide when aligning subsequent images.

Presentation/Retouching

No matter how much care is taken in the darkroom, blemishes, spots and scratches will still sometimes occur. These can almost always be corrected by retouching; obviously it is better to retouch the print since, unlike a spoilt negative, it can always be replaced. When working on a print the only requirement is a firm, solid surface, but to make retouching and bleaching easier, it is advisable to mount the print on to card. Dry mounting (see page 192) is preferable, but a rubber-based solution is acceptable.

When working on negatives and transparencies it is essential that light shines through them towards the retoucher. Photographers' retouching desks are available, but they are expensive; a home-made device can be constructed by placing the negative on a raised sheet of ground glass with a light source beneath.

Equipment for retouching

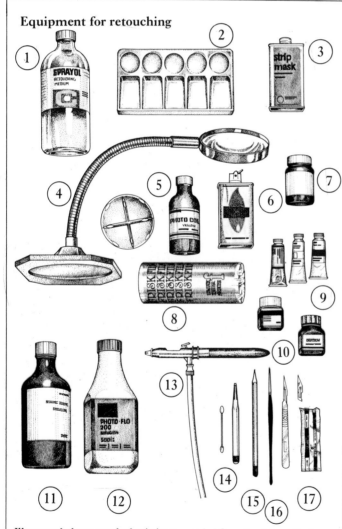

Illustrated above are the basic items needed for retouching, all of which are available at most art shops. The chemicals can be bought from general chemists.

1. Retouching medium fixative
2. China pallet
3. Strip mask
4. Magnifying glass
5. Photo-dye
6. Petrol lighter fuel
7. Hypo-crystals
8. Clear adhesive low-tack film (Frisk film)
9. Designers' gouache
 (permanent white and lamp black) and sepia (water colour)
10. Photographic dyes
11. Strong iodine solution
12. Wetting agent
13. Airbrush
14. Swab sticks
15. Fibreglass pencil
16. Sable-hair spotting brush
17. Scalpel and various blades

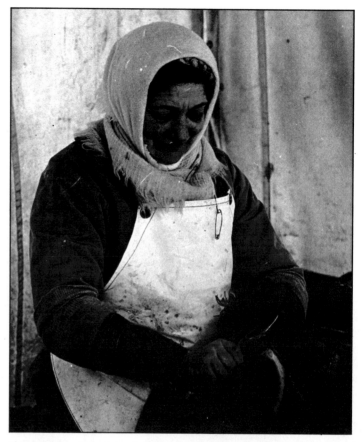

Retouching black and white and colour prints

The black and white and colour photographs (*above and below*) required a certain amount of retouching to improve their general appearance and quality.

Black and white prints

In the black and white picture the background, which contributed little to the image, was deleted to give more emphasis to the woman at her work. This can be done by bleaching and airbrushing or simply by airbrushing alone with designers' gouache (see caption 7 on the opposite page). The lower right corner of the print was too dark overall and was lightened with a bleach solution of diluted iodine. Lightening smaller areas than this, as opposed to deleting them altogether, can also be done with a fibreglass pencil.

Though the pins on the woman's apron tell us something of her work (and her methodical nature) they were deleted as a retouching exercise. The whole print was then

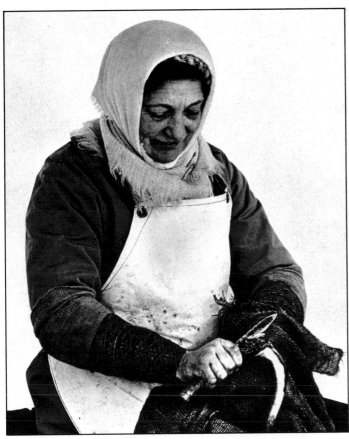

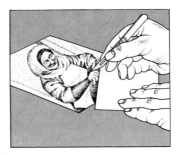

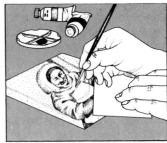

Dark spots can be removed with a scalpel. It should be sharp and held low down to aid control. The print's surface is scratched gently without breaking into the emulsion.

White spots are removed by applying photo-dye in varying strengths with a brush. A magnifying glass is helpful on very small spots.

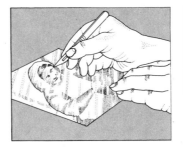

Gauging the amount of pressure needed to cut through low-tack masking film without cutting the emulsion is a matter of practice—initially on inferior prints.

When 35 mm film is blown up there is apt to be grain on the print. To obtain a matching effect when spraying with designers' gouache a splatter nozzle should be used.

spotted and scalpelled to remove both dark and light spots, such as the ones on the woman's scarf. Finally, the edges of the scarf (which appeared to be disappearing into the now grey background) and other detail were "held" with photo-dye. The picture was then sprayed with retouching medium to prevent smudging.

Colour prints

The corrections required on the negative-positive (C-type) colour print largely involved eliminating scratch marks and black and white spots. Unlike black and white prints, C-types and silk finish prints cannot be scalpelled. The C-type emulsion surface is made up of different layers of colour and scalpelling will merely expose another colour. Glazed prints present another problem because designers' gouache becomes matt when dry and is easily recognisable as being retouched. The answer in such cases is to use colour dyes on white spots and designers' gouache on the dark areas.

The retouching sequence

Deleting unwanted background is essentially a simple process, provided the steps are followed strictly in the correct order.

1. Lighter fuel on cotton wool should be applied to the whole surface of the print to remove any greasy deposits, like finger marks.

2. Cover the print with Frisk film, a low-tack masking film available from art shops. Since this does not adhere to the emulsion of the print, the emulsion will not be pulled up. If the subject to be masked is intricate, such as a skyline with numerous chimneys, a rubberized strip mask is available, and this is applied with a brush over areas not to be bleached.

3. If Frisk film has been used, lay tracing paper over the print and burnish with the side of a pencil.

4. With a scalpel, cut through the Frisk film around the area to be bleached, making sure not to cut into the emulsion of the print. The amount of pressure needed can be gauged with practice.

5. Remove the Frisk film from the area to be bleached. Prior to bleaching, a weak solution of wetting agent should be applied to

this area to ensure even application of the bleaching solution.

6. Bleaching. Apply a strong iodine solution of bleach with a swab of cotton wool, and leave until the image disappears.

7. The bleaching agent must then be neutralized with hypo-crystals, again applied with a cotton wool swab. An alternative method is to use an airbrush with designers' gouache. After masking, mix lamp black and sepia together with permanent white to the desired grey. The overall tone of a print varies from very cold to warm and can be matched by different combinations of these colours.

8. Whichever method is used, when retouching is complete the print should be sprayed with a retouching medium fixative. This will prevent delicate areas smudging but will still allow further retouching at a later stage if necessary.

9. To lighten an area rather than delete it altogether, the procedure is the same as for bleaching, but the iodine solution must first be diluted to an appropriate strength (see caption 6). A fibre-glass pencil can also be used to lighten small areas slightly.

Presentation/ Mounting and storage

MOUNTING PRINTS

Mounting a photograph for display is the last stage in the photographic process and, unfortunately, it is all too often given the least care and thought. This is a needless waste: a good picture will lose much of its impact if poorly or in-appropriately mounted, while even the very best of photo-graphs will be enhanced by suitable presentation.

Many photographs benefit from the use of a cut-out mount. This is simply a piece of card in which an aperture is cut, preferably with a bevel, to the size of the print area, then secured on top of the mounted print and trimmed flush. Consideration must also be given to a suitable type of frame.

Warm-air dryer

A new generation of waterproof papers impregnated with plastic no longer absorbs developer or fixer chemicals. Long contact with heat is therefore unnecessary. A typical dryer (*right*) for modern resin-coated paper grabs the paper, squeegees surface moisture back into the drip tray and, as the paper is transported through the machine, gently dries it with a flow of warm air.

Wet mounting

The simplest method of mounting prints on to card or hardboard for display purposes is to use an adhesive. Not all glues are suitable for photographic papers, however, since some react to the materials and can cause discolouration. A strong binding latex solution or an aerosol mounting spray are ideal and are the most commonly used. The process is essentially simple provided that it is followed step by step with care.

1. Briefly soak the print to be mounted and a reject print for backing purposes in cold water.

2. Remove excess water from the surfaces of the two prints with a squeegee.

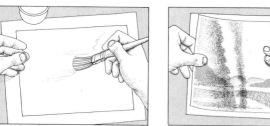

3. Brush or spray a thin, even film of adhesive on to one side of the mounting board.

4. Align the print to be mounted and press firmly and evenly on to the glued side of the board.

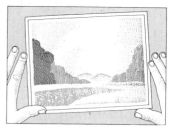

5. Affix the reject print to the back of the board; trim the print with a craft knife or scalpel.

6. The process is now complete and the mounted print is ready for framing and display.

Dry mounting

In all respects more effective than wet mounting, dry mounting involves sandwiching a sheet of special tissue between the print and its mount and applying heat and pressure to melt the tissue and form a bond between them. Although special equipment can be bought, it is a simple technique to carry out with an ordinary domestic flat iron on a low heat.

1. Put the print face down on clean card and position tissue on the back; tack tissue with the iron.

2. Turn the print face up and trim print and tissue together so they are flush.

The dry mounter

For photographers who undertake a great deal of dry mounting, a special machine will save the somewhat laborious use of a flat iron. The print is put on its mount, with a layer of adhesive tissue between them, and aligned on the baseboard. A handle enables a hotplate to be pulled down, pressing print to mount.

3. Put print on mounting board, peel back corners and tack tissue with iron to fix it to the mount.

4. Place a piece of clean card over the print and apply firm pressure with the iron from the centre.

STORAGE

There are two considerations when choosing a method for storing slides and negatives: they should be easy to locate when required, and they must remain in good condition. The first presents little difficulty, provided the photographer decides on a method of classification and keeps strictly to it. Transparencies, for example, can be fitted into numbered slots in special transparency boxes; an index card in the lid provides space for a short description of each slide. Coloured adhesive labels, usually in the form of small circles, or dabs with different colours of ink, are another method of indicating subject categories or distinguishing batches or years. The method is largely a matter of personal preference.

Several types of files, boxes and drawers for storage are now available from photographic suppliers—again it is a matter of function, size and personal preference—but consideration must be given to the storage site. In most rooms in a well-heated house there are no problems, but if an attic or a garage has to be used, where damp may be present, sealed containers are a wise precaution. Special containers are also available for very hot or tropical conditions.

Uncurling a print
Because most print papers consist of a paper base coated with an emulsion, and the two often shrink unevenly in drying, prints tend to curl at the edges. To correct this, the print must be placed face down on a clean surface and the back dampened with a sponge. The print is then sandwiched between clean sheets of blotting paper and pressed down with heavy objects larger than the print area.

Storing prints
Steel cabinets are important for storing prints, especially colour prints, which fade with sunlight. Prints should be protected with acid-free interleaving papers, such as the black type used to wrap black enlarging paper.

Interleaf material

Plastic file sleeve

Cardboard container

Plastic holder

Brown paper sleeve

Metal files

File book and tissue sleeves

Storing negatives
Because they are highly susceptible to gases given off by low-grade paper, negatives must be stored with great care. An old shoe box, for example, will not do. They can be adequately protected by transparent sleeves, secured in vinyl binders. There are many suitable filing cabinets on the market and the choice is merely one of size and cost.

Acetate sleeve

Brown acid-free sleeve

Plastic drawers

Case file

Marking slides
Transparencies should be kept in slide holders. Coloured spots will help identification while a diagonal line drawn across the frame is useful for keeping the sequence.

View pack

Acetate sleeve

Cassettes

Storing slides
Transparencies are extremely susceptible to moisture and storage should allow for fully circulating air. Many boxes and cassettes fulfil this requirement and also provide strong and compact housing. Viewpacks fit conveniently into filing cabinets and have the extra advantage of allowing a number of slides to be seen at the same time.

Presentation/Projectors

Undoubtedly the most effective way of presenting colour slides is through a projector, and although it involves a degree of inconvenience, a well planned slide show will usually produce a satisfied audience and the sheer size of the photographs will add greatly to their impact.

Editing the slides

Probably the most important aspect of a successful slide show is careful editing; nothing is guaranteed to bore an audience more than a succession of slides of the same subject when there is little change in the viewpoint or the action. It is worth being quite ruthless in this respect, selecting only the very best of each sequence—unless of course the sequence develops a theme or leads to a specific climax.

The order of slides is an important consideration and should be planned carefully. Variety is essential and in some ways a slide show should follow the lines of a well directed and edited film. Distant views should be interspersed with mid-distance shots and close-ups, but violent changes in colour or density of slides should be avoided unless used for dramatic effect. Ideally, the slides should be shown in an order which tells a story or develops a theme, and to avoid boredom too many slides without human interest should be avoided.

Preparation for the show

It is also necessary to make all preparations carefully—the projector set up, the image sized up and focused on the screen, the magazines loaded carefully in the right sequence and numbered clearly, and a check made that all slides are the right way up. It is also advisable to have a spare projector lamp and fuse at hand in case of electrical mishap. All of this should be done well in advance of the audience's arrival. A trial run through is strongly recommended.

There are many refinements that can be introduced. Some form of background music is often an advantage and, if there is to be a commentary, this should be well planned or pre-recorded. For the real enthusiast it is well worth considering two projectors, enabling fades and dissolves to be achieved.

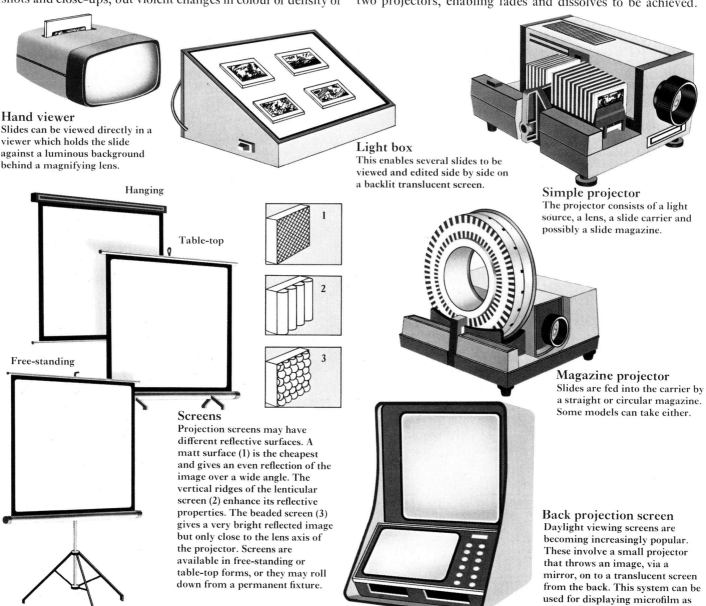

Hand viewer
Slides can be viewed directly in a viewer which holds the slide against a luminous background behind a magnifying lens.

Light box
This enables several slides to be viewed and edited side by side on a backlit translucent screen.

Simple projector
The projector consists of a light source, a lens, a slide carrier and possibly a slide magazine.

Magazine projector
Slides are fed into the carrier by a straight or circular magazine. Some models can take either.

Hanging

Table-top

Free-standing

Screens
Projection screens may have different reflective surfaces. A matt surface (1) is the cheapest and gives an even reflection of the image over a wide angle. The vertical ridges of the lenticular screen (2) enhance its reflective properties. The beaded screen (3) gives a very bright reflected image but only close to the lens axis of the projector. Screens are available in free-standing or table-top forms, or they may roll down from a permanent fixture.

Back projection screen
Daylight viewing screens are becoming increasingly popular. These involve a small projector that throws an image, via a mirror, on to a translucent screen from the back. This system can be used for displaying microfilm as well as for showing transparencies and 8mm cine films.

PROJECTED BACKGROUNDS

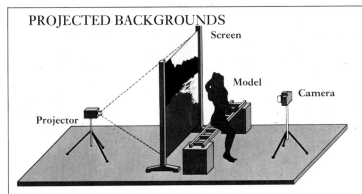

Screen

Model

Camera

Projector

A background for a photograph may be provided by a projected slide. The illustration shows an idealized set-up for back projection, but the problems involved—projecting a bright enough image to be recorded by the camera, and lighting the subject so that no front light falls on the screen and washes out the image—mean that separate exposures must be made for the subject and the background as described on page **90**. Professionals usually avoid the problems by using the front projection technique described on the same page.

Lecture hall projectors
Heavy-duty projectors for lecture theatres (*below*) can project both prints and slides through different optical systems.

Remote control projector
Some projectors can be controlled from a distance by a hand-held console by which individual slides may be selected and focused.

Dissolve projectors
A gradual dissolve from one projected image to another can be achieved by using a special type of twin-lens projector.

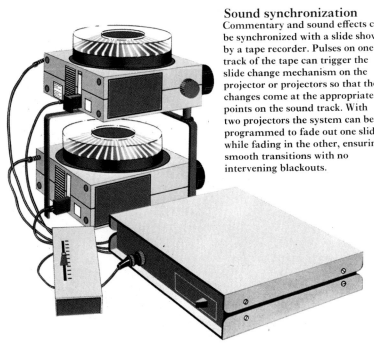

Sound synchronization
Commentary and sound effects can be synchronized with a slide show by a tape recorder. Pulses on one track of the tape can trigger the slide change mechanism on the projector or projectors so that the changes come at the appropriate points on the sound track. With two projectors the system can be programmed to fade out one slide while fading in the other, ensuring smooth transitions with no intervening blackouts.

COPYING TRANSPARENCIES

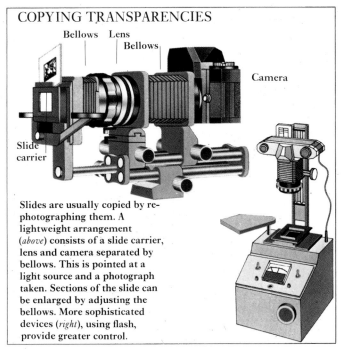

Bellows Lens
Bellows

Camera

Slide carrier

Slides are usually copied by re-photographing them. A lightweight arrangement (*above*) consists of a slide carrier, lens and camera separated by bellows. This is pointed at a light source and a photograph taken. Sections of the slide can be enlarged by adjusting the bellows. More sophisticated devices (*right*), using flash, provide greater control.

EQUIPMENT GUIDE

" *Simplicity is the prime requisite. The equipment of Alfred Stieglitz or Edward Weston represented less in cost and variety than many an amateur can 'barely get along with'.* "

ANSEL ADAMS

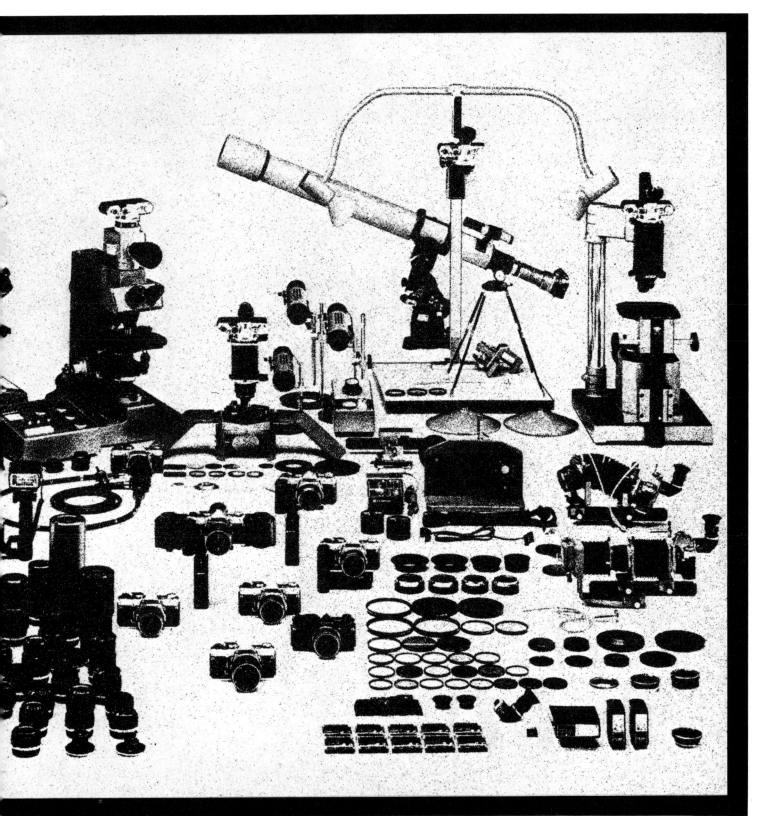

The camera

FORMAT

The variation in camera format, in quality, size and portability is bewildering, providing a staggering choice for the would-be photographer. In roll film it offers subminiature/ 110, 126, half-frame (or more correctly single-frame) and full- (double-) frame 35mm, 6×4.5 cm, 6×6 cm/$2\frac{1}{4} \times 2\frac{1}{4}$ in, 6×7 cm, and 6×9 cm; in cut or sheet film there is 6×9 cm, 6.5×9 cm, 5×4 in, 5×7 in, and 10×8 in. An indication of the range is given on the opposite page.

Subminiature Some, like the *Minox*, are exquisite pieces of precision engineering, but they are essentially a rich man's toy. Film (16mm) is limited in both range and quality, home processing is almost impossible and processing laboratories handling it are few. The format is tiny and big enlargements are essential for acceptable, viewable results.

110 The 110 camera, also using 16mm film, has pre-loaded drop-in cartridges to suit the novice. Most have limited shutter speeds and are at the opposite end of the engineering spectrum from the *Minox*, usually with a fixed-focus lens. The quality of the image depends largely on the precision of the cartridge moulding. Its great asset is its pocket size.

126 This was initially *Kodak*'s earlier attempt at a cartridge-loading camera, though the designation of *Instamatic* led many people to assume it was an instant picture, rather than an instant load, camera. This format suffers from the same drawbacks as the 110 regarding choice of film, factory processing, and lack of accuracy in focusing due to the absence of a proper pressure plate (manufacturers' efforts to market a precision version have met with little success), but the 126 transparencies are returned from processing in 5×5 cm mounts, the same size as for 35mm film. Thus the slides can be shown in the same projector. This, plus its simplicity, makes it an ideal camera for children or for anyone who merely requires quick, small snapshots. Both 110 and 126 films are more expensive per shot than 35mm.

Half-frame 35mm These cameras use standard 35mm cassettes and share the precision finish of the full-frame 35mm. They are now almost completely obsolete.

Full-frame 35mm With a selection from simple viewfinder cameras to very expensive SLRs, this is the natural choice of format unless there is an excellent reason for deciding otherwise. Apart from the wide range and the superb quality of the best cameras which employ it, the dominance of 35mm provides a massive choice of film types, lenses, enlargers, processing equipment and projectors. It is also the largest format for which the ubiquitous and reliable *Kodachrome* is available.

127 Now largely defunct, 127 roll film is used in cameras such as the *Baby Rollei*, which have produced some of the finest colour slides in history. Though larger than 35mm at 4×4 cm, the slides will fit certain up-market projectors.

120 The medium-format roll film, 120 produces negatives or transparencies in format size 6×6 cm (12 shots), 6×7 cm (10) and 6×9 cm (8), as well as the reintroduced 6×4.5 cm (16) with some new SLRs. The cameras using 120 film include some famous and respected names, notably *Hasselblad*, *Bronica*, *Rolleiflex*, *Yashica*, *Pentax* and *Mamiya*.

Large format Essentially, anything larger than 6×7 cm can be considered large format. Technical cameras are mainly of monorail construction, although baseboard types are still made in the smaller sizes. These cameras, giving excellent quality and allowing great control over depth and perspective with their movements, are known as studio, view or, sometimes, field cameras. Because of their price and lack of portability they tend to be used mostly by the professional. The film—in sheet form loaded into dark slides—comes in 6×9 cm, 6.5×9 cm, 5×4 in, 5×7 in and 10×8 in.

CHOOSING A CAMERA

There are two basic considerations in selecting a camera—financial and functional. Few people are lucky enough to be able to buy exactly what they want, and resources are a problem, but remember that with a good quality, reasonably sophisticated camera the lenses and other accessories can be added gradually. The other consideration is less simple: most amateurs (and many professionals) do not specialize and need a camera which is capable of handling most eventualities.

The economy outfit

Because economy 35mm viewfinder cameras do not possess sophisticated controls, the photographer can make only one or two basic decisions. However, a good, well-made instrument used intelligently can produce excellent results. They are small, light and quick and easy to use. The disadvantages are big ones: they cannot provide the scope given by long-focus or wide-angle lenses, and they cannot handle extremes of light levels. An example of this sort of beginner's camera would be an *Olympus Trip* **35**, with its automatic meter, 40mm lens and minimum accessories.

The medium outfit

This would comprise a low-cost body with a moderate lens of normal focal length (50/55mm) and an aperture of $f2.8$ or even $f2$. A wider range of lenses and accessories can be added later. Cameras such as the *Pentacon Praktica* or those wearing "house brand" labels from the *Chinon* factory would be a fair choice. *Pentacon*, the Russian *Zenith* and some *Asahi Pentax* use the very popular 42mm screw lens mount, thereby ensuring a fabulous range of optics in almost every price range available. For an "ideal outfit", see page 200.

The camera dealer

A good dealer can be a huge asset to a photographer. In exchange for regular custom he should be able to provide sound advice from years of experience in the trade, back-up systems and even tuition where necessary. If your local store is not friendly or fair, find one that is. The same principles apply to repairs: you will have to pay for top-quality workmanship, but do not accept poor work or indifferent service.

Buy new equipment where the budget allows, and if this is not possible for some items seek advice on second-hand purchases from the specialist dealer. Buying cameras is like buying cars in many respects: after some months you can discover that the first choice is uncomfortable to use or inappropriate for your purpose. A new model may have come on the market and the camera buff has immediately had to buy it. All these factors tend to make for an interesting second-hand market.

Some equipment is never obsolete. Most modern *Nikon* accessories, for example, will fit their early cameras, and the same can be said of most up-market equipment. Be cautious with equipment bearing strange names, even though it looks identical to those with familiar ones, and of equipment made by manufacturers who have gone out of business: the camera may be sound but spares may be non-existent. In all these cases the good dealer should be able to offer advice.

The largest format available, the view or studio camera, is most commonly 5 × 4 in, but 5 × 7 in and 10 × 8 in are also used for quality work in the studio.

The medium-format technical cameras, taking mainly 6 × 7 cm, 6 × 9 cm and 9 × 12 cm film, are valuable in aerial photography and for quality general-purpose work.

Both the TLR (*right*) and the large-format SLR (*left*) take 6 × 6 cm/ 2¼ × 2¼ in roll film; these are mostly precision cameras with superb attachments and accessories.

The large formats

View cameras, having the largest film area, can produce the maximum of information, but are essentially confined to the studio. The movements of both film and lens planes allow the photographer to manipulate the image to control perspective and depth of field. Medium format loses the movements of the view camera (though a few 6 × 9 cm monorail and technical cameras are available) but gains by being hand-held. The 6 × 9 format, together with the later 6 × 7, now finds keen support among serious photographers. The 6 × 6 cm SLR combines the benefits of that camera type with a film size larger than the conventional 35 mm.

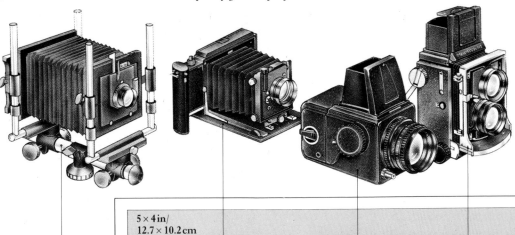

5 × 4 in/ 12.7 × 10.2 cm

6 × 7 cm/ 2¼ × 2¾ in

6 × 6 cm/ 2¼ × 2¼ in

35 mm (24 × 36 mm/1 × 1½ in)

126 (28 × 28 mm/ 1⅛ × 1⅛ in)

110 (13 × 17 mm/½ × ⅝ in)

The small formats

Of the smaller formats really only 35 mm can be used for anything but "snaps", and in general terms it is unbeatable. The range of cameras, films and back-up equipment is enormous in both size and price. Viewfinder cameras run from fixed-lens cameras to quiet precision instruments, like the *Leica*, with superb attachments. The SLR, however, with its visual benefits and increasing sophistication, dominates the higher end of the whole camera market and is the natural choice for the vast majority of general photographers. Though some 110s are quality cameras, miniatures have only limited applications.

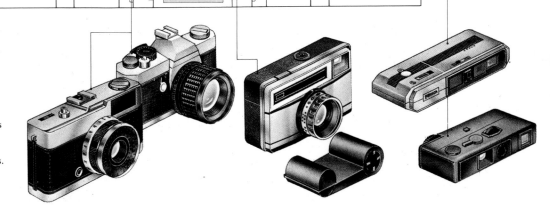

The 35 mm fixed-lens compacts (foreground) usually couple quality with low cost; the 35 mm SLR, with its lens change facility and mirror box, costs more.

The 126 instant-load cameras are low-cost, easy-to-use instruments ideal for the beginner. These should not be confused with the instant picture cameras.

The 110 instant-load cartridge cameras are today's miniature. Precision versions are available, but they cannot be considered for serious photography.

Camera systems

THE MODEL OUTFIT

The ideal system for the dedicated all-round amateur should be based on a first-class SLR body—*Nikon*, *Pentax*, *Olympus*, *Canon*, *Minolta* and *Contax* are all suitable. The standard lens can be backed up with one about half the focal length and one about twice the focal length, giving a range of 28/55/105 mm or, say, 24/50/85 mm. The range of lenses should be studied carefully (the makes are rarely interchangeable) and it may be advisable to hire one or two before purchasing. Remember, too, that more lenses means more weight, especially when a substantial protective case is included, and that it is all too easy to become a "Christmas tree photographer", laden with all sorts of dangling bits and pieces, half of which are never properly understood or used.

This arrangement of camera, spare body and three lenses would cover most shots, and would duplicate the sensitivities of most film in black and white, colour reversal and colour negative. But it is only a broad suggestion. A superb viewfinder camera with a quieter shutter and interchangeable lenses (the *Leica* is without peer) might be preferred to an SLR; the reportage or sports photographer may begin with the 85 mm as "standard" and increase to 150 mm or even up to 400 mm for his candid or action shots. The load could always be lightened by a zoom lens: this is a single unit with an infinite range of magnifications within the limits of the focal lengths and saves both space and time.

Motor drive

All leading SLR cameras are capable of accepting motor drive attachments. Different manufacturers offer different facilities—high framing speeds, preselected frame bursts, etc.

Viewfinder cameras

One of the more popular 35 mm compacts, the *Olympus Trip* offers precision with accurate automatic exposure control and quality optics. Most of the leading manufacturers—*Konica*, *Yashica*, *Minolta*—offer similar facilities at various prices.

Equipment for sport and action

Motor drive, long lenses and zoom lenses are all valuable assets in action photography. The motor drive attachment (*left*) allows the photographer to concentrate on capturing the action rather than winding the film on and enables complete physical movements to be taken. It is especially useful in conjunction with the basic prerequisite of the sports fan—the zoom or variable-focus lens (*below left*). This gives a wide range of picture possibilities as well as lightening the load, and is available in a variety of focal length combinations. For details of motor drive, see pages 206–7.

Light meters

Though most quality cameras have accurate built-in meters, these are limited in measuring range and are unable to indicate very long exposures. As well as performing its normal function, a hand-held meter can also be used to calibrate the camera's meter. The *Weston* (*below*) and *Lunasix* (see page 56) are perhaps the best.

50 mm /*f* 1.4

Extra body

24 mm/*f* 2.8

105 mm/*f* 2.5

The "ideal" outfit

The priorities for selecting a camera are a first-class body and the range of accessories. *Nikon*, the all-time best seller in 35 mm, in common with all leading manufacturers, offer a comprehensive choice. A sensible general-purpose range of lenses would be a 24 or 28 mm, a 50 or 55 mm and a 105 mm; this would cover urban shots and landscapes, portraits and some sports.

80–200 mm/*f* 4.5 zoom lens

The large-format SLR

In addition to combining the benefits of the 35mm SLR with a bigger film size (6×6 cm/$2\frac{1}{4} \times 2\frac{1}{4}$ in), the large-format SLRs also have interchangeable film magazines and a range of viewfinders—giving a fabulous choice of lens, film and viewfinder. The *Rollei SLX* is the most sophisticated, but *Hasselblad* now have the electronic *2000 FC*. The *Mamiya* twin-lens reflexes also have different viewfinders.

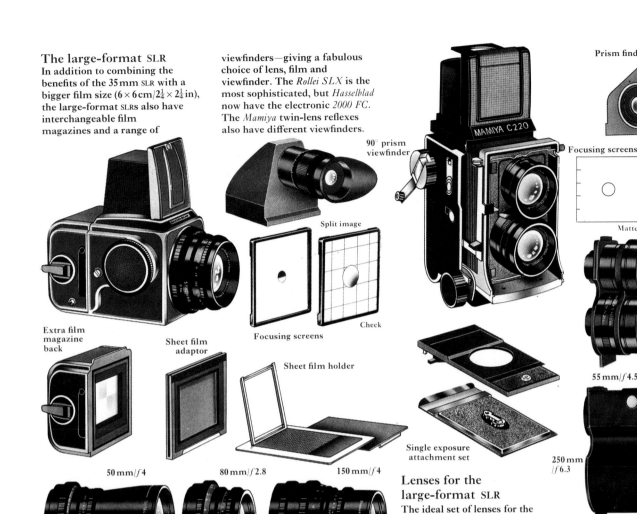

90° prism viewfinder

Prism finder

Focusing screens

Matte

Check

Split image

Focusing screens

Check

Extra film magazine back

Sheet film adaptor

Sheet film holder

Single exposure attachment set

55 mm/f4.5

80 mm/f2.8

250 mm /f6.3

50 mm/f4

80 mm/f2.8

150 mm/f4

Lenses for the large-format SLR

The ideal set of lenses for the 6×6 cm *Hasselblad* would be a 50 mm medium wide, an 80 mm standard and a 150 mm medium telephoto. This would cover most assignments and opportunities.

Lenses for the TLR

Good TLRs, such as the *Mamiya C* series, have interchangeable lens units. A basic set would be a 55 mm, an 80 mm and a 135 mm.

CAMERA CARE

Cameras can be encased in hard or soft covers, but these are often as much cosmetic as useful. They do, however, allow quick access. The safer bet is a soft shoulder bag called a clutch bag or, better still, a divided case made from aluminium or other strong material.

Hard cover

Soft cover

Clutch bag

Long lens cover

Hard case

Hard box-case

Aluminium case

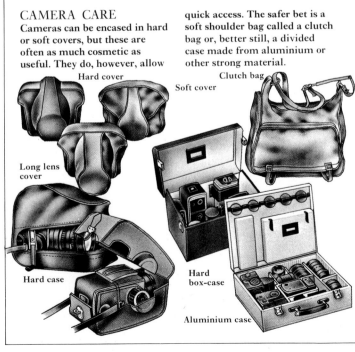

To clean lenses and the camera, inside or out, use a soft blower brush or small artist's paintbrush.

For sticky deposits on the lenses use cotton buds with distilled water and a little wetting agent.

Remove all traces of grit with the soft brush before using tissues to remove dust.

Cleaning can be done with cloth for optical glass, rolled and torn in half to provide a ragged edge.

The instant picture camera

For all practical purposes instant picture cameras have eliminated the time gap between making an exposure and seeing the result. The first model, and also the first camera using a diffusion transfer system for general photography, was introduced by Edwin Land in 1947. It produced sepia-toned positive prints in 60 seconds. Improvements quickly led to black and white prints and to a reduction in the processing time, in some cases to 10 seconds. Special materials now yield black and white transparencies, recoverable black and white negatives and, most impressive of all, colour prints.

Instant picture cameras have a number of obvious advantages. The most beneficial is that if a photograph is not satisfactory another can be taken immediately. On the standard instant picture cameras, exposure control is automatic and the camera easy to operate; most models are inexpensive and all take flashbulbs or cubes. Many professional cameras take special *Polaroid* camera backs, allowing the use of instant film to check exposure and lighting balance before the actual shot.

On the other hand, instant picture cameras tend to be bulky compared with a 35 mm compact because they are in effect a camera and a portable darkroom combined. Processing is necessarily of a simple nature, so that the quality of the results, although continually improving with new developments, is far below that achieved with conventional cameras. Nor are all subjects suitable for instant picture cameras; reasonable portraits and general shots can be obtained, but ambitious pictures may be disappointing. Formats are limited to four sizes— 7.75×7.75 cm/$3\frac{1}{8} \times 3\frac{1}{8}$ in, 8.25×8.5 cm/$3\frac{1}{4} \times 3\frac{3}{8}$ in, 8.25×10.75 cm/$3\frac{1}{4} \times 4\frac{1}{4}$ in—and a professional size, 12.7×10.2 cm/5×4 in. Finally, with one exception, they produce only a simple print with no negative, although prints can of course be copied and enlarged. In short, they will give good, immediate "snaps".

The simplest and cheapest instant picture cameras are for black and white only; at the other extreme, the most technically advanced model is a single-lens reflex camera using a type of instant film which is automatically ejected from the front of the camera immediately after exposure. For nearly 20 years *Polaroid* were alone among manufacturers of instant picture cameras, but *Kodak* are the first of a number of other firms producing new models to their own specifications.

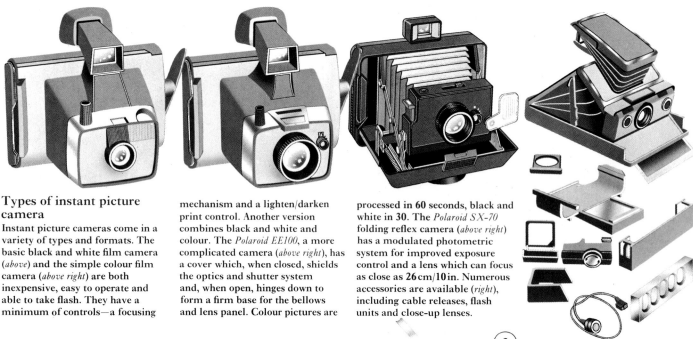

Types of instant picture camera

Instant picture cameras come in a variety of types and formats. The basic black and white film camera (*above*) and the simple colour film camera (*above right*) are both inexpensive, easy to operate and able to take flash. They have a minimum of controls—a focusing mechanism and a lighten/darken print control. Another version combines black and white and colour. The *Polaroid EE100*, a more complicated camera (*above right*), has a cover which, when closed, shields the optics and shutter system and, when open, hinges down to form a firm base for the bellows and lens panel. Colour pictures are processed in **60** seconds, black and white in **30**. The *Polaroid SX-70* folding reflex camera (*above right*) has a modulated photometric system for improved exposure control and a lens which can focus as close as **26 cm/10 in**. Numerous accessories are available (*right*), including cable releases, flash units and close-up lenses.

The development process

After the exposure, the self-processing equipment takes over. Film comprises negative and positive materials, folded separately in a container that fits into the back of the camera (1). The developer is contained in pods sandwiched between the two. After exposure, a tab of paper (2) is pulled to bring negative and positive into contact. The photographer then pulls a second tab to draw positive and negative through rollers (3), which squeeze the processing reagent between the two sheets. The negative is developed and the image migrates to the positive. After development the positive is peeled away (4).

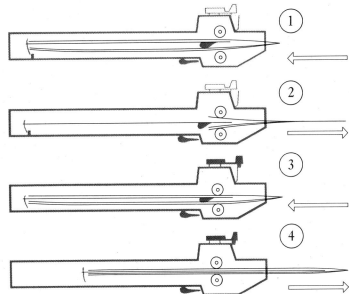

REUSABLE NEGATIVES

Type **105** and **55** black and white films give a reusable negative in addition to an immediate print. After processing for **30** seconds, the paper print is peeled from the film negative; the negative must then be cleared of developing chemicals by being immersed in a **12%** sulphite solution. It is then washed and allowed to dry. A clearing tank may be used during the clearing process.

The SLR instant picture camera

When light enters the *SX-70* it is reflected by mirrors to the eyepiece, where the subject appears the correct way round and upright.

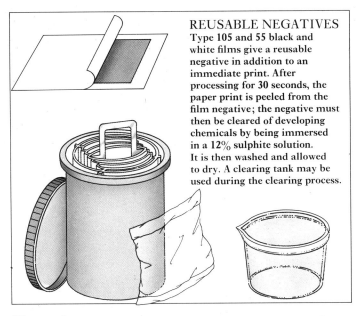

During exposure, a hinged Fresnel viewing mirror snaps up against a fixed viewing mirror; the image is then reflected downwards on to the film by a "taking" mirror on the lower side of the Fresnel mirror.

The film is ejected from the front of the body. The camera may be folded flat (*below*).

Adapting view cameras

A special holder (*left*) to fit **5 × 4** in format cameras takes film packets with the sandwich of negative and positive sheets and processing pod enclosed in a protective envelope. The packet is inserted into the holder (**1**), the outer envelope partially withdrawn (**2**) and the film exposed. The envelope is reinserted (**3**) and the control arm set to processing position. The envelope is pulled through the rollers and out of the holder (**4**). After processing, the packet is stripped apart.

The SLR instant picture

This *Polaroid SX-70* (*left*) is powered by a battery in each film pack. On exposure, a silicon diode photocell measures the intensity of the light, controlling the electronic shutter to give correct exposure. After exposure, the film is driven by a motor through rollers to burst the processing pod and spread developer within the film sandwich. A blank, dry print emerges from the camera, and in seconds a positive colour image appears (*above*). The final image (*right*) is visible in a few minutes.

Lenses

Lenses for the 35 mm camera

A large range of interchangeable lenses are available for the more sophisticated versions of most camera types. The 35 mm SLR offers the best selection, from the fisheye (*near right*) to the 2000 mm super-telephoto mirror lens (*see box*). Those featured on the right are all made by *Nikon*, and are only a selection from their range. No photographer will use all of them—most professionals only carry three or four, or save weight with a zoom lens—but it illustrates the variety now made.

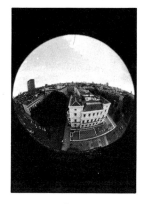
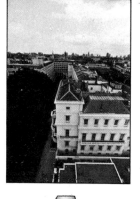
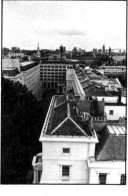
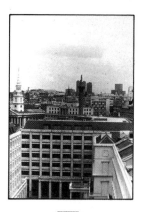

8 mm/*f*2.8 15 mm/*f*5.6 35 mm/*f*2.8 85 mm/*f*1.8

Virtually every camera is offered with a so-called standard or normal lens. This is usually of a focal length approximately equivalent to the diagonal of the negative format. The very popular 35 mm format offers in full frame a negative 24×36 mm. The diagonal of this is approximately 43 mm, and lenses in the range of 45 to 55 mm are usually provided.

Many photographers have expressed a preference for either the 35 mm semi-wide or 85 mm long-focus lens as a standard, choosing the 28 mm as a true wide-angle, the 135 mm as a portrait lens and the 200 mm for sports and reportage.

Lens speed

Lenses of all focal lengths are spoken of as having speed—the facility for the photographer to use a fast shutter speed. Thus the owner of the expensive *f*1.2 lens can, all other factors being equal, use a faster shutter speed than the owner of the more modest *f*2.8 lens. Most lenses, in fact, offer the best results within two stops of open and two stops of closed. A *f*1.2 lens would thus be best from about *f*2.8 to *f*8, while a lens with a maximum aperture of *f*2.8 would equal the performance of the bigger lens from about *f*5.6 to *f*11. A photojournalist would appreciate the light transmission of the bigger lens, while the landscapist would prefer the quality of the imaging at *f*11 on the smaller lens. It would appear, regardless of lens sales, that most pictures are actually taken at apertures between *f*8 and *f*16.

Lens mount: screw or bayonet?

Ever since the advent of the SLR camera in the 1930s there has been argument over whether screw-mounted lenses or bayonet-mounted lenses offer the greater degree of precision and convenience. In practical terms, there is little difference. The bayonet gives a fast interchange, but some of the time saved is wasted in locating the orientation marks; bayonets are more expensive to manufacture and the coupling for iris trip and metering is complicated. The threaded mount, which does not require the lens to be pre-located before engaging the camera flange, is easier and cheaper to make and, to an extent, self-compensating for wear. Apart from cost, the real advantage of the screw mount is the multitude of lenses, both new and second-hand, that are available at every price level.

Normal lens

Subject

Long-focus lens

Subject

Subject

Wide-angle lens

Subject

The *normal* lens is one where the angle of view corresponds roughly to that of the eye: e.g. 5×4 in $= 135$ mm, 6×6 cm $= 80$ mm, 35 mm $= 50$ mm.

Long-focus and telephoto means a lens giving a larger image within a fixed distance when compared with the normal lens.

The *wide-angle* lens is not necessarily just one of shorter focal length than normal. It must be specially computed to give a wide view.

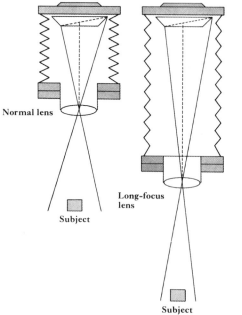

Brand name
Focal length (mm)
Widest aperture
Serial number
Manufacturer

Distance scale (ft)
Distance scale (m)
Depth of field scale (*f*-stops)
Aperture settings (*f*-stops)

Information on a lens

The focal length (50 mm) and open aperture (*f*1.9) are shown as a ratio—1:1.9/50—indicating a clear glass of 26.31 mm, the amount of light transmitted. This ratio is reduced in photographic slang to *f*-stop or speed. The distance scale is set twice.

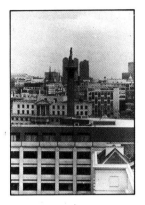

135 mm/*f* 2.8

200 mm/*f* 4

300 mm/*f* 4.5

600 mm/*f* 5.6

1200 mm/*f* 11

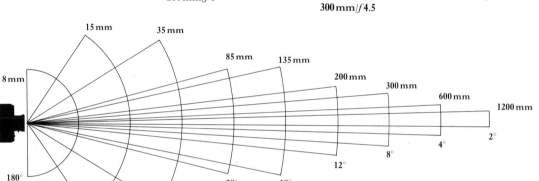

15 mm 35 mm

85 mm 135 mm

8 mm 200 mm

 300 mm

 600 mm

 1200 mm

 2°

 4°

 8°

 12°

 18°

180° 28°

110° 62°

The angle of view
A change in the focal length equals a change in the angle of view: the shorter the focal length, the wider the angle. With 35 mm format a lens of about 50 mm is accepted as the norm, giving an angle of view of between 45° and 50°. A wide-angle lens gives a view of 70° or over, while that of long-focus and telephoto lenses rarely exceeds 25°.

Lens caps and hoods

Front cap

Rear cap

Haze filter

Body mount cap Lens hood

Most lenses are supplied with a front cap and either a rear cap or plastic case. These items, especially the rear protection, should be used at all times. Screw caps are preferable to the clip-on type; this also applies to filters and lens hoods.

Lens cases
Cases for lenses should be considered in the same vein as camera cases (see page 201): choose the case offering the optimum protection. The soft case may enable you to slip the lens into your pocket, but it will not protect it from the same knocks you receive.

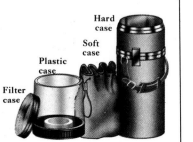

Hard case

Soft case

Plastic case

Filter case

Converter lens
This is available in ×2 and ×3 forms to double or treble the focal length of a lens. It is smaller and cheaper than a prime lens, but the results are poor unless care is taken to buy a top-quality example and it is used only with a medium long lens (85–135 on the 35 mm SLR).

Rear converter

Right-angle lens

Right-angle lens
A gimmick rather than really practical, enabling the voyeuristic photographer to take pictures (presumably of people) while pretending he is looking elsewhere.

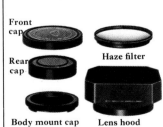

Mirror lens

Mirror lens
The mirror or reflex lens uses spherical mirrors and corrector plates instead of refractive glass elements, giving very high optical quality and correction. Though a 2000 mm is illustrated here with a support, mirror lenses begin at 200 mm. Unfortunately, they lack an iris diaphragm.

Special accessories-1

CAMERA SAFETY

It should never be forgotten that, no matter what the price of a camera, each instrument is a marvel of precision engineering, with the lenses receiving as much care on their curvatures and mounting as any piece of fine jewellery. A good camera should, in fact, be treated like an item of expensive jewellery.

When not in actual use, protect it from the elements. Leave it in its case with the front and back kept away from fumes, water, sand, dust and extremes of heat and cold. Possibly the most damage is caused by grit: this jams the mechanics, scratches lenses and films and wears lens threads. Water is next on the danger list; rust will ruin the accuracy of lens iris movements and shutter gear trains, and a camera that has been introduced to water, especially salt water, should really be in the repair shop within a couple of hours if it is not to be useless.

High humidity is also a problem. Apart from encouraging rusting of the steel parts, it also leads to the formation of moulds, which grow quite merrily between lens components and harbour a multitude of minute animal life. More than one photographer has monitored the transition across his viewfinder of some small bug while trying to compose and frame a masterpiece.

When the camera is in use filters will help to protect the lens against dust and dirt. An ultraviolet or haze filter, which does not affect exposure, can be left in place permanently. The lens hood, too, offers protection.

Motor drive

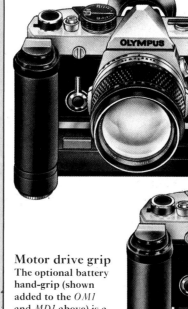

Basic motor drive

One of the most comprehensively equipped modern SLR cameras is the *Olympus OM1*. Here it is fitted with the *Motordrive 1*, a basic version enabling photographs to be obtained at rates up to 5 pps (pictures per second). The motor uses AA cells.

Motor drive grip

The optional battery hand-grip (shown added to the *OM1* and *MD1* above) is a useful motor drive accessory; when demounted, it can be attached by means of a relay cord. This means the photographer can wear the batteries close to the body to keep them warm, an essential precaution in cold climates if maximum framing speed is required.

Film back

An additional item for most motor drive systems is the 250-exposure film back (*below*), allowing bulk film loading for long runs.

Data recording

The data recording back can be used with some models of SLR cameras. This automatically records such information as date and time on to the film to show exactly when it was exposed.

Bulk film loader

The bulk film loader (*below*) is essential for utilizing the motor drive system and film back, and can be used to measure films into cartridges.

Bulk film loader

Relay cord

Control box

Film back

Control grip

Film magazines

Battery holder

Motor drive unit

Motor drive set

A comprehensive motor drive outfit would comprise the units shown here. The *MAC* control box converts household AC to DC for motor drive and also contains time-lapse equipment.

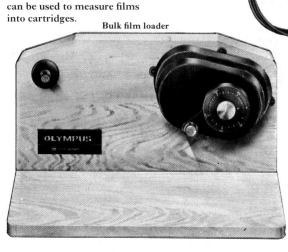

Bulk film back

Intervalometer

Motor drive unit

Command unit

Large-format SLR motor drive

The Hasselblad EL/M is the motorized medium-format camera. The motor is a little more leisurely in framing frequency due to the heavier load it has to shift but, like its smaller counterparts, the *Hasselblad* motor can use bulk film backs (this time with 70 mm film) and can use time-lapse controls and radio-operated remote control. The command unit will trigger up to four synchronized cameras.

VIEW CAMERA ACCESSORIES

Sinar Handy

Filter holder

Bellows

Filter

Light meter
(*Sinar Six*)

Magnifying glass

The large-format camera requires little in the way of accessories compared with small- or medium-format cameras, but its adaptability is formidable. Though the usual film stock is sheet, roll film backs and *Polaroid* film backs are readily available. Also, half a *Sinar* 5×4in can be mounted on to a hand-grip with a film back and wide-angle lens to make a real hand-held, large-format wide-angle camera.

Quadruple camera

Cable release

Roll film holder

Polaroid **film back**

Stereo attachment for the SLR

This enables three-dimensional stereo pairs to be recorded as two slightly dissimilar pictures side by side. It can be viewed with a binocular type stereo viewer or projected with special stereo projectors.

Wide-angle cameras

Wide-angle cameras like the *Widelux* (*above*) use a lens with optical slit that rotates about its axis and records a negative up to three times the normal width.

The special optics of the *Linhof Technorama* produce an image $6 \times 17 \text{cm}/2\frac{1}{4} \times 6\frac{3}{4}$ in with the convenience of a 35 mm camera. This gives four exposures on 120 film or eight on 220 film.

Special accessories-2

FILTERS

Because filters are the cheapest of all accessories and hundreds of types are available, they tend to be bought in unnecessary numbers. They can have as many abuses as uses, and until skill and knowledge have been acquired and tested, it is as well to leave most of them alone. Only if intelligently used can a filter improve a picture.

Before purchasing filters, it is worth considering some basic tips. First, buy only what you need: a large bunch of filters will leave you with so many to choose from you may not have the time to remove or refit in time to capture a shot. Second, no filter, irrespective of manufacturer or cost, will improve the quality of your optics; use filters only when you need one. Third, if you have spent a large amount of money on the best optics available, cheap filters will waste that previous investment. Most lens manufacturers market their own brand filters and, as most are exceedingly jealous of their reputations for quality, they would not risk marketing poor filters. Fourth, optical glass is soft, so handle filters with as much care as your lenses: dirt and scratches result in soft definition.

AERIAL CAMERA

Aero cameras, of which the *Aero Technica* is typical, are usually of medium to large format in order to enable maximum information to be recorded. The *Technica* shown is fitted with double hand-grip, open frame finder and large controls.

Underwater equipment

Dual-purpose underwater camera

Highly specialized underwater cameras are not common, but *Nikon* market a small 35mm camera (*above*) with interchangeable lenses and a full range of accessories, suitable for use to depths of 50 m/160 ft.

The underwater large-format SLR

Hasselblad offer no less than three underwater housings—for *500 C/M*, for *Superwide*, and a housing for *EC/M*. The *Hasselblad* combination housing (*below*) for *500 C/M* and *Superwide* is suitable for depths of 150 m/500 ft.

The underwater twin-lens camera

The *Rollei-Marine* housing (*above*) converts the *Rolleiflex* TLR to underwater usage. Links bring all the controls to large knobs mounted externally, and the housing is equipped with open frame viewfinder—essential with a face mask.

General housings

Several specialist manufacturers make plexiglass housings for 35 mm SLR and compact cameras, but contact your local dealer or diving club for advice: these will not stand the same depths and pressures as the *Hasselblad* units.

The underwater outfit

A full programme of special underwater lenses and accessories exist for the *Nikonos* (shown *above left*). The lenses, generally wide-angle, are corrected for use underwater, where the refractive and optical property of the water has to be considered as part of the lens. Underwater flash and frame viewfinders are also available.

Highly selective *spot meter* sees only 1°; enables accurate measurement from distance.

Colour temperature meter indicates correction filter required to balance film to light source.

Incident type *studio meter* gives instant reading of aperture by means of speed slide.

Flash meter measures flash exposure and indicates correct aperture.

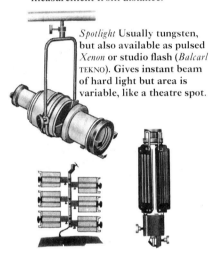

Spotlight Usually tungsten, but also available as pulsed *Xenon* or studio flash (*Balcarl* TEKNO). Gives instant beam of hard light but area is variable, like a theatre spot.

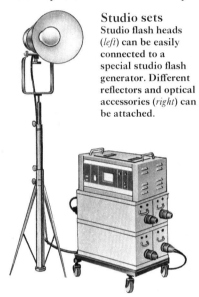

Studio sets
Studio flash heads (*left*) can be easily connected to a special studio flash generator. Different reflectors and optical accessories (*right*) can be attached.

Portable lighting kit
The lightweight portable tungsten lighting kit can be used for stills and movies. *Creto* light kits and *Red Heads* offer similar portability.

Flash pack
Balcar/TEKNO studio flash pack offers very high levels of illumination with rapid recycling, and is used by some professional photographers as a standard because of the quality of light.

THE MIRED SCALE

Filters can be calibrated on the Mired (*micro-reciprocal degree*) scale of colour temperature. The Mired value is calculated by the formula:

$$\text{Mired} = \frac{\text{one million}}{\text{colour temperature in }°K}$$

The relationship of degrees Kelvin to Mireds over the colour temperature range used for most photography is shown.
Colour conversion filters designed to allow a scene lit by one colour temperature to be recorded on film made for another are rated in positive or negative Mired numbers, the positive being orange/red and the negative blue. The Mired values of the filters represent the differences between the Mired ratings of the light source and of the film. As with all filters an exposure increase will be necessary.

CONVERSIONS FROM DEGREES KELVIN TO MIREDS

Colour temperature in degrees Kelvin

Blue flash 6000	Daylight 5000	Clear flash 4000	Photoflood 3500	3000	Household lamp 2500°K
		4500			

| 150 | 200 | 250 | Mireds | 300 | 350 | 400M |

THE USE OF CONVERSION FILTERS

Film type	Lighting	Mired shift (with *Kodak Wratten* equivalent)	Exposure increase
Daylight	Heavy overcast sky	+50 (*81EF*)	⅓ stop
Type T	Photofloods	−120 (*80B*)	1 stop
Type S	3200°K lamps	−140 (*80B+82A*)	1 stop
	Clear flash	−80 (*80C*)	⅓ stop
	Daylight Electronic flash	+110 (*85*)	⅔ stop
Type A	Clear flash	+40 (*81C*)	⅓ stop
	3200°K lamps	−20 (*82A*)	⅓ stop
Type B	Daylight		
Type L	Electronic flash	+120 (*85B*)	⅔ stop
Type K	Clear flash	+60 (*81EF*)	⅓ stop
	Photofloods	+20 (*81A*)	⅓ stop

Darkroom materials

Half the creative fun of photography occurs in the darkroom. Even a child can improve a good photograph by careful cropping or masking of a projected image on the enlarger easel. Acquired manipulative skills will enable you to indulge in advanced techniques involving chemical adjustment and application of selected area dyeing of the print. With colour materials the control is infinite.

Film-developing equipment

One of the most essential pieces of darkroom equipment is the developing tank. This should be of a suitable size to take film spirals of the correct sizes to match the films you use. Many of the so-called multi-tanks will accept spirals for films in all sizes up to and including 120 roll films. Special tanks must be obtained for 220 roll, 70 mm and 35 mm bulk and sheet film.

Where the budget allows, stainless steel should be chosen. Stainless-steel tanks and spirals will last a lifetime, and though the initial purchase price may be as much as four times that of plastic alternatives, the eventual saving will be enormous. Recommended makes are *Kindermann* and *Brooks* for stainless-steel equipment, *Paterson* and *Vivitar* for plastic.

In addition, two or three precision chemical measures in glass or hard plastic will be required for mixing and measuring the developers and the associated processing chemicals. One measure should be a finely graduated glass measure for up to 50 ml (about 2 fluid ounces), and the largest should be of a suitable size to match the developing tank in use; there is little point in using a 250 ml measure if your developing tank requires 500 ml of solution. Essential for all processing procedures and mixing of chemicals is a good thermometer, preferably a mercury one. Film hanging clips are also necessary, although clothes-pegs can do the job quite efficiently. This equipment will enable the photographer to produce his own negatives. Colour negatives are just as easy to process.

Printing equipment

To make the print an enlarger is the first requirement. This should be chosen to suit the size of your film stock, and if you are using several sizes the choice of a so-called universal-format machine may be indicated. This should obviously be capable of accepting the largest of your film sizes and should be suitably equipped with matched lenses, negative carriers and light sources for all the other formats in use. If you use only, say, 5 × 4 in and 35 mm films, then it will be more sensible, if the budget allows, to buy two enlargers, perhaps including a good second-hand one.

Remember when working out your budget that the information contained in your negative can only be transmitted to the printing paper via a lens of similar or better quality than the lens on the camera that took the picture. There is little point in having a fine camera lens if a cheap lens is used on the enlarger. The final print is the sum of the quality of both optical systems.

The measures already purchased for film processing are suitable for mixing and measuring the print developers and the other chemicals. The same thermometer can also be used. The extra equipment needed includes at least three print-developing trays of suitable dimensions for the maximum print size, together with perhaps a set of dishes of each of the sensible lower print sizes. For instance, if you intend to make prints up to 40 × 51 cm/16 × 20 in, you will need trays that are sufficiently large to enable the print to move in the tray to ensure sufficient agitation of chemicals over the paper's surface. A tray of approximately 50 × 60 cm/20 × 24 in would be suitable. Obviously if this size of print-developing tray is required then the same size of tray is needed for the stop bath and for the fix bath. If small prints are to be made in large quantities the large tray is ideal, but a small tray will be more suitable for limited numbers. Stop bath and fixer chemicals are not used up to the same extent as developing chemicals and so the large trays could be used all the time for these. Developers are subject to surface oxidation and will deteriorate if they are lying in a large tray doing nothing.

A good easel, a safelight, a set of print tongs and a timer would complete the basic darkroom. If funds are available an enlarging exposure meter and a colour analyser for colour prints would make life easier, as would a print dryer and a negative-drying cabinet, although these are not essential.

A good negative filing system, such as the albums provided by *Paterson*, and a contact printer to enable a sheet of negatives to be printed at once and filed with the negatives for easy identification will both save a great deal of time when your negative collection reaches a reasonable size.

Chemicals

Negative and print developers differ in subtle ways and are not really interchangeable, but for black and white work the stop bath (a 2% solution of glacial acetic acid) and the fixer bath are almost identical for both prints and negatives and the stop bath and fixer concentrates used for the one process may also be used for the other.

For straightforward black and white negative developing you will require a suitable developer—use the one recommended by the manufacturer initially—a stop bath and a fixer. For the paper print you will require a special print developer. Once again, it is best to use the type suggested by the paper manufacturer.

Colour processing requires more chemicals and more processing stages. Extra chemical processes are bleaching of the silver image and stabilization of the dye image as well as an extra hardening of the gelatin bearer. For the reversal process to produce transparencies a fogging agent is also required. This is rather toxic and so good ventilation is required. Although colour processing involves more work it is really just as easy as black and white, and you should not be put off by the apparent complexity of the process.

Do it yourself?

With the vast choice of photochemicals now readily available, there is little sense in setting up your own apothecary's shop. While there is an obvious schoolboy pleasure to be obtained by measuring, mixing and testing home-made brews, financially it is not viable. It is better by far to use the chemicals mixed by the manufacturer of the film of your choice. Then, when the need to experiment occurs, look out for specialist developers manufactured by such companies as *Paterson*, *Phototechnology*, *May and Baker*, *FR Corporation* and *Tetenal*, all of whom market first-class products. The manufacturer of the film stock, be it *Kodak*, *Agfa* or whoever, certainly knows what formulation will give the best results for his product. Another manufacturer will at best only match the quality, although most claim to give a different effect, such as finer grain, enhanced acutance or better contrast control.

In addition, although formulas for alternative processes are

available from such sources as the *British Journal of Photography*, *Leica Fotographie* and similar publications, the raw chemicals mentioned may prove to be a problem since most manufacturing chemists give different names to what is basically the same chemical. Raw chemicals have to be bought in fairly large quantities, the packaging of some being more expensive than the contents.

Developers

A fairly simple developer contains at least four constituents. The basic ingredient is a reducing chemical that will turn the colourless silver salts that have been affected by light into black metallic silver, thus changing the latent image on an exposed piece of film or printing paper into a visible image. The most common of these chemicals are *Phenidone*, *Metol*, *Hydroquinone* and *Amidol*, and they work by extracting the oxygen from water. Hydrogen remaining in the water combines with bromine in the emulsion and forms hydrobromic acid, which must be neutralized by an alkali in the developer before it halts the process. The alkalis used can be sodium carbonate, sodium or potassium hydroxide or sodium borate. As the main constituent of the developer is a reducing agent, it would tend to absorb oxygen from the air and its potency would deteriorate. Consequently a chemical with a strong affinity for oxygen is added to prevent this. Sodium sulphite is the most usual chemical used. Finally a chemical must be used to prevent the developer from reducing the unexposed silver salts as well as those that have been exposed. This chemical is known as a restrainer and is usually potassium bromide; without it the whole negative or print would fog.

These are the four basic ingredients of a black and white developer. They vary a great deal from manufacturer to manufacturer and to suit the purpose for which they were produced. A typical negative developer may, in a litre, have 0.75 gm phenidone, 6.0 gm hydroquinone (reducing agents), 2.5 gm sodium borate (alkali), 75 gm sodium sulphite (oxygen absorber) and 1 gm potassium bromide (restrainer). A typical print developer may have 2.2 gm metol, 17 gm hydroquinone (reducing agents), 6.5 gm sodium carbonate (alkali), 75 gm sodium sulphite (oxygen absorber) and 2.8 gm potassium bromide (restrainer). These have essentially the same ingredients but the proportions differ significantly.

With colour processing chemicals, the problems are increased by the need to keep to fairly tight pH factors. A change in the acidity has a marked effect on the colour balance of the resulting transparency or colour print. Repeatable quality is obtained only by exact formulation, and this means strict quality control and monitoring. This can only really be obtained in factory production.

Printing materials

Printing paper consists of a sheet of paper with a light-sensitive emulsion coated on one side. The emulsion consists of silver salts that undergo chemical changes when exposed to light. Full details of this process are given on pages 38–9.

The basic printing papers are covered on page 178, but many specialized printing papers are available, including those with a coloured base and those with fluorescent bases. Plastic is often used as a base, especially in certain modern colour processes such as *Cibachrome* (see page 181). When both sides of a transparent sheet of plastic are coated with emulsion a print can be made on each. This will give the individual images when viewed by reflected light and the two images superimposed when viewed by transmitted light.

Sometimes unusual bases are used. The emulsion can be spread on linen or wood to achieve various effects. One enterprising astronomer had a series of metal globes coated with photographic emulsion so that he could project on to them negatives of the moon as taken through a telescope. In this way he was able to smooth out the distortions of the surface features as seen from the earth and enable them to be observed in their true perspective.

For colour prints the choice of papers has improved recently, and a choice of contrast and surface is now available for amateurs. Individual papers are produced by the manufacturers of colour film so that both their products complement each other. Dye destruction prints—those in which the dye already in the emulsion loses its colour in response to light leaving some of the colours behind to form the image—are available both on white plastic bases, to give prints, and transparent bases for slides. The images produced are rich and stable and are suitable for long-term displays.

Holding the paper

The printing paper is usually held in position by an easel or a masking frame. This consists of a heavy flat base made of metal or plastic edged by two permanent abutments making a right angle. Movable arms slide along the abutments to form the opposing sides of the rectangle that will be the picture area. Calibrations along the abutments help in this.

Larger sheets may be exposed by laying them on the floor and swinging the head of the enlarger around on its column so that the beam misses the base and the work bench. Some enlargers have heads that can be swivelled into a horizontal position so that an image can be projected on to a wall.

During enlarging, masks may be used to give different image shapes—for example, keyhole shapes and heart shapes for wedding photographs. Dodgers can be used to reduce tones locally and to ensure that some areas of the print have less exposure than the others. These dodgers consist of cardboard shapes on the ends of rods and they can be moved around over the area of the print where less exposure is required. Special screens can be bought to be placed over the paper during enlarging to give a simulated surface texture. These textures include canvas and oil-painting surfaces.

Finishing the print

Photo-finishing is the final stage in making an exhibition print. In handling the negative, damage of a greater or lesser degree is inevitable. A minute and almost invisible scratch on a 35 mm negative will be enlarged by the same degree as the image and on a large print will be objectionable. Dust and drying marks will also be enlarged. The dark lines of a scratch can be knifed out with a finely pointed scalpel, while the light spots caused by dust can be filled in with carefully matched water colours or special print retouching dyes. For colour prints and enlarged display transparencies the same would apply, although the skills required for colour matching are harder to attain. A really good colour retoucher will earn more than a good photographer. For retouching, a good desk is required together with good lighting (colour-matched for colour work) and a magnifying lens on a goose-neck, a set of fine sable paintbrushes down to 00 size and a set of knives. Full details of retouching are given on pages 190–1.

Fault-finder

All photographic materials have their own idiosyncrasies. Techniques which are perfectly satisfactory when used in conjunction with one combination of materials may produce unexpected and often unwanted effects when applied to a slightly different combination. Moreover many of the chemicals are prone to deterioration, either in time or as a result of prolonged exposure to light, extremes of temperature, the atmosphere, or contamination with each other.

Another cause of faults is poor equipment, though it is often the case that results which appear to be due to a malfunction in your camera or damage to your film may in fact be the result of your own techniques; this is particularly true if you are not familiar with the exact nature of the materials being used or with the hazards of the darkroom. The purpose of this fault-finding guide is to help you to identify the most common peculiarities in the process, and the faults they can give rise to, and to enable you to distinguish between a fault you can correct yourself by modifying your technique and a fault which requires professional repairs.

EXPOSURE AND DEVELOPMENT: TOO DARK

Underexposure and underdevelopment both result in thin, pale negatives, which in turn result in dark prints. Their effects, however, are not identical, and it is important to be able to distinguish between them: an *underexposed negative* is lacking in detail, while an *underdeveloped negative* is lacking in contrast. Naturally it is in the shadows that detail will suffer first if you are underexposing your pictures. Pictures showing neither shadow detail nor reasonable contrast are likely to be both underexposed and underdeveloped, in which case each fault must be corrected independently.

Underexposure Something may be wrong with your equipment—a faulty meter or a faulty shutter mechanism, for example—but there are a number of other simple possibilities that should be checked first. You may have forgotten to set the right ASA on your meter last time you changed film; you may have forgotten a filter factor (or that you were using a filter at all); you may have been using stale film that has lost some of its original speed. Finally, under certain circumstances, underexposure can result from reciprocity failure.

Underdevelopment This may simply be caused by stale developer, but this is not the only possible reason. Film developer may cool a few degrees when it is poured into a cold developing tank, and it is likely to lose heat slightly during the development process itself. Check the temperature of the developer in the tank when you first pour it in by inserting a thermometer down into the centre of the spiral. The chemical manufacturers usually provide a graph of temperature against time, from which you can read off the exact development time needed at any given temperature. A negative showing either of these faults may be successfully improved by chemical or optical intensification (by making a contrasty duplicate).

EXPOSURE AND DEVELOPMENT: TOO LIGHT

Overexposure and overdevelopment produce dense negatives that result in light prints and loss of highlight detail. In the case of overexposure the picture suffers from loss of contrast as well as blocked-up highlights, while an overdeveloped negative has excessive contrast, with good detail in the shadows but also blocked highlights. The border of the negative is often a useful guide: if it is dark or foggy, then overdevelopment is more likely to be the cause.

Overexposure A faulty light meter or a faulty shutter are possible causes of overexposure, just as they are of underexposure. Similarly it is again worth checking the ASA setting on your meter before assuming it is damaged. Another mechanical failure which can cause overexposure is damage to the automatic diaphragm on the lens of an SLR. If the diaphragm does not close down quickly enough, or fails to close at all, the negative will be overexposed. Alternatively, you may be using some attachment that deprives you of the automatic system altogether (some extension tubes, for instance), or an unfamiliar lens that is not automatic.

Overdevelopment A faulty thermometer may be giving misleadingly low temperature readings, and this would cause you to develop at too high a temperature. Alternatively, if you agitate the developing tank more than recommended you must take care to make compensations in the development time: some manufacturers give you alternative figures for continuous agitation.

An overexposed negative can be improved by subtractive reduction, an overdeveloped one by proportional reduction.

SHARPNESS

Camera faults Serious lack of sharpness in the image is necessarily a mechanical rather than a chemical fault. Camera shake is common: hand-held shots at shutter speeds lower than $\frac{1}{30}$ sec are usually regarded as impractical, and anything below $\frac{1}{250}$ sec requires care. Even with a tripod there is a danger of vibration from the mechanism of the camera itself, such as the retracting mirror of an SLR or a focal plane shutter. An image might be unsharp simply because the shutter speed selected was too slow for a moving object. It is also possible that an unsharp image may be caused by bad focusing. One of the elements of the lens may be out of alignment, in which case the lens needs repair, or the pressure plate at the back of the camera may be damaged in some way, which would mean that the film was not held flat during exposure.

Darkroom faults During the enlarging process it is important to focus the image as accurately as possible, and stopping down before exposing the paper helps improve the depth of focus. The two most common causes of blurred images at this stage are enlarger vibration, and "popping" caused when the heat from the enlarger bulb makes the negative bulge during exposure, throwing it out of focus. To decide between unsharp negative and print, check the grain or dust spots; if sharp, the negative is at fault.

FOGGING

A large area of increased density, sometimes covering all of the negative or print, in which the image is obscured, is known as fog. The most common cause is light reaching sensitized material where it is not wanted. If a negative is fogged but the borders are clear then the fogging could have been caused while the film was in the camera—by light entering through damaged bellows or a faulty shutter, for example. If most fogging is at the edge of the negative, it is probably due to a badly-fitting camera back or a roll film being too loosely rewound on the spool, allowing light to leak in. The fogging of a negative over its whole area, including the borders, can be due to a large number of faults. These include excessive developing time; too high a developing temperature; developer exhausted or incorrectly mixed; unsafe darkroom light; light leaks in the camera, packing, darkroom or tank; stale film; and excessive exposure to air during processing. Developer that is too warm or exhausted may also give a dichroic fog that appears red by transmitted light and blue by reflected light.

This may also be caused by a fixing bath that is too warm or exhausted or contaminated by too much developer from previous prints, or by exposure of the negative to a strong light before completely fixed. The same faults also give rise to fogging on prints. Stray light from the enlarger during exposure may also fog prints, and in this case it can be diagnosed because the edges masked by the masking frame are left clear. Fogging along the edge of a print may be due to the paper having been stored in a damp or very warm room or close to a gas fire. Because film fog may also be caused by

X-ray examination at airports, it is best to remove undeveloped film from luggage while travelling by air. Papers left lying near a safelight may be fogged overall and may show the outlines of those on top of them.

SPOTS

Spots on prints and negatives, whether dark or light, are usually caused by dust particles or other pieces of foreign matter.

White specks on the negative suggest the presence of dust on the film before the exposure or before development, or grit floating in the washing water (these show up as black specks on the final print). White specks on the final print are usually caused by dirt on the negative during enlarging or, sometimes, by dirt on the printing paper surface. Fuzzy white spots on the print may be caused by dust that has gathered on the top surface of the enlarger condenser system. The remedy is meticulous attention to cleanliness at all stages of the operation.

If the spots are fairly large and round they may be caused by air bubbles trapped against the film or the paper during developing. Such spots appear white on the negative and black on the print if this occurred during processing of the film, and white on the print only if during the developing of the print. Insufficient agitation is usually the cause, and it can be avoided by tapping the developing tank as soon as it is filled. These faults can usually be rectified by retouching the negative or the print.

Fairly large areas of staining on the negative, sometimes with increased emulsion density round the edges, are drying marks caused by persistent drops of water that dry slowly. This can sometimes be rectified by washing again and drying.

LINES

The most common reason for lines on a picture is scratching. This may be caused by clumsy handling of the film, by grit in the entrance of a cassette or by the end of the film being pulled so that the roll tightens against itself. In less serious cases this may be rectified by retouching. Scratches on prints may also be caused by careless handling of papers—scraping sheets against each other or handling them with sharp tongs.

UNEVEN IMAGE DENSITY

A picture showing different image densities from one area to another means that either the negative or the print has had an uneven development. If it occurs on the negative it indicates that the developing tank has not had sufficient agitation or that there has not been enough developer in the tank. If it occurs only on the print then the tray has not been agitated enough or the print has not been completely covered by the developer during developing. A gradual increase in density towards one end of the negative may indicate an uneven drying.

DEPOSITS ON THE NEGATIVE

Hard water may give rise to a fine-grained coating of insoluble chalky residues on a processed negative. This can be cured by washing in a 2% solution of acetic acid followed by washing in clean water. A similar effect may be due to a precipitation of aluminium sulphite formed when the fixing bath loses its acidity. The remedy is to harden the negative in a 1% solution of formalin and then wash it in a 5% solution of sodium carbonate, then washing in water.

DISCOLOURATION

A yellowish-white negative is probably due to a deposit of sulphur from decomposing fixer and can be rectified by hardening in a 1% formalin solution and washing in 10% sodium sulphite solution at $38°C/100°F$. Greenish-black tones on prints are due to underdevelopment of chloride and bromide prints, overdevelopment of chlorobromide prints, exhausted developer or excess potassium bromide in the developer. In these cases the print may be dyed.

Yellow or brown stains on the print may be due to insufficient agitation during fixing, exposure to white light before completion of fixing, insufficient rinsing between developing and fixing or exhausted fixer. Such a print may be bathed in the appropriate stain remover. Brown marks on hot glazed prints are often formed by insufficient fixing or washing and can sometimes be remedied by bleaching in a potassium permanganate bleacher and then redeveloping.

Green image tones may occur when stale paper is used or when the developer is exhausted and can be avoided by using a developer improver. A red, blue or green tinge on the negative support is the anti-halation backing which should disappear during the processing. If it does not it can be soaked in 5% sodium sulphite solution.

REVERSAL OF NEGATIVE IMAGE

Partial or total solarization may turn the negative image to a positive one after accidental exposure of the unprocessed negative during development. Care in handling the equipment is the only answer.

LIGHT SPREADING FROM DENSE TO LESS DENSE AREAS

Light may scatter within the emulsion of a negative to give a dark shadow surrounding a high-density area. Alternatively, light may be reflected from the negative backing to give haloes or rings around very high density points in the picture. If this is not too great, the negative or the final print may be retouched.

STATIC MARKS

Electrical discharges that crop up when handling unexposed film can lead to dark marks on the negative. These can take the form of uneven diffused bands along the film where fingers have wiped it or branching, lightning-like patterns due to sudden movements in a hot, dry atmosphere.

FINGERMARKS

These are almost invariably caused by handling sensitized materials with dirty fingers. White marks on negatives may be caused by handling before developing with fingers contaminated by grease or fixer. Dark marks on negatives are usually caused by wet fingertips or fingertips covered with developer. Where the damage is slight the film or the print can be retouched.

POLYGONAL SHAPES ON NEGATIVES

Dark shapes corresponding to the configuration of the diaphragm on the negative, often associated with dark streaks, are due to reflections of light between the lens elements. The only way to avoid these is to ensure that the lens is shielded from direct sunlight.

RETICULATION

The network of fine cracks in the emulsion, known as reticulation, is due to washing the film at high temperatures or to using solutions of greatly differing temperatures.

IMAGE MISPOSITIONED ON NEGATIVE

If this is consistent over a number of negatives, the viewfinder of the camera may be wrongly aligned. This is most common on cheap snapshot cameras. If the viewfinder cannot be reset, the amount of deviation must be taken into account when sighting for subsequent photographs; if the image does not reach into the corners of the negative, it suggests that the wrong size of lens for the particular camera is being used; if these blocked-out corners are fairly sharp it may mean that the lens hood is of the wrong design. In all these cases the final picture may be saved by selective enlarging of part of the image.

DOUBLE EXPOSURE

When two totally different images appear on the one negative, the film has not been wound on between exposures. With simple cameras this may be due to an oversight on the part of the photographer, but with sophisticated equipment the winding mechanism may be damaged. If the latter is the case the more likely result is two images overlapping one another to some degree. If a moving element of a single image is recorded twice in a slightly different position it may be due to shutter bounce, when the shutter opens again after exposure.

Glossary

Aberrations Lens defects likely to mar the image produced. Commonest variants are astigmatism, chromatic aberration, coma, distortion, and spherical aberration.

Acutance Measure of image sharpness at boundaries between light and dark areas. High acutance-type developers accentuate this boundary definition, thus apparently enhancing sharpness.

Additive synthesis Method of producing colour images by mixing the primary colours—blue, red and green.

Aerial perspective Impression of depth in a landscape photograph, largely created by haze, which renders farther planes softer than nearer ones.

Against-the-light shooting Photographing a subject when the light source is behind it (popularly known as *contrejour*). Requires exposure increase to give detail in subject side facing the camera, but the rim-lighting effect is attractive.

Agitation Circulating solutions round sensitized materials, especially film, during processing.

Air-bells Bubbles which form on a film because of ineffective agitation during development. They leave clear spots on the negative.

Airbrushing Method of retouching prints. Airbrush uses high-pressure air to spray dye over selected area.

Alkalinity Degree of alkali in a solution, measured by the pH value (above pH7 is alkaline).

Anamorphic lens Lens able to compress a wide image in one direction.

Angle of incidence Angle formed between an incoming light ray and the normal (at right angles to the surface).

Angle of reflection Angle formed between the reflected ray and the normal. Equal to the angle of incidence.

Angle of view Optimum angle between two light rays passing through a lens.

Antifoggant Agent added to developer to hold off the formation of chemical fog. Especially useful for prolonged or higher temperature development, or when film is outdated.

Aperture Hole in a lens through which the image-forming light passes. Adjustable, by an iris diaphragm, in controlled marked steps called *f*-stops.

Artificial light Illumination other than daylight; main sources employed in photography are photofloods or flash from bulbs, flashcubes or electronic flashguns.

ASA American Standards Institute. The most commonly used film speed rating system. The faster (more sensitive) the film speed, the higher the ASA number; doubling, e.g. 50 to 100 ASA, denotes an increase equivalent to one aperture increment or shutter speed setting.

Astigmatism Lens aberration that makes simultaneous sharpness in vertical and horizontal lines unattainable.

Automatic camera Camera in which the exposure is partly or completely controlled by the internal system. In completely automatic cameras, sensors adjust exposure without aid. Partial automation may require the user to choose either an

aperture or shutter speed setting, the camera's exposure automation adjusting the other function.

Auto-winder Camera attachment that employs a battery-driven motor to wind on film automatically, some models permitting automatic operation for two consecutive frames. Simplified form of motor drive.

Available light photography Taking pictures without addition of supplementary lighting, more usually in weak daylight conditions. Best tackled with fast films.

Average reading metering Camera TTL metering method that measures light over most of the screen area of the viewfinder.

Backing Coloured layer coated on the back of films and plates to minimize halation.

Back projection Projecting a slide (or a film) on to the back of a translucent screen. Used in commercial still photography (as well as cine and TV work) to provide false backgrounds, or where projection space is limited.

Ball and socket head Tripod fitment which permits controlled securing of a camera at virtually any angle.

Barn doors Hinged flaps for spotlights and floodlamps to control direction and width of light beam.

Base Usually the cellulose esterfilm, polyester film, glass or paper support on which the emulsion is coated.

Bas-relief Sandwiching together of negative and positive identical images slightly out of register to give an impression of relief.

Bellows Flexible extension between lens and camera body, usually on large-format cameras or older small-format models.

Bellows focusing unit Means of flexibility extending the film-to-lens distance. Thus objects much closer than the closest marked distance of the lens can be focused sharply.

Between-lens shutter Shutter type consisting of thin blades, opening from the centre outwards, mounted between lens elements. Permits flash synchronization at all speeds.

Bleaching Chemical process that converts the black metallic silver image into a colourless silver complex.

Blisters Bubbles on emulsion caused by gases forming between emulsion and paper surface due to extreme changes in temperature or excess alkalinity during processing.

Boom-light Light attached to a long arm, allowing overhead position.

Bounce flash System of reflecting the light from a flash unit to the subject from a nearby reflective surface (usually a ceiling), or by directing the flash into a light-coloured umbrella near the subject.

Brightness range Range of luminance between brightest-lit and darkest areas of an image. Scenes with a wide range are known as contrasty, low-range scenes as flat.

Bromide paper Most popular of sensitized papers for making prints. Available in several grades (usually 6 or 7) to permit contrast control over a wide range of sizes and surfaces.

B setting "Brief" time camera speed setting, at which pressure on the release button holds open the shutter until it is released.

BSI British Standards Institute. Now obsolete film speed rating system.

Bulk loader Container from which long rolls of 35mm film can be dispensed in measured short lengths for loading, in total darkness, into cassettes. Aids economical film buying in bulk lengths.

Burning-in Giving extra exposure in enlarging to dense, highlight areas of a print. The remainder of the print is shielded by the hands or a card.

Cable release Bowden-type cable attaching by screw-thread to the shutter for releasing it smoothly by means of a plunger depression at the other end, thus minimizing camera shake risk during long exposures.

Cartridge Pre-loaded film container, usually made of plastic.

Cassette Metal film container holding small-format film sizes.

Catch lights Pinpoint reflections of light in the eyes of a portrait subject.

Centre-weighted metering Camera TTL metering method in which the reading is biased towards the intensity at the centre of the viewfinder.

CdS cells Exposure meter cell of resistance type requiring an external power source supplied by a battery. More sensitive to low light level than a selenium cell; but takes time to adapt to rapid wide light level changes.

Characteristic curve Graph line plotting the proportional reaction of a film to the influence of light density on development. The steeper the curve the more contrasty the film or other sensitive material.

Chloride paper Low-sensitivity printing paper with silver chloride emulsion, used for contact printing.

Chlorobromide paper Printing paper of medium sensitivity that produces warm-tone images.

Chromatic aberration A lens with this fault cannot bring light of different colours to the same place of focus.

Cinching Pulling the film over-tight in a cassette; bad practice, as it may cause scratches.

Circle of confusion A point is imaged by a lens as a small circle, known by this name. The smaller this circle, the sharper the result; in a print viewed normally, the largest acceptable size is $\frac{1}{250}$ cm/$\frac{1}{100}$ in diameter.

Clearing time Time between first immersing and clear film when a film is being fixed. Fixation is complete after twice the clearing time.

Close-up lens A form of spectacle lens, correctly called a supplementary, in a mount. It is screwed into the camera lens front, permitting closer range focusing, according to the strength (graded in diopters) of the close-up lens.

Coated lens Coating of air-to-glass surfaces in a lens to improve light transmission and reduce flare. The coating is usually magnesium fluoride.

Cold cathode enlarger Diffusion type of enlarger using a fluorescent tube as the light source. Used mainly for large formats, it gives soft illumination that suppresses negative defects, and is cool-running.

Colour analyser Metering device for assessing the necessary degree of colour filtration and exposure in colour printing.

Colour casts False hues in a colour

picture. May be caused by reflection from a nearby strong colour, by incorrect processing or in printing. Casts can be removed in printing by addition or removal of filters.

Colour compensating filters Filters used when printing colour materials to achieve correct colour balance. They are usually purchased in sets of three colours—cyan, magenta and yellow—each in a range of densities. Commonly known as colour printing filters.

Colour conversion filters Filters used on the camera lens to match the colour temperature rating of a colour film to that of a specified light source, e.g. so that daylight film can be used in artificial light and artificial light-type film can be used in daylight.

Colour light balancing filters Camera filters for use with colour film to give a colour-balanced result. They modify slightly the colour temperature of the light in use to that for which the film is balanced, avoiding a too-warm or too-cool appearance. Bluish filters raise the temperature, reddish or amber ones lower it.

Colour negative Film that produces a negative image in colours complementary to those in the subject —blue as yellow, green as magenta, red as cyan. It is used to give colour prints, but black and white prints and colour transparencies can be produced.

Colour reversal film Popularly known as slide film. Gives a positive transparency, viewed against a clear light source or by projection.

Colour sensitivity Relative response of film to the colours of the spectrum.

Colour synthesis Additive or subtractive methods by which a final colour photograph is formed.

Coma Lens aberration giving rise to tear-shaped blemishes in areas off the lens axis.

Compound lens Lens containing two or more elements.

Combination printing Enlarging a section of two or more negatives on to one print. Most common use is in adding an attractive sky to a landscape with bald sky area.

Complementary colours Two colours that together produce white light. Colour filters absorb light of the complementary colour. Complementaries of the three primary colours red, green and blue, are cyan, magenta, and yellow respectively. Also used to denote colours opposite each other in the colour wheel.

Computer flash Electronic flash units that eliminate the need to calculate the flash exposure and set aperture accordingly. A sensor assesses the strength of light reflected back from the subject which the flash fires. Internal circuitry gauges when the amount of light delivered is adequate for a correct exposure.

Condenser Lens system for concentrating a light source, primarily used in an enlarger, projector or spotlight.

Contact prints Prints made by direct contact with negatives. Usually used for quick reference, especially when an entire film is contacted.

Contrast Relationship between tones of an image; a print with wide tonal differences is said to be contrasty, one restricted in tonal range is flat.

Contrast filters Tinted lens filters for use with black and white films that darken or lighten tones considerably. They give greater separation of colours which would appear as similar tones in a monochrome print. Often used for deliberately exaggerating an effect; a red contrast filter, for example, renders a blue sky almost black.

Converging lens Simple convex lens causing rays of light to converge to a point.

Converging verticals Distortion caused by pointing the camera upwards at, say, a tall building. Can be corrected with cameras that have perspective control movements, with a perspective control lens, or in enlarging by tilting the paper support.

Converter Accessory lens for use in combination with a camera lens to give a longer focal length, usually doubling or trebling that of the main lens. Fitted between main lens and camera, though a few types attach in front of camera lens. Best results when used with lens of longer than standard focal length.

Convertible lens Compound lens of which a part can be unscrewed to give a new lens of longer focal length.

Correction filters Filters used on the lens to modify slightly the tonal rendering of colours on black and white film so as to give a more natural appearance on the print. Most common is a yellow or yellow-green filter, which gives a light grey rendering of blue sky.

Covering power The image area over which a lens will give optimum results; outside this area definition is inferior. For small-format cameras coverage is generally extended just beyond the diagonal of the negative. View cameras require coverage beyond this area to take advantage of the camera's movements.

Cropping Leaving out parts of a negative when printing to enlarge only a selected area.

Cut film Sheets of film cut to a specific size for use mostly in large-format cameras.

Delayed action (DA) A camera function (or separate accessory) which delays shutter operation for a few seconds (sometimes adjustable) after the release button is pushed.

Density Degree of darkening of a negative, transparency or print, by exposure and development.

Densitometer A meter for measuring accurately density in selected parts of an image, and thus for assessing overall tonal range.

Depth of field Zone between nearest and farthest parts of a scene extending either side of the focused subject that reaches acceptable sharpness.

Depth of field previewer Button or lever on a reflex camera that stops the lens down to a selected aperture, allowing visual assessment of depth of field.

Depth of field tables Tables setting out acceptable depth of field ranges for given focusing distances and apertures. The depth varies according to the focal length of the lens, distance focused on, and aperture. Engraved scales around camera lenses also give an approximate estimation.

Depth of focus Very small range of acceptable variation of lens-to-film distance within which critical sharpness can be maintained. Term often wrongly used for depth of field.

Development Processing in a specified chemical (the developer) of film or other light-sensitive material to render visible the latent image produced by exposure. There are many developers to suit different materials and results required from them. Results may be influenced considerably by the degree and method of development.

Diaphragm Means of controlling light passed by a lens. Usually a cluster of thin blades, the iris, that opens from the centre. Degree of opening is marked by *f*-numbers. Opening and closing can be controlled automatically as shutter release is operated.

Diaporama Continental term for a slide–sound show, usually employing techniques of dissolving one slide into the next during changes.

Diapositive Alternative term for a transparency.

Dichroic fog Purplish-red and green stain veiling on negative material caused by poor or exhausted acid fixing bath.

Differential focus Controlled use of focus point and depth of field so as to enhance the feeling of depth in a photograph, such as rendering the subject sharp against a background well out of focus. One of the most valuable pictorial tools of photography.

Diffusion Slight scattering of light to soften image rendering of lens or quality of light source, usually by means of a diffusion filter in front of camera or enlarger lens or translucent fabric on light source.

DIN Deutsche Industrie Norm. The film speed rating widely used in Europe. An increase of three units— e.g. 21 to 24 DIN—denotes a doubling of film speed, equivalent to one exposure stop difference. Logarithmic, whereas ASA is arithmetical.

Diopter Measure of power of supplementary lenses; it is the metre reciprocal of the lens focal length—2 diopters is 0.5 metre.

Dissolve Fading out of one slide or film image as another is introduced.

Distortion Lens aberration. Two main types are barrel distortion, in which straight lines at the edge bow out (most noticeable in wide-angle lenses), and pin-cushion distortion, the opposite effect.

Diverging lens Concave lens, one which causes rays to bend away from the optical axis.

Dodging Giving less than the overall exposure to parts of a print which would otherwise appear too dark. Done by interposing a small, appropriately shaped object in the light path of the area of the image to be dodged during exposure. Also called shading.

Double exposure Superimposing one image over another on a film frame or print. Sometimes unintentional, though most modern cameras have built-in prevention. It is often created intentionally for striking or amusing effect, either at taking or printing stage, though it is often called photomontage if done deliberately with the enlarger.

Double image Inadvertent sharp movement of camera or enlarger, causing duplicated images to appear.

Drying marks Tear-like stains on a film caused by impurities in wash water being left behind as film dries. Occurs especially in hard-water areas.

Dry mounting Bonding a print to a still mount by means of interposed shellac tissue, the bond being made by applying heat and pressure.

Duplication Making identical copies of negatives or slides ("dupes") by rephotographing them.

Dye transfer Method of making colour prints from transparencies and other colour prints using separation negatives and printing colour dye matrixes in register.

Electronic flash Artificial lighting, in the form of a repeatable high-intensity short-duration flash. The flash unit discharges a high-voltage impulse of electrical energy through a gas-filled tube when a circuit is closed by the camera's shutter synchronization mechanism. Units use either dry-cell batteries, rechargeable cells or mains power.

Emulsion The medium that carries the image on film or photographic paper. Usually takes the form of silver halides suspended in gelatin.

Enlargement A print larger than the negative made by projecting the negative image to desired enlargement on to light-sensitive printing paper.

Ever-ready case (ERC) "Tailor-made" case to carry a particular camera model, with drop front, usually removable.

Exposure Amount of light given to film or paper to form the latent image. Controlled by a combination of the aperture, which controls the intensity, and the shutter, which governs the exposure time.

Exposure bracketing Taking of extra pictures at exposures more and less than "correct", to allow for error.

Exposure counter Camera function for recording number of exposures made.

Exposure latitude Tolerance of a film to record satisfactorily if exposure is not exactly correct. Colour films generally have less latitude than black and white films, while fast black and white films have most latitude.

Exposure meter Light-measuring instrument using the principle of light energizing a photosensitive cell to produce a current that actuates a pointer to indicate a reading. Meters may be either separate units or built into a camera, the latter sometimes setting exposure automatically.

Farmer's reducer Solution of potassium ferricyanide/sodium thiosulphate (hypo) for bleaching prints and negatives.

Fill-in light Additional light to the main light source which directs light to the shadows to cut down contrast. Much used in portraiture.

Film speed Accurate measure of a film's sensitivity. Most popular scales are ASA and DIN.

Filters (optical) Pieces of clear glass, gelatin or other translucent material that modify the nature of light passing through. They may be used at the taking stage, with black and white or colour film, or in colour enlarging to give correct colour balance. Also used in darkroom safelights to give the right light quality for a specific material. Main types are colour compensating, colour conversion, contrast, correction (last two used with black and white film), infra-red, polarizing and ultraviolet.

Filter factor The factor by which exposure must be increased for a particular filter. Usually marked $1\frac{1}{2}\times$, $2\times$ etc., on the filter mount. Light-coloured types require no or little increase, deeper hues up to $16\times$.

Fisheye lens Lens with extremely wide coverage angle, possibly 180°. Distortion is inevitable, and image may be circular.

Fixing Process whereby the developed image on film or paper is made permanent so that no further darkening or fading takes place. The material is immersed in a fixer solution for a short time, then washed to remove it.

Fixed-focus lens Lens on a simple camera with focus that cannot be altered. It is set to a distance which will give greatest depth of field.

Flare Non-image-forming light in a lens, usually caused by reflections, which degrades the image.

Flash Instantaneous form of artificial light. Provided by electronic flashgun, flashbulb, flashcube, or *Flipflash*. After igniting to give a brilliant flash, a flashbulb is thrown away; flashcubes contain four such bulbs; *Flipflash* units have six or more in a bank.

Flash exposure Calculated by means of a guide number, stated for the particular flash unit and film being used. The flash–subject distance (in feet or metres according to the guide system used) is divided into this number. The result is the approximate aperture setting.

Flashing Technique of giving extra exposure to a small area in enlarging by means of a small-area light source such as a torch.

Flash synchronization Means of ensuring the shutter is open while flash is at peak of intensity. Main types are x for electronic flash, requiring a relatively slow shutter speed, usually about $\frac{1}{60}$ sec with focal plane shutter, and M, which permits between-lens shutters to be synchronized at all speeds with flashbulbs.

Floodlight An artificial, constant light source employing high-wattage lamps placed within reflectors to give even lighting over a wide area at fairly high level. Photofloods are a popular form, usually rated 500-watt, some having built-in reflector system.

***f*-number** Number on a lens diaphragm that indicates its light-passing power. It is derived by dividing the focal length of the lens by the diameter of its effective aperture. A standard scale of *f*-numbers is used to give progressive halving of light-passing power to quantify exposure setting.

Focal length Distance from the optical centre of a lens focused at infinity and the film plane. The longer the length, the more enlarged the image.

Focal plane Image line at right angles to the optical axis passing through the focal point. Forms the plane of sharp focus when camera is focused at infinity.

Glossary

Focal plane shutter A shutter that operates just in front of the film plane. It takes the form of a blind with a variable slit moving horizontally or vertically, exposing the film progressively in transit. Varying the slit width varies the shutter speed. Used in most SLRs.

Focal point Point on the focal plane where the optical axis intersects it at right angles.

Focusing screen Screen, usually ground glass in reflex cameras, which permits easy viewing and focusing of the scene to be photographed.

Fog Veiling of an image caused by light leak to the emulsion, by chemical means or by poor or over-long storage. Chemical or poor storage fog can be minimized by adding an antifoggant chemical to the developer.

Forced development Developing for longer than prescribed or at higher temperature to increase density. Fog may be a hazard.

Format Size of negative, camera viewing angle or printing paper.

Fresnel lens Special design of lens; used to give even brightness all over a reflex camera ground-glass screen.

Gamma Means of comparing contrast in the subject and that in the image when developed. It indicates the degree to which a change in exposure will affect photographic material. Developer instructions usually state a time and temperature required for a film to reach a specified gamma, this being further related to the type of enlarger to be used.

Gelatin Used in sensitized emulsion for suspension of light-sensitive silver halides. Also material for cheaper filters.

Glazing Imparting a high glaze to glossy surface printing papers by drying them in close contact with a high-glaze surface, usually with the addition of heat.

Gradation Tonal range of a negative or print. Few tonal steps indicate hard gradation, and the image is said to be contrasty. Many steps mean soft gradation—a flat image.

Grade Means of denoting printing paper gradation character. Most ranges have six or seven grades from 0 (very soft) through 2 or 3 (normal) to 5 or 6 (very hard). This permits a high degree of contrast control.

Grain Tiny black particles of silver halide in the emulsion which form the image.

Graininess Clumping together of the silver halide grains forming the image to give a rough, granular appearance, especially noticeable in areas of even tone at high degrees of enlargement. Use of fast films, long development, and overexposure are the chief contributory factors.

Grey card method Using a grey card of 18% reflectance, used to give an average-subject reading for an exposure meter.

Ground-glass screen Focusing and viewing screen of advanced cameras.

Halation Reflection from the film backing that forms a diffused image around the main image of a bright light source. It thus occurs mainly in night photographs.

Half-frame Format utilizing half the normal 35 mm frame (24 × 18mm).

Half-frame cameras give 72 shots on a full 35 mm load rather than the 36 of full-frame.

High key Photograph using mostly the lighter tones, conveying lightness and delicacy in suitable subjects.

Highlights Brightest areas in a print or transparency, densest areas of a negative.

Hot shoe Metal slot on cameras for taking flash attachments, and providing cordless sycnhronization.

Hyperfocal distance The nearest point to the camera giving acceptable sharpness at a given aperture when the lens is focused at infinity. Focusing on this distance extends depth of field, since everything will be sharp from half the hyperfocal distance to infinity.

Hypo Common name for the fixer agent sodium thiosulphate. Also used in Farmer's reducer.

Hypo eliminator Solution for removing hypo more rapidly from film or print and thus speeding up washing.

Incident light reading Taking a reading of the light falling on (incident on) the subject rather than reflected from it. Generally done by pointing a meter fitted with an incident light attachment (a translucent covering) towards the camera position.

Infinity Far distance, and in photographic terms anything beyond 1,000 m/3,330 ft. Symbol used is ∞.

Infra-red film Film that records infra-red radiations, those below the red end of the visible light spectrum. It permits photography in the dark if an infra-red light source is used. Characteristic in black and white is recording foliage as white and marked haze penetration when used in conjunction with an infra-red filter.

Intensification Chemical strengthening of the density of a weak negative image.

Intermittency effect Illustrates that a number of brief exposures does not give the same density as a single exposure of equivalent duration.

Inverse square law Law stating that illumination on a surface is inversely proportional to the square of the distance from it of the light source; twice the distance, one quarter the light.

IR mark This, on lens focus mounts, is the focus setting index when using infra-red film, as this comes to a focus forward to the visible light setting.

Joule Unit of measurement applied to the output of an electronic flash and used to compare outputs of flash systems; equivalent to a watt-second.

Kelvin Unit of measurement for colour temperature. Colour film types are balanced for a specific °K rating, such as daylight film at 5400°K.

Latent image Invisible image formed on the film by exposure, made visible by development.

Latitude Extent to which exposure level can be varied and still produce an acceptable result. Usually greater on fast films than on slow ones.

Lens cap Removeable protective cover of a lens. Interchangeable lenses should be kept with a cap covering both ends.

Lens hood Accessory for shading the front of the lens from bright light

outside the field of view. This non-image-forming light is a cause of flare.

Lens mount Means of attaching the lens to camera body. Most are bayonet or screw-thread fitting. Some lens manufacturers provide a choice of interchangeable mounts.

Lens tissue Very soft tissue free of impurities suitable for gentle cleaning of lenses.

Light leak Indicated by fogging of film. Most likely to occur around camera back joints and, in older types, through bellows pinholes.

Light loss No lens passes 100% of light entering it; some is scattered by lens/air surfaces or absorbed by glass. A complex lens of many elements loses most. Coating and multi-coating techniques reduce loss.

Linear enlargement Degree of enlargement based on increase in one dimension.

Long-focus lens One with a focal length longer than that of the diagonal of negative it covers (longer than 50–55 mm with a 35 mm camera, for example). Not an interchangeable term with telephoto. The physical length of the long-focus lens approximates its focal length.

Long Tom Popular name for very long telephoto used for press work.

Low key Photograph using mainly the darker tones, conveying sombre impressions or drama. This effect is created mainly by allowing the lighting to create heavy shadows.

Lumen Unit of measurement of light intensity.

Macro lenses Prime camera lenses which have the facility for focusing closer than normal lenses, often to a closest focusing distance of 20 cm/8 in and essentially giving life-size reproduction directly, without accessories. Lenses giving relatively close focusing, but not 1:1 reproduction ratio, are not macro lenses.

Macrophotography Close-up photography at reproduction enlargement from life-size to 10× life-size. Enlargement usually achieved by means of bellows or extension tubes, close-up supplementary lenses or macro lenses.

Magnification ratio Close-up term (sometimes known as reproduction ratio) denoting the size ratio of the actual subject to its image on film. Macro photography denotes a magnification ratio of between 1:1 and 1:10 (actual size to 10× life-size).

Maximum aperture The largest f-number (opening) on a lens. Lenses with large maximum apertures (wider than f2) are known as fast lenses.

Microfilming Copying of documents for archival storage on to film, usually 35 mm.

Microphotography Correct term is photomicrography.

Microprism Viewfinder aid of a prism system allowing a sharp image only when focus is correctly adjusted. Used in many SLR viewfinders.

Mirror lens Compact lens with very long focal length (500mm upwards) which forms the image by means of mirrors rather than lens elements. Has no aperture adjustment.

Monobath developer Processing solution that combines developer and fixer in one solution.

Montage Photograph formed from several others with the enlarger or cut out and mounted together. The second technique is also called collage.

Motor drive Camera attachment that automatically winds on film and releases shutter for a sequence of shots at the rate of several a second. Valuable for sports photography.

Negative Photographic image, usually on film, in which the tones of the original scene are reversed.

Negative formats Most popular small-format sizes are 110 (image size 13–17mm), 126 (28 × 28mm), 35mm or 135 (24 × 36mm), 120 (6 × 6cm/ $2\frac{1}{4} \times 2\frac{1}{4}$ in). Variants on the last roll film size are 4.5 × 6cm, 6 × 7cm and 6 × 9cm. Larger-format cameras mainly use $3\frac{1}{4} \times 4\frac{1}{4}$ in ($\frac{1}{4}$-plate), 5 × 4in and $6\frac{1}{2} \times 8\frac{1}{2}$ in (whole-plate), and 10 × 8 in.

Neutral density filters Filters that block a degree of light without modifying its colour content. Employed when light intensity is too great for the film, or to give some exposure control with telephoto mirror lenses, which do not have a diaphragm.

Newton's rings Rainbow-hued rings that appear between film and glass. Slides with treated surfaces minimize the problem.

Opacity Ratio of the intensity of incident light to transmitted light. The reciprocal of transmission.

Open flash Firing of flash when the shutter is held open, usually for night shots with negligible ambient light.

Orthochromatic Photo emulsion not sensitive to the red end of the spectrum. Now chiefly used for copying work.

Overexposure Action of too much light on the emulsion. An overexposed negative is very dense, requires a long printing time and may show excessive graininess. An overexposed transparency is too thin.

Panchromatic Type of black and white film in general use which is sensitive to the complete visible spectrum.

Pan head Tripod attachment that aids taking of a panoramic view in sections which will match up exactly.

Panning Technique of holding and following a subject moving across the field of view, releasing the shutter during this swing.

Paper negatives Negative image on thin paper from which same-size prints can be made.

Parallax error Difference between the field of view seen through a viewfinder and that recorded on the film. Difference is most marked when close up. SLRs avoid it completely.

Pentaprism Prism arrangement on top of SLR cameras that renders the image in the viewfinder the right way round.

Photo-electric cell Exposure meter component that generates an electrical current when light falls on it.

Photoflood Lamp with a filament used in floodlights.

Photogram Photo-images made by placing solid or translucent objects on sensitive paper and exposing to light to produce an image of their outline or skeletal structure.

Photomicrography Photography through a microscope, the camera

being attached to the eyepiece to give magnifications over 10×.

Polarized light Light that has been caused to vibrate in one plane by being reflected from a surface.

Polarizing filter Filter that cuts out polarized light to eliminate reflections from water and shiny surfaces (but not metal). It also darkens blue skies on colour film without altering other colour values.

Positive A photograph with tones having a recognizable relationship to those in the subject; that is, a print or transparency.

Positive lens Simple lens which causes light to converge to a point.

Posterization Technique whereby several negatives and positives are made from an original image, each step restricting the range of tones. When printed together in register, the result shows only a restricted range of tones.

Print contrast control Main control is by selection of appropriate paper grade. Use of soft or vigorous working developer also affords control, and techniques of burning-in and dodging give localized control.

Process film Slow film used for copying work.

Push-processing Known as pushing film, this is prolonging development to permit rating of films at faster speeds than recommended. Most successful with fast films on low-contrast subjects, and particularly useful in photo-journalism and sports photography.

Rangefinder camera Type of camera with focusing aid which relies on the exact aligning of two images of part of the subject.

Reciprocity law Principle which shows that if the product of exposure (light intensity × time) is constant, then exposure effect will be the same. Thus $\frac{1}{25}$ sec at f 11 produces the same density as $\frac{1}{100}$ sec at f 5.6.

Reciprocity law failure Failure at long and very short exposures for the reciprocity law to apply. Practically, long exposures may require longer than a meter-indicated exposure. This condition starts at about one second with colour film.

Reducer Chemical applied to reduce density of a negative. Best known type is Farmer's reducer.

Reflector Surface for directing and concentrating light. Flashlight sources and other artificial light sources utilize bright metal surfaces, often dome-shaped. White cards or sheets may be used outdoors to direct light to shadow areas.

Reflex camera One in which the image seen by the lens (or a second lens) is directed by mirrors to form the viewfinder image on a screen. Main types: single-lens reflex (SLR) and twin-lens reflex (TLR).

Refractive index Numerical value of the light-bending power of transparent materials, particularly glass.

Reproduction ratio Close-up term (also commonly known as magnification ratio) denoting the size ratio of the actual subject to its image on film.

Resin-coated paper Bromide paper with a plasticized surface that fixes, washes and dries very quickly

compared with conventional bromide paper.

Resolving power The degree of ability of a lens to provide a sharp detailed image. Scale in general use indicates line pairs per millimetre resolved. Also relates to the ability of a film to reproduce fine detail.

Reticulation A minutely detailed crazed pattern that may appear on film if temperatures of the different processing solutions differ widely.

Reversal material Film that is processed direct to a positive image, such as a colour transparency.

Reversing ring Ring for attaching a lens to a camera body (or extension bellows) back to front. This avoids loss of definition at close-focus distances.

Ring flash Unit that has a ring-shaped flash tube. When positioned round the lens it gives flat, shadowless lighting. Useful for some close-up work.

Safelight Light allowing illumination in the darkroom without damage to sensitized materials (e.g. green for bromide paper).

Scheimpflug effect Principle that notes that if projections of the planes of subject, lens and negative or film meet, then all the subject plane will be in focus. It is applied to maintain sharpness all over a subject of some depth when using a technical camera with a range of movements, or to maintain sharpness all over an enlarger baseboard tilted to correct verticals, if negative plane can also be inclined.

Selenium cell Exposure meter cell type which does not need an external battery for operation. Its spectral response is close to that of panchromatic film. As it has a relatively wide measuring angle, it is most suited for use in hand-held light meters.

Shutter Means of controlling the time that light is allowed to pass to the film. Calibrated in fractions of a second, commonly in equal steps from $\frac{1}{1000}$ sec to 1 sec. Two main types, focal plane and between-lens shutters.

Silhouette Technique of photographing a subject in outline only, achieved by shooting dark object against light background.

Silicon photodiode cell Exposure meter cell (resistance type) of high sensitivity. Needs a battery to supply power. Very sensitive with faster response and recovery that CdS cells. Incorporated in some recent camera metering systems.

Silver halides Light-sensitive salts for silver bromide, chloride and iodide in a photographic emulsion.

Silver recovery Process of recovery of the unexposed silver salts liberated in fixing. Of increasing importance because of the scarcity of silver.

SLR Abbreviation for single-lens reflex, popular camera in which the image that appears on film is also, by means of a mirror and viewing screen, that seen in the viewfinder.

Soft focus Diminishing of normal definition of a lens to give a soft, romantic appearance to a photograph. Achieved by special filters on the camera lens or by a diffusing material such as muslin in front of the enlarger lens.

Solarization Correct term for the usual application is pseudo-

solarization or Sabattier effect. A brief exposure to light is given to a print after normal enlarger exposure and short development, then development and the subsequent processes are completed.

Spectrum Bands of colour into which white light is split on passing through a prism.

Speed Sensitivity of photographic emulsions to light (incident radiation). Films have ASA and DIN numbers denoting speed.

Spherical aberration Lack of sharpness in a lens caused by light passed through the lens edges coming to a different point of focus to that passing through the centre.

Spot metering Camera TTL metering in which exposure is based on a very small area in the centre of the frame. Reading should be on a mid-grey tone. Separate spot meters are highly sensitive meters taking a reading from a very small angle of measurement, around 1°.

Standard lens That with a focal length approximately equal to the diagonal of the format it covers. It is the lens generally supplied with a camera; for 35mm models it is around 50mm focal length.

Stop Alternative name for aperture.

Stop bath Process following development, usually a dilute solution of acetic acid to neutralize the developer.

Stopping down Decreasing the size of the aperture.

Subminiature camera Small-format camera, generally using 16mm film stock.

Subtractive synthesis Method of producing colour images from complementary dyes of yellow, magenta and cyan.

Supplementary lenses Close-up lenses for attachment to the normal camera lens.

Synchronization Ensuring coincidence of the flash firing with the shutter's maximum opening.

Telephoto lens Lens of longer than standard focal length, but with shorter physical length than a true long-focus lens. This is achieved by a telephoto's optical construction.

Test strip Progressive proportionate exposing of a strip of printing paper to assess correct print exposure.

TLR Abbreviation for twin-lens reflex, a camera type with a viewing lens mounted immediately above a taking lens.

Tonal range Difference in the density between the brightest and least bright part of an image, or in the reflective power of a subject.

Tone separation Making from an original of separate negatives or positives, each containing a limited tone range, usually shadows, mid-tones and highlights. Same as posterization.

Toning Altering the natural colour of a print by a chemical toning bath. Best known application is sepia toning by sulphide and selenium toners. Gold, red, green, yellow and other tones can also be attained by using the appropriate formulas.

Transparency Positive image in a transparent base, called a slide.

Tripod Sturdy three-legged camera support, essential for long exposures.

T setting "Time" setting. Shutter opens at first pressure, remaining open until depressed.

TTL metering Abbreviation for "through the lens". Common feature of SLR cameras, the camera's internal exposure metering being actuated by light passing through the lens to a cell in front of the film plane.

Tungsten-halogen lamp Improved smaller version of the tungsten lamp, with whiter and brighter light.

Type A and B colour films Colour film types balanced for colour temperature. Type A colour temperature balance is 3400° K, Type B 3200° K.

Ultraviolet Invisible radiation having a wavelength shorter than that of the blue-violet part of the spectrum. Though not seen by the eye it will cause blue cast in colour film. Prevalent at high altitudes, near sea and in misty conditions.

Ultraviolet filter Absorbs excessive ultraviolet radiation and particularly necessary at high altitudes. Needs no exposure adjustment.

Underexposure Condition where insufficient light has fallen on the emulsion to form a sufficiently strong image. An underexposed negative is too thin, a transparency too dense, a print too dark.

View camera Large-format plate camera where image is seen on a ground-glass screen. Used mainly in the studio or for architecture, where its movements give great control of depth and perspective.

Viewfinder Apparatus for viewing and sometimes focusing, either direct vision, optical, reflex or ground glass.

Viewpoint Position of the camera in relation to the subject or scene.

Vignette Printing technique in which the image fades into the edges and corners.

Washing Immersion of a fixed emulsion in running water to rinse out the fixer salts.

Weston speeds An obsolescent speed rating system, similar to ASA but $\frac{1}{3}$ stop "slow". Modern Weston meters use the ASA system.

Wetting agent Solution in which a film is immersed after washing. It reduces surface tension, enabling the film to dry quicker.

Wide-angle lens Lenses with a wider angle of view than that of standard for the format.

Working solution A processing solution at the correct dilution for use.

X-ray Electromagnetic radiations that can produce a visual representation of the internal structure of an object.

Zone system Complex system relating exposure readings to tonal values in negative and print. Evolved by Ansel Adams.

Zoom lens A lens of variable focal length. Various types available cover a focal length range from moderate wide-angle to medium telephoto, from about standard to moderate telephoto, or from moderate to long telephoto. There are two methods of changing the focal length: helical, the barrel being turned, or rectilinear, when it is pushed back or forward. Similar to zooms are "variable-focus" lenses, but they require refocusing after altering the focal length.

Index

Index

Index

Acknowledgements

The editors would like to express their gratitude to the following for their assistance in the production of this book:

Pat and Julian Busselle; Brian Coe of the Kodak Museum; Peter Sutherst of Kodak; Simon de Courcy Wheeler.

British Journal of Photography; The Photographer's Gallery, Great Newport St, London WC2; Sir John Soane Museum, London WC1; Susan Griggs Agency.
Chelsea Cobbler, Irvine Sellars, Mr Henry and Top Shop, all of London.

Photographers

Paul Brierley
Julian Calder
Simon de Courcy Wheeler
John Garrett
Angelo Hornak
Eric Hosking
Naru Inui
Eugeniusz Kokosinski
Leo Mason
Roger Phillips

Retouching

Roy Flooks

Index

Michael Gordon

Artwork

Brian Delf 48 (shutters), 192–3
Bill Easter 170–1
Tony Graham 172–3, 180–1
Hayward & Martin 62–3 (frieze), 179
Trevor Hill 42 (lens), 46–7, 50–1, 52–3, 54–5

MITCHELL BEAZLEY STUDIO:
Chris Forsey 32–3, 58–9, 60, 74–5, 112–13, 142–3, 161, 176–7, 182–3, 190–1, 199, 200–1, 206–7
Mick Saunders 41, 56–7, 100–1, 133, 140–1, 200–1, 208–9
Alan Suttie 38–9, 40, 42–3, 44–5, 62–3 (equipment), 64–5, 66–7, 72–3, 82, 194–5, 200–1, 202–3, 204–5

Equipment

KEITH JOHNSON PHOTOGRAPHIC, Great Marlborough St., London W1.

Dixon's Photographic Ltd., Edgware, Middlesex.
Durst Inc., Bolzano, Italy.
E. Leitz (Instruments) Ltd., Luton, Bedfordshire.
Hasselblad (GB) Ltd., Wembley, Middlesex.
Japanese Cameras Ltd., Newcastle, Staffordshire.
Kodak Limited, Hemel Hempstead, Hertfordshire.
Olympus Optical Co. (UK) Ltd., Honduras St., London EC1.
Paterson Products Ltd., Boswell Court, London WC1.
Pelling & Cross Ltd., Baker St., London W1.
Polaroid (UK) Ltd., St Albans, Hertfordshire.
Rank Photographic, Rank Audio Visual, Brentford, Middlesex.
Rentacamera, Broadwick St., London W1.

Unless otherwise indicated in accompanying captions or listed below, all photographs in this book were taken by the author.

Associated Press (Wide World) 165 bottom right
McCord Museum 35 centre right
Bettmann Archive 30 top and centre bottom, 31 bottom right, 33 top right
Bob Carlos Clarke 4–5
Bruce Coleman Agency 90 left, 150, 158 top and bottom, 159
Colorific 90 right
Daily Telegraph Syndication 154 bottom
Eugeniusz Kokosinski 185 bottom, 188 centre and bottom (four pictures)
Kodak Museum 30 bottom left, 31 top, 34 centre right, 36 bottom, 37 bottom left, 38 centre (three photomicrographs)
Leica 52 top
Library of Congress 166
Mansell Collection 32 top left, top right and centre left
Mary Evans Picture Library 32 bottom left, 36 left and centre

Michael Barrington-Martin 195
Neill Menneer 1, 2–3
Olympus 196–7
Polaroid 201
Popperfoto 37 centre left
Radio Times Hulton Picture Library 30 centre, 31 centre left, 32 centre left, 33 centre, 37 top
Rex Features 110 top
Royal Photographic Society 31 bottom left, 34 centre left, centre and bottom, 35 top left and bottom
Science Museum, London 31 centre right, 33 centre top, 37 bottom right
Slavin Processing 70–71 (Photograph: Michael Busselle)
Snark International 35 top right
Société Française de Photographie 30 centre right
Victoria and Albert Museum, London 35 centre left, 37 second from top and centre right